W9-CJM-675

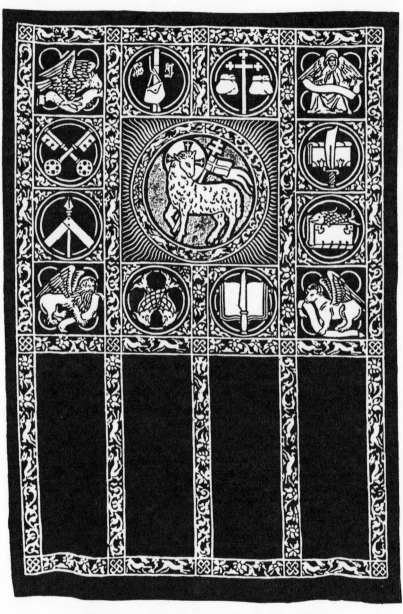

Dorsal for St. Giles' Chapel, Garden City, Long Island.
DESIGNED AND MADE BY J. M. AND A. T. HEWLETT.

CHURCH SYMBOLISM

AN EXPLANATION
OF THE MORE IMPORTANT SYMBOLS OF THE OLD
AND NEW TESTAMENT, THE PRIMITIVE, THE
MEDIAEVAL AND THE MODERN CHURCH

F. R. WEBBER

INTRODUCTION BY
RALPH ADAMS CRAM
LITT.D., LL.D., F.A.I.A., A.N.A., F.R.G.S.

SECOND EDITION, REVISED

Republished by Omnigraphics • Penobscot Building • Detroit • 1992

246.55
Wec

Library of Congress Cataloging-in-Publication Data

Webber, F.R. (Frederick Roth), 1887–1963.
 Church symbolism : an explanation of the more important symbols of
 the Old and New Testament, the primitive, the mediaeval, and the
 modern church / F.R. Webber : introduction by Ralph Adams Cram.
 p. cm.
 Originally published: Cleveland : J.H. Jansen, 1938.
 Includes bibliographical references and index.
 ISBN 1-55888-941-8 (lib. bdg. : alk. paper)
 1. Christian art and symbolism. I. Title.
BV150.W4 1993
704.9′482--dc20 92-42460
 CIP

∞

This book is printed on acid-free paper meeting the ANSI Z39.48 Standard.
The infinity symbol that appears above indicates that the paper in this book
meets that standard.

Printed in the United States of America

TABLE OF CONTENTS

LIST OF PLATES — PEN DRAWINGS

LIST OF PLATES — PEN DRAWINGS

LIST OF HALF-TONE ILLUSTRATIONS

LIST OF HALFTONE ILLUSTRATIONS — *Continued*

LIST OF HALFTONE ILLUSTRATIONS — *Continued*

INTRODUCTION

PHILOSOPHERS tell us that the Absolute, the ulti-
mate Truth that lies behind the show of things, can
only be apprehended or expressed through the sym-
bol. Man touches and sees only the outer fringes, the
deceptive phenoma of Reality, for by his very nature, the
limitations of his quality and sensible powers, he is forever
(within the limits of earthly life) debarred from laying hold
of substantial Verity. Yet this final Truth is there, under-
lying and sustaining and motivating all things, and dim
intimations thereof are always darkly revealing themselves
in dream and vision, for "God has never left himself without
a witness", and it is by these vague revelations that we live.

Absolute Truth is not for us here on earth, for its flame
would not vitalize but destroy. As in the classical fable,
the mirrored reflection alone is harmless; and the mirror
is dim and clouded, sometimes even the agency of distor-
tion. So also when the effort is made sensibly to show forth
in visible form the partial revelation of the reflective glass,
it must be by means of these similes familiar to us in life;
the partial approximation, the creative and stimulating an-
alogy; the Symbol.

That is why we have art in all its varied forms, for in its
highest aspect and function art is the symbolical expression
of otherwise unexpressible ideas. No other faculty or

power of man can do this thing, and as the power of appre-
hending Reality (though "as in a glass darkly") is the chief-
est discriminating mark of Homo Sapiens, so art is his most
priceless attribute and possession. And this is true of all
the arts–architecture, music, painting, sculpture, poetry,
drama, and in perhaps lesser degree the so-called "artist
crafts" and even the dance. Art, if it is worthy the name, is
primarily the manifestation of beauty of some sort, and this
beauty is not, as some curiously hold today, a variable and
a personal reaction or idiosyncrasy; it is in certain ways
absolute. Neither personal taste nor changing fashion can
make the parabolic curve of a Doric capital or a Gothic
moulding other than beautiful, or a cubist sculpture or post-
impressionist still-life or an art nouveau apartment house
other than ugly. In some mysterious way there is kinship
or analogy between this visible beauty and the underlying
truth of creation, just as there is between the swift curves of
a Greek vase and mathematical laws and geometrical for-
mulae. The Greek potter knew nothing of mathematics;
he fashioned his amphora or calyx on certain lines because,
being a cultured man, though ignorant, he felt the lines
were right and knew they were beautiful. It has been for
us, two thousand five hundred years later, to discover the
analogy.

Now these lines, together with colours, textures, musical
sounds, and a score of other elements besides, may be com-
bined into great and intricate syntheses that we call works
of art, and as they increase in complexity and approach the

fullness of perfection, so does their power grow for the expression and the revelation of emotion. Minor symbols coalesce into a great symbol, and so life is made richer, its significance and potentiality more clearly revealed. Through the symbol man lays hold, though doubtfully, on the fringes of Reality itself.

But it is not alone in art that the symbol becomes potent, revealing, evocative. In a sense all things in nature partake of this symbolic quality, while art and gesture and the spoken word, and the concrete idea, may add to their primary and obvious significance, symbolic character. All the highest impulses and emotions we have are expressible only through symbolic agencies. That is why ceremonial, both secular and religious, is inseparable from social life the functions of the state, above all from religion itself. The abandonment of ceremonial in the affairs of life that, for some inexplicable reason, accompanied the spread of democracy and was held to be of its esse; the renunciation of ritual and liturgics as well as all forms of art and beauty that was equally held to be (and probably was) a part of Protestantism, were not only a fatal weakening of the causes themselves, but a clear evidence of an internal and essential lack for which no substitute was possible, or even imaginable. Man lives by symbols, and if those that are just and veracious are taken from him he will invent others, but these are always thin, poor, ugly and without significance, in that they are made to order by ingenious though ignorant mechanicians, and do not lay hold on ultimate things.

Of course, being a great virtue, symbolism has its danger, and that is that in degenerate times the symbol may be taken as the very thing symbolized. This is what is meant by "idolatry" and it is against this that the Lord's commandment was declared; not as the Jews, Iconoclasts, Mohammedans and some Protestant sects have held, against the image or the symbol itself. After a long period of the rejection of the symbol by many peoples, with the consequent loss of sense of Reality, there is now surprisingly, a recurrence of this old idolatry. The symbol returns, but it is now not this, but a fetish. Of course, at the same time, though thus far chiefly in certain manifestations of religion, the true use of the symbol and of symbolism is being restored. The true and the false confront each other, diametrically opposed in nature and in ideal. It is impossible too strongly to emphasize the importance of the subject at this time, for along one line lies life, along the other death. Such a book as this, to which I am permitted to affix this prefatory note, can only play a most valuable part in fortifying truth against falsity and in furthering the great restoration of sound and creative ideas in a society that has suffered grievously from their absence.

RALPH ADAMS CRAM.

PREFACE

A SYMBOL is a story told by a familiar sign. We are familiar enough with the devices used to direct the traffic of our city streets and our railways. We recognize at once the signs used by various tradesmen, and the trade-marks of the manufacturers. All these things are symbols.

Religion has its symbolism, and the books on this subject, if collected, would form a small library. The altar expresses outwardly our belief in the Holy Eucharist, and the font indicates that we believe in Baptismal Redemption. The crucifix on the altar reminds us of the Passion of our Lord, and the plain cross on the spire symbolizes Finished Redemption. Even the three-fold and the seven-fold divisions so commonly used in ecclesiastical design are significant.

A symbol is also a mark of identification. It is simpler, more quickly understood and perhaps more artistic than a line of lettering. The architect will place five carved figures in the reredos, and we will assume that they represent our Lord and the Four Evangelists. In order to identify them, he will encircle the head of our Lord with the tri-radiant nimbus, and at the feet of St. Matthew he will place a winged man, while beside St. Mark will be a winged lion, beside St. Luke a winged ox, and beside St. John an eagle.

If the stained glass man decides to use the Twelve Apostles in the windows, he will use some device or symbol to distinguish each one. To St. Peter he will give two keys, to St. Andrew a saltire cross, while St. John will hold a chalice out of which a viper is emerging. All of these marks of identification are very old, and are known the world over.

Symbols have been used to express abstract ideas. It would be hard to portray in Christian art the idea of the Atonement. The pelican, feeding her young with her blood, expresses this fact. Eternity could hardly be represented in Christian art except by the circle, nor could the Trinity be expressed without the triangle or the interwoven circles.

There is danger today of carrying the matter too far. Many of our newer churches have used symbols where there is no reason for using them. If there are seven panels in a reredos, many a designer will insert seven shields, each charged with a symbolic device, even though there be no carved figure to identify nor an abstract thought to express. He does it because a shield with an IHC or a cross on it is more easily drawn than a good traceried panel.

The triptych in Ashburton parish church, shown elsewhere in this volume, is an illustration of a thoughtful use of symbolism. It illustrates the use of symbols both as an identifying mark and as an expression of abstract ideas. In the upper part of this triptych are about forty carved figures. Some of these are easily identified, such as our Lord on the cross, with the Blessed Virgin and St. John at either side of Him. Others, less easily recognized, are distinguished from one another by their traditional symbols. St.

Peter holds his keys, Bishop Grandisson is given his pastoral staff and model of a shrine, St. Gabriel the Annunciation lily, St. Sidwell her scythe and book, St. Gudwell his staff and model of a church, St. Lawrence his gridiron and martyr's palm, and St. Andrew his cross saltire. In the lower part of the reredos it was necessary to express twelve truths connected with the suffering and death of our Lord. This was done by the use of twelve angels, each of which holds a shield, charged with a symbol whose meaning is at once apparent. This reredos, by Herbert Read, Esq., the famous Exeter sculptor, is an example of symbolism thoughfully used, for here the symbols themselves are secondary to the thoughts they so well express.

There is a close analogy between the correct use of symbolism and the use of church music. Any thoughtful musician will say that church music is not to be used as an end in itself. It is only a means to an end. Its purpose is to express beautifully certain religious truths. To do this, it must be impersonal. When music becomes so ornate or so assertive that we are led to admire the melody itself, and lose sight of the truths it seeks to proclaim, it has failed in its purpose. It has become a mere performance, to exhibit the skill of the singers, rather than a vehicle used to express profound thoughts. So it is with symbolism. Like music, it must be subordinated to the truths it seeks to set forth. Too much of our modern symbolism has attracted attention to itself, rather than to the meaning back of it. In doing this, it becomes little better than the story of the foolish apothecary, who placed a sign in his window so

large and so arresting that it obscured entirely the prod-
ucts to which he was calling attention.

It must not be forgotten that some symbols call for a
certain sequence. Should we attempt to use the symbols of
the Church Year, there should be a complete set of them,
beginning with Advent, Christmas and Epiphany, and rep-
resenting each important festival or season down to Mich-
aelmas and All Saints' Day. Where the Passion Instruments
are shown, they must begin with the chalice and pointed
cross of Gethsemane, and tell the entire story in logical
order. It is not well to disregard this sequence, neither is
it good to add to it things which do not belong there. We
have in mind a church, over the door of which are the
symbols of the Holy Trinity and the seal of a sixteenth
century reformer. In another church are grouped together
a font, a chalice, a hand resting upon a child's head, a Bible,
a smoking censer, and a scroll with a few notes of Plain-
song. In the one case the impression is given that there are
four Persons of the Holy Trinity: in the second example
it would seem to indicate that the Sacraments of the Church
are Holy Baptism, Holy Communion, Confirmation,
Preaching, Prayer and Church Music. Symbolism can be-
come the means of teaching sound doctrine, but we must
avoid careless blunders which would make it teach bad
theology.

There is an appropriateness in the use of symbols. To
place the Passion Instruments upon the sides of an Octa-
gonal font is hardly appropriate; neither need one paint a

cross, or an IHC on each organ pipe, as was done some thirty years ago. Many utilitarian things do not require symbolism. There is no reason why a symbol need be placed upon a shield. A circle will do just as well in some instances, or else some such figure as Mr. Cram has used in the Malden altar, a plate of which is shown at the end of this book.

We have made no attempt to confine ourselves to any one denomination. A book on symbolism is like a dictionary. It must contain a wide variety of things, if it is to be useful at all. To make the book more complete, we have included a number of Jewish symbols, as well as those commonly used both in Catholic and in non-Catholic churches. The architect and the designer must be ready to lay his hand on all of these, and the general reader will want to know, at least their meaning when he sees them on the facades of the churches which he passes daily.

We wish to express once more our thanks to several men who placed photographs and other material at our disposal when the first edition of this book appeared some years ago. Their names were mentioned in the Preface to that edition. To those who have contributed photographs and line illustrations to the present revised edition, or have assisted otherwise, sincerest thanks is extended.

F. R. WEBBER

Feast of the Holy Trinity,
1938.

CHAPTER I.

THE LANGUAGE OF SYMBOLISM

EVERY department of human thought has a language of its own. When a Philadelphia lawyer undertakes to sell a tract of land, he does not simply sell it. He states in an imposing document that he has "granted, bargained, sold, alienated, enfeoffed, released and confirmed, and by these presents do grant, bargain, sell, aliene, enfeoff, release and confirm" the following parcel of land as described hereinafter to wit. No attorney, however matter-of-fact in other things, would think of discarding the traditional verbiage of his profession. The same may be said of the physician, the chemist, the scientist, the architect, and of all the trades and crafts.

Such technical language serves an important purpose. It may sound absurd to the uninitiated, but it is of highest value to the specialist, for it enables him to express exact shades of meaning. The title to one's property, or his very life, may depend upon the ability of one's attorney or his physician to express his intentions accurately.

In all branches of Christian art, whether it be architecture, painting, sculpture, music, ceremonial or symbolism, there are certain technical terms employed by all writers, regardless of their theological views. To disregard such

traditional expressions would cause a person to seem as ridiculous as a seminarian of some years ago who had an hour of extreme practicality, and translated the stately language of the old Church Year Collects into very pithy, modern, Anglo-Saxon terms. He was utterly sincere, but his efforts resulted in furtive merriment rather than the edification of those who heard him.

In writing or speaking on the subject of Christian art, or any of its subdivisions, good usage and an unbroken tradition demand that we speak of the Holy Trinity, the Ever Blessed Trinity, or the Holy and Undivided Trinity, and not simply the Trinity.

In all works pertaining to any of the fine arts in the Church's service, it is considered improper to speak of the Second Person of the Trinity merely as Jesus Christ. The customary term used is Our Lord. Often the term Our Saviour is used, always spelled with the lower-case u. Or, He may be called Our Redeemer, or Our Lord Jesus Christ, but never merely Jesus, or Christ, or the ultra sectarian expression "the Master." We would most earnestly commend this custom to any clerical reader of this volume who might have fallen into the modernistic, somewhat flippant and all too familiar habit of speaking of our Divine Redeemer simply as Jesus, or Christ. Few things jar so painfully upon the cultivated ear as the tent-meeting habit of speaking of our Saviour without using some adjective of respect in connection with His name.

In writing or speaking of symbolism and the other arts,

it is considered bad form to say simply Baptism. The proper term is Holy Baptism. Likewise one refers to the Sacrament of Our Lord's Body and Blood not as communion, but as the Blessed Sacrament, for the symbologist looks upon this as the one Sacrament pre-eminent. In Christian art the expression Blessed Sacrament refers to the Lord's Supper and nothing else.

In Christian art, we may also speak of the Holy Eucharist, or the Holy Communion, but rarely if ever do we hear of the Blessed Eucharist or the Blessed Communion. The Lord's Supper, in works pertaining to Christian art, is said to be celebrated, and never merely served, observed, or administered, as is said by those who do not accept the doctrine of the Real Presence. Likewise the Real Presence is taken for granted by writers on symbolism and the other arts, for such writers always assume the maximum, rather than the minimum of belief and never indulge in blue-pencilling the Holy Scriptures, or whittling down the teachings of God's Word to meet the desires of the liberalistic mind.

In speaking of the Virgin Mary, it is customary among men of every theological connection who have written on matters artistic, to refer to her as the Blessed Virgin, or Our Lady, or the Mother of Our Lord. Even the most radically minded of today's Protestants adopt these traditional terms the moment they essay to discuss the subject of Christian art.

Similarly, they speak of many persons, never canonized outside of the Roman Catholic Church, as saints. Even

the most ardent sectarian will not object to speaking of
the great missionary to the Gentiles as St. Paul, or to the
beloved disciple as St. John. Most religious bodies refer
to all of the holy men of the New Testament as saints, such
as St. Thomas, St. Luke, St. Stephen and St. John the Bap-
tist. But Christian art goes farther, for it applies the same
term to the Church Fathers and to any man or woman who
may have rendered conspicuous service to the cause of re-
ligion, whether we agree with all of his theological postu-
lates or not. Thus, in all books on Christian symbolism
with which the writer of these lines is familiar, it is custom-
ary to speak of St. Ambrose, St. Basil, St. Augustine of
Hippo, St. Patrick, St. Boniface, St. Elizabeth of Hungary,
St. Denis and St. Martin of Tours, to mention but a few.

Why should there be any objection? Even the most
dyed-in-'he-wool Calvinist will not hesitate to say that he
lives in St. Paul, St. Louis or San Antonio, or that his store
is located on St. Clair avenue, or that he expects to have a
holiday on St. Patrick's Day, go to church on St. Sylves-
ter's evening, or see the Cathedral of Notre Dame (Our
Lady), or the church at Mont-Saint-Michel.

Times are changing in this respect. A few years ago,
when Puritan influence was still strong and Calvinistic
simplicity still very evident, such expressions as the Blessed
Sacrament, Saint John the Baptist, or the Blessed Virgin,
might be relied upon to bring down upon the unhappy
speaker charges of high-churchism. But matters are dif-
ferent today. Not long ago a man of decided Unitarian

belief delivered a lecture in which he referred repeatedly to Our Lord's Mother as the Blessed Virgin and Our Lady. Shortly afterward, a man of most pronounced Protestant theological views delivered an evening lecture two hours in length on St. Francis of Assisi, and was interrupted by the ringing applause of several hundred people representing the non-Catholic denominations.

The violent revulsions of the Puritans are certainly on the wane, and "the Churches" are reaching a stage where it is once more possible to spell Bible with a large B, and Heaven with an upper-case H without bringing upon one the charges of ritualism; when a true altar of ample architectural scale, a chancel of comfortable depth, even crosses, candle-sticks, clerical vestments, surpliced choirs, absolution, and the sign of the cross in the benediction are not looked upon as superstition.

Since certain expressions are decreed by long and unbroken usage in matters of symbolism—expressions such as the Ever Blessed Trinity, the Blessed Sacrament, the Holy Christian Church, and Our Lady, we will not be so eccentric as to refuse to conform to long established terminology, for after all, an eccentric person is he who refuses to follow the beaten path, but carries his cherished right of private judgment to all manner of absurd extremes. Even though the more supersensitive of our readers may frown at the very idea of the terms Blessed Sacrament, or St. Gregory, custom decrees that we use them, or else abandon all

attempts to discuss Christian symbolism. We have said **A,** and we must say the proverbial B also.

A shouting evangelist in a deal-wood tabernacle may prove to be quite forceful in his matter-of-fact language, but who will say that his picturesque Anglo-Saxon terms carry with them the same feeling of devotion as the dignity of the King James Version, or the Church's ancient liturgies? Above all things we want to use the respectful language of Christian art, and assume that all men are sincere until they have been proven otherwise, whether they live in the thirteenth century or the third.

CHAPTER II.

THE PURPOSE OF SYMBOLISM

SYMBOLS have been used in all ages because of their recognized educational value. Even pagan nations have made use of them. A symbol, as Mr. M. Williams has noted, must be a representative of something and not a representation. In other words a picture of Samson slaying the Philistines is not a symbol of Samson, but the jawbone of an ass is.

The early Christians employed symbolism freely in the catacombs, those endless underground mausoleums of early days. We will discuss that subject later. St. Clement of Alexandria, in the second century, urges Christians to give attention to symbolism, even in the decoration of their household utensils. He mentions the dove, the lyre, the fish, the ship and the anchor. Dr. Bennett's *Christian Archaeology* will give one an idea of the extensive use of symbolism in early days. The golden age of symbolism, however, was reached in the Middle Ages. A few years ago it was popularly supposed that nothing worthy of note happened before the Renaissance. It was believed that men lived in utmost darkness, with soul-destroying superstition and grossest ignorance rampant; that the world was overrun with cruel feudal princes and stupid monks, none

of whom could so much as read or write, much less produce intelligent symbolism or any other work of art. We were assured that it was the Renaissance that brought about an era of enlightenment and a revival of learning.

Professors of philosophy have been known to tell their classes to "skip the next 200 pages," assuming that nothing worthy of note was done between the years 500 and 1500. Now it is a fact that we cannot understand Mediaeval art of any sort unless we possess at least a working knowledge of Mediaeval philosophy. If we assume that no such school of philosophy existed, then it is but natural that we' deny the existence of any worth-while Mediaeval art.

We have neither the time, the available space, the erudition, nor the desire to burden the reader, hence we will not digress to the extent of giving an outline of Mediaeval philosophy. In order to be brief, we will refer the reader to such great men of the earliest period of Mediaeval philosophy as John Scotus Erigena, Rabanus Maurus, Eric and Remigius of Auxerre, Gerbert, Fulbert, Berengarius of Tours, Lanfranc and Hildebert of Lavardin. For the day of further growth we might select such names as those of St. Anselm of Canterbury, Roscellinus of Compiegne, William of Champeaux, Abélard, St. Bernard of Clairvaux, Bernard of Chartres, Peter Lombard, Hugo and Richard of St. Victor, John of Salisbury, William of Auvergne and several others whose names we cannot recall offhand. The period of full bloom comes with such men as Alexander of Hales, Albertus Magnus, Robert Grosseteste of Lincoln, Michael

Scotus, Vincent of Beauvais, St. Bonaventure, Albert of Bollstaedt, St. Thomas Aquinas, Duns Scotus, Henry of Ghent, Ricardus de Mediavilla, Siger of Brabant, Peter of Lisbon, Raymond Lully, Petrus Aureolus, William Durandus, William of Occam, John Buridan, Peter of Ailly, Albert the Saxon, Marsilius of Inghen, Thomas of Bradwardine, Thomas of Strasbourg and Roger Bacon. The list is far from complete. We feel tempted to add St. Peter Damian, Peter of Poitiers, David of Dinant, David of Augsburg, and the German mystics Eckhart and Tauler. Even then the list is fragmentary. Then there were the great Mediaeval Jewish and Arabian schools of philosophy. Philosophical ideas of the period, almost as much as the theology of the age, had its effect upon the development of Mediaeval art, and especially upon symbolism.

We might excuse learned folks for passing by Mediaeval philosophy with an impatient gesture, for there are no monuments in three dimensions to remind us of the period. But just why it is that men have been passing by such magnificent monuments as Reims and Chartres without being impressed with the fact that such great achievements could not possibly have been the product of an age of absolute ignorance, is a mystery.

What strange reason lay back of this? Reims Cathedral towered in all her majestic perfection as she had stood for seven hundred years. Yet Reims was a thing too beautiful for our ultra-practical age, unable as we were to interpret the endless wealth of mystic symbolism carved upon her

glorious west front, and to be seen in her equally splendid stained glass. Her structural organism, easily the greatest engineering triumph of any age, was ignored.

Chartres had existed for as many centuries as Reims, with her justly famous sculptured portals, the 1,500 carved figures, the celebrated southwest tower; and her windows, 130 in all, which have been described fully by the late Henry Adams, and praised by scores of other critics who consider them superior to all.

Both of these products of the early Middle Ages were close to Paris, but who of all the learned ones who visited Paris annually were able to detach themselves long enough to make the short trip to see Reims and Chartres? Only a small minority, and when they returned singing the praises of these superb monuments, who was there to listen? It was only when Reims was showered by a hail of shrapnel, and her amazing carvings, her glorious glass and her matchless interior ruined forever that the world began to realize the enormity of the loss. The Parthenon, the sphinx and the pyramids might better have been destroyed.

That Reims and Chartres, and a long list of efforts almost equally wonderful, had no message for the mammon-mad, commercialized civilization of the past century or two, fairly disrupts one's conjectural faculty. Fairford's windows, St. Neot, and the glory of Chartres' glass, and the perished glass at Reims, and what still exists at St. Denis, Bourges, Poitiers, Le Mans, Angers, York, and in the north aisle of the choir, the Trinity Chapel and the Corona at Canterbury,

was passed by with a word or two of momentary admiration, and then forgotten. The message of the legendary sculptures at Reims, Amiens, Laon, Senlis and Notre-Dame-de-Paris were ignored as much as the over-ripe magnificence of the Sainte Chapelle, Rouen, Troyes and the nineteenth century stiffness of Cologne were admired.

Who, other than a small group of especially interested persons took the trouble to pass by Stoke Poges, Ann Hathaway's cottage or Peeping Tom's house, for the sake of seeing some of the elaborate wood carvings that crowd almost every little, thick-walled church in Devonshire, Cornwall and Somersetshire? The fine Mediaeval metal work of the German craftsmen was hardly known even to the interested minority. In the matter of painting, who ever was known to mention anybody before the days of Raphael and Leonardo? True enough, little remains of the early school of Monte Cassino, and only battered fragments tell us of what the works of Cimabue, Duccio, Cavallini, Giotto, Simone Martini and Pietro and Ambrogio Lorenzetti must once have been. As for the acres of glowing Bible pictures and the scenes from Church history that once covered the walls of many Mediaeval churches, almost every trace has been scraped away in the larger churches.

Grope your way down the dark stairways and visit the crypt of the Yorkshire Philosophical Society's building in York, (unless you are more interested in the collection of birds' eggs and the skeletons of race horses in the museum proper), and turn on the pale, dusty electric lights. There,

piled as high as one's head, in the gloomy crypt may be seen sculptured figures and symbolic detail as finely and painstakingly done as anything in the days of Phidias, Polyclitus, Praxiteles and Skopas. Pick up a severed head of pure alabaster, and note the Grecian-like perfection of perfect craftsmanship, but with a spiritual, devotional quality that the immobile Grecian faces never possessed. It has a technical perfection that is the rival of the Hermes of Praxiteles, and a haunting mysticism about it that one will see in the darkness of the night for a week. Pick up a carved capital, with delicate foliage so deeply undercut that one may hardly plumb its depth with the length of one's lead pencil. Pick up a carved *Agnus Dei* shield of blue Purbeck marble, or a strip of pierced grape-vine moulding, minutely perfect, and then say if you will that the Middle Ages were actually fallow in artistic things.

There is more than artistic excellence in these carvings. Whether one beholds the shamefully calcined medallions on the doorways of St. Mary's, Glastonbury, or the too-much restored figures that crowd the west fronts of Exeter, Wells, Salisbury, and Lichfield, or whether it be a bit of detail in the enormous fastnesses of Durham, the supreme merit of each lies in the fact that it is primarily symbolical, and not just clever decoration, designed with F pencil and a T square.

What Reims, Chartres, Laon, Bourges, Bordeaux, St. Mary's at York, Glastonbury, Tewkesbury, Romsey, Guisborough, and possibly even Jumièges, Caen, St. Martin of Tours, Cérisy and thousands of other great churches must

have been before they were robbed of much of their splen-
dor, one may only guess. One thing is certain. Just
enough remains to assure us that every Mediaeval church
was a great picture book, and that the pictures were highly
decorative. There was no striving for theatrical effect,
no decoration merely for decoration's sake. Every detail
had its meaning, whether it was wrought in stone, in wood,
in painted glass, in beaten metal, in mural paintings, in rich
tapestries or in sumptuous needlework.

The Mediaeval artist and craftsman turned every church
into a richly colored text book on Bible History. Almost
all the screenwork at Ashton, Ken, Holbeton, Harberton,
Halberton, Kenton, South Pool, Swymbridge, and scores
of other Devonshire churches was overlooked in the days
of destruction. A little of the twelfth and thirteenth cen-
tury glass remains elsewhere, but almost every church is
scraped quite bare of the wonderful color and gold that
once covered carved detail, and even the walls. The great
tapestries are all but extinct, and almost nothing remains of
the old-time needlework, and the wealth of metal work.

The purpose of all this was educational. Books were
lettered by hand, and very costly. Many of them were
chained to their desks for the same reason that we chain a
cup to the town pump: to keep folks from walking away
with it. Churches were so huge that public speaking must
have been difficult. The abbey church at Glastonbury is
just 594 feet long, including the Edgar Chapel lately
excavated, which stood back of the high altar. Since books

were scarce, and churches were enlarged so often that oral instruction finally became very difficult, the early artists and craftsmen came to the rescue, and made each church a great, glowing picture gallery. The smaller churches followed the example of the larger ones. The theory was that the ear is not the only avenue to the soul, nor the printed page the only method of expressing truth. It was believed that men might be trained to interpret symbols, and that an emblem of the Fall of Man might remind the sinner of his own lost condition, and a symbol of the Crucifixion might recall to his mind the only way of salvation.

We may learn from what remains of the magnificent screens at Ashton, Lapford, Kenton, Kentisbere and Bridford, Dartmouth, Atherington, Pinhoe and a hundred other equally interesting examples, the unbelievable amount of labor that was bestowed year after year upon the smallest churches. But try to visualize the paintings that covered walls and carved screenwork, the glass that filled every window, the shields that adorned the roof trusses (some still exist), the encaustic tiles in the floors that rivalled Rouge Flambeau in richness of coloring, as very recent excavations at the site of some of the old abbeys have disclosed, and the elaborate carvings that covered the great, rectangular bench ends. We reproduce a few details of such pew in the plates at the end of this volume.

Preposterous as the statement may sound, yet it is true that wherever one might look, whether within a great abbey church or cathedral, or whether in a small country church

seating but forty people, a wealth of carved, painted, em-
broidered or otherwise cunningly fabricated symbolism
met the eye. Attention was given even to the exterior, as
may be seen from the carved doorways at Adel Church just
north of Leeds, Iffley near Oxford, the western processional
doorway at Ely, and countless others. Symbolical carv-
ings may be found carved in lofty places, so that even the
organ-tuner, climbing to his dizzy runway sixty feet above
the choir steps, might see delicately wrought reminders of
man's sin and the fact of Redemption. Visit Alan of Wal-
singham's terribly desecrated Lady Chapel at Ely, and from
the shattered wall-arcade try to picture what this extraor-
dinary place must have been in the fourteenth century, be-
fore cruel fanaticism reduced these long stretches of deli-
cate, stone-wrought lace into battered wreckage.

These words are positive wormwood to many really
splendid people who believe in all sincerity that religion
and art were equally corrupt in the Middle Ages. But go
and see. Forget London and Paris and Berlin long enough
to explore forgotten by-paths in those locations missed by
the destroyers, and where the hand of fanaticism dealt with
moderation! Go with a heart open to conviction, and the
change of mind will be cataclysmic.

Ask the kind-hearted vicar of St. Cuthbert's Church at
Wells, to conduct you through this shell of former magni-
ficence. A few hints, pathetically wrecked, remain of the
elaborate Jesse Tree carvings. The great screens are gone,
the glass has been replaced by inferior modern work, the

fine pulpit is no more, but has been replaced by one of later date. Not a sign of a mural painting remains. On a long shelf near the west door a few fragments of the old stone sculptures are kept, giving us an inkling of what is no more. St. Cuthbert's is but one of thousands of examples.

Whatever one may think of the theology of those days, even the most extreme anti-mediaevalist must admit that it was an age of unexcelled art, and that religion was a passion to a degree that might be called fanaticism today. At what other period have kings and princes laid aside their royal finery, and peasants left their ploughs to rust in the field, while all worked side by side, from early dawn until dark, dragging great stones to the hilltop where a mighty cathedral was rising? Just this thing happened. Read the vivid description of it in the late Henry Adams' *Mont-Saint-Michel and Chartres.*

At the chance of being cursed with book, bell and candle for venturing so ridiculous a theory, yet we will risk the reader's wrath by advancing the timid suggestion that it was not so much an artistic urge that prompted Mediaeval craftsmen to cover their great churches with such extraordinary carvings and symbols, as it was a wish to make known the faith. They wanted to express their current religious beliefs in a manner that all might see and understand. The impulse back of it all, we venture to suggest, was not a sense of artistic pride that could not be repressed (that came later) but rather a desire to shout aloud from the house tops the religious opinions of the day, and to do it in a language that

an age, accustomed to think in allegorical and symbolical terms, might understand. Today the printed book and the newspaper are our media of religious publicity: in olden times it was necessary to resort to carving and painting.

The habit of the Mediaeval mind of reading into every leaf, and animal, and bird, and inanimate object, and number, and ecclesiastical vestment a mystical meaning, and using it to point out some moral, either true or fanciful, is one of the characteristics of that age. The impulse back of those extraordinary carvings and paintings was not art for art's sake, but rather art for religious publicity's sake. There is no such thing as a natural-born, full-fledged artist or craftsman. The instinct for art may be there, but the ability to execute it artistically must be developed by painstaking effort, and with a driving force back of it so strong that all obstacles will be overcome. This driving force must be something more powerful than the mere creation of ornament.

Were their efforts worth while? In looking at some photographs of old rood-screens not long ago a man remarked, "What a sinful waste of time and energy! A man must have been a moron to be able to devote all the leisure hours of the best part of his maturity to the task of carving a series of grape-vine mouldings as broad as one's hand!" Having said this he took his leave and went to the shop where he has devoted twenty years of his maturity to the task of fashioning small bolts for automobiles—destined to last half a dozen years and then become rusty junk. His

evenings are spent watching a comedian on the silver screen throw pumpkin pies into the face of another comedian with a definite certainty of aim. Just whether the fashioning of a great rood-screen, with its lavish enrichments, is a greater gift to humanity than making hexagonal-headed bolts, or watching the pie-throwing episode, or spending hours absorbing the newspaper details of a sensational divorce hearing is a matter of opinion. Many things are possible with one's leisure time.

When man became wealthy, and even before the wheels of the factory system had begun to whirr, an artistic decline set in. Read Mr. R. H. Tawney's recent *Religion and the Rise of Capitalism* and escape that conclusion if you can. When artistic effort ceased to be devotional , and became pictorial and vain-glorious, when the pride of man asserted itself, then art declined swiftly.

Even before that day, the great churches had been stripped to a large extent of their symbolism. Henry VIII and his menials raged throughout the land, leaving in ragged ruins most of the great ecclesiastical buildings. Among the hundreds of great churches that went down were such marvels as Glastonbury, St. Mary's at York, Guisborough, Whitby, Osney, St. Edmundsbury, Beaulieu, Fountains, Evesham, Buildwas, St. Augustine's at Canterbury, Furness and literally hundreds of others. Today archaeologists are excavating what remains of them.

We find fanatics in the days of Edward and Elizabeth and Cromwell spreading further havoc. In days of religious

frenzy and in political uprisings, crazed populaces hacked and tore away carvings, paintings, stained glass, tapestries and beaten gold and silver. Sometimes it required several days to complete the task of purging a single church of such "idolatrous" things as crucifixes, organs, stained glass windows, carved bench ends and altar paraments, so vast was the amount of such material to be destroyed. Great organs were pulled down, and bonfires made of their chests, cases and wood pipes. People surged through the narrow streets in mock procession, blowing the metal pipes and praising God, and ended the day by breaking the pipes over one anothers' heads. They leave us triumphant records such as these: "Item. Pulled down great organs in the church. Exceeding idolatrous. Item. Removed from church and burned at market-cross one carven figure of our Lord. Exceeding superstitious. Destroyed to glory of God images of Twelve Apostles, and removed dove from font cover."

In some old records it is stated that the amount of glass removed from a single cathedral was so large that cartloads of it were used to fill marshy ground and ditches. Fine roads were built across swampy ground, and stone sculptural details from the ruined churches used to form their foundation, as road repairs in our own day so often bring to light. We find records of exquisitely carved stone sold in quantity lots to stone cutters, to be recut into tasteless tombstones and hitching posts. Almost within the memory of living men, lime kilns existed within the precincts of certain ruined abbeys, and carved figures of an unsurpassed excel-

lency of execution were burned into lime, on the theory that it was a good service to humanity to transform graven images into useful building materials.

Old records tell of stones sold for a sixpence a load, and we may well believe it, for there are cow stables in which one may still find delicately wrought symbols of the Four Evangelists or fragments of ecclesiastical window tracery. Carved capitals and bosses form pleasing edgings for many a gentleman's driveway.

One writer records the fact that entire shiploads of ancient illuminated books were sent to the Continent, and sold for common wrapping paper, or else given to the peasants to light their kitchen fires. Who knows what priceless early manuscripts may thus have perished?

Even in modern days destruction has been going on. Wyatt, the notorious restorer, is said to have taken enough ancient stained glass from Salisbury Cathedral to fill the city ditch, much to the delight of the village selectmen. In other cases, where fanaticism passed secluded districts by, the old work was allowed to fall into slow decay. Many ruined and roofless churches may be seen today in remote localities. The craze for restoration on the one hand, and the Puritan mania for barren interiors on the other, were such strong impulses that the large majority of churches were denuded of all their mural paintings, and their interiors neatly whitewashed. Their windows were smashed, and plain glass substituted, so that the people might enjoy the beauties of the landscape outside, should the three-hour

sermons of the seventeenth and eighteenth century domin-
ies prove tedious.

The same story might be told of many parts of Europe.
In the northern part of the Continent, over fifty of the finest
great churches were razed during the political uprisings of
a century or so ago. All of us recall the wholesale destruc-
tion during the great war, and entire villages, literally
pounded to gray powder, greet the eye as one journeys
through the war-swept area.

Lately there has been a wide-spread revival of interest
not only in symbolism, but in Mediaeval art of every kind.
Lowell has said:

> "For Humanity sweeps onward: where today the martyr stands,
> On the morrow crouches Judas with the silver in his hands;
> Far in front the cross stands ready, and the crackling fagots burn.
> And the hooting mob of yesterday in silent awe return
> To glean up the scattered ashes into History's golden urn."

This is true in artistic things as well as in the sense in
which Lowell intended it. We find men today carefully
gathering up what is left of the old churches. A start was
made in England when Pugin made his measured drawings.
Others followed him. They were ridiculed at first, and
often insulted, but they have published data of inestimable
value to the architect and the designer, and have made a
revival of the old art possible.

Foremost on the list of modern workers must be placed
the name of the late Francis Bond. He has given the
world three very large, closely printed volumes, profusely
illustrated, relating to Mediaeval Gothic art in general, and

a whole series of smaller books on the details of Gothic art. Mr. Frederick Bligh Bond has laboured for years as an archaeologist, bringing to light many startling things from the chaotic ruins of the tremendous churches of Mediaeval days, proving beyond doubt that missionary work was carried on in the days of the Apostles, in northern lands. The same man has given us two large volumes of fine pictures and scholarly text on the carved rood-screens and rood-lofts of England. The Rev. Dom Bede Camm gave valuable assistance in this last work.

Mr. F. E. Howard and Mr. F. H. Crossley have published most valuable works on ancient ecclesiastical woodwork, so amazingly rich in symbolism. Mr. S. Smith has stayed within the very shadow of Lincoln Cathedral for years, making thousands upon thousands of remarkable photographs of the details of that great building. We hope that these may be published some day. The Rev. P. H. Ditchfield, the Rev. Ernest Geldart, Dr. J. Charles Cox, Mr. R. W. Paul, Mr. Breakspeare, the Rev. Fr. Ethelbert Horne, Mr. Raymond Hood and many others are at work; not forgetting the splendid efforts of His Majesty's Office of Works, the Historical Monuments Commission, and other such bureaus that have done much to preserve what remains.

From old walls, from the foundations of roads, from ditches, and even from the ruins of stone barns and the pavements of pig sties, venerable sculptured stones and other things that throw light on bygone ages, have been collected and taken back to where they belong.

A start has been made in lands other than England. In Italy M. Colasanti has collected his marvellous pictures of Byzantine work, and published them in his fine *L'Arte Bisantina in Italia.* Dehli has contributed most valuable information along the same lines. Similar work has been going on in France, and even in Spain many astonishing things have been found quite recently. Very little literature is available on Germany, and much must have existed there before Carlstadt and his ilk decended like misguided avenging angels upon the land.

During the past thirty years England and America have made surprising progress in architecture and the allied arts. Many of the pioneers in this restoration have died. We think of such architects as Bodley, Pearson, Bentley, Tapper, Vaughan, Goodhue, Comes, Corbusier and Medary; such artists in stained glass as Young, Willett, Wright and Wright Goodhue; such carvers as Kirchmayer and Maene, and many others. Among those still living who were either pioneers or their immediate successors are Cram, Scott, Nicholson, Klauder, Frohman, Robb & Little, Mayers, Murray & Phillip, Maufe, Cachemaille-Day and others, all architects. Among glass workers are Connick, D'Ascenzo Mrs. Willett, Henry Willett, Mrs. Wright, Burnham, Lakeman, Sotter, Hogan, Blanchford, Hunt, Reynolds, Frances & Rohnstock and a few more. We have such sculptors and carvers as Read, Angel, Lawrie, Galloway, Gill, and others; and mural painters such as Sears, Wade, Cartwright, Miss Oakley, Miss Miere, Lieftuchter

and Schubert. Two or three companies dealing in wood-work and equipment have made valuable contributions, as well as Yellin, Krasser, Koralewski and Rose in metal work. Then there is the Mediaeval Academy and its journal the *Speculum*.

Among the many churches where one may find good use of symbolism in sculpture, wood-carving, stained glass and murals, one might list St. Thomas's, St. John the Divine and Chapel of the Intercession, in New York; Mt. Kisco and Westchester nearby; Lake Delaware in the Catskills; the Washington, Wheeling and Toledo cathedrals; Calvary, First Baptist, East Liberty Presbyterian, Sacret Heart, Holy Rosary and St. Agnes's, all in Pittsburgh; St. Agnes's in Cleveland; St. James' in Lakewood nearby; St. Paul's Cathedral, St. Trinity and Christ Church Cranbrook, in and near Detroit; Bryn Athyn and Valley Forge, near Philadelphia; Peterborough, N. H.; Emmanuel in Newport, R. I.; the Mercersburg and the Muhlenberg chapels, and a number of others.

CHAPTER III.

OLD TESTAMENT SYMBOLS

IT DOES not lie within the scope of this book to go into minute detail concerning Old Testament symbolism. Very few writers have attempted to do so. And yet the fact confronts us that Old Testament symbolism is a rich field of study, and forms the background for all later symbolism.

From the very beginning, God Almighty used symbolism in order to teach important truths. The flaming sword of the angel of Eden was a symbol of the authority of God. The mark placed by the Lord upon Cain was a symbol to be read by all men. The blood sprinkled upon the doorposts of Egypt was a symbol, and the angel who slew the first born of every creature spared the households upon which this sign was placed. Tradition states that it was the Tau cross. When the Lord gave minute directions for the construction of the tabernacle and its furnishings, symbols were used everywhere. The same is true in regard to Solomon's temple. Nobody can read the oft repeated references to the numbers three, seven, twelve and forty, without realizing that these had a symbolical meaning.

We will not attempt to give an exhaustive list of Old Testament symbols, but will mention a few of them, leav-

ing to the reader the interesting task of discovering more.

The Creation. Every one who has stood before the sculptured portals of Strasbourg Cathedral will recall the symbolical carvings of the Creation and the Redemption of man, and will realize the immense possibilities that lie within reach if only we might learn from the Middle Ages to decorate our churches with ornamental forms that have a meaning. Pictorial representation must be avoided in symbolism, unless such representation is treated symbolically. Instead of trying to picture the creation of the world, it is better to show a simple scroll with the first verse of the first chapter of Genesis carved upon it. In Figure 1 of Plate I we reproduce, with the Massoretic vowel-pointing, this first verse of the Bible. Often vowel points are omitted.

A very common symbolical representation of the Creation is the six-pointed star, known as the Creator's Star. This has been used from time immemorial as a symbol of the Creation, just as the five-pointed star signifies our Lord's Epiphany, and the eight-pointed star man's regeneration. See Figure 2.

Sometimes a triangle is used, with the word Jehovah within it, in Hebrew characters. See Plate V, Figure 7. Some authorities state that this may be used only in Christian churches. Or the triangle may contain either one or two Hebrew Yods within the center. See Plate V, Figure 9, in which we show the double triangle, forming a Creator's Star. Or, the word *Adonai*, meaning "Lord," may be used with either a triangle, a double triangle, or rays of glory

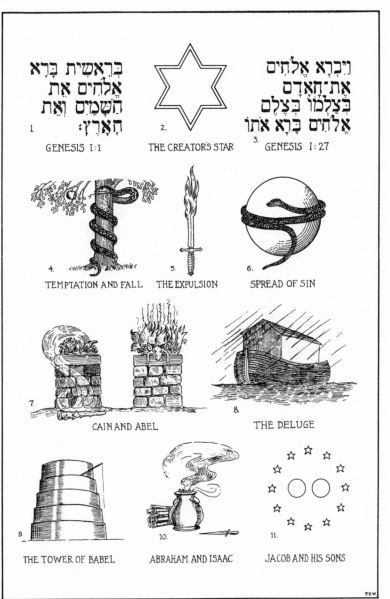

The Old Testament

PLATE I.

around it. See Plate V, Figure 10. Figure 12 of the same
plate shows the name "the Almighty" within the circle
of glory.

The shield of David, which is made by weaving together
two equilateral triangles, as shown on Plate III, Figure 8,
is used in many Jewish Temples. In Christian places of
worship it denotes the Holy Trinity.

Various attempts have been made to represent the cre-
ation of man, but most of them are not strictly symbols, but
pictures. Perhaps the best way is to show a shield, upon
which may be painted or carved the Hebrew rendering of
Genesis 1, 27, wherein God creates man in His own image.
We have copied this verse, or part of it, and show it on Plate
I, Figure 3. It is about the simplest of the creation symbols.

The Fall of Man. Man's temptation and fall is often
shown by drawing the trunk of a tree, with a suggestion of
leaves and fruit, and with the serpent, symbolical of Satan,
coiled about the tree, Plate I, Figure 4. An apple is another
symbol of the fall. The expulsion of our first parents from
Eden is best represented by the flaming sword. See Figure
5, Plate I. The traditional way of representing man's fal-
len condition, as a result of sin, is to show a snake coiled
entirely around the earth. Figure 6, Plate I. In paintings
of our Lord's Crucifixion, a human skull often lies under
the cross, upon which the blood of our Redeemer drops.
This skull represents Adam, and sin in general, for which
the Saviour makes atonement. A dragon, a symbol of Satan,
may also be used to symbolize sin, the result of Adam's fall.

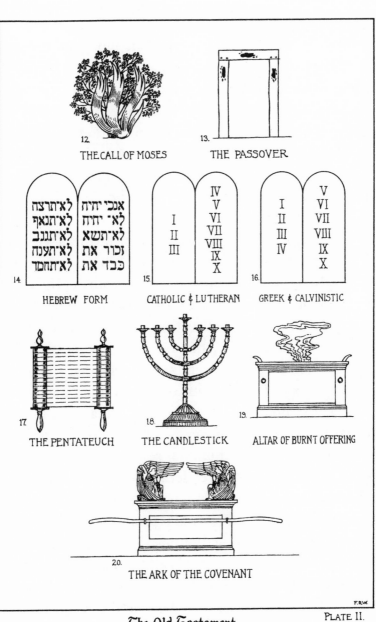

12.
THE CALL OF MOSES

13.
THE PASSOVER

14.
לא־תרצח | אנכי יהוה
לא־תנאף | לא־ יהוה
לא־תגנב | לא־תשא
לא־תענה | זכור את
לא־תחמד | כבד את

HEBREW FORM

15.
I
II
III

IV
V
VI
VII
VIII
IX
X

CATHOLIC & LUTHERAN

16.
I
II
III
IV

V
VI
VII
VIII
IX
X

GREEK & CALVINISTIC

17.
THE PENTATEUCH

18.
THE CANDLESTICK

19.
ALTAR OF BURNT OFFERING

20.
THE ARK OF THE COVENANT

F.R.W.

The Old Testament

PLATE II.

Thorns and thistles, woven together, represent the curse placed upon the earth. A spade has been used to depict the fact that man must earn his bread by the sweat of his face.

Cain and Abel. The first murder is represented by two altars. Upon one is fruit, and upon another an animal of the flock. The smoke of Cain's altar swirls downward, while Abel's ascends toward Heaven. Before the altar of Cain lies a knotted club, with which he slew his brother. See Plate I, Figure 7.

The Deluge. The common symbol of the flood is the ark of Noah, which is always shown as a boat with a building erected upon it. Figure 8. A dove, with a sprig of olive in her mouth is another familiar symbol. The altar of Noah may be used, as well as the rainbow. The rainbow must not be naturalistic, but rather of the heraldic sort, namely an arc of the circle ending in a cloud at either base.

The Tower of Babel. This tower, so often used in Old Testament symbolism, is usually shown as a stone building erected in diminishing stages, something after the fashion of the modern set-back building restrictions in New York. Figure 9 shows the usual rendering.

Abraham and Isaac. Abraham's symbol is the sacrificial knife. His call, and God's promise to Abraham are shown by painting a shield of deep blue, with many stars, with one star much larger and brighter than the others, signifying the Messiah. A bundle of wood, in the form of a cross, is the symbol of Isaac. The sacrifice of Isaac is rep-

resented by a brazier of burning charcoal, a bundle of wood and a sacrificial knife. See Figure 10.

Jacob and His Sons. Jacob and his twelve sons are indicated by a sun and a full moon, representing Jacob and his wife, and twelve stars. Fourteen sheaves of wheat are also used, with the tops of thirteen of the sheaves inclined toward the fourteenth one, which stands erect. Both symbols are based upon the dreams of Joseph—we show the former symbol in Figure 11. Esau's symbol is a vessel containing his mess of pottage, or a bow and arrows. The young Jacob is shown by a hairy arm, the reference being to his act of deception. His vision is indicated by a ladder reaching toward Heaven.

The Exodus. Israel in bondage is delineated by means of a taskmaster's whip and a pile of bricks. The birth of Moses is shown by a woven basket, surrounded by bulrushes. The call of Moses is represented by an acacia bush with three or more long flames, heraldically treated, issuing out of it. Realistic effects must not be attempted. The form which we show on Plate II, Figure 12, is copied from the window of a Jewish temple, and is about as good as any rendering that we have come across.

Moses and Aaron before Pharaoh are identified similarly by picturing a staff and a serpent, recalling their miracles at the Egyptian king's court. The ten plagues are difficult to picture, and it is usually sufficient to show the tenth plague: the death of the first born of every creature. This may be indicated by a sword. The Passover is depicted by a door-

way, with blood upon the posts and the lintel. Either these may be shapeless spots, as in Plate II, Figure 13, or else these spots may be in the form of a Tau cross.

The Ten Commandments. The giving of the Ten Commandments is invariably shown by picturing a two-fold tablet of stone. Many blunders have been made in this respect, for tablets of stone which might prove acceptable in a Jewish temple would not do at all in other places of religious assembly, and vice versa. From the window of a temple in Cleveland we have copied the Hebrew form of the Ten Commandments, as usually used today among modern Jewish congregations. Plate II, Figure 14. The commandments are not written out in full, but only the significant words used, without vowel pointings. In other examples, the word "Jehovah" is not spelled out, but two Yods are used instead.

The Roman Catholic Church, and all Lutheran bodies retain strictly the ancient division of the Commandments into two tables. The first table contains the mystic number three, and the second shows the mystic number seven. The first table contains the commandments expressing our duties toward God, and the second table enumerates our seven duties to our fellow men. In Roman Catholic and Lutheran art, the usual symbol is that which is shown on Plate II, Figure 15. The commandments are not given in full, but in the form of Roman numerals, with three on the first table and seven on the second.

In the Greek Church, and among the Calvinistic bodies,

a different division is used. Roman Catholics and Lutherans look upon Exodus 20, 2 as an introduction, and upon Exodus 20, 3 as the First Commandment. The Calvinistic denominations make each of these verses a separate commandment, and combine into one commandment the two statements as to coveting. For this reason the proper delineation of the Ten Commandments in a Calvinistic church is to show four commandments upon the first table and six on the second. See Figure 16. Occasionally one sees the two tables with five commandments on each, even in a Calvinistic church. In such cases the first five commandments are said to represent the duties of piety, and the second five those of probity.

The Law. The Law in general is represented by a scroll, or by the ancient Hebrew form of book, which we show somewhat conventionalized in Figure 17, Plate II.

Old Testament Worship. This is represented by the seven-branched candlestick, as in Figure 18, or by the Ark of the Covenant, Figure 20, or by the Altar of Burnt Offering, Figure 19. The Altar of Incense, the Brazen Laver, the Table of Shewbread, the Breastplate and Mitre of the High Priest, and the Tabernacle itself may be used. An altar, upon which lies a slain lamb, may be used, or else the red heifer of Numbers 19, 1-6.

Old Testament Festivals. The Passover or Pasch is represented by a spotless lamb; Pentecost by the roll of the Law and a sheaf of wheat; Tabernacles by a tent made of boughs; and the Atonement by the red heifer and a censer.

The Promised Land. The entry into Canaan is shown by a huge cluster of grapes hung on a staff, by a vessel of milk and a comb of honey, or by seven trumpets of rams' horns.

The Sixteen Judges. Gideon or Samson are often used as representatives of the Judges. Gideon's symbol is the fleece, or the fleece and a bowl, or else a pitcher and a light. Samson's symbol is a lion, or the jaw-bone of an ass, or the gates of the city of Gaza, or seven cords, or two great pillars out of alignment.

The Twelve Patriarchs. The list of the patriarchs is given variously by various writers, and there seems to be no fixed rule as to just what names shall be included. Adam's symbol is a spade, or a mattock, or keys. Noah is represented by his ark, or by an oar, or by a dove with a sprig of olive, or by a vine. Abraham's symbol is a knife, or a brazier of fire, or a number of stars. Isaac's symbol is a bundle of wood in the form of a cross. Jacob is represented by a ladder. Joseph is represented by a multi-colored coat, or a star, or a sheaf of wheat, or an open pit, or an Egyptian column, or a sceptre and chain, or by a mummy. Moses is delineated by two tablets of stone, or an ark of bulrushes, or a burning bush, or a rod and serpent, or two horn-like rays of light upon his brow, or by a rock from which flows a stream of water. Aaron is shown by a budding almond staff, or a rod and serpent, or a golden censer or by a golden calf. Melchizedek's symbol is a loaf of bread and a chalice, or a mitre and a crown, or a crown

and a censer. Joshua is depicted by a sword and a trumpet, or by a sceptre and a trumpet. David is represented by a young lion, by a harp, or a sling and five stones, or a horn of oil, or the head of Goliath and a great sword, or by a crown, or by a turreted castle. Gideon is shown by the fleece, or the fleece and bowl, or by a trumpet, or by a light and a pitcher. Solomon is shown by a model of his temple, or by a scroll and sceptre, or by an idol. If Seth's name be included in the list, he is shown by three seeds of the tree of life, or by a thread wound thrice around a thumb. If Cain be included, his symbol is a plough, or an ox-goad or a yoke. Abel's symbol is a shepherd's staff or a lamb. If Esau be shown, his emblem is a bow and arrows, or a mess of pottage. Eve's symbol is a spindle or a distaff. Deborah is represented by a crown, Ruth by a wisp of wheat, and the Widow of Sarepta by a cruse of oil.

The Four Major Prophets. Isaiah's symbol is a saw, the instrument of his reputed martyrdom, or a sack, or tongs and a burning coal from the altar, or a scroll with words from his prophecy, or by a tiny figure of St. Matthew on his shoulder. Jeremiah is represented by a stone, since he is said to have been stoned to death, or by a wand, or by a cistern, or by a scroll containing words of his prophecy, or by St. Luke carried upon his shoulder. Ezekiel is shown by a closed gate, or a turreted gateway, or a plan of the New Jerusalem, or by a tiny figure of St. John upon his shoulder. Daniel is pictured by several lions, by a ram with four horns, by the great image of the king's dream which Dan-

iel interpreted, or by a small figure of St. Mark upon his shoulder. Fine examples of some of these symbols are to be found in the windows of Chartres.

The Twelve Minor Prophets. The symbols of the Minor Prophets are: Hosea is shown by a cast-off mantle, representing the infidelity of Israel against which he testified, or by a skull, or by a shattered idol. Joel is shown by a pointed hood and the Trumpet of Zion, or by lions. Amos is shown by his shepherd's crook. Obadiah is shown by a pitcher and loaves of bread, or by the entrances of two caves in which the ancient Jews believed that he concealed one hundred prophets. Jonah is delineated by a great fish, or a gourd or by a ship. Micah is pictured by a broken sword and a lance, a temple upon a mountain, or by a strong tower. Nahum is depicted by a mountain and the feet of an angel emerging from a cloud, or by a broken yoke. Habakkuk is represented by the angel which supported him, or by the Holy Temple of the Lord. Zephaniah is symbolized by men, animals, birds and fishes, or by a walled city with a great sword above it. Haggai is shown by timbers, or by a temple under construction. Zechariah is delineated by an ass, or by four horns, or a red horse, or a measuring line, or a winged scroll, or by four chariots, or by a stone full of eyes. Malachi is represented by an angel issuing from the clouds.

If Elijah be shown, his symbol is a scroll and a red vestment, or a sword, or a mantle or a fiery chariot. Elisha's symbol is Elijah's mantle, or a double-headed eagle.

The Four Greater Prophets may be used together with the Four Evangelists, and the Twelve Lesser Prophets with the Twelve Apostles.

The Sibyls. In Mediaeval days and during the Renaissance artists were often known to picture the Twelve Sibyls in company with the prophets. These Sibyls are supposed to have been prophetesses who uttered Messianic testimony in pagan lands. Persica proclaimed our Lord in Persia, it is said. Her symbol is a lantern, and she tramples a serpent or a dragon under foot. She revealed the Messiah by means of the Book of Genesis. Libyca's field of activity was in Africa. She is represented by a torch or a burning candle, because she is said to have declared Jesus Christ as a Light to enlighten the Gentiles. Erythraea, who went to the lands bordering the Red Sea, holds a sword, or is shown by a horn, or a white rose. She declared the Annunciation. Cumana went to Cumea. Her symbol is a manger, because she is reported to have declared the Nativity of our Lord. Samiana, who labored in Samos, is given a reed or a cradle, for she spoke of our Lord's birth in a cattle shed. Cimmeriana, who went to the lands around the Black Sea, is shown by a horn of milk, for she foretold the nurture of the Holy Child. Europeana went to Europe, it is said, and preached concerning the slaughter of the Innocents. Her emblem is a sword. Tiburtina proclaimed the Lord's coming in Tivoli. She is given a hand or a rod, for she spoke of the smiting of our Saviour. Agrippa is shown by a scourge, for she is thought to have predicted the

scourging of our Lord. Delphica, who went to Delos, is
shown by a horn or a crown of thorns. She is said to have
foretold the crowning of our Lord with thorns. Helles-
pontica, who preached at the Hellespont, is shown by
means of a flowering rod or a Tau cross. She spoke of the
Incarnation and the Crucifixion. Phrygiana, whose field
of activity was in Phrygia, carries a processional cross or a
banner of victory, for she proclaimed the Resurrection.

Examples of these Sibyls may be seen in the south aisle
windows of St. Ouen of Rouen, at Sens, at Autun, on the
west of the church at Aix, in Michelangelo's mural paint-
ings in the Sistene Chapel, in Giotto's Tower at Florence,
at St. Jacques' at Dieppe, and in Raphael's "Adoration of
the Kings." Two Sibyls are introduced in the famous
polyptych at St. Bavon's Cathedral in Ghent.

The Twelve Tribes. The symbols of the Twelve Tribes
of Israel are based upon Genesis 49, 1-27. They are: Reu-
ben, water. Simeon, a sword. Levi, a sword or a censer.
Judah, a lion's whelp or a sceptre. Zebulun, a ship in har-
bor. Issachar, an ass with two burdens. Dan, an adder.
Gad, a banner or implements of warfare. Asher, a horn of
plenty. Naphtali, a running hind. Joseph, a fruitful bough
by a well. Benjamin, a wolf.

CHAPTER IV.

SYMBOLS OF THE HOLY TRINITY

SYMBOLS representing the idea of the Holy Trinity were not so common in the early days of Christianity as one might expect. Our Lord Himself taught clearly the fact that there are Three Persons. In His last words to His disciples He said, "Go ye therefore, and teach all nations, baptizing them in the name of the Father, and of the Son, and of the Holy Ghost."—St. Matthew 28, 19. The names of the Three Persons occur frequently throughout the New Testament, and in the liturgical formulae of the early Church.

Although the doctrine of the Holy Trinity was taken for granted by the early believers in the primitive Church, the word "Trinity" did not come into use for some time. Theophilus, Bishop of Antioch, is thought by some to have been the first to use the term, although the best authorities nowadays usually credit the first use of the word to Tertullian, who flourished at the beginning of the third century.

The names of the Three Persons are found in Christian inscriptions from the very beginning, but such inscriptions usually state the belief of the primitive Church in the Three Persons, with no attempt at a symbolical portrayal of the mystery. One early inscription reads, "*In Nomine Sanctae*

Trinitatis," that is, "In the name of the Holy Trinity."
Another reads, "*Patris et Filii et Spiritus Sancti,*" or "Of
the Father, and the Son, and the Holy Spirit." Yet another
tomb erected to the memory of an early member of the
Christian Church bears an inscription which reads, "*Quin-
tilianus Homo Dei Confirmans Trinitatem Amans Casti-
tatem Respuens Mundum,*" meaning "Quintilianus, a man
of God, holding firmly to the Trinity, loving chastity,
renouncing the world."

An early symbol of the Blessed Trinity is to be found on
a tomb in the cemetery of St. Priscilla, and contains the
palm branch of martyrdom and of victory, together with
two symbols of the Son of God, and the equilateral triangle
of the Holy Trinity.

It seems that the earliest Christians hesitated to express
so profound a mystery as that of the Trinity in the form of
symbols. With the coming of fierce controversies in the
early Church, where it was necessary to defend the doctrine
of the Trinity against false teachers both within the Church
and outside of it, certain definite symbols were developed.
What Christians had always believed was now expressed in
graphic form.

The Equilateral Triangle. The equilateral triangle, Fig-
ure 1, with its apex upward is one of the oldest of the Trin-
ity emblems. Its sides are equal, its angles equal, and it
carries with it the idea of unity, because it has three sides and
three angles which are identical to one another in every
respect, and yet are three distinct sides and angles. They

1.

EQUILATERAL TRIANGLE

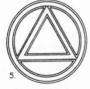

2.

THE CIRCLE OF ETERNITY

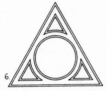

3.

INTERWOVEN CIRCLES

4.

FROM AN OLD MANUSCRIPT

5.

TRIANGLE IN CIRCLE

6.

CIRCLE WITHIN TRIANGLE

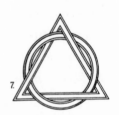

7.

INTERWOVEN CIRCLE & TRIANGLE

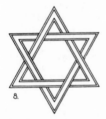

8.

TWO TRIANGLES

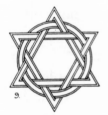

9.

TWO TRIANGLES & CIRCLE

10.

THE TREFOIL

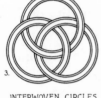

11.

TREFOIL AND TRIANGLE

12.

TREFOIL WITH POINTS

The Holy Trinity

PLATE III

are combined so as to form not three figures, but one figure. The equality of the three distinct sides and angles expresses the equality of the three distinct Persons. Their union, resulting in but one figure, suggests the one and inseparable Divine Essence. Later the circle, emblematic of the idea of eternity, was combined in various ways with the equilateral triangle, which was done in order to bear witness to the eternity of the Trinity. Figures 5 and 6.

The Three Circles. Three circles of equal size, but interwoven, were used at a later period to express the doctrine of the equality and the unity of the Triune God. Their equal size indicated the fact of the equality of the Three Persons. Their form, Figure 2, a figure having neither beginning nor end, attested the fact of the eternal nature of the Three Persons. When interwoven the fact of their unity is delineated. Figure 3. In Figure 4 we reproduce a famous example from a manuscript in the *Bibliotheque Communale* at Chartres.

The Triangle and Circle Interwoven. Sometimes we find but one circle, representing eternity, interwoven with the equilateral triangle, expressing the idea of the eternity of the Three Persons and of the Divine Essence. Figure 7.

Two Interwoven Triangles. Another familiar emblem of the Holy Trinity is a combination of two equilateral triangles, one with its apex upward, and the other with its apex downward. See Figure 8. When thus combined they form a six-pointed star enclosing a hexagon. The six-pointed star, which is a symbol of creation, expresses the fact that it

was the Triune God Who created the heavens and the earth, the Second and Third Person concurring with the Father in the act of creation. This is a figure that is said to be based upon the Shield of David.

Two Triangles and a Circle. Since the two interwoven triangles alone are apt to be confused with the Shield of David, a circle is often used in combination with them, by weaving it through their six points. Thus the idea of eternity is added to the symbolism of the two triangles. Figure 9.

The Trefoil. A familiar Trinity emblem is that of the trefoil, with three lobes of equal size, yet one figure. It is a modification of the three interlaced circles which we have mentioned above. See Figure 10.

The Trefoil and Triangle. A decorative figure is formed when the equilateral triangle and the trefoil are combined. It has been used frequently in stained glass, mural decoration and church embroidery. Figure 11.

The Trefoil and Three Points. Often one meets with a Trinity emblem composed of an equilateral triangle with a point projecting from the intersection of each arc with its neighbour. This is a modified form of the symbol just mentioned, and is made by combining a triangle with a trefoil, and then eliminating the lines within the trefoil. It is a very decorative figure. Figure 12.

The Triquetra. One of the finest of all the Trinity symbols is the triquetra. See Figure 14. This mystical symbol is quite simple in form, yet full of meaning. The three equal arcs of the circle express the equality of the Three Divine

Persons, their union expresses the unity of divine essence, their continuous form symbolizes eternity, and the fact that they are interwoven denotes the indivisibility of the Blessed Trinity. In the center of the triquetra is an equilateral triangle, the most ancient of the Trinity symbols, and each pair of arcs forms a vesica, the symbol of glory. Thus the one simple figure reminds us of many important truths.

The Triquetra and Circle. Somewhat less common, but equally good, is the combination of the triquetra and the circle of eternity. Figure 15. The circle is woven through the ends of the three-lobed figure, and results in a most decorative figure worthy of wider use.

The Triquetra and Triangle. A very fine symbol of the Holy Trinity is an interwoven triquetra and equilateral triangle. We reproduce one from the glass of Temple Church, in London. See symbol on the title page.

The Shield of the Trinity. If one examines closely the stained glass of the mediaeval churches, he will find examples of what is known as the Shield of the Blessed Trinity. Figures 16 and 17. A number of variations exist, but the simplest form is that of a figure with three curving sides, each exactly equal in length. At each angle is a small circle, and in the center is a larger circle. Bands connect the central circle with the outer ones. The smaller circles bear the words *Pater, Filius, Spiritus Sanctus,* (Father, Son, Holy Spirit). On each of the curving bands are the words *non est* meaning "is not." On the short diagonal bands are the words *est,* meaning "is."

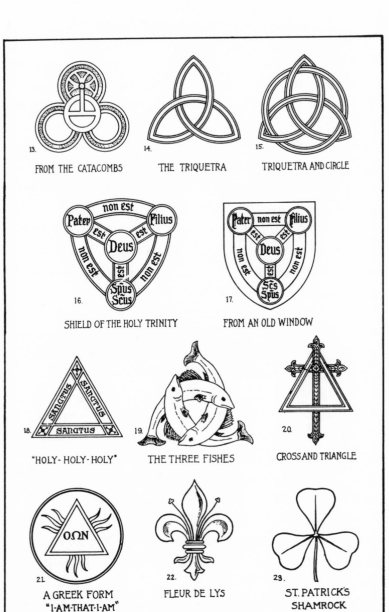

13. FROM THE CATACOMBS

14. THE TRIQUETRA

15. TRIQUETRA AND CIRCLE

16. SHIELD OF THE HOLY TRINITY

17. FROM AN OLD WINDOW

18. "HOLY - HOLY - HOLY"

19. THE THREE FISHES

20. CROSS AND TRIANGLE

21. A GREEK FORM "I-AM-THAT-I-AM"

22. FLEUR DE LYS

23. ST. PATRICK'S SHAMROCK

The Holy Trinity

PLATE IV.

This shield may be read in any direction and yet make good sense, for example: "The Father is not the Son," "The Son is not the Father," "The Father is not the Holy Spirit," "The Holy Spirit is not the Father," "The Son is not the Holy Spirit," "The Holy Spirit is not the Son." Reading diagonally the sentences run, "The Father is God," "The Son is God," "The Holy Spirit is God." Reading from the center outward, the sentences state that "God is the Father, God is the Son, God is the Holy Spirit." These statements are based upon the Athanasian Creed.

In the best examples of this Shield of the Blessed Trinity, the sides are all equal in length, the outer circles exactly equal in size, but the inner circle is slightly larger than the three outer ones, for the sake of design.

The Three Fishes. A symbol of the Holy Trinity often seen in European churches is that of the three fishes. Occasionally they are placed parallel to one another, but more often they are arranged either in the form of a triangle, or of a figure with three curving sides. The last named is the most decorative of the three forms. Figure 19.

The fish is a very ancient symbol of the Saviour, since the Greek word Ἰχθύς, meaning "fish," is composed of five letters. In early Christian symbolism these five letters were used as a rebus, reading Ἰησοῦς Χριστὸς Θεοῦ Υἱὸς Σωτήρ that is, "Jesus Christ, Son of God, Saviour." See under Symbols of the Saviour for a fuller statement.

One fish pictured alone was the symbol of the Second Person of the Holy Trinity. The three fishes are based

upon St. John 3, 16, in which we are taught that all **Three** Persons have a part in man's salvation. The prompting cause is the love of the Father. The means of our salvation is the sacrifice of the Son. The application of salvation to the sinner is through the work of the Holy Spirit. Thus the three fishes pictured together teach the important truth that man's salvation proceeds from the Triune God.

The Cross and Triangle. In church embroidery one meets with certain combinations of the equilateral triangle and the cross. Figure 20. This teaches the same doctrine as the three fishes, namely that man's salvation is the work of the Son of God, prompted by the Father's love, and applied to man by means of the work of the Holy Spirit. The usual form of this symbol, when used on embroidered altar frontals, pulpit and lectern hangings, or more often on book markers, is that of a slender Latin cross with floriated ends, and with an equilateral triangle woven about it. On copes and chasubles one sometimes sees a slender **Cross** Fleurée (see chapter on the Cross), Greek in form, within an equilateral triangle, and the triangle surrounded with the golden circle of eternity.

The Fleur-de-Lys. Although the fleur-de-lys often signifies the Blessed Virgin, yet it is widely used as a symbol of the Holy Trinity. Figure 22. Some of the finest damasks used for dorsals and paraments have the fleur-de-lys used together with other emblems of the Holy Trinity.

The Shamrock. The familiar legend of St. Patrick and the shamrock has caused this plant to be used as a **Trinity**

symbol. Figure 23. When the angered pagans demanded of him to prove that the Father, Son and Holy Spirit are Three Persons, yet one in essence, the sturdy missionary was nonplussed at first. His eyes lighted upon a shamrock growing nearby. He plucked a leaf, demanding of his opponents whether or not he held up one leaf or three leaves. If one leaf, then why three lobes of equal size? If three leaves, then why only one stem? His accusers were silenced, for they could not explain. "And if you cannot explain so simple a mystery as the shamrock, how can you hope to understand one so profound as the Holy Trinity?" he asked.

CHAPTER V.

SYMBOLS OF THE FATHER

FOR about a thousand years, no attempt was made to portray the First Person of the Holy Trinity in human form. The early Christians believed that the words of Exodus 33, 20, "Thou canst not see my face: for there shall no man see Me and live," and also St. John 1, 18, "No man hath seen God at any time," were meant to apply not only to the Father Himself, but to all attempts at picturing Him as well.

For eight or nine centuries the universal symbol of the Father was a hand emerging from a mass of bright clouds.

The Manus Dei. Sometimes this Hand of God was shown as open, with rays of light proceeding from each finger. The idea of the Hand of God was based upon many Bible passages, such as, "His right hand, and His holy arm, hath gotten Him the victory."—Psalm 98, 1. Figure 8.

The Latin Form. In the Western Church it was very common to picture the Hand of God with the thumb and first two fingers extended, and the third and fourth fingers closed. Figure 1. The three extended digits were used to represent the idea of the Holy Trinity, and the two closed fingers the two-fold nature of the Son. This Hand of God is properly surrounded with the circular nimbus with three

rays. The nimbus is the sign of sanctity, and the three rays within it represent the Deity. It is customary to represent the idea of benediction, or blessing, with a hand whose thumb and first two fingers are extended.

The Greek Form. The Greek form of the Hand of God, in the attitude of benediction, is shown in Figure 2. The first finger is extended, the second finger curved, the thumb and third finger are crossed, and the fourth finger is curved. Thus the fingers and thumb form the Greek letters IC XC, which is the ancient Greek symbol for the name of our Lord Jesus Christ. In ancient Greek uncial manuscripts, the letter Sigma was made similar to our letter C. The idea of this symbol is that God has blessed the world through the gift of His Son, Jesus Christ.

The Hand and Cloud. Often the Hand of God was shown as in Figure 3, with thumb and first two fingers extended, proceeding from a cloud of glory, and the hand surrounded by the three-rayed nimbus.

The Souls of the Righteous. Figure 5 shows a well known symbol. The Hand of God extends from a bright cloud, and within it are five tiny human figures, representing the souls of the righteous. This idea is based upon Psalm 139, 10, "Thy right hand shall hold me," and to the beautiful passage from the Book of Wisdom, "The souls of the righteous are in the hand of God."

The All-Seeing Eye. A rather disquieting symbol, Figure 4, is that of the Eye of God within an equilateral triangle. In many restored English churches, this eye may

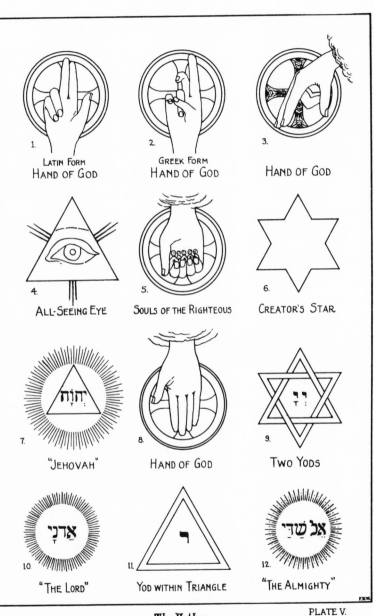

1. LATIN FORM
HAND OF GOD

2. GREEK FORM
HAND OF GOD

3. HAND OF GOD

4. ALL-SEEING EYE

5. SOULS OF THE RIGHTEOUS

6. CREATOR'S STAR

7. "JEHOVAH"

8. HAND OF GOD

9. TWO YODS

10. "THE LORD"

11. YOD WITHIN TRIANGLE

12. "THE ALMIGHTY"

The Father

PLATE V.

be seen, looking down with stern disapproval. It was a
popular symbol in the days of three-decker pulpits and
three-hour sermons. Today it is a well known secret so-
ciety emblem, except that the triangle of the Trinity is
usually omitted.

The Creator's Star. Figure 6. This is always a six-
pointed star, formed by superimposing one equilateral tri-
angle (the symbol of the Trinity) upon another. It is quite
common in Christian art.

The Father's Name. Often the Hebrew letters forming
the word "Jehovah" are used. See Figure 7. In Christian
churches this is surrounded by the equilateral triangle of
the Holy Trinity, with rays of glory surrounding it.

The Face of God. Some of the earlier Christian paint-
ers represented the First Person of the Trinity in human
form. Usually this was no more than a face, surrounded by
clouds of glory. Later a bust was shown, then a half-length
figure, and finally an entire human figure.

Two Yods. Since the Hebrew people thought of the
name of God as a thing too sacred to utter, various substi-
tutes were devised. One of these was to place two Hebrew
Yods in a circle of rays of glory, or else within the Shield
of David. We show this latter form in Figure 9. Again,
but one Yod is used within a triangle, as in Figure 11.

The Word Adonai. Much has been written about the
word *Adonai*, or *Adhonai*, meaning "Lord." In symbol-
ism it has been used by showing the Hebrew letters within

a circle of glory. It is used as a substitute for the word
"Jehovah."

The Words El Shaddai. As already stated, the Hebrew
people considered the name of Jehovah (*Yahweh*) too
sacred to utter, even in the religious service. Either the
word *Adonai*, meaning "Lord," or *El Shaddai*, usually
translated "the Almighty," were substituted. Figure 12
shows the latter form. Sometimes the word *'Elyon*, mean-
ing "the Highest," was used.

The nimbus, tri-radiant in form, surrounds the Hand
of God. See the chapter on the Nimbus and the Aureole.
When the various Hebrew names of God are used, they are
surrounded with rays of light, either with or without the
triangle.

In present day work, it is better to use one of these sym-
bols of the Father than to attempt to picture Him as an aged
man with a long beard, as we often see in children's Bible
story books.

The Hebrew word *Elohim* is not commonly used in
Christian art to denote the Father. To the Christian, the
plural form of the word suggests the idea of the Triune
God, rather than the Father only. While the Small Cate-
chism attributes to the Father the work of creation and
preservation, yet only the most servile deist will deny the
concurrence of the other Divine Persons in the work of
creation, redemption and sanctification.

A Right Triangle, whose base is longer than its two
sides, and with the word *Jehovah* within it, is listed by some

authorities as a symbol of the Father, and may be found in certain old engravings, in old Bibles, and on old fashioned baptismal and confirmation certificates. But, as one authority notes, it does not convey the idea of a Triune God, because it does not denote equality.

Strictly speaking, we doubt whether Figures 7, 9, 10, 11 and 12, shown on Plate V, will withstand strict investigation. What assurance have we that the words *Elohim, Jehovah, Yahweh, Adonai, El Shaddai,* or *'Elyon* denote the First Person, to the entire exclusion of the Son and the Holy Spirit? We feel tempted to list these five figures under the symbols of the Trinity, but since this book follows the traditional use of symbolism, and attempts to explain how various symbols are customarily used, we will not attempt to introduce any novel ideas. A symbol ought to be regarded in its historic sense, or else rejected and some other symbol used instead. Just as soon as symbolism, or spelling, or grammar, or the principles of musical harmony, or of good proportions, become a matter of individual caprice, they lose their force and become mere eccentricities. We list Figures 7, 9, 10, 11 and 12 as a matter of custom, but in actual practice we would use one of the other seven symbols shown on Plate V.

CHAPTER VI.

SYMBOLS OF OUR LORD JESUS CHRIST

THE symbols of our Saviour are many in number. Some of them go back to the days of the catacombs. At Rome, Naples, Milan, Syracuse, Alexandria and elsewhere are between six and seven hundred miles of winding, underground passages, cut out of the rock, called catacombs. These contain over six million niches, in which are the ashes of the dead. In the case of a Christian, it was customary to cement slabs of stone or marble over his niche, and to place a suitable inscription, and very often a Christian symbol, upon it. Some of the inscriptions in the catacombs are as early as 72 A. D., while the Apostle Paul's immediate associates were still alive. The latest inscription is said to be 410 A. D. From these catacombs we get many of our best known Christian symbols, either in the form of carvings or frescoes.

We will reserve the discussion of the so-called sacred monograms to the next chapter.

Orpheus. One of the earliest representative types of our Lord Jesus was Orpheus. This was a symbol borrowed from pagan sources. It was said that the exquisite music of Orpheus caused even the wild beasts to become tame. This was used by the early Christians to express the fact that the

exquisite teachings of the Lord Jesus are able to subdue the wildest passions of sinful man. He is shown, therefore, with a lyre in His hand, and with allegorical beasts, representing sinful men, standing quietly around him.

The Good Shepherd. This symbol is based upon our Lord's words in St. John 10, 11: "I am the good shepherd." In all the earlier examples He is shown as a beardless youth, clad in a tunic, carrying a lamb over his shoulders in true oriental fashion. He wears the three-rayed nimbus, indicating His divinity. This rendering is traditionally, symbolically and historically correct, and it is devotional. The exact opposite in form is the modern, sentimental portrayal, which shows a stocky, middle aged, bearded Bavarian peasant, clad in female apparel, carrying a 200-pound lamb on his forearm. The eyes of the lamb are rolled upward in a most outrageous manner, as though the lamb were suffering excruciating pain. While art must have an emotional element, yet this must be subordinated strictly to a devotional quality. As soon as it becomes sentimental, it becomes cheap and vulgar, and of the department-store bargain-basement type of "art." It is when weak sentimentality, and photographic realism take the place of the ancient devotional treatment, that art becomes artifice. The Good Shepherd ought to show strength, setting forth the teaching that our Blessed Lord is able to carry His lambs, and defend them against the wild beasts that seek their hurt.

The Agnus Dei. The use of the Lamb of God is likewise

1.

THE GOOD SHEPHERD
ANCIENT TYPE

2.

THE AGNUS DEI
AND BOOK OF SEVEN SEALS

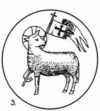

3.

THE AGNUS DEI
AND BANNER OF VICTORY

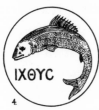

4.

THE FISH
WITH IXΘYC. REBUS

5.

THE STAR OF JACOB
NUMBERS XXIV: 17

6.

THE FOUNTAIN
FOUNTAIN OF SALVATION

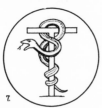

7.

SERPENT OF MOSES
ST. JOHN III: 14-15

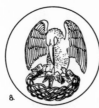

8.

PELICAN-IN-HER-PIETY
THE ATONEMENT

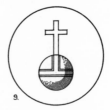

9.

CROSS AND ORB
TRIUMPH OF THE GOSPEL

10.

THE LION
LION OF THE TRIBE OF JUDAH

11.

THE OX
PATIENCE AND SACRIFICE

12.

THE ROCK
ROCK OF SALVATION

R.E.W.

Our Blessed Saviour

PLATE VI.

of most ancient origin. It is based upon such Scripture verses as Isaiah 53, 7, St. John 1, 29 and Revelation 5, 12. Myriads of examples exist, whether carved on primitive burial monuments, or in the form of paintings, wood carvings, embroideries, illuminated manuscripts, stained glass, mosaics or encaustic tiles. Perhaps the most notable example is that extraordinary polyptych of twenty-two panels in St. Bavon's at Ghent. It was painted by two brothers, Hubert and Jan Van Eyck, and finished in the year 1432. It shows the Lamb of God enthroned, and men and angels in adoration. It deserves a place among the greatest paintings of the world. Soon after that date, a decline set in. Painting ceased to be symbolical. It lost its devotional, educational character, and became a demonstration of clever realism, to the glory of the painter rather than to the glory of God, and stirred man's admiration, or aroused his sentimental nature or his pity, rather than stirring his spiritual nature. It degenerated through realistic renderings and muscular anatomical studies until it reached the weak sentimentalism, the vapid exactitude and the upturned eyes of the Munich school.

Any form of art must be symbolical if it is to convey a spiritual message. A representation of the Lamb of God must tell the story of man's sin, and the Sacrifice of the Lamb of Calvary, if it is to be devotional.

In ancient examples the *Agnus Dei* may be seen lying upon the Book of Seven Seals, as in Figure 2, or carrying the Banner of Victory, as in Figure 3. It must be crowned with

the three-rayed nimbus, signifying that it is a symbol of divinity. In other examples the Lamb stands upon a hill from which flow the Four Rivers of Paradise, signifying the Four Gospels.

The Lamb of God, like all other symbols, ought to be somewhat conventional, rather than minutely realistic. It must not look like a wooly little lamb, but may be ever so slightly archaic in drawing, so that the devotional meaning back of it is not lost sight of, and only the skill of the artist noticed. This Lamb of God is one of the finest of all symbols.

The Fish. The Fish is another very early symbol. A rebus was made of the Greek word Ἰχθύς, meaning "fish." Each letter was regarded as the initial of a word in the sentence, Ἰησοῦς Χριστὸς Θεοῦ Υἱὸς Σωτήρ, meaning "Jesus Christ, Son of God, Saviour." Used at first in the first century, its meaning may not have been known to pagan persecutors, yet to the early Christians it was an emblem of profound significance, and at all times it was a sermon in stone, expressing the fact of man's need of a Saviour, and the fact of salvation only through Jesus Christ.

I = Ἰησοῦς
X = Χριστὸς
Θ = Θεοῦ
Y = Υἱὸς
C = Σωτήρ

DERIVATION OF
THE "ΙΧΘΥC" SYMBOL

The Star. The five-pointed star is not a Christmas symbol, as most people suppose, but a symbol of the Star of Jacob, namely our Lord Jesus Christ. It is one of the best known of the Messianic symbols of the Christians. It is based upon the prophecy, "There shall come a Star out of Jacob,"—Numbers 24, 17, and our Lord's words, "I am

the root and the offspring of David, and the bright and morning star."—Revelation 22, 16.

In using the star, care should be taken not to use it as a Christmas symbol, either in church decorations or on printed programs. This will bring about hopeless confusion in the minds of the people. The star is a proper symbol of our Lord's Epiphany, or manifestation to the Gentiles, and not of His birth. The wise men from the east (their number not mentioned in Scripture) did not come on Christmas morning, but a reading of St. Matthew 2, 1-11 will make it clear that they went first to Jerusalem, not to Bethlehem. When they finally reached Bethlehem, the Holy Child had been removed from the manger to a house, as St. Matthew's Gospel states. To picture the shepherds and the wise men kneeling together at the manger is taking undue liberties with the inspired Word of God. The two scenes are separate and distinct, and ought to be kept just as separate as the Annunciation and the Visitation.

The Sceptre. The sceptre is associated with the same prophecy which we have quoted above, which says, "a Sceptre shall arise out of Israel." The sceptre symbolizes the kingly office of our Lord. The usual form of this sceptre is that of a long staff, terminating in an orb, crowned with a cross. See Figure 33. The kingly crown may be shown with it, or else an upright sceptre may be displayed upon a shield. This sceptre must not be confused with the Sceptre of the Virgin, found in Mediaeval art, which sceptre is crowned with a lily or a fleur-de-lys.

The Sun. Another Messianic symbol of our Lord is the sun in full glory. Often this is conventionalized, as in Figure 27, which we have adapted from Geldart's book. The reference is to the prophecy in Malachi 4, 2, "But unto you that fear My name shall the Sun of Righteousness arise with healing in His wings." The symbol which we show is composed of an IHC, surrounded by the Circle of Eternity, with alternating straight and wavy rays of glory proceeding from it. In some ancient and Mediaeval examples, the sun contains a human face.

The Branch. Yet another Messianic, or prophetic symbol is derived from Zechariah 3, 8, "For, behold, I will bring forth my Servant, the Branch." Also Jeremiah, 23, 5, "Behold, the days come, saith the Lord, that I will raise unto David a righteous Branch." This Messianic symbol is found several times in the inspired prophetic writings.

The Fountain. In Zechariah 13, 1 we read, "In that day there shall be a Fountain opened to the house of David and to the inhabitants of Jerusalem for sin and for uncleanness." This fountain may be shown in its heraldic form, as we show in Figure 6, rather than attempting to draw a modern, realistic fountain such as one sees in public parks.

The Serpent of Brass. One of the most important prophetic symbols of our Saviour is the brazen serpent which Moses lifted up in the wilderness. Our Lord Himself recognizes this incident as a type of His crucifixion. See St. John 3, 14. The serpent is shown upon a slender Tau cross, which is the Anticipatory cross of the Old Testament.

The Sacrifice of Isaac. This is often used as a type of our Lord Jesus Christ. Sometimes Isaac is shown as a boy bearing sticks of wood in the form of a cross. Perhaps a more strictly symbolic way is to show the bundle of wood, a sacrificial knife and a brazier of charcoal. See Plate I, Figure 10.

The Pelican-in-Her-Piety. This is one of the most widely used, and most striking symbols of our Lord's Atonement. A pelican is shown plucking open her breast, feeding her young with her own blood. See Plate VI, Figure 8. Several explanations are given. In times of famine, the female pelican is supposed to tear open her breast and feed her young with her own life blood. She dies in order that they may live. In like manner our Blessed Lord died upon the cross that we may live. Another variation of this legend of the pelican is that the serpent is the enemy of the pelican, and that his sting brings death to the young. The mother mourns over her dead brood, and then vulns herself, and her warm blood flowing upon them restores their lives. Fine examples of the Pelican-in-Her-Piety may be seen in a great many of the old churches, such as in Freiburg, in St. Etienne at Bourges, among the exterior carvings at Strasbourg, and in countless English examples. A fine example exists on the dossal canopy in the Chapel of the Intercession, New York. The symbol is a touching one, reminding us that our Lord Jesus Christ has redeemed us, delivering us "from all sins, from death and from the power of the devil, not with gold or silver, but with His

holy, precious blood, and with His innocent suffering and death."

The Cross and Orb. This emblem, consisting of a small cross resting upon an orb, as shown in Figure 9, signifies the triumph of our Saviour over the sin of the world. It is the symbol of the world-conquest of His Gospel through the Means of Grace, namely Word and Sacrament.

The Crucifix. This is the commonest of all the symbols of our Saviour. It is a pity that foolish prejudice has caused it to be banished from so many churches. If a painting of the Crucifixion is quite proper, why is not a carving of the same event equally proper?

The Renaissance form of the Crucifix shows an agonized Figure, almost wholly nude, writhing in torture upon the cross. This painfully realistic form, with its livid Figure, may be realistic, but it is not symbolic, nor does it have the devotional quality of the earlier forms. In Figure 5, Plate XI, we show the common form. Much better is the symbolical treatment which shows our Lord, clad in vestments indicative of His prophetic, His priestly and His kingly office. He hangs erect upon the cross, with right hand in the posture of benediction, and a three-rayed nimbus placed vertically back of His head. This type of crucifix is better because it is symbolism and not an attempt at realism. As the late Professor A. Graebner pointed out, preaching ought not to lay stress upon the physical sufferings of our Lord, but rather upon the great purpose back of it. The former awakens only pity: the latter brings the poor sinner

to a realization of his sin, and the atoning Sacrifice of Calvary. The same idea holds good in artistic matters.

The Tree of Jesse. This familiar symbol is popular in stained glass work and in carvings. It is to be found in many illuminated manuscripts. It is based upon the 11th chapter of Isaiah's prophecy. Jesse is shown reclining upon the ground, and from his loins a great tree rises above him. Numerous figures of his descendents are pictured upon the tree, signifying our Lord's human genealogy, according to St. Matthew. In the top of the tree is the Virgin holding the Holy Child, both nimbed, and both surrounded by an aureole. Seven doves, symbols of the Seven Gifts of the Holy Ghost, surround Him. Both the tree and the figures are conventionalized, and never realistic in treatment. By far the finest example is the celebrated Jesse Tree window in the west front of Chartres. It is about nine feet wide by twenty-five feet in height, and is one of the oldest and finest of all the 130 great windows in this cathedral. Its date is about 1145 A. D. Remains of an admirable Jesse Tree window exist at St. Denis, near Paris. Le Mans, Sens and Beauvais possess Jesse Trees, and there is a late one, and not nearly so good in treatment in the Church of St. Etienne in Beauvais. One of the chapels at Reims had one. Two of the churches in Rouen have Jesse Tree windows. Canterbury formerly had a good one. Traces of interesting examples still exist at York and Salisbury. Cirencester, Shrewsbury, Westwell in Kent, St. Cunibert's at Cologne, and various other old churches have boasted of

THE UNICORN
THE INCARNATION

LILIUM CANDIDUM
THE ANNUNCIATION

THE FLEUR-DE-LYS
HUMAN NATURE OF OUR SAVIOUR

THE GLADIOLUS
THE WORD MADE FLESH

THE DAISY
INNOCENCE OF THE HOLY CHILD

GLASTONBURY THORN
THE NATIVITY

CHRISTMAS ROSE
THE NATIVITY

ESCALLOP
OUR LORD'S BAPTISM

CIBORIUM
THE LAST SUPPER

THE PHOENIX
THE RESURRECTION

THE BUTTERFLY
ETERNAL LIFE THROUGH JESUS CHRIST

THE PEACOCK
IMMORTALITY THROUGH JESUS CHRIST

Our Blessed Saviour

PLATE VII.

eye open. So also is it said that "He that keepeth Israel shall neither slumber nor sleep,"—Psalm 121, 4. Because of their closed eyes, the people of olden times thought that the cubs of the lioness were born dead, and were brought to life on the third day by the breath of the lioness, or the voice of the lion. In like manner was our Lord brought to life on the third day by the voice of the Father.

The Lion likewise opens the seals of the Book of Life, (Revelation 5, 5), and is thus pictured in many an old church. The Lion of the Tribe of Judah is shown with the three-rayed nimbus, in order to distinguish Him from the Lion of St. Mark, and the roaring lion symbolizing Satan.

Examples of the lion symbol are too numerous to mention, but among many others we might note the lions of St. Mark's at Venice, St. Laurence at Nuremberg, Augsburg, Mayence, in one or two of the older churches in Cologne, at St. Nicholas of Stralsund, Maulbronn, Bebenhausen, Freiburg, Strasbourg, Lyons, Pisa, Ratisbon, St. Stephen's at Vienna, St. Etienne at Bourges, Dunfallandy in Scotland, Exeter, Ripon, Manchester, Ely, Westminster Abbey and on the font at Eardisley. In the Abbot Suger's marvellous windows at St. Denis is a remarkably fine nimbus-crowned Lion of the Tribe of Judah.

The Ox. This is based upon our Lord's words in St. Matthew 11, 30, "For my yoke is easy and my burden is light." The ox is the symbol of strength, of patience and of sacrifice, ready either for the plough or for the altar. For this reason the ox is a symbol of our Redeemer. If the ox

has wings, it is the symbol of St. Luke. The ox shown in Figure 11 is rather too realistic to be a good symbol. A more heraldic form is better.

The Rock. This appropriate symbol of our Blessed Saviour is based upon I Corinthians 10, 4, "For they drank of that spiritual Rock that followed them: and that Rock was Christ." The Rock may be shown in any one of several ways. If it be shown as a great rock standing alone, it suggests the idea of Psalm 18, 2, "The Lord is my Rock and my Fortress," or the words of the *Venite Exultemus* "Let us make a joyful noise to the Rock of Our Salvation." In this case it may be crowned with a cross, as we show in Figure 12. It may be shown as the Rock of Horeb, from which the saving waters gushed forth, Exodus 17, 6. Moses smiting the rock is a type, rather than a symbol, of the waters of salvation and Holy Baptism. A house built upon a rock has reference to St. Matthew 7, 24, and reminds us that we must erect our spiritual house upon the sure foundation of Jesus Christ and His Word. A rock with four streams of water flowing from it is common in Mediaeval symbolism, and represents the Four Rivers of Paradise, and the Four Gospels. If a church is shown standing upon a great rock, the reference is to St. Matthew 16, 18.

The Unicorn. The unicorn is a familiar symbol of our Lord Jesus Christ. This fabled animal is pictured as a graceful creature with a horse's head, a goat's beard, an antelope's legs and a lion's tail. From the center of his forehead rises a great spiral horn. It is a symbol of our Lord's Incarna-

tion and His sinless life. The unicorn of olden times was said to evade all efforts to capture it, and the only possible manner of overtaking it was to place an undefiled virgin in the forest. The unicorn was said to run to her and lay his head in her lap. This was regarded as a symbol of our Lord, Whom the heavens could not contain, but Who humbled Himself and was born of a Virgin, and was made man.

Ancient writers, both pagan and Christian, had great faith in the unicorn, and several of them give minute descriptions of this animal. A certain Oriental antelope, very swift of foot, when seen in profile, seems to have but one horn. This may be the creature which was mistaken for the unicorn. Various horns of the unicorn exist in museums, all of which are narwhal horns. Among the many notable examples of the unicorn as a symbol of our Saviour we might mention those to be seen in the form of carvings or paintings at Strasbourg Cathedral, at the famous Grimmenthal Church, now destroyed, on the doors of Pisa, at Lyons, Toledo, St. Sebald's at Nuremberg, St. Botolph's at Boston, at Erfurt, Bourges, Beverley, Lincoln, Ely, Chester and Manchester. We show an heraldic form in Figure 13, Plate VII.

The Lilium Candidum. A popular symbol of the Annunciation of our Lord is the *Lilium candidum*, shown in Figure 14. In all pictures of the Annunciation it is shown, either growing in a pot, or else held in the hand of the Virgin or the Angel Gabriel. As a rule it is stamenless, and may even have a tiny flame of fire resting upon it.

The Fleur-de-Lys. This is another symbol of the Annunciation of our Lord, likewise of His human nature, and of the Virgin Mother. See Figure 15.

The Gladiolus. Somewhat less common is the Gladiolus as a symbol of the Incarnation. See Figure 16.

The Daisy. The daisy, usually shown in a slightly conventionalized form as in Figure 17, is a symbol of the innocence of the holy Christ Child.

The Angel. The Archangel Gabriel, with his right hand raised in the attitude of benediction, and holding a lily in his left hand, is a familiar symbol of the Annunciation.

The Herald Angel. An angel floating in space, with his right hand raised in benediction, is a symbol of the Nativity of our Lord.

The Glastonbury Thorn. The ancient thorn-tree, *Crataegus oxyacanthia praecox,* which stands just within the gates of the great ruined abbey at Glastonbury, Somersetshire, is believed by many to be a descendant of the thornwood staff planted by St. Joseph of Arimathaea, who is said to have introduced Christianity into England in the year 63 A. D. The Glastonbury Thorn has the remarkable habit of bursting into bloom about Christmas Day each year, as any of the citizens of the town will attest. Because of this fact, the blossoms of the Glastonbury Thorn are symbols of our Lord's Nativity. Recent archaeological investigations carried on at Glastonbury by Mr. F. Bligh Bond and others seem to verify the tradition of the extreme antiquity of British Christianity, and to make it possible that the thorn tree

was planted by early missionaries. The original tree, which was of great age, was destroyed by a Puritan fanatic. We show the thorn blossom in Figure 18.

The Manger. An Oriental manger with supports resembling a cross saltire is another symbol of our Lord's Nativity. It may be empty, or may be represented with the Holy Child in it, His head surrounded by a nimbus.

The Ox and Ass. These lowly creatures have been used as symbols of our Saviour's birth. The ox is a symbol of patience and sacrifice, and the ass of humility and readiness to serve. The ox has been said to represent Israel and the Old Testament sacrificial worship, and the ass the Gentile nations, because of the fact that it wears a cross upon its shoulders and back. We doubt whether this last idea will ever gain widespread popularity among the Gentile nations.

The Shepherd's Crook. The shepherd's staff is an emblem of the Nativity. A shepherd ought to be shown clad in the true Oriental shepherd's tunic, and not in a long, flowing robe. He must not be shown following a star, nor riding upon a camel, for these are symbols of the wise men and of the Epiphany.

A Burning Torch. Originally a pagan symbol, the torch was adopted by Renaissance artists as a symbol of the Nativity. It is not common today.

The Christmas Rose. The *Helleborus niger*, Figure 19, is a Nativity symbol. The poinsettia is believed by some to have the same meaning.

The Starwort. The Christmas Starwort, *Aster grandi-*

florus, is listed by some authorities as a symbol of the birth of our Lord.

The Rosemary. The Rosemary, or *Rosmarinus officinalis*, is one of the flower symbols of the Nativity. Because of its traditional healing properties it has been used to express the truth contained in Malachi 4, 2.

Three Caskets. Three caskets, containing gold, frankincense and myrrh, symbolize the Epiphany, or manifestation of our Lord to the Gentile wise men. The gold is said to represent our Lord's kingly office, the frankincense His priestly office, and the myrrh (symbol of martyrdom) His prophetic office.

The Star. A star with five points, Figure 26, is a symbol of the Epiphany, or revelation of the Christ Child to the Gentile wise men. It must not be used as a Christmas symbol.

An Apple. If the Holy Child Jesus is shown holding an apple in His hand, it is a symbol used to remind us of the Fall of mankind, for the expiation of which our Saviour came into this world.

The Olive. Because the oil of the olive was used in olden times to soothe pain, the olive tree, or a sprig of olive, is a symbol of the grace of our Lord Jesus Christ which is able to give peace to the sorrowing sinner.

A Child. A child, clad in white, holding a scroll in one hand, is a symbol of the Christ Child in the temple among the doctors.

An Escallop Shell. Although originally a symbol of

the pilgrim, yet an escallop shell, with water dripping from it, has been used as a symbol.of our Lord's baptism. Pictures exist showing St. John the Baptist pouring water from a shell upon the head of our Saviour, Who stands knee deep in the waters of the Jordan. We show an escallop shell in Figure 20.

The Palm. Branches of the palm tree represent our Lord's triumphal entry into Jerusalem.

A Chalice and Host, a Vine with Heads of Wheat, a Pyx and a Ciborium are among the symbols of the Last Supper. We show a picture of a ciborium in Figure 21.

The Passion Symbols are discussed in a later chapter.

The Phoenix. One of the most widely used of all the symbols of our Lord's Resurrection is the phoenix. The legends concerning this fabled bird vary slightly. According to one version of the phoenix legend, this bird, which resembles an eagle somewhat, lives to an age of four or five hundred years. Then it gathers a nest of sweet smelling twigs and spices. These are set on fire by the heat of the sun (a variation of the legend says by the fanning of the bird's wings), and the phoenix is consumed in the fire. Out of the ashes the bird rises again, recreated and young, destined to live another five hundred years. A different legend states that the phoenix, having attained an age of five hundred years, flies to Heliopolis, in Egypt, and burns itself upon the high altar in the temple. When the priest comes, he finds among the ashes on the altar a small worm of very sweet savor. This worm turns into a bird, which

attains full growth on the fourth day, and the phoenix flies away with its youth renewed.

Of course there is no such bird as the phoenix. The Greek word for date-palm is *phoinix*, and the ashes of an old date-palm tree are thought to be excellent fertilizer for seedling palms. This is supposed by some authorities to be the basis of the legend. See Psalm 92, 12. In early Byzantine work, so rich in symbolism, the date-palm is often substituted for the phoenix. We show an example or two from the famed church of St. Apollinare in Classe, at Ravenna, so interesting in symbolic carvings. This illustration is among the plates at the end of this volume. The phoenix appears on early coins of such emperors as Constantine and others. It is a common symbol on Roman and Byzantine sarcophagi. Noted examples exist among the exterior carvings at Strasbourg, on the main door of St. Laurence's at Nüremberg and at St. Sebald's in the same city, at Tours, Le Mans, and in fact in nearly all of the leading churches.

The symbolism of the phoenix is two-fold. It may pertain to the Resurrection of our Lord, or it may signify the fact that those who fall asleep in Christ shall rise again to newness of life. Without forcing a meaning into it, the phoenix might be said to symbolize Holy Baptism also, for it is through the regenerating power of this Sacrament that the Old Adam in us is drowned and destroyed with all sin and evil lusts, and the new man comes forth, born again of

water and of the spirit. In Figure 22 we show the familiar
form of the heraldic phoenix.

The Butterfly. This is one of the finest of all the sym-
bols of the Resurrection, and of eternal life through Jesus
Christ. With such splendid symbols as this available, why
confine ourselves to two or three threadbare examples?
The three stages in the life history of the butterfly repre-
sent three stages of the Christian. First is the crawling
larva, representing the lowly condition of mortal man on
this earth. Next is the chrysalis, lying in its shell, and seem-
ingly lifeless. This depicts the body of man in the grave.
Finally the pupa bursts its outer shell, emerges, dries its
wings and soars heavenward with a beautiful new body. So
also does our Lord Jesus raise up all the dead at the last day,
and the soul and glorified body are reunited, to dwell in
Heaven forever. What finer symbol is there of the power
of our Saviour to raise up the faithful believer? A form of
the butterfly is shown in Figure 23.

The Bee. The bee was a pagan symbol, and is compara-
tively rare in Christian art. A few examples exist in the
catacombs. Peter of Capua calls the Risen Lord *apis
aetherea*. It is a symbol of the Resurrection, and of the
immortality of the soul.

The Peacock. This was a very popular symbol of the
Resurrection in early days, and of immortality as well. The
peacock is said to shed his brilliant feathers annually, after
which he has new feathers, finer and more brilliant than
before. Likewise there is an old legend which states that the

25.

POMEGRANATE
THE RESURRECTION

26.

STAR
THE EPIPHANY

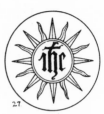

27.

THE SUN
SUN OF RIGHTEOUSNESS

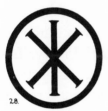

28.

X.I. MONOGRAM
IHCOYC (JESUS) XPICTOC (CHRIST)

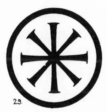

29.

GREEK CROSS AND LETTER X
MEANING XPICTOC" OR CHRIST

30.

MONOGRAM OF THE VIRGIN
THE VIRGIN BIRTH

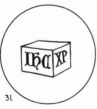

31.

THE CHIEF CORNER STONE
EPHESIANS 2.20

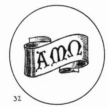

32.

ALPHA-MU-OMEGA="YESTERDAY,
TODAY, AND FOREVER"-HEB.13.8

33.

THE KING FOREVER
ST. LUKE 1.33

34.

THE ANCHOR
"THE ANCHOR OF THE SOUL"

35.

THE ROSE
MESSIANIC PROMISE

36.

CANDLESTICK
CHRIST THE LIGHT OF THE WORLD

F.R.W.

Our Blessed Saviour

PLATE VIII

peacock's flesh is incorruptible. In like manner our Lord's body did not see corruption, but was raised up glorified on the third day. So also does He raise up all true believers to a more glorious existence.

The peacock symbol is very common in the catacombs, and in Byzantine church art. Examples from burial monuments in St. Apollinare in Classe, St. Apollinare Nuovo and other churches are shown among the illustrations at the end of this book. Noteworthy examples exist at Ancona, Durham, New College at Oxford, Cartmel Priory, Lincoln, Exeter, on fonts at Winchester and Monmouth, and in many of the continental cathedrals. Often it is represented as standing upon an orb, signifying the world. Again there may be two peacocks drinking out of vases, as on many Byzantine sarcophagi, symbolical of the waters of life, and of life and salvation through the Sacraments.

The Bursting Pomegranate. In Figure 25, Plate VIII we show a bursting pomegranate, symbol of the Resurrection. It is a symbol of the power of our Lord, Who was able to burst the tomb on Easter Day and come forth alive. In a secondary way it is regarded as a type of the resurrection of all true believers in Jesus Christ. The pomegranate has also been used to symbolize royalty, hope, the future life and fertility. It was used on the robes of Aaron, (Exodus 28, 33-34). St. Gregory the Great speaks of the pomegranate as an emblem of the unity of the Church. It is used a great deal today, and is often found in fine damasks used for altar paraments and clerical vestments.

The Easter Lily. Because it blooms at Eastertide, the familiar Easter Lily is a common and extremely popular symbol of our Lord's Resurrection.

The Egg. In some countries the Easter egg is taken in all seriousness as a symbol of our Saviour's Resurrection. The bursting of the shell, and the coming forth of the young chick is looked upon as the coming forth of our risen Lord from the tomb.

Jonah and the Fish. In early days the symbol of Jonah and the great fish was used as a popular symbol of the Resurrection of our Lord. Our Saviour Himself uses the comparison in St. Matthew 12, 40. Many examples exist, among the most notable of which are the exterior carvings on Strasbourg. The Bible, by the way, does not state that it was a whale that swallowed Jonah. The Hebrew word *dag* means a great fish. The Greek word *ketos*, in St. Matthew 12, 40 means a great fish or sea monster. In picturing this event, a great fish ought to be used rather than the whale.

Elijah's Chariot. The flaming chariot of Elijah was a favorite symbol in olden days. It may be seen on many a tomb, especially of those who suffered martyrdom. It is a symbol of the Ascension of our Lord.

The Crown. The crown, Figure 33, denotes not only our Lord's kingly office, but expresses the fact that we have eternal life through Him as well. "The crown of life" is a symbol borrowed directly from Scripture. St. James 1, 12; I Peter 5, 4; Revelation 2, 10 and 3, 11 are among the principal Scripture verses where this idea is set forth.

The Stag. The stag is the legendary enemy of the serpent, with which it battles, and which it always overcomes. Thus has our Saviour been pictured as a stag, trampling upon and slaying the serpent Satan.

The Otter. This symbol was borrowed from early pagan writers, such as Pliny and Plutarch. The otter was said to coat itself with mud, which dries, forming a hard protecting coat. Then it rushes down the throat of the crocodile, and slays it by attacking it from within. This symbol of the otter was used in early times as a type of our Lord's descent into hell for the purpose of declaring His victory over death and Satan. Many old pictures exist of the otter in the act of rushing into the open mouth of the crocodile.

The Candlesticks. Upon every altar stand at least two candlesticks, and sometimes six. These represent our Lord's own words, "I am the Light of the world,"—St. John 8, 12. In their primary sense they set forth this idea. In their secondary sense they represent the two-fold nature of our Lord,—His human nature and His divine nature. If six candlesticks be used, as for example the splendid ones designed by Mr. Hervey Flint for Redeemer Lutheran Church, Chicago, or those in Cram, Goodhue and Ferguson's All Saint's Church at Ashmont (to mention two of a great many examples), the six candlesticks represent the six days of creation, and the cross standing in their midst represents the Day of Redemption. Seven candlesticks are proper only in a bishop's own church, and then only when he himself celebrates. Eight candlesticks may be used, but

in this case two of them must be eucharistic lights, either larger or smaller than the six on the gradines.

The Anchor. One of the oldest of all the symbols of our Blessed Saviour is the anchor. It originated in the days of the catacombs. The imagery is borrowed from Hebrews 6, 19, "Which hope we have as an anchor of the soul, both sure and steadfast." The anchor is always shown as in Figure 34, so that it forms a cross. This anchor-cross, the symbol of our hope in Jesus Christ, is found on the earliest Christian burial monuments. A cross, an anchor and a heart are the usual emblems of Faith, Hope and Charity.

The Panther. In ancient folk-lore, the panther was said to have a sweet-smelling breath, beloved of all the animals except the dragon. In like manner does the sweet savor of the grace of our Lord Jesus draw all true believers to Him, but His words are despised by Satan and his followers.

The Remora. Ancient folk-lore usually spoke of the remora, which was said to be a small fish of supernatural strength, able to fasten itself to the keel of a ship and to keep it from rolling or pitching even in the most violent tempests. This was used in old-time art as a symbol of our Lord Jesus, Who is able to protect the ship of the Church in the most violent storms of this life.

The Rose. This refers to the prophecy of Isaiah, where it is stated that the desert shall blossom as the rose at the coming of the Kingdom of Righteousness. The rose is said to date back only to the thirteenth century. It is used in a conventional form, as in Figure 35, and seldom in a natural-

istic manner. The rose is extremely common in Gothic wood carving, and many a bench end is adorned with it. It is a common charge of heraldry. The wild rose details at Amiens Cathedral, somewhat less conventionalized, are among the finest examples of perfect sculpture extant.

Five Crosses. Every altar that is properly designed has five small Greek crosses incised upon its mensa. These are ancient symbols of the Five Wounds of our Lord, and the custom of carving them upon the altar top has been perpetuated by all churches that have the altar. These crosses are two to three inches high, of the Greek form, and are found at the corners of the horizontal table of the altar, with a slightly larger cross exactly in the center of the mensa. The fairlinen, which ought to lie upon the altar at all times, has five crosses, embroidered in white, arranged to lie at each corner of the mensa, and one in the center.

The Door. Our Lord Himself said, "I am the Door: by Me if any man enter in, he shall be saved,"—St. John 10, 9. This Door of Salvation is a symbol of our Lord Jesus. It is shown as a massive, battened door of great timbers, with huge iron hinges, and is studded with nails.

The Eagle. If an eagle be shown, his head surrounded by a cruciform nimbus, it is a symbol of our Saviour. There is a tradition, perpetuated by the translators of the Bible, that the eagle is able to renew its youth. When it becomes old and its eyes are dim, it is said to fly as high as possible, and to look into the sun. Then it flies swiftly to the earth, plunges thrice into a fountain of crystal-clear water, and

emerges with perfect eyesight and renewed youth. So likewise did our Lord, after lying in the tomb, come forth with a glorified body. Thus also does He, through the Sacrament of Holy Baptism, enable all those baptized in the name of the adorable Trinity, to come forth with the old man purged away, and born anew through the washing of regeneration, and the renewing of the Holy Ghost.

It is also said that the female eagle flies toward the sun with her eaglets. Those of her young that cannot look into the sun with unflinching eyes, are cast down to the earth to perish. Those that are able to gaze into the sun are tenderly reared. So also are those who cannot look upon the face of the Son of God cast into outer darkness, while those who through God-given faith can regard him unflinchingly, are given richer measures of His grace, and finally taken to life eternal.

Examples of eagle legends, applied to our Saviour, exist at Strasbourg, Pisa, Lyons, Wells, New College at Oxford, and elsewhere.

The Charadrius. When a person was seriously ill, the ancients were said to bring a bird called the charadrius to his bedside. If the bird turned away from the sick man, it was thought that he would not recover. Thus does our Lord Jesus Christ turn away His face from those nations and individuals who reject Him, and thus does their unbelief result in eternal death.

The Olive and Balsam. The two-fold nature of our Lord, the human and the divine, has been expressed sym-

bolically in several ways. One is the symbol of the olive
and the balsam. Olive oil was used among the Jews because
of its restoring and refreshing effect when used to anoint the
body of a weary man. So also did our Lord, when on earth
among men, restore and refresh a world worn out with sin.
The balsam was prized because of its healing properties. So
also does our divine Lord, through His heavenly grace, heal
man of all spiritual diseases. This may be somewhat far-
fetched to us, but to the Oriental mind, and to the Mediae-
val churchmen, accustomed as both were to find mystical
meanings in all things, it was a symbol of His two-fold na-
ture. Their holy oil, used in anointing the sick, was com-
posed of olive and balsam.

The Mermaid. If we lift the massive misericord seats of
the old Mediaeval churches, and examine the carvings on
their under sides (these seats are made to turn up, somewhat
after the fashion of a theatre chair), we often find a beauti-
fully carved mermaid. At first the mermaid was a symbol
of the man whose speech is fair, but his deeds treacherous.
Some authorities, however, believe that the mermaid, which
was part woman and part fish, was a symbol of the union of
the divine and the human natures in our Lord Jesus Christ.
Mermaids are common in Mediaeval carving, and among
numerous examples might be mentioned Wells, Norwich,
Beverley, Edlesborough, Ludlow, Gloucester, Westminster
Abbey, Exeter, Ripon, Carlisle and St. Botolph's at Boston.

The Dolphin. The dolphin, according to St. Gregory of
Nyssa, is the most **kingly** of swimming things. It was used

on some of the oldest of tombs as a symbol of our Lord. The dolphin was said to bear the souls of the righteous across the sea to the land of the blest. This figure of speech led to its use on ancient tombs. It may be found in Mediaeval art at Ludlow, Beverley, Gloucester and elsewhere.

The Centaur. The centaur is a mythical creature which is said to be a horse with the head, arms and chest of a man. Among the pagans it was used to personify the evil passions in man. As a rule this is the meaning of the centaur when used in Mediaeval art, as it often was. A centaur armed with bow and arrow was called Sagittarius, and was used to personify the fiery darts of the wicked. But it had a secondary meaning, for the bad centaur was transformed into a good centaur, and made to symbolize the two-fold nature of our Saviour. Centaurs may be seen in countless churches, such as Adel Church near Leeds, West Rounton, Chichester, Lavenham, Ely, Exeter, Worcester, Lincoln, Augsburg, Brenz, Freiburg, Arles, Halberstadt, Zurich, Sienna, and in fact in the large majority of the old churches.

The Swallow. The swallow was believed by some, including Luther, to sleep in the water all winter, and to reappear in the spring. Thus it was used as a symbol of our Lord, Who slept in the tomb, but rose again on Easter Day.

The Oil Cruse. The oil cruse, or cruet, of the widow of Sarepta, mentioned in I Kings, 17, brought forth an unfailing supply of oil, regardless of how much was used. So likewise is the grace of our Lord Jesus Christ unfailing and inex-

haustible. It is usually pictured as a small earthenware jar, with handles.

The Cresset. A cresset is either a lantern-like frame of iron in which a flare is placed, or else a stone eighteen or more inches in diameter, with several holes in which lights are burned. A cresset from Lewannick Church, Cornwall, is shown in Plate XXXVII. A great flare was mounted in the lofty tower that once crowned Beauvais Cathedral, and could be seen for many miles. Thus does our Lord Jesus Christ, the Light of the World, guide His people on their journey to the New Jerusalem.

The Wine-Press. This symbol, we presume, is based upon Revelation 19, 15-16. We recall but one example of its use as a symbol of our Saviour, and that is in a window, seemingly of the seventeenth century, in the cathedral at Troyes. Doubtless many other examples have existed.

The Horse and Rider. The same 19th chapter of the Revelation furnishes the artist another symbol, that of our Lord riding in triumph upon a snow-white horse. The best-known example of this is to be found in a painting at the cathedral of Auxerre.

The Great Judge. A great many of the Mediaeval cathedrals contain the figure of the Great Judge of the quick and the dead. Almost without exception this is on the tympanum of the main western doorway. Where there are the three portals, so common to the older cathedrals, this carving is to be found over the central door. Our Saviour is pictured as the Judge, surrounded by an aureole,

and seated on His throne. All around Him are crowded figures symbolizing the nations of the earth. Thus we see popes, bishops, kings, princes, merchants, peasants and in fact every class and calling. Those on His right are shown clad in fair garments, and are escorted by angels to the gates of Heaven, which stand open. Those on His left hand are naked, except for some distinguishing mark of rank or occupation, and are shown bound with chains, led by demons into a monstrous, dragon-like open mouth, called the "jaws of hell," which emits flames and smoke. The Mediaeval artist seems to have believed that God is no respecter of persons, for noted examples exist showing kings with their crowns, bishops with their mitres and rich men with their bags of money, numbered among those who are departing into everlasting fire prepared for the devil and his angels.

This picture of the Last Judgment is found on a great many churches, and almost always over the west doorway, which was the main portal of the church. It was placed there to symbolize the fact that the church building was looked upon as a type of Heaven, which we enter only by passing through a portal at which the Judge sits, separating the sheep from the goats, and as soon as a man dies, his next conscious experience is the Day of Judgment. The portals of Reims, Amiens, Paris, Bordeaux, Auxerre, Autun, Bourges and Bayonne are examples that we recall. One of these is reproduced among the plates at the end of this volume. We cannot recall similar carvings in America,

although on the main portal of Fourth Presbyterian Church, Chicago, is a tympanum carving, beautifully executed, showing our Lord in glory, with the elect gathered around Him to receive His blessing.

In this apostate age of ours, when Bible teachings are often submitted to the popular vote of a denominational convention, there is a tendency to do away with the idea of future punishment, just as the ostrich is said to avoid his pursuers by sticking his head into the sand. Thus it is that the idea of the Last Judgment is unpopular in our day. Were this carved over more church doors, its lesson might become a wholesome thing for the passing multitudes,— much more so than a smart saying on a church bulletin board. Were we to borrow from the "dark ages" the idea of carving allegorical figures with the symbols of kings, bishops, clergymen, merchants, laborers, rich men and beggars, all gathered before our Lord Jesus Christ, the Judge of Quick and Dead, it might have the effect of causing the beholder to give thought to the eternity which awaits every son of Adam, and the final separation which none may avoid.

The Angel With a Trumpet. Where the entire scene of the Day of Judgment is not pictured, an angel bearing a trumpet has been used as a symbol of the Last Day. Some of the old cathedrals have had such an archangel, mounted on the easternmost pinnacle of the church, facing the rising sun, as a solemn reminder to the city below to remember that all must die, and that Judgment Day is sure to come.

Such symbols as these are legitimate, but all symbols of a chiliastic or millennialistic nature are to be avoided, as contrary to the Scriptures and the teachings of the Christian Church. Anything that would give the idea of a kingdom of glory or perfection on this earth should be avoided.

The Weighing of Souls. A favorite type of the Last Day in Mediaeval art, was that of an archangel holding a pair of scales, weighing the souls of men. Often the devil is shown trying to pull down one side of the balances.

There are many other symbols of our Lord, which are so palpable that they need no description. Among these are the symbols of the Chief Cornerstone of Ephesians 2, 20 and I Peter 2, 6, which we show in Figure 31; also the Alpha, Mu, Omega, signifying that our Lord Jesus is the beginning, continuation and end of all things (Figure 32); the Crown and Sceptre of Jesus our King (Figure 33); the Bread of Life of St. John, 6, 35; the Captain of our Salvation, Hebrews 2, 10; the Day Star, II Peter 1, 19; the Morning Star, Revelation 22, 16; the High Priest, Hebrews 3, 1, etc.; the Horn of Salvation, St. Luke 1, 69; the Light of the World, St. John 8, 12; the Passover, I Corinthians 5, 7; the Prince, Acts 5, 31; the Prince of Peace, Isaiah 9, 6; the Prophet, St. Luke 24, 19, etc.; the Rejected Stone, St. Matthew 21, 42; and various others.

The Two States. Our Saviour's State of Humiliation is symbolized by the manger at Bethlehem, the stable, or the humble home at Nazareth. His State of Exaltation is shown by the Lamb of God enthroned, crowned with a

nimbus, with figures representing all classes of men worshipping Him.

The Two Natures. Our Lord's Human Nature is depicted by the lily, the fleur-de-lys, the AM monogram, or any of the other symbols of the Virgin displayed on a shield. His Divine Nature is pictured by a corresponding shield, upon which may be almost any of the many symbols of His power, such as an IHC or a XP symbol, surrounded by the triangle of the Holy Trinity.

The Threefold Office. If it is desired to represent the prophetic, priestly and kingly office of Jesus Christ, the traditional way is to clothe Him in the long robe of the prophet, over which is the chasuble, stole, cincture and maniple of the priest, and upon His head the jeweled crown of the king. Caskets containing gold, frankincense and myrrh have been used to represent the threefold office. Their symbolical meaning has been mentioned above.

CHAPTER VII.

THE SACRED MONOGRAMS

SEVERAL groups of letters have been used from the days of the primitive Christian Church onward, to symbolize our Lord Jesus Christ. In popular language, these are known as sacred monograms, although several of them might properly be called abbreviations.

The Chi Rho Symbol. This is among the most ancient of the so-called monograms of our Lord Jesus Christ. It is the abbreviation of the word "Christ." This name of our Saviour was spelled XPICTOC in ancient Greek uncials, the letter C having been used instead of the letter Sigma more familiar in our day. Taking the first two letters of this word XPICTOC, the abbreviation XP was the result. This is called Chi Rho, from the names of the Greek letters X and P. A horizontal line over the two letters is the sign of an abbreviation.

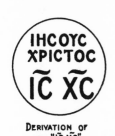

DERIVATION OF
THE "IC XC"

Countless examples of the Chi Rho symbol exist in the catacombs, as well as on early coins, lamps, pottery and other objects brought to light by the archaeologist. Entire books have been written upon the subject.

On Plate IX we show a few of the more familiar forms,

some of which are rather crude in their original ancient form, others beautifully made. We show them in their slightly modernized form, as used today in Christian art. Figures 10 and 11 are very common on early burial inscriptions, lamps and coins. Figure 12, from the catacombs, combines the Alpha and Omega with the Chi Rho, signifying that our Lord Jesus is the beginning and end of all

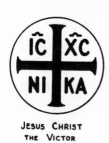

JESUS CHRIST
THE VICTOR

things. Figure 13, also from the catacombs, combines a true Chi Rho with the Greek Cross. Figure 14 contains the letter N, meaning *Nika*, or "Jesus the Conqueror," or "Jesus Conquers." Some authorities believe that is a combination of the Greek Chi Rho and the Latin word *Noster*, and that it means "Our Christ." Figure 15 shows an ancient form of the Chi Rho with the Rho placed upon one arm of the letter Chi. Figure 16 is another variation, made by combining the first letter of the Greek word IHCOYC, meaning "Jesus," and the word XPICTOC, meaning "Christ." Another form of this same symbol is shown on Plate VIII, Figure 28. Still another form, combined with the Greek cross, is shown on Plate VIII, No. 29.

The IHC Symbol. Even more popular today, but not quite so ancient as the Chi Rho symbol, is the IHC. This is the abbreviation of the Greek word IHCOYC, meaning "Jesus." Often it is written IHS or even I. H. S. The form IHS is not so good as the ancient IHC, which is historic-

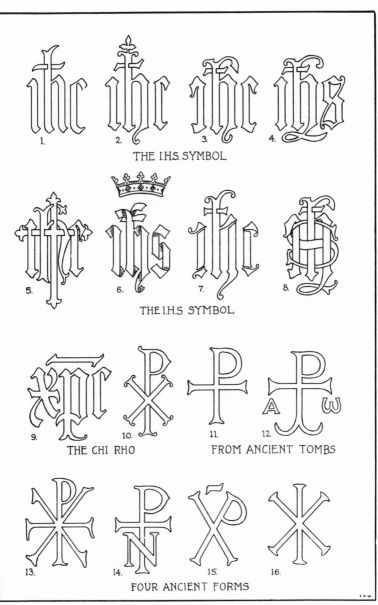

THE I.H.S. SYMBOL

THE I.H.S SYMBOL

THE CHI RHO FROM ANCIENT TOMBS

FOUR ANCIENT FORMS

Sacred Monograms PLATE IX

ally and traditionally the better form, and certainly produces a more balanced composition when used in church decoration. To use periods after each letter is unpardonable thoughtlessness, for IHC is a symbol, derived from one word, and not the initial letters of three words. Modern sign-writer's block letters ought not to be used, for they have no artistic value. The old black letter text, of Church art, is the more artistic.

It is commonly supposed by uneducated people that IHS stands for *Iesus Hominum Salvator*, and even good dictionaries have been known to state this notorious error. The three Latin words just mentioned, meaning "Jesus, Saviour of Mankind," are comparatively modern. They are usually credited to a somewhat eccentric monk known as St. Bernardine of Sienna, who died in 1444. He is said to have carried about with him this motto, written on a bit of parchment. The early Church knew nothing of such a rebus, and no authority of any standing takes it seriously.

The modernized form, J. H. S., seen on cheap altar paraments and sometimes carved on cheap altars, is the result of most ghastly ignorance, for the name "Jesus" begins with the letter I both in its Greek and its Latin form, and J. H. S. means nothing.

The IHC symbol, as well as the Chi Rho, ought to have a horizontal line over it, signifying that it is an abbreviation. Often this horizontal line may be combined with the H, so as to form a cross.

We have adapted from various sources several forms of

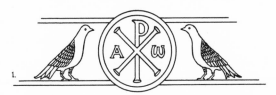

ALPHA-OMEGA-CHI RHO, FROM AN EARLY MONUMENT

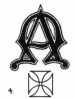

2.

FROM THE CATACOMBS

3.

AN ENGLISH VERSION

4.

A MODERN RENDERING

5.

6.

7.

THREE EXAMPLES WITH CROSSES

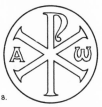

8.

AN HISTORIC EXAMPLE

Alpha and Omega

PLATE X

the IHC symbol. No. 1 is a simple form from Pugin's "Glossary." No. 2 is slightly more ornate. No. 3 is a rendering often seen today in the color-and-gold stencilings on the ceiling beams of churches. No. 4 is adapted somewhat freely from the cornerstone of a church by Cram, Goodhue and Ferguson. No. 5 shows the IHC with a cross intertwined. No. 6 is a ribbon-like treatment of the sacred symbol. No. 7 is from a beautiful card printed some years ago by the Mowbray people of Oxford. No. 8 is not so good, for it combines the modern English S with the Greek Iota and Eta. From the ceiling of an old English church we reproduce the form of the Chi Rho shown in Figure 9, where three letters, XPC are used. This is not a rare form, but is very useful where two spaces are to be filled, and it is desired to place the contractions of "Jesus" and "Christ" in them.

Another variation of these symbols is the form IC XC, each pair of letters with a line over it. This is a traditional rendering of the name "Jesus Christ," and in this case the first and last letters of the Greek form of each word are used.

Alpha and Omega. Perhaps the most abused of all symbols is the one known as the Alpha-Omega emblem. It is based upon several Scripture verses, such as Revelation 1, 8. It means that our Lord Jesus is the beginning and end of all things. Alpha and Omega are the first and last letters of the Greek Alphabet. This symbol ought to be used in connection with some other symbol, such as the cross. Its abuse lies in the fact that the other symbol,

which gives it meaning, is usually lacking, and thus it becomes the symbol of the Greek alphabet and nothing more.

In Figure 1 we show an historical form from the catacombs, where the Alpha and Omega are properly used in connection with the monogram of our Lord's name. In Figure 2, also from the catacombs, the Alpha and Omega are used together with the Chi Rho. Figure 3 shows the Alpha and Omega, with a kingly crown over it. Figure 4 shows it with the Cross Patée. Figures 5 and 6 show combinations of the Alpha, the Omega and the Cross. Figure 7 shows a combination of both with the cross. Figure 8 is an historic example familiar to many.

In some of the earlier inscriptions, the large Alpha and the Omega resembling the modern form of the small letter of today, were used. Figure 8 is a case in point.

Alpha, Mu, Omega, signifying that our Lord Jesus Christ is the beginning, continuation and end of all things, is another traditional symbol. See Plate VIII, Figure 32.

"IESUS NAZARENUS REX IUDÆORUM"

Other Forms of Abbreviation. The familiar I. N. R. I. means *Iesus Nazarenus Rex Iudaeorum*, as has been previously explained, that is, "Jesus of Nazareth, the King of the Jews." The Greek letters ΘC, or Theta Sigma, with a horizontal line over them, stand for ΘEOC, meaning "God."

The letters XI, shown in Figure 28, Plate VIII, are the first and third letters of the Greek word XPICTOC, mean-

ing "Christ." If these letters are reversed so as to read IX, then the I stands for IHCOYC, meaning "Jesus" and the X for XPICTOC, meaning "Christ." These forms often occur on old burial inscriptions.

The sacred monograms ought to be displayed in such a manner that unintended disrespect is not possible. A pastor who boasted of having used twenty different variations of the IHC and XP symbols in the encaustic titles of his chancel floor, certainly did not give the matter thought. The place for symbols of sacred things is not underfoot. Thought should be given to the proper location of symbols as much as to their design.

CHAPTER VIII.

THE CROSS

THERE are over four hundred forms of the cross. Of these, about fifty have been used in Christian symbolism. Many of them undoubtedly had their origin in heraldry, and are included in most of the standard books on the subject of Christian symbolism.

In the days when bad taste ran riot, it was the fashion to decorate our American parish churches in a most frightfully wonderful fashion, with various scroll-work and pseudo-Saracenic patterns. Not only were such things ugly beyond descriptive adjectives, but they were meaningless as well. Nowadays one seldom sees such outrages against good taste committed by an intelligent parish. Church decoration today is much more restrained and simple. Decoration is focussed upon certain spots where it may enhance the architectural forms of the church, rather than clash with these forms. Today there is a most sensible demand that such decoration mean something.

About fifty forms of the cross have been used in church decoration. In fact, almost all of the heraldic variations of the cross may be used in this manner. Such forms may be carved in stone on the exterior of the church building. They may be carved in wood, perhaps upon shields, and emblazoned with their proper tinctures. They may be used in stained glass windows, or painted on the beams or

the wood ceiling. Some distinctive form of the cross, beau-
tiful in design, may be used in festival decorations at the
various seasons of the Church. In fact there are certain
decorative forms of the cross traditionally associated with
Advent, with Christmastide, with Epiphany, with the
Lenten season, the Trinity season, and in fact with the en-
tire cycle of the Christian Year.

The field of church embroidery draws largely upon
Christian symbolism, and even upon heraldry, and many
of the fifty or more common variations of the cross may
be seen on the frontals and super-frontals of our altars,
upon the hangings of pulpit and lectern, upon the dossal
and riddle curtains that often form a background for the
altar, and upon book-marks and banners.

In order that our readers may have a ready reference list
of the more common forms of the cross, we have collected
from a dozen standard works on Christian symbolism, and
an equal number of books on heraldry, the more familiar
variations of the cross. It is not intended that all these shall
be used. Some of them are included by way of compari-
son. In one or two cases crosses have been included mere-
ly as a warning against an incongruous use of symbolism.
Certainly a church of pronounced Protestant traditions
would not use the cross of the Pope, with its three horizon-
tal bars, nor would a Jewish temple display a symbol of the
Holy Trinity on its corner stone.

The Latin Cross. This form of the cross is appropriate
the world over, and may be used by any religious body

whose doctrines include a confession of the Lord Jesus Christ and His atoning death. It is the actual form of cross upon which the Saviour died, and it is safe to use it almost anywhere. It is known as the *Crux immissa.*

Most Latin crosses, when designed by amateurs, are bad in proportion. The usual fault is that they are too thick and clumsy.

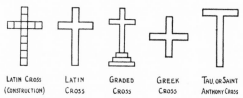

LATIN CROSS (CONSTRUCTION) LATIN CROSS GRADED CROSS GREEK CROSS TAU, OR SAINT ANTHONY CROSS

A cross of satisfactory proportions may be made by cutting twelve perfect squares out of cardboard, and arranging them as shown in our first figure. This is eight squares high and five squares wide. Anything thicker than that is clumsy. If used in church embroidery, it ought to be considerably more slender even than the proportions just given. A gable or a spire cross ought never to be less than eight squares high and five squares wide, and if anything, more slender. It ought to be made of material octagonal in section, or it will look heavy when seen from below.

The foolish custom of trying to set a paragraph of printer's type in the form of a stubby cross ought not to be attempted. It is better to get a small zinc etching or an electrotype of a cross of proper design.

The Crucifix. A cross with a figure of our Lord upon it is called a crucifix. It is a symbol of the Passion and of

the Atonement. This form is traditionally correct for an altar, and it ought to be placed on the highest level, higher even than the candlesticks. If a plain altar cross be used, it may be the form shown in our third figure. It may have either the I H C or the Chi Rho symbol in the center. Other good forms show the *Agnus Dei* in the center in a medallion, and the symbols of the Four Evangelists at the end of each of the four arms of the cross.

A crucifix ought to be symbolically treated, and not realistic. The best form is the early one, which shows our Lord fully clad, possibly with His prophetic, priestly and kingly vestments, and crowned, showing that He was true God, even in His sufferings.

In many of the older churches, the transition from nave to chancel is marked not only by a change in level and a great arch, but by a rood beam as well. This is a great beam of oak, cambered in the center, with a crucifix rising above its center. On the right of our Saviour is His Mother, and upon His left the Beloved Disciple. It is unfortunate that puritanic prejudice brought about the destruction of many of these carved representations of the Crucifixion, for the symbolism is beautiful. It signifies that we pass from the Church Militant (symbolized by the nave), to the Church Triumphant (symbolized by the chancel), only by passing under the cross of the Crucified.

Before turning to the heraldic forms of the cross, nowadays used for decorative purposes, permit us to mention the more common forms of the purely ecclesiastical cross.

The Graded Cross. This is a Latin cross, the vertical member eight to ten squares high and the horizontal member five to seven squares long. It stands upon a base composed of three steps, hence its name. The lower step represents Charity, the broadest and greatest of the three Theological Virtues. The second step denotes Hope, without which Charity avails little. The highest step is Faith, and is placed next to the cross to express the fact that Faith is the gift of the Crucified Lord, and not a thing of man's own creating. This Graded cross, somewhat more slender than the proportions indicated above, is often used upon the altar.

The Greek Cross. This ancient Greek cross, which must not be confused with the cross of the Eastern Church, is made by arranging seven perfect squares vertically and seven horizontally. The arms are all of equal length, and a perfect circle may be drawn about them, just touching the end of each arm.

On all properly designed altars, five Greek crosses are used. One of these is incised in the exact center of the mensa, or top slab of the altar, so that the sacramental vessels, at the celebration of the Holy Eucharist, may be placed over it. Four other Greek crosses, somewhat smaller in size, are incised close to each corner of the mensa of the altar. These five Greek crosses, of very ancient tradition, represent the Five Wounds of our Lord.

If the altar be of stone, they are incised either V shape in cross-section, or else simply rebated. If the altar is of wood, they may be either incised, or else inlaid.

The fair-linen, which lies at all times on top of the altar, and is placed over the season vestments, must also have these five crosses, of slender design, perhaps treated ornamentally. They must be embroidered in pure white, and not in colors. If a dust-cloth is placed over the altar at any time, it may have the five crosses embroidered upon it in simple outline, in red.

The Tau Cross. This is sometimes called the Old Testament cross, the Anticipatory cross, the Cross Commissée, the Egyptian cross, the Advent cross or St. Anthony's cross. It is said to be the true form of the cross raised up by Moses in the wilderness. In Roman times it was called the *Crux commissa.* It is merely a Latin cross minus its upper arm. In Christian painting, the two thieves are shown hanging upon this type of cross. St. Anthony and St. Matthew are both said to have died upon such a cross, and it is used as symbols of these two martyrs. In paintings of the Crucifixion, Dismas is shown upon our Lord's right, and Gesmas upon His left, both hanging upon Tau crosses.

The Tau cross is the cross of prophecy, and the uplifting of the serpent of Moses is a type of our Lord Jesus Christ. Hence this cross is used upon the violet altar and pulpit hangings for the Advent season, and upon printed matter announcing the special Advent services of the Church. It is one of the very oldest forms of the cross.

The Cross Saltire. This is likewise known as St. Andrew's cross, as well as the *Crux decussata.* It is composed of two arms of equal length, crossed like the letter X.

St. Andrew the Apostle is believed to have died upon this form of a cross, preaching joyously for a number of hours to the people around him, of the Saviour of mankind.

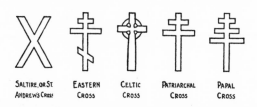

SALTIRE, OR ST. EASTERN CELTIC PATRIARCHAL PAPAL
ANDREW'S CROSS CROSS CROSS CROSS CROSS

This cross is used to symbolize the beginning and end of the Christian Church Year, which is governed by the Sunday nearest St. Andrew's Day. It is likewise the symbol of martyrdom and of humility. It is the national cross of Scotland, and sometimes known as the Scottish cross. It is often used on the seal, and on the cornerstone of congregations bearing the name of St. Andrew's Church. If its color is red, it is known in symbolism as St. Patrick's cross. It is also the cross of St. Alban.

The Eastern Cross. Within recent years, many churches have been erected with a cross on their spires composed of a vertical and two horizontal arms, and a third arm placed in a slanting position. Such a cross may be used only by the Eastern Church, and its presence upon a spire or a dome signifies that the congregation is a member of the Eastern Orthodox Church.

American architects, unfamiliar with this cross, have often designed it improperly. To design such a cross properly, one must first lay out a slender Latin cross. Then

add a shorter arm above the usual cross arm. Finally add a lower arm the exact length of the upper arm, which must slant "backhand," or dexter, and never sinister. This lower arm must be placed somewhat below the long arm, it must be exactly the length of the uppermost arm, and its ends must be cut so that they are vertical. Its pitch is less than 45 degrees.

The upper arm of this Eastern cross, often called the Russian cross, represents the inscription placed over the head of our Lord. The lower, slanting arm represents the foot-rest, since the Eastern Church believed that He was crucified with His feet side by side, and not placed one on top of the other, as the Western Church and the Protestant bodies usually picture the Crucifixion.

Many strange reasons have been given as to why the lower bar slants. The Russian Raskolniks are said to charge the Russian Orthodox Church with teaching that our Lord's limbs were of unequal length! Others say that the foot-rest was disturbed because of the earthquake, or that it was set aslant at the deposition. The true explanation seems to be that the foot-rest is set at an angle in order to suggest the Cross Saltire, or St. Andrew's Cross, this Apostle having introduced Christianity into Russia, according to an old tradition of that land. The Uniates, a group of eastern churchmen who lean toward Rome, have attempted to introduce various strange modifications of the traditional cross of the Eastern Church.

The Celtic Cross. This is also known as the Irish cross

and the Cross of Iona. It is a very ancient form, having been used by the early Celtic Christians, who trace their origin to the earliest centuries of the Christian era. Many such crosses, of extremely ancient origin, may be seen in Great Britain, where they were used in primitive times as wayside crosses and cemetery crosses.

The vertical member of this cross usually tapers, often with a slight entasis. At the junction of the vertical and horizontal members, the cross is hollowed out in four places, and a circle, representing Eternity, placed about it. Usually this circle lies on a different plane than that of the cross proper. Many ancient forms of the Celtic cross are most elaborately carved, with intersecting circles and bas-ket-weave patterns, and often with medallions in which are figures carved in low relief.

Some years ago, when Protestant bodies were afraid to use a true Latin cross, due to some fancied association with Rome, many a crudely designed Celtic cross might have been seen on a church spire. Such crosses were described most aptly by a wag as "disguised crosses."

The Patriarchal Cross. In many paintings, and often in stained glass windows, certain patriarchs are shown carry-ing a cross with two horizontal arms, the upper one slightly shorter than the lower one. This is known as the Patri-archal cross. The upper arm represents the inscription placed over the head of the Saviour when He was crucified.

The Papal Cross. In a little town in Eastern Pennsyl-vania may be seen a church with twin spires, each one of

which is crowned with a cross having three horizontal
arms, each a little longer than the other. This is a curious
blunder, for such a cross is known as the Papal cross. It
is the cross carried before the Roman pontiff, and may be
used by none other, for it is a distinctive mark of his office.
The illustration shown above will give an idea of the form
of this cross.

The Shield of Faith. This is a simple Latin cross placed
upon a shield. The cross is couped, that is, its ends do not
reach the edge of the shield. It is the symbol of Christian
Faith, also of the Faith for which the Christian is to con-
tend earnestly. Shields bearing the cross, the anchor and
the heart are common, representing Faith, Hope and
Charity. The ends of the cross must not reach the edge
of the shield, for then it at once becomes the emblem of a
well-known secret society.

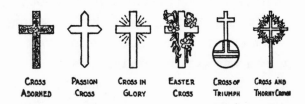

| CROSS | PASSION | CROSS IN | EASTER | CROSS OF | CROSS AND |
| ADORNED | CROSS | GLORY | CROSS | TRIUMPH | THORNY CROWN |

The Cross Adorned. There are several variations of this
cross. A Latin cross, whose surface bears painted or
carved lilies, Passion flowers or other floral forms, is called
a Cross Adorned. Another common form shows each arm
of the cross ending with a beaded moulding, from which
spring fleurs-de-lys.

The Passion Cross. This is a cross whose ends are cut to points. It is also known as the Cross Urdée, and the Cross Champain, sometimes as the Cross Pointed. It represents the sufferings of our Lord, and has been called by some authorities the Cross of Suffering. If pictured as rising out of a chalice, it represents our Lord's agony in the Garden of Gethsemane. It may be used as a symbol of Maundy Thursday, or of Good Friday.

The Cross in Glory. This is also called the Rayed cross, and the Easter cross. It is a Latin cross, behind which is a rising sun, sending forth twelve or more rays of light. This form of cross is suitable for Easter decorations, or for the Easter Day altar vestments. Its colour is white.

The Easter Cross. The Cross in Glory. Also a white Latin cross with Easter lilies twined about it. Symbolical of our Risen Lord, and of Easter Day. It is widely used on Easter cards, and on parochial printing for Eastertide.

The Cross of Triumph. Also known as the Cross of Victory, the Cross of Conquest, the Cross Triumphant, the Cross and Orb and the Mound. A small Latin cross resting upon a banded globe. It typifies the triumph of the Gospel throughout all the earth. A small orb is often placed under the cross on a church spire to denote the same fact. The sceptre held by our Saviour when pictured in His Kingly office, is surmounted with the cross and orb. In Christian painting our Lord is often pictured holding the cross and orb in His left hand. It is a symbol of the

Glorified Lord, and must never be used in pictures referring to His state of humiliation.

The Cross and Thorny Crown. A very slender Latin cross about which is twined a crown of thorns. A Passion symbol. Very appropriate for the altar and pulpit vestments for Good Friday.

The Advent Cross. The Tau cross. See above, under symbols of ecclesiastical origin. Also called the Old Testament cross, the Anticipatory cross and the Cross of Prophecy.

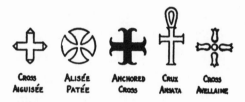

Cross Aiguisée Alisée Patée Anchored Cross Crux Ansata Cross Avellaine

The Cross Aiguisée. A decorative cross, of heraldic derivation. The ends are couped, that is, cut off square, and terminate with obtuse points. A symbol of the Passion.

The Cross Alisée Patée. The Cross Patée inscribed within a circle. See above, under Cross Patée.

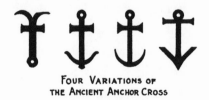

FOUR VARIATIONS OF
THE ANCIENT ANCHOR CROSS

The Anchored Cross. A form of the cross, originating in primitive days in the catacombs, formed by combining

an anchor and a cross. The symbol of Christian hope. Also an heraldic cross whose ends are curved outward like the flukes of an anchor.

The Cross Ankh. The Crux Ansata.

The Crux Ansata. A cross, supposedly of ancient Egyptian origin. It may be either a Tau cross with a loop above it, or a Latin cross similarly looped. A symbol of life.

The Anticipatory Cross. See above, under Tau Cross.

The Cross Avellaine. A decorative form, based upon heraldic lore, and deriving its name from its resemblance to four husks of the *nux avellana.* An example of this form of cross surmounts the dome of St. Paul's cathedral, in London.

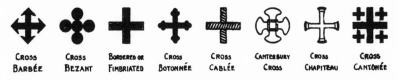

| Cross Barbée | Cross Bezant | Bordered or Fimbriated | Cross Botonnée | Cross Cablée | Canterbury Cross | Cross Chapiteau | Cross Cantonée |

The Cross Barbée. A cross whose ends resemble the barbs of fish hooks, or fish spears. Symbolical of the ICHTHUS symbol of our Lord. Also suggestive of the idea of "fishers of men."

The Cross Bezant. A cross whose surface is charged with golden discs. Also a cross composed of five to seven discs, either Greek or Latin in its form.

The Bordered Cross. Also termed the Fimbriated cross or the Edged cross. Much used in churchly printing, in

decoration, in heraldry and in ancient stained glass work. One of the most useful of the decorative forms of the cross. Any cross, regardless of its form, if edged with a narrow band, usually of a different color, is said to be bordered or fimbriated.

The Cross Bottonnée. Also known as the Cross Bourbonee, or the Cross Trefflée. A very beautiful form, either Greek or Latin in design, whose ends terminate in trefoils. Once commonly·stamped on the covers of hymnals, it is now used widely where a decorative form of the cross is desired. It is often used on corner stones.

The Cross Bourdonée. A cross whose four limbs end with spherical knots. Some authorities state that these knots or knobs must end with fleurs-de-lys.

The Cross Bretissée. A cross whose limbs show indentations similar to battlements, except that the battlements are not opposite one another. Compare with the Cross Embattled. A symbol of Christian warfare, and the Church Militant.

The Cross Cablée. A cross composed of two members resembling cables. Purely decorative.

The Calvary Cross. This is the same as the Graded cross. See above. Also, a cross containing the figure of our Lord, with His Mother and St. John on either side, is called a Calvary. The simple Latin cross is sometimes termed the Cross of Calvary.

The Canterbury Cross. A cross with four hammer-like arms which spring from a square.

The Cross Capital. A cross, derived from heraldry, and now used decoratively, whose limbs terminate in architectural forms suggesting the capitals of columns. Also known as the Cross Chapiteau.

The Cross Cantonnée. Any large cross closely surrounded by four smaller ones of similar design, is called a Cross Cantonnée.

The Celtic Cross. See above, under the crosses of purely ecclesiastic origin.

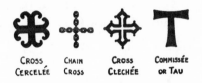

CROSS CHAIN CROSS COMMISSÉE
CERCELÉE CROSS CLECHÉE OR TAU

The Cross Cercelée. Somewhat like the Anchored cross, except that its curved ends resemble a ram's horn.

The Chain Cross. A cross composed of links of a chain. It originated in the days of heraldry, but today may be used to express the idea of the fetters of sin broken through the power of the Cross of Calvary.

The Cross Champain. See under Passion Cross.

The Cross Chequy. Also called the Cross Echiquette. A cross composed of at least three rows of squares of alternating colours.

The Cross Clechée. A cross with spear-like ends, usually having small knobs or loops, charged with another cross of the same design and colour but smaller, so that only a narrow border of the under cross is visible. The smaller cross

is the same color as the field. Other authorities define it as
a cross having spear-like ends, voided and pometted. A very
decorative form of cross, and like all others may be used
either in the Greek or Latin form.

The Cross Commissée. The Tau cross of the Old Testa-
ment. See above, under Tau.

The Cross Componée. Also called Gobony. A cross
formed of rows of small squares of alternating colours,

The Cross of Constantine. A combination of the cross
and the Chi Rho symbol, said to have been seen by Con-
stantine, together with the words *In hoc signo vinces*. It is
the proper symbol for Ascension Day.

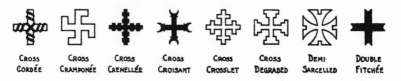

| CROSS CORDÉE | CROSS CRAMPONÉE | CROSS CRENELLÉE | CROSS CROISANT | CROSS CROSSLET | CROSS DEGRADED | DEMI-SARCELLED | DOUBLE FITCHÉE |

The Cross Cordée. Likewise called the Corded cross.
A cross, either Latin or Greek, around which is wound a
rope. In Christian symbolism it may be used to recall the
rope used to bind our Lord before His Crucifixion. Of
heraldic origin.

The Cross Cotised. A cross whose ends are adorned
with scrolls. These may be said to represent the Four Gos-
pels, although this, like many other ideas, may have been
read into a cross purely heraldic in its origin.

The Cross Couped. A cross whose ends are cut off
straight and do not reach the edge of the shield upon which

it is painted or carved. The symbol of Christian faith. Also termed the Cross Humettée.

The Cross Cramponée. A Cross Potent with a part of each termination missing. Similar to the Swastika, except that the returned arms are shorter.

The Cross Crenellée. Also known as the Embattled cross. A cross whose edges suggest the battlements of a fortress. The symbol of the Church Militant. Compare with the Cross Bretissée.

The Cross Crescented. Also known as the Cross Croisant. A cross whose ends terminate in crescent-like ornaments.

The Cross Croisant. Same as the Cross Crescented.

The Cross and Thorny Crown. See above, under the symbols of purely ecclesiastical origin.

The Cross and Kingly Crown. A Latin cross, usually Bottonnée, thrust through the Crown of Eternal Life. The cross ought to stand erect, rather than at an angle.

The Cross Crosslet. Four Latin crosses arranged so that their bases overlap. It may be said to represent the spread of Christianity to the four corners of the earth. This form is appropriate for Epiphanytide, when the missionary idea is stressed.

The Crucifix. A Latin cross, upon which is shown a painting or a carving of our Lord. See above, under ecclesiastical symbols.

The Crux Commissa. The Tau cross.

The Crux Decussata. The Cross Saltire.

The Crux Imīnissa. The Latin cross.

The Cross Dancette. Similar to the Indented cross, except that its teeth are fewer and more obtuse.

The Cross Degraded. A cross whose arms end with steps which touch the edge of the shield upon which it is charged.

The Cross Demi-sarcelled. A cross of the Patée type, with square indentations in its outer edges. Purely decorative.

The Cross Dismembered. A cross cut into five parts. See under Cross Trononée.

The Cross Disguised. A term, applied in jest, to an attempt at concealing the true design of a Latin cross, such as placing a circle about it.

The Cross Double-Fitchée. A cross whose ends terminate in two points, as shown in our diagram.

The Cross Double-Parted. Similar in design to the Interlaced cross, except that its four members are shown in solid color instead of in outline.

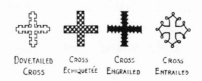

DOVETAILED CROSS CROSS CROSS
CROSS ECHIQUETÉE ENGRAILED ENTRAILED

The Cross Dovetailed. A cross whose sides have indentations resembling the cabinet-maker's dovetailing.

The Eastern Cross. See above, under crosses of ecclesiastical origin.

The Cross Echiquette. See under Cross Chequy.

The Egyptian Cross. The Tau cross is occasionally called the Egyptian cross.

The Eight-Pointed Cross. Another name for the Maltese Cross. Symbol of the Eight Beatitudes, and of regeneration.

The Cross Equisée. A cross whose ends are pointed. See under Cross Aiguisée.

The Cross Embattled. See above, under Crenellée.

The Cross Engrailed. A cross whose arms show thorny projections, forming concave semi-circles. These projections are supposed by some to express the sharpness of the suffering of our Lord upon the cross, although any heraldic figure may be engrailed.

The Cross Engoulée. A peculiar form, in heraldry, in which the ends of the cross project into the mouths of lions. Often shown in books on symbolism, but rarely used in modern times. We list it for the sake of reference.

The Cross Entrailed. A decorative form of cross, which springs from heraldry. It is voided, being formed of narrow lines similar in shape to the Cross Clechée, except that each arm is ornamented with three loops.

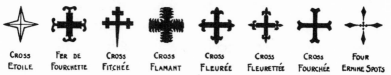

CROSS ETOILE FER DE FOURCHETTE CROSS FITCHÉE CROSS FLAMANT CROSS FLEURÉE CROSS FLEURETTÉE CROSS FOURCHÉE FOUR ERMINE SPOTS

The Cross Etoile. A cross in the form of a four-pointed star.

The Cross Fer-de-Fourchette. A decorated cross, of heraldic origin, whose ends resemble the forked irons once used by soldiers as rests for their muskets, hence its name.

The Cross Fitchée. Any form of the cross whose lower arm is drawn out to a sharp point, is said to be fitched, or pointed. This form is said to have originated at the time of the Crusades, when the crusaders carried small crosses with pointed lower arms, capable of being thrust into the ground at the time of daily devotions. Our illustration shows a Cross Crosslet fitched, although almost any form of the cross may be thus fitched at its base.

The Cross Fimbriated. Any cross, regardless of its form, which has a border of a different colour, is said to be fimbriated. Also called Cross Bordered.

The Cross Flamant. An unusual form of the cross with flame-like edges. Also a cross with several flame-like ornaments proceeding diagonally from the intersection of its arms. A symbol of religious zeal.

The Cross Fleurie. A most beautiful decorative form of the cross, either Latin or Greek, with ends terminating in three petals. One of the most useful forms of decorative cross. Compare with the Cross Patonce.

The Cross Fleurettée. Somewhat similar to the cross just described, except that its ends are couped, or cut off straight, with three graceful petals, each resembling the fleur-de-lys. A symbol of the Holy Trinity, and appropriate for altar and pulpit vestments for the Trinity Season.

The Cross Fleur-de-Lys. A cross whose arms end with

fleurs-de-lys. Symbolical of the Holy Trinity.

The Cross Formée. A Cross Patée, whose edges do not reach the borders of the shield upon which it is charged.

The Cross Fourchée. A decorative form of the cross, derived like many others from heraldry, whose ends are forked, but not pointed. A Cross Moline with its points cut off.

The Cross of Four Ermine Spots. A beautiful form of the cross, useful in church decoration, embroidery and printing, composed of four heraldic ermine spots. See illustration.

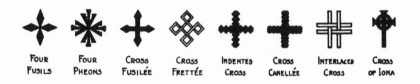

| Four Fusils | Four Pheons | Cross Fusilée | Cross Frettée | Indented Cross | Cross Canellée | Interlaced Cross | Cross of Iona |

The Cross of Four Fusils. A cross composed of four elongated lozenges of solid color.

The Cross of Four Pheons. An heraldic cross, made up of four dart heads whose points touch. The inner edges of the dart heads are serrated. It may be said to remind one of the "fiery darts of the wicked," and the Christian's duty to resist them, through the power of the Cross of Christ.

The Cross Fusilée. A cross whose ends terminate with diamonds. See figure. If the tips of the diamonds are cut off, it is a Cross Fusilée Couped.

The Cross Fretted. A decorative form, of heraldic origin,

composed of interwoven bands which form five perfect squares. Compare with the Cross Mascly.

The Cross Fylfot. The Swastika.

The Crux Gammata. The Swastika.

The Cross Gobonée. See Cross Componée.

The Cross Graded. A Latin cross whose lower limb rests upon three steps, representing *Fides, Spes* and *Caritas,* that is, Faith, Hope and Charity. If all four arms are thus terminated, it is called a Cross Degraded.

The Greek Cross. A simple cross with four arms of equal length.

The Cross Gringolée. A cross whose arms are couped, with two serpents' heads issuing from every end. Symbolical, perhaps, of sin and salvation.

The Cross of Hope. A combination of a Latin cross and an anchor. See illustration under Symbols of Our Saviour.

The Cross Humettée. A cross whose ends are cut off at right angles, and do not reach the edge of the shield upon which it is charged. The Cross Couped.

The Cross Indented. A cross whose edges are notched similar to the teeth of a saw. Compare with the Cross Dancette.

The Cross Invected. A cross somewhat similar to the Cross Indented, except that its projections are rounded instead of pointed. Compare with the Cross Engrailed.

The Cross Inverted. A Latin cross with the head downward. The symbol of St. Peter, also St. Jude.

The Cross Interlaced. A cross composed of four mem-

bers which are woven together as in our diagram. Compare with the Cross Double Parted.

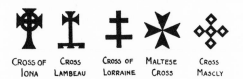

CROSS OF CROSS CROSS OF MALTESE CROSS
IONA LAMBEAU LORRAINE CROSS MASCLY

The Cross of Iona. The Celtic, or Irish cross.

The Jerusalem Cross. Four Tau crosses whose lower limbs are joined. See Cross Potent.

The Jeweled Cross. A Latin cross studded with five red jewels, symbolizing the five wounds of our Lord.

The Cross Lambeau. A Cross Patée, with a long lower limb, resting upon a horizontal bar, and having three pendent labels beneath this bar.

The Latin Cross. A full description of the Latin cross may be found at the beginning of this chapter.

The Long Cross. A term sometimes applied to the Latin or the Passion cross.

The Cross of Lorraine. Similar to the Patriarchal cross, except that the longer bar is near the base. The cross of the Holy League.

The Maltese Cross. A cross resembling four spear heads with the points touching. The eight outer points of this cross must all be equidistant from one another. It is a well-known symbol of the Eight Beatitudes, and is called the Regeneration cross. Also the symbol of St. John's Day. It was worn by the Knights Hospitallers, or Knights of

St. John of Jerusalem. It must not be confused with the Cross Patée.

The Cross Mascly. A cross composed of five voided meshes, whose points touch. Not to be confused with the Cross Frettée.

The Cross Mascly Pommettée. A Cross Mascly, with twelve knobs on its twelve outer points.

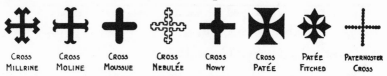

| CROSS MILLRINE | CROSS MOLINE | CROSS MOUSSUE | CROSS NEBULÉE | CROSS NOWY | CROSS PATÉE | PATÉE FITCHED | PATERNOSTER CROSS |

The Cross Millrine. A cross whose ends resemble somewhat the clamp on the upper millstone.

The Cross Moline. A decorative form of the cross, with arms ending in two petals.

The Cross Moussue. A cross whose ends all terminate in a semi-circular fashion.

The Cross Nebulée. Somewhat like the Dovetailed cross, except that all its points are rounded, not pointed.

The Cross Nimbed. Any form of the Greek cross, if surrounded by a circle which gives forth rays, is said to be nimbed. Used in decorations and church needlework. A Latin cross may have a nimbus surrounding the junction of its vertical and horizontal arms.

The Cross Nowy. Any form of a cross with a sphere or round disc at the junction of its limbs is termed Nowy, such as a Greek Cross Nowy, Cross Patée Nowy, Cross Patonce Nowy, etc.

The Pall. A peculiar variation of the Tau cross, often found in the catacombs. Its form resembles the letter Y.

The Cross Pandell. A cross whose four arms resemble four spindles, or elongated globes.

The Cross Parted and Fretted. A cross made up of two parallel vertical members and two parallel horizontal ones, woven together in the center. See Cross Interlaced.

The Papal Cross. A cross with three horizontal arms of different lengths, the uppermost of which is the shortest and the lowest one the longest.

The Passion Cross. Another name for the Long cross.

The Cross Patée. One of the most beautiful and most widely used forms of the decorative cross. Its four arms curve outward, and its outer edges are straight. Many variations of this cross exist. If each outer edge is pointed, it is a Cross Patée Fitched throughout. If the outer edges curve outward, it is a Cross Patée Convex. If they curve inward, it is called the Cross Patée Concave. If scalloped, it is the Cross Patée Invected. If designed within a circle, it is the Cross Alisée Patée, etc. If the design is large, the Cross Patée ought to be shown in outline only. A very fine design is obtained by combining the Cross Patée with the Cross Quadrate. This is known as the Cross Patée Quadrate. Scores of pleasing variations may be obtained by combining the Cross Patée with other forms, such as the Cross Patonce, the Cross Fleury, the Cross Clechée, etc.

The Paternoster Cross. A cross composed of a number

of circular discs, so called because of a fancied resemblance to strings of beads. Symbolical of prayer.

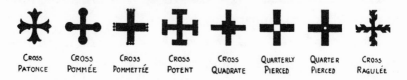

| CROSS PATONCE | CROSS POMMÉE | CROSS POMMETTÉE | CROSS POTENT | CROSS QUADRATE | QUARTERLY PIERCED | QUARTER PIERCED | CROSS RAGULÉE |

The Cross Patonce. An extremely beautiful form of cross, similar to the Cross Fleurie, except that its arms are more expanded. It may be used, like nearly all the others mentioned, either in the Greek or the Latin form. No more beautiful form of cross exists, and it may be used with excellent effect by the decorator or the needlewoman.

The Patriarchal Cross. A Latin cross with a shorter horizontal arm added above the long horizontal one. Often seen in Christian painting in the hands of the patriarchs. One of the symbols of St. Peter, St. Philip and St. Helen.

The Cross Per Pale Countercharged. A cross sometimes seen in armorial decorations and coats-of-arms. It is divided vertically by a line, and the two halves of the cross differ in colour.

The Cross Pierced. A cross with a circular hole at the intersection of its arms.

The Cross Quarterly-Pierced. A cross with a square hole the full width of the arms, at the intersection of its arms.

The Cross Quarter-Pierced. A cross similar to the one just mentioned, except that the square hole is much smaller.

The Cross Pointed. A cross whose arms end in sharp points. See under Passion Cross at the beginning of this chapter.

The Cross Pommée. A cross whose arms end in single knobs.

The Cross Pommellée. A cross very similar to the one just mentioned. Some authorities say that its arms may end with one knob or ball, others say that two, or even three knobs may be used. We include a picture of the last named form.

The Cross Portate. A cross inclined dexter, so called because it suggests the cross carried on the back of our Lord on the way to Calvary. Its use is somewhat doubtful, for correct symbolism decrees that a cross must never be shown except in a perpendicular position, either erect or else inverted.

The Cross Potent. Also known as the Jerusalem cross. Four Tau crosses whose lower ends meet. Called Cross Potent because of its resemblance to an ancient crutch. A very fine form, and symbolical of the Saviour's power to heal the diseases of men's bodies and souls.

The Cross Potent Quadrate. A combination of the Cross Potent and the Cross Quadrate. Also called the Cross of St. Chad.

The Cross Quadrate. A cross with a square at the intersection of its arms.

The Cross Quarterly-Pierced. See under Cross Pierced and the two paragraphs following.

The Cross Quarter-Pierced. See under Cross Pierced and the two paragraphs following.

The Cross Ragulée. A cross with protrusions on its four arms, said to suggest the knots and lopped-off branches of a tree. A knotted cross.

The Rayed Cross. A cross having rays of light proceeding from its center. Symbolical of the Resurrection.

The Cross Rayonée. A cross from which shafts of light proceed. Also a cross having flames or rays proceeding diagonally from the intersection of its arms.

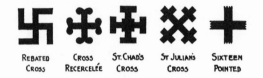

REBATED CROSS ST. CHAD'S ST JULIAN'S SIXTEEN
CROSS RECERCELÉE CROSS CROSS POINTED

The Cross Rebated. The Fylfot, or Swastika. A cross of extremely ancient origin, each arm of which is bent at right angles. It is believed by some to have symbolized the four cardinal points of the compass. This form of cross was known to many non-Christian races.

The Cross Recercelée. Similar to the Cross Moline except that the curving ends are rounded instead of pointed.

The Cross Recrossed. The Cross Crosslet.

The Cross of Regeneration. The Maltese cross, and so called because of its eight points. Eight is the number symbolical of regeneration.

The Russian Cross. Another name for the Eastern cross.

St. Alban's Cross. The Cross Saltire.

St. Andrew's Cross. The Cross Saltire, which is the form upon which St. Andrew is believed to have died. The emblem of Christian humility. The cross of Scotland.

St. Anthony's Cross. The Tau cross. For a full description, see under Tau, at the beginning of this chapter.

St. Chad's Cross. The Cross Potent Quadrate.

St. George's Cross. A plain red cross on a white field. The cross of England.

St. James' Cross. A cross whose upper arm ends with a heart-like ornament, whose horizontal arms terminate fleury, and whose lower arm is shaped like a sword. Also called the Cross of the Knights of St. Iago, and the Spanish cross.

St. Julian's Cross. The Cross Crosslet Saltire.

St. Patrick's Cross. The Cross Saltire, red in color. Sometimes also the Celtic cross.

St. Peter's Cross. A Latin cross with the head downward, so shown because of the traditional death of the Apostle Peter, who was crucified head downward.

St. Philip's Cross. The patriarchal cross. Also a knotted cross.

The Cross Saltire. A cross shaped like the letter X. St. Andrew is said to have been crucified upon such a cross. Also known as St. Andrew's cross, the *Crux decussata,* St. Patrick's cross and St. Alban's cross. Numerous variations of the Cross Saltire exist, such as the Cross Saltire Wavy, Cross Saltire Patée, Cross Saltire Invected, Cross Saltire Embattled, Cross Potent Saltire, etc.

The Scottish Cross. The Cross Saltire.

The Shield of Faith. A shield, upon which is charged a Latin cross, whose ends do not reach the edge of the shield.

The Sixteen-Pointed Cross. A cross whose four ends each terminate in four points, resembling the teeth of a saw.

The Slavic Cross. See under Eastern Cross.

The Cross of Suffering. A Latin cross whose ends are pointed. The Passion cross.

The Tau Cross. A Latin cross minus its upper arm. Also known as the Old Testament cross, the Anticipatory cross, the Cross Commissée, the Egyptian cross, the Advent cross, the *Crux commissa.* For further details see under Tau at the beginning of this chapter. The symbol of the Advent Season, and of eternal life.

The Cross Treflée. A cross whose arms end in trefoils. See Cross Bottonnée.

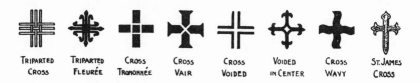

| TRIPARTED CROSS | TRIPARTED FLEURÉE | CROSS TRONONNÉE | CROSS VAIR | CROSS VOIDED | VOIDED IN CENTER | CROSS WAVY | ST.JAMES CROSS |

The Triparted Cross. A cross with three vertical and three horizontal limbs, all of equal length, and three arranged vertically and three horizontally in such a manner that their intersections resemble basket-weaving.

The Cross Triparted Fleurée. A cross of three parallel vertical members and three parallel horizontal ones, and

with all ends terminating in leaf-like ornaments suggesting the fleur-de-lys.

The Cross of Triumph. A Latin cross resting upon a globe. For a full description see the beginning of this chapter, under crosses of purely ecclesiastical origin.

The Cross Tron-onee. Any cross cut into five or more parts, so that the field shows between the parts. The Dismembered cross.

The Cross Urdée. The Passion cross. Also called the Cross Aiguisée, and the Pointed cross. See above.

The Cross Vair. A cross composed of four figures, each one roughly resembling a bell. It derives its name from the heraldic fur called Vair.

The Cross of Victory. See under Cross of Triumph at the beginning of this chapter.

The Cross and Banner of Victory. A long and very slender Latin cross, often ornamented bottonnée, from which waves a white banner with three points. Upon the banner is a long, red Latin cross. This cross is carried by the *Agnus Dei,* also by St. John the Baptist. Symbol of our Lord as the Lamb of God, also of His Forerunner, who exclaimed *"Ecce Agnus Dei."*

The Cross Voided. Any cross, shown in outline only, so that the color of the field or background shows through it, is called a Cross Voided.

The Cross Wavy. An heraldic charge, occasionally used in church decoration. Its arms are of a slightly undulating character, like conventionalized waves of the sea.

The Cross Wreathed. A cross about which is twined a wreath of leaves, such as laurel, cypress, bay or oak. A symbol of victory, if of laurel. If of cypress it is a symbol of the hope of immortality. If of oak, it denotes the idea of strength. If of bay leaves, death.

A number of other forms of the cross might be mentioned, but we have collected those most commonly described in books on Christian Symbolism, and have redrawn all of the crosses in question.

Practically all of these crosses may be shown in either the Latin or the Greek form.

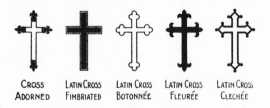

CROSS LATIN CROSS LATIN CROSS LATIN CROSS LATIN CROSS
ADORNED FIMBRIATED BOTONNÉE FLEURÉE CLECHÉE

Many other forms of the cross exist, but those not mentioned in this chapter are either purely heraldic, and seldom used in church symbolism and decoration, or else are combinations of two of those pictured above, as for example, the Cross Moline Fitchée, the Cross Barbée Quadrate, the Cross Bottonnée Nowy, etc. Those listed above, while derived in many cases from heraldry, have been used by the decorator, the needlewoman, the glass painter and the wood carver, in adorning the church. Many of the ornamental examples mentioned date from the time of

the Crusades. Others are based upon forms carved in the catacombs. One or two seem to have originated with Mediaeval illuminators of manuscripts, and even with the designer of movable types.

Any of the crosses shown might be developed into interesting decorative motives, but it will mean much thought, and the wearing out of many erasers rather than slavish copying of what others have done. Any use of symbolism must go deeper than mere surface decoration. Mr. Philip Hubert Frohman stated in *The Cathedral Age* that a mere surface application of symbols will never make a church "churchly." The very fabric itself must be symbolic, and more important still, the designer must believe in the things that he is trying to express symbolically.

"Unless the designer believes in that which his decoration is supposed to symbolize," said Mr. Frohman, "and has a full appreciation of the underlying purpose of decoration, it would be better to have the church bare and undecorated. The use of sacred symbols in a commercialized art becomes a sacrilege, and cannot increase the true value of the structure as a work of Christian art. Works without Faith in the realm of religious art become dead. It is a Faith which gave beauty and meaning and conviction to the architecture, and art, and symbolism of the Middle Ages. To achieve an architecture and an art which will adequately express the Church in this day and generation, we must be fired by the same Faith and must make an equal effort to express it."

Our age may look with horror at the doctrines and practice of Mediaeval times, but nobody will say that the Mediaeval artist and craftsman pictured things in which they did not believe. The men who painted the glorious glass at Reims (portions of which were rescued in the midst of a hail of shrapnel and concealed in the crypt of the Pantheon, and later at Bordeaux, and which M. Jacques Simon and M. Gaston Lassabe are now trying to restore), at least believed in the things that they painted, regardless of whether we look upon it as truth, or grossest superstition.

Much of our church symbolism today is cold and unconvincing simply because those responsible for it did not believe in the truths that they were trying to represent. A man whose idea of worship rises no higher than Sunday sermon-sampling by means of a radio, will never produce a church, or a carving, or a painting, or a stained glass window that is satisfying. It may be technically perfect, but it will lack the breath of life. Much of the wealth of symbolism that has blossomed forth lately in many a sectarian church only leaves one cold, because it does not reflect the conviction of the men responsible for it, be they clergymen or craftsmen. The most untrained workman may learn to create objects of greatest interest, if only he is fired with faith in the truths that he is trying to express symbolically.

CHAPTER IX.

SYMBOLS OF OUR LORD'S PASSION

SOME men who have not yet reached middle age recall the days when the sectarian denominations looked with horror upon clerical robes, prayer books, crosses, candles on the altar, liturgical services and the use of any Christian symbolism other than the Ten Commandments painted on the wall, and a cross-and-crown book mark. The change in this respect is one of the wonders of this topsy-turvy age. Each new sectarian church adds to our amazement when we note the progress that is made in restoring all these useful adjuncts of worship, temporarily banished by those with Puritan notions regarding beauty.

Architects and designers who were pioneers in this artistic restoration tell amusing tales. The way was blazed by Mr. Ralph Adams Cram, that incredibly gifted man of such a wide diversity of talents. He tells of a Protestant clergyman who was anxious to have a rather poor painting of the crucified Lord in his church, but who was scandalized at the mere suggestion of a beautiful carving of the same event. To the clergyman's mind a painting was entirely proper, but a carving was abject popery! The late Bertram Goodhue, whose knowledge and use of intelligent Christian sym-

bolism was marvellous, had many a story to tell, in his win-
some manner, of similar cases, one of which involved a group
of laymen, some years ago, who were horrified at the dis-
covery of seven steps leading up to their communion table.
Seven was regarded by some of them as a mystical Roman
number! Another member of the same committee was dis-
pleased at a Latin inscription high on the gable of one of
Mr. Goodhue's beautiful churches.

Mr. J. W. C. Corbusier, another church architect, told
of having been ordered to remove a stone cross from the
gable of a fine church. He asked the irate committee
whether they loved the flag, the symbol of liberty. Why
then hate the cross, the symbol of Finished Redemption?
Why did they love to sing "In the Cross of Christ I glory,"
and "When I survey the wond'rous cross," and yet refuse
to see it? It is good to hear about a symbol, and bad to see
it? The committee capitulated, and fairly covered their
new church with crosses, even to the leader-heads of their
down-spouting.

Mr. Charles J. Connick, or the late John Kirchmayer,
Henry Wynd Young or R. Toland Wright have had
experiences of the same sort, and all might tell similar tales.
The last named was about to treat the four Latin Fathers in
the traditional manner, showing them clad in their distinc-
tive vestments. The pastor promptly objected. When
asked whether he would tell his congregation that St.
Jerome was a cardinal, he replied in the affirmative. If there
is no harm in telling them an historical fact, then what harm

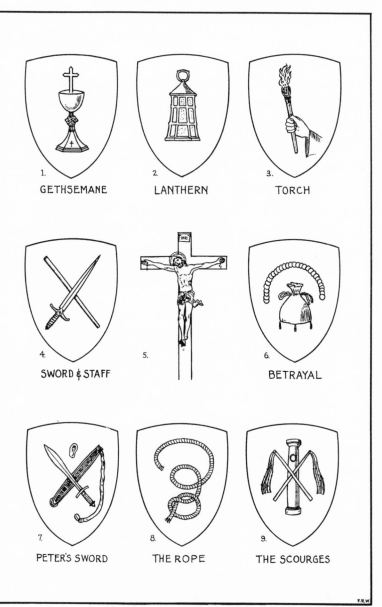

1. GETHSEMANE

2. LANTHERN

3. TORCH

4. SWORD & STAFF

5.

6. BETRAYAL

7. PETER'S SWORD

8. THE ROPE

9. THE SCOURGES

F.R.W.

𝕮𝖍𝖊 𝕻𝖆𝖘𝖘𝖎𝖔𝖓

PLATE XI.

is there in picturing it? If hearing a thing is no harm, how is seeing it a sin?

Today the most lavish use is made of Christian symbolism in the churches of all denominations. Presbyterian, Baptist, Methodist, Congregational and Unitarian churches in the larger cities vie with one another in the use of carved and painted emblems of sacred truths. Of course the Roman Catholics, the Greek Orthodox church, the Episcopalians and the Lutherans have used symbolism for years.

Foremost amongst the symbols which have been revived today are those of our Lord's Passion. Writers often speak of the "thirteen Passion symbols," but in reality there are more than that. As far as we know at present writing, there is but one universally accepted symbol of the Agony in Gethsemane, seven or more of the Betrayal, seven of the Trial and Condemnation, seven or more of the Crucifixion, and about the same number of the Descent from the Cross and the Burial.

The Chalice and Cross. The Agony in Gethsemane is almost invariably pictured by the use of a jewelled chalice out of which is rising a small cross, with pointed ends. This is called the Cross of Suffering. The chalice is golden in color, and the cross is red. The reference, of course, is to our Saviour's prayer in Gethsemane concerning the Cup of suffering, as recorded in St. Luke 22, 42. Figure 1.

A Gnarled Olive Tree. An old, knotted olive tree may be used to symbolize the Mount of Olives, but whether it

has been used to represent the Agony in the Garden we cannot say at present.

The Lanthern. The lanthern, or lantern of the Roman guard is a symbol of the betrayal. Its usual form is hexagonal, sometimes octagonal, and its design archaic. It refers to St. John 18,3 where Judas and the band of ruffians "cometh thither with lanterns and torches and weapons." It is shown painted or carved on a small shield, usually on the reredos back of the altar. Figure 2.

The Torch. From the same verse is taken the symbol of the torch, which is usually shown crossed in saltire with a club or a sword, to distinguish it from other forms of symbolical torches. Figure 3.

A Sword and a Staff, crossed in saltire (that is, like the letter X), is a well known symbol of the Betrayal. Figure 4.

A Purse, above which are the thirty pieces of silver of Judas, is frequently used as a symbol of the Betrayal. Sometimes the purse is shown open, with but a few of the silver coins issuing out of it. Figure 6.

The Kiss of Betrayal. This is sometimes seen in carvings, both ancient and modern. The heads of our Saviour and Judas are shown, the latter giving our Lord the hypocritical kiss, which was the sign agreed upon by the enemies of the Redeemer of mankind.

The Sword of Simon Peter. A single sword, and the severed ear of Malchus, or sometimes two swords and the severed ear, are used to indicate the scene in the garden at our Lord's arrest. It has been supposed that Simon Peter

smuggled one or more of the two swords mentioned in St. Luke 22,38 into the garden, one of which was used in the attack on the servant of the high priest. Figure 7.

A Rope. The rope used to bind the Saviour, when He was led away to Annas and Caiaphas, is one of the familiar emblems of the Betrayal and Arrest. Figure 8.

The Head of Judas, with a nimbus composed of thirty pieces of silver, and with a rope tied around his neck, is yet another common symbol of the same scene.

A Pillar. A symbol of the trial and condemnation of Jesus Christ is a pillar, with base and capital, and with a large ring fixed some distance above the floor. It is supposed that the Lord was tied to such a pillar when He was scourged by Pontius Pilate. Figure 9.

Two Scourges in saltire are likewise used to represent the Scourging. These are usually shown in the form of rods, to which are attached a number of straps with bits of lead and bone woven into them. Sometimes both pillar and scourges are shown on the same shield. Figure 9.

A Scarlet Robe and a Reed. This symbol is not so common as some of those just mentioned, but it has been used to depict the mockery which our Saviour suffered at the hands of His captors, who, hearing the charge concerning the King of the Jews, insisted upon having a mock investiture and coronation.

The Crown of Thorns. This symbol is too well known to need detailed description. Sometimes the crown is shown alone, again it is shown with the letters I. N. R. I.

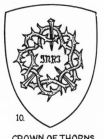

10.

CROWN OF THORNS

11.

BASIN AND EWER

12.

COCK

13.

NAILS

14.

LADDER AND REED

15.

SEAMLESS COAT

16.

REED & HYSSOP

17.

CROSS & WINDING SHEET

18.

THE EMPTY CROSS

F.R.W.

The Passion PLATE XII.

within it, and again with either three or four nails thrust through it. There are other examples of a crown of thorns with three nails, forming the monogram VI within it, derived from two Latin words which signify that Jesus is Victor over sin. Figure 10.

The Ewer and Basin. A basin, with a ewer above it, refers to Pilate's act in ordering a basin and water, and washing his hands of the blood of the Saviour. Figure 11.

The Reed. The reed used by the ruffians to smite the Lord, a clenched fist, used in buffeting Him, and a blindfold or bandage used while the soldiers mocked Him may often be seen on Mediaeval and modern carvings, among the Passion symbols.

A Crowing Cock. This is a very familiar symbol of the trial and condemnation of our Saviour, and is connected with Simon Peter's denial. Many carvings and paintings of it exist, and every tourist remembers the cock on the top of the great clock in Strasbourg cathedral. This cock crows realistically whenever the figure of Simon Peter appears among the walking apostles. Figure 12.

The Latin Cross. The symbol pre-eminent of the Crucifixion is the cross. The cross upon which our Redeemer was nailed was not the usual Tau cross, but one composed of four arms, the short upper one used to bear the inscription ordered by Pilate, which was placed over the head of the Lord, St. Matthew 27, 37. St. Mark 15, 26. St. Luke 23, 38. St. John 19, 19.

The Five Wounds. Following ancient precedent, the

usual manner of picturing symbolically the suffering of our Lord on the cross is to show a human heart, two hands and two feet, each with a wound in it, rather than showing His entire body. If an entire body is shown, it is a pictorial representation. When only the heart, hands and feet are shown, it becomes one of the symbols of the Crucifixion.

A Scroll, bearing the letters I. N. R. I., meaning *Iesus Nazarenus Rex Iudaeorum*, ("Jesus of Nazareth, King of the Jews"), is one of the common Passion Symbols referring to the Crucifixion. Sometimes the entire inscription, in Hebrew, in Greek and in Latin, is shown.

A Ladder, with a Reed and Sponge in saltire, may be used as a symbol of the Crucifixion, and is often seen. As a rule, the reed is much too long, for the cross upon which our Saviour was crucified was not of great height, as modern painters love to picture it. In one modern carving in one of our own churches, the ladder and reed occur, with a vessel supposedly containing vinegar on the ground below. We do not recall having seen the vessel of vinegar introduced in any of the examples of Mediaeval carving abroad, although such examples doubtless are not rare. Figure 14.

Hammer and Nails. Another symbol of the Crucifixion is a hammer, and either three or four large, rough nails with square heads. This is a favorite subject with Mediaeval wood carvers, and countless examples remain. Figure 13.

The Vessel of Vinegar and Gall. This symbol, not so

common as the others mentioned, is usually merely a tall jar, sometimes with a sponge lying beside it.

The Reed and Hyssop. Scholars have been at a loss to account for the presence of the reed and hyssop, the latter mentioned by St. John. The late Rev. S. Baring Gould suggests in his book *The Seven Last Words* that the bunch of hyssop was tied to the reed and used in the purgative rites of the Jews, and that the soldiers, in mockery, dipped this hyssop in the very blood of the Saviour and sprinkled it on the mob surrounding the cross, thus fulfilling literally the old-time prophecy. That the bunch of hyssop was used in the ceremonial rites of the Jews is a fact. That it was used in mockery by the soldiers, and that the enemies of the Lord were sprinkled by His blood is an interesting conjecture. Figure 16.

The Seamless Coat. This very common Passion symbol shows a seamless tunic, with sleeves outspread. Above it are two dice, and below it a third. The reference, of course, is to the soldiers who sat beneath the cross casting lots for His seamless coat. Figure 15.

The Veiled Sun and Moon. At one time these were commonly included among the Passion symbols, representing the face of the sun darkened at noon, and the moon darkened also, since it is supposed to derive its light from the sun.

A Skull. Often a skull is shown lying at the foot of the cross. This represents the skull of Adam, and its location at the foot of the cross is symbolical, rather than a proved

fact. It is symbolical of the sin of man; and the blood of the Lamb of God which drips down upon it is typical of the washing away of the believer's sins through the power of the shed blood of Jesus Christ.

The Passion Flower. Although of modern origin, and although rejected with great indignation until a few years ago by many persons, the Passion flower lately has been used in company with the Passion symbols. The flower is said to contain all the symbols of the Passion. Its central column represents the column of the Scourging. The ovary is shaped like the hammer used to drive the nails. The three styles, each with a roughly rounded head, are the nails. There are five stamens, symbolical of the five wounds. The rays within the flower form a nimbus, symbolical of our Lord's divine glory. The leaf is shaped like the spear which pierced His heart. The ten petals represent the ten apostles who forsook Him and fled, leaving only Judas the traitor, and St. John, who followed Him and stood beside His cross. The flower is said to bloom but three days, representing the time which our Lord lay in the tomb. Much of this symbolism may be somewhat farfetched, but since the Passion flower lately is used in church embroidery, we mention these things for what they may be worth, reminding the reader that it isn't one of the proverbial symbols of the Crucifixion, with ages of traditional use back of it.

A Heart Pierced by a Lance. This is one of the common Passion symbols relating to the descent of our Lord

from the cross, because it was shortly after the soldier pierced the heart of the Lord that His body was taken down.

The Ladder and Winding Sheet. From ancient times these have been identified with the descent from the cross. Often the sheet is shown draped over the horizontal arms of the cross, with or without the ladder leaning against it. Figure 17.

The Pincers. In old carved wood work, and in a great many present day examples, the pincers, supposedly used to draw out the nails, are pictured. The pincers, holding a single nail, is the usual form of the design. In some examples, the pincers and hammer are shown, in saltire.

The Empty Cross. Sometimes the empty cross, with the nails sticking into it, is shown. We presume that the presence of the nails in the cross *after* the Crucifixion, is symbolical. Another curious custom, occasionally met with, is to show the sheet used to wrap the body of our Lord draped on the cross, with nails and foot-rest also. Figure 18.

The Vessel of Myrrh and Aloes. The vessel of Nicodemus is sometimes shown in the form of a tall alabaster jar. Nicodemus, who came furtively to his Lord by night on a previous occasion, came boldly to the cross, and helped to prepare the body of the Saviour for the tomb.

The Linen Burial Cloths. These are used sometimes in order to represent the Entombment. It is somewhat difficult to make a symbol out of these things, and yet cause it to be recognized by the beholder.

The Tomb of Joseph. A very common symbol of the

Burial of our Saviour is the tomb of Joseph of Arimathaea. It is shown with a circular slab of stone rolled across its entrance, a large rock either rolled against this slab or else a great, flat, quarried stone leaning against it. Across the stone is a cord, at each end of which is the seal of the imperial governor.

It is not often that all of these symbols are to be seen in one church. Usually a selection of from ten to fifteen of them is made, and they are arranged in such a manner that the story of our Lord's Passion may be read in proper order.

These Passion Symbols ought always to be used in the proper place. Misplaced symbolism is an indication of slovenly thinking. The best place for them is on the reredos, or on its cresting. They may be used in the window over the altar, if there is one. Almost any of them may be used on the violet altar vestments, and on the hangings used on the pulpit and lectern during Lent. Symbols such as the crown of thorns and the cross are appropriate for the black altar and pulpit hangings, properly used on but one day in the year, and that is Good Friday.

In any event, a symbol may be used only by those who are entitled to it. Let those whose religion is hollow pretense and sham, indulge in architectural and structural sham. A sham religion will almost always reflect itself in false structural devices, such as vertical columns of steel, masked by a hypocritical four-inch veneer of stone, or steel roof-trusses concealed within thin boards that are designed so as to look like genuine timbers. But with symbolism, it

is not always the case. Lately there has arisen a desire to use symbolism by those who are not entitled to it.

What can be more hypocritical than the Passion symbols displayed on the reredos of a church wherein the very purpose of our Blessed Lord's Passion is denied? Or how is it possible for a decadent sect which denies the Real Presence to use the symbols thereof on their altar, or even to have an altar at all, for that matter? And how may sects that deny the Christian Sacraments presume to employ the symbolic expressions thereof? To do so is not only humbug, but it is a scandal that cries aloud for its well-merited rebuke.

Those who believe in our Lord's Vicarious Sufferings not only may, but ought to employ every legitimate means to testify against the false teachers who deny it, whether it be through the medium of the spoken word, the printed book, or symbols which appeal to the eye. For, as one has said, a symbol is a reminder. And anything that reminds us of our Blessed Lord's sufferings and death to redeem a fallen race, may be, and ought to be used by those who believe in that which they are endeavoring to express.

CHAPTER X.

SYMBOLS OF THE HOLY GHOST

STRANGE to say, the symbols of the Holy Ghost are few in number. The early Christians seldom attempted to picture Him except in two or three well known forms. Although pictorial representation of Him is not lacking, yet these early symbols have stood the test of time.

The Descending Dove. The most usual delineation by far is to represent the Holy Spirit by a descending dove This is one of the oldest and best of symbols. The dove ought to be somewhat conventionalized, and not shown in too realistic a manner. Happily the fad of thirty years ago of calling in a theatrical scene painter, and indulging in aerial perspective, making the wall above the altar appear to fade out into an Italian sky with cumulus clouds, among which a very realistic pigeon is flying, is all but an extinct thing. Besides being somewhat conventionalized, the dove must be snow white in color, and ought to be shown with the three-rayed nimbus. We have attempted to draw such a dove in Figure 1. Figure 3 shows another form, slightly more realistic, and therefore not so good. Figure 8 shows the realistic form which is to be avoided in mural decora-

tion and stained glass, although it may not be open to criticism in the case of an easel picture. The example which we reproduce is from Zurbaran. Figure 6 shows the best form of all, perfectly flat and decorative, which we have attempted to reproduce from the beautiful color plate in Audsley's *Christian Symbolism*.

The Flame of Fire. Next to the dove, the most common symbol of the Holy Spirit is the cloven flame of fire which appeared on the Day of Pentecost. Either a single flame may be shown, or else seven flames, as in Figure 7.

The Seven Burning Lamps. Sometimes the seven lamps before the Throne of God have been used to symbolize the Holy Ghost. Various renderings have been given. We give one interpretation of the seven lamps in Figure 5.

The Eagle. This symbol is somewhat rare, but a good example of it exists in St. Alban's Cathedral. The eagle must be shown with the three-rayed nimbus to distinguish it from the eagle of St. John the Evangelist.

The Winged Wheel. This symbol, also rarely used, has been listed by some writers. We do not recall having seen an example of it.

The Scroll. In order to depict the Seven Gifts of the Holy Spirit, a scroll may be used, with the names of the Seven Gifts upon it. The Old Testament form is given by the Prophet Isaiah, chapter 11. He mentions the Spirit of Wisdom and Understanding, of Counsel and Might, of Knowledge and the Fear of God. The traditional rendering is: *Sapientia, Intellectus, Consilium, Fortitudo, Scientia,*

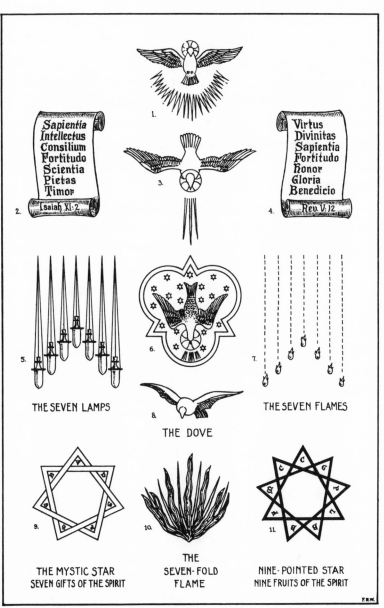

1.

2.
Sapientia
Intellectus
Consilium
Fortitudo
Scientia
Pietas
Timor
Isaiah XI: 2.

3.

4.
Virtus
Divinitas
Sapientia
Fortitudo
Honor
Gloria
Benedicio
Rev. V: 12

5. THE SEVEN LAMPS

6.

7. THE SEVEN FLAMES

8. THE DOVE

9.
THE MYSTIC STAR
SEVEN GIFTS OF THE SPIRIT

10.
THE
SEVEN-FOLD
FLAME

11.
NINE-POINTED STAR
NINE FRUITS OF THE SPIRIT

F.R.W.

The Holy Ghost

PLATE XIII.

Pietas, and Timor, the seventh gift probably derived from the verses following. The New Testament list, found in Revelation 5, 12 is different. It includes Blessing, Glory, Wisdom, Thanksgiving, Honour, Power and Might. In Christian art it is rendered: *Virtus, Divinitas, Sapientia, Fortitudo, Honor, Gloria, and Benedicio*—these used more often than the Old Testament list. We show the two forms in Figures 2 and 4.

Seven Doves have been used from early times as symbols of the Seven Gifts of the Holy Spirit. They may be shown holding scrolls in their beaks, each scroll bearing the Latin name of the virtue or gift. In stained glass they are often shown surrounding the Glorified Saviour, each dove surrounded by a vesica, or rays of glory.

A Seven-Branched Candlestick has been used to represent the Seven Gifts, or else a columbine with seven petals.

The Mystic Star, shown in Figure 9, likewise represents the Seven Gifts of the Holy Spirit. It is a star of seven points, and within each point is the initial letter of the gift represented.

A Seven-fold Flame, Figure 10, expresses the same idea.

The Nine Fruits of the Holy Ghost. The Nine Fruits of the Holy Spirit are based upon Galatians 5, 22. In Christian art they are called: *Caritas , Gaudium, Pax, Longanimitas, Benignitas, Bonitas, Fides, Mansuetudo and Continentia*. They may be shown as in Figure 11 by a nine-pointed star, each point containing the name, or the initial letter of the gift which it symbolizes.

The most usual place for the symbols of the Holy Ghost is either with the symbols of the Father and the Son, or else on the baptismal font. His symbol is also used in connection with the inspired writers of the Bible. Often He is pictured in the top of Jesse Tree windows, in representations of our Lord's Baptism or of Pentecost.

One of the favorite devices of the Mediaeval wood carver was to place a dove at the pinnacle of the spire-like octagonal cover which once surmounted many a baptismal font. Here the symbol was used to express the fact of Baptismal Regeneration. For some strange reason this custom seems to have drawn the fire of Calvinist and iconoclast, for many an old record shows an entry to the effect that the "superstitious" graven image of the Holy Ghost was removed from font-cover or wall, to the glory of God! Many beautiful font spires of amazing richness of carving still exist, but minus the dove which once surmounted them, minus the carven figures that stood in each canopied niche, and minus the symbolical paintings that at one time covered even the carved wood-work in almost every church building.

Were these things still in existence, we might not meet so often with the assertion that the Mediaeval carver confined himself to ornament for ornament's sake, rather than to the creation of symbolism. Many of the carved font covers, octagonal in cross-section, and often almost as high as the ceiling of the church, show signs of a carved finial which has been ruthlessly removed. Undoubtedly many of the carved doves, which symbolized Baptismal Regener-

ation, were removed. Then it must not be forgotten that much of the old wood-work was intended to receive symbolical decorations of pure color and gold, practically all of which has been removed either by religious fanatics or else by nineteenth century restorations.

In Mediaeval days the Sacrament was often reserved within a hanging pyx of silver, made in the form of a dove, and suspended from the ceiling with chains of silver. Amiens still retains such a dove, we believe. Such a representation denoted that the Lord's Supper is a means of grace through which the Holy Ghost operates. In days of destruction these silver doves formed part of the spoils of many a church. It is a curious commentary on human nature that in the days when men, in the name of religion, removed "superstitious images" from the old churches, all such things as wood-carvings, tapestries and embroideries were burned with solemn hymns of praise, but silver doves, golden chalices and all other things made of precious metal were carefully retained in order to be converted into ready money!

CHAPTER XI.

THE NIMBUS AND THE AUREOLE

IN all forms of artistic representation, the heads of certain holy people are almost invariably surrounded by what is known as a nimbus. Uninformed people call this a "halo." A nimbus may be nothing more than a thin circle of light surrounding the head of a holy person, or it may likewise show rays, jewels, or richest adornment.

It is customary in all branches of Christian art to surround the heads of the Three Persons of the Holy Trinity with nimbi. Archangels and angels are shown with nimbi, as well as apostles, evangelists, martyrs, and persons noted for an unusual degree of piety, or who may have won great distinction in the early Christian Church.

The forms of the nimbi differ. Many serious errors have occurred, for a nimbus that is traditionally correct for one person might be quite wrong for another. Even unintended irreverence on the one hand, or unconscious blasphemy on the other, has been perpetrated by good folks, either through thoughtlessness or carelessness. The nimbus, like all other things in Christian art, is a distinctive thing. It is used to distinguish persons appearing in a picture, whether carved or painted. One needs to know but a few

of the more common forms of this symbol in order to find our Saviour, His Mother, His Apostles, or any of the heroes of early New Testament days. In Christian art, each one has his own symbolical nimbus.

We have reproduced two plates of nimbi, showing about twenty of the more common variations, together with two examples of the aureole. For those who read French, nothing is more helpful than the chapter on the nimbus in volume 1 of Msgr. X. Barbier de Montault's *Traite D'Iconographie*. We have copied rather freely several of his many illustrations of the nimbus, and herewith record our acknowledgements. (Plates XIV and XV.)

The Pagan Form. The nimbus is not strictly of Christian origin. Like many other forms of artistic expression, it seems either to have been borrowed from secular models and redesigned to suit Christian ideals, or else it may be one of those simultaneous artistic ideas which seem to spring into existence in widely separated places. In Figure 1 we reproduce a form found in pagan art and symbolical of divine power, by which their deities were often distinguished from human beings. The winged Mercury is the person shown.

Rectangular Form. In some countries, distinction has been made between living and dead persons by showing the former with a rectangular nimbus. While there may be exceptions to this rule, yet we believe that the rectangular form generally indicates that the person so distinguished was living when the picture was made. Figure 2.

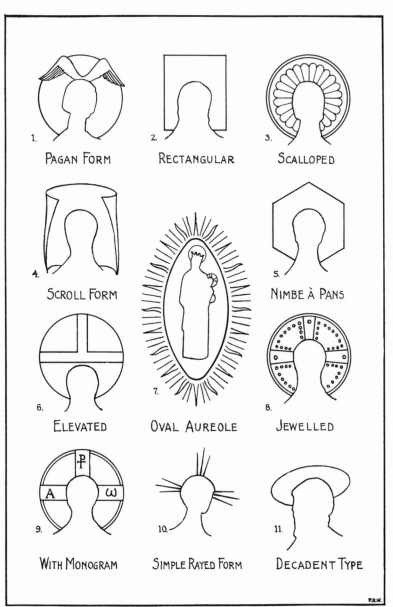

1. Pagan Form
2. Rectangular
3. Scalloped
4. Scroll Form
5. Nimbe à Pans
6. Elevated
7. Oval Aureole
8. Jewelled
9. With Monogram
10. Simple Rayed Form
11. Decadent Type

F.R.W.

Forms of the Nimbus and the Aureole PLATE XIV.

Scalloped Nimbus. Sometimes a nimbus is enriched by lines which radiate from the head, and end in scallops within a circle. It is so called because of its resemblance to a shell. Figure 3.

Scroll Nimbus. This form is not so common as other forms, and is probably but an artistic variation of the square or rectangular form.

Nimbus à Pans. This is hexagonal in form, and is used in Italian art more often than elsewhere, and usually to distinguish some allegorical figure, such as Justice or Faith. See Figure 5. It may be enriched with scallops.

Elevated Nimbus. This is a nimbus given to one of the Three Persons of the Holy Trinity. The three rays, always confined only to the Father, Son or Holy Ghost, are raised so that all three bars may be seen above the head, as in Figure 6.

Jeweled Nimbus. In some pictures, the nimbus of the Three Persons is not only shown with three radiating bars, but is also jeweled, in order to convey the idea of great glory, just as a jeweled crown might be shown on the head of a king of unusual dignity. See Figure 8.

Nimbus with Monogram. Sometimes a nimbus is shown with three radiating bars within the circle, each bar bearing a sacred monogram, such as I H S, Chi Rho, or Alpha and Omega. These have been used to distinguish our Saviour. Figure 9.

Simple Rayed Form. Some artists have shown the Christ

Child without a circular nimbus, but have substituted nine rays of light, in groups of three, as in Figure 10.

Decadent Form. In the days of decline, the nimbus was often shown in perspective. In much modern art it is thus shown. See Figure 11. This form ought not to be used, for it borders on the ridiculous, reminding one of a dinner plate precariously balanced upon the head. In the days of purer art, the nimbus was almost always shown as a perfectly flat circle, standing upright back of the head, either simple or enriched in form.

The Tri-Radiant Form. The nimbus, which was used in the sixth century and thereafter, was a simple circle of light at first. But it was soon found that some form must be devised in order that even a child might distinguish the Saviour from other figures in the picture or carving. The tri-radiant, or so-called cruciform nimbus was employed. This form shows three bands of light, one vertical and two horizontal. Controversy has raged as to whether these are symbolical of the Holy Trinity, or whether it is intended to represent a Greek cross, the lower arm of which is concealed by the head of the person to whom it is given. We are inclined to accept the former view, although there are examples in the carvings at Amiens, and in paintings by Fra Angelico where a nimbus with the entire Greek cross is shown. The tri-radiant nimbus must be confined absolutely to one of the Persons of the Holy Trinity, and must never under any circumstances be given to any other being. As a rule it is confined only to our Saviour, although the

Father and the Holy Spirit have been shown with the tri-radiant form. See Figure 12.

Rayed Form with Circle. A variation of the tri-radiant nimbus is one which has nine rays, in groups of three. These may be confined within the circle, or they may penetrate through it, as shown in Figure 13.

Tri-Radiant Patée. Even more common than the tri-radiant form with three straight bands, is the tri-radiant patée form. In this type the three bands either curve out gracefully to the circle, or else take the form of elongated triangles. Figure 14 shows the former type. The rays are quite often enriched with decorative designs, especially in painted glass.

Lozenge-Shaped Nimbus. This is likewise called the diamond-shaped nimbus. It may take the form of rays of light ending so as to form a diamond-shaped figure, or the diamond may be shown in outline, either with or without the rays. Often the outlines of the diamond are curved slightly, for a more graceful effect. Generally the lozenge nimbus is given only to God the Father, although a few examples exist, we believe, where the other Persons have been thus representd. See Figure 15.

The Patée Adorned. See above, Tri-Radiant Patée.

The Triangular Form. This form certainly must always be restricted to the Holy Trinity. It originated in the eleventh century, and is almost always restricted to the Father only, in order to distinguish His picture from those of the Son and the Holy Spirit. See Figure 17.

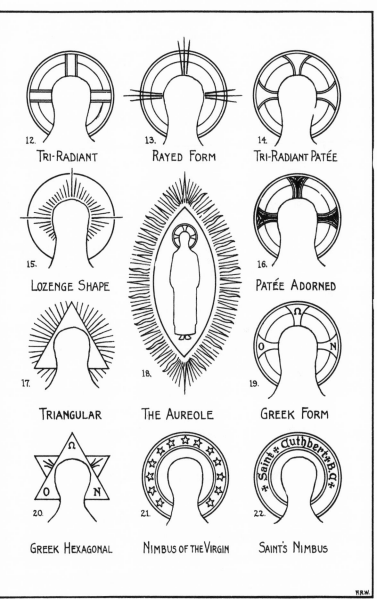

12. TRI-RADIANT 13. RAYED FORM 14. TRI-RADIANT PATÉE

15. LOZENGE SHAPE 16. PATÉE ADORNED

17. TRIANGULAR 18. THE AUREOLE 19. GREEK FORM

20. GREEK HEXAGONAL 21. NIMBUS OF THE VIRGIN 22. SAINT'S NIMBUS

Forms of the Nimbus and the Aureole PLATE XV.

The Greek Nimbus. In the Eastern Church it was often customary to place the Greek letters Omicron, Omega and Nu within the rays of the tri-radiant nimbus. This is the abbreviation for the words ἐγὼ εἰμὶ ὁ ὤν, meaning "I am that I am," which God spoke to Moses from the burning bush. Sometimes the Western Church used the same idea, substituting the three letters of the word *Rex*, meaning "king," to express the kingly nature of the Lord.

The Hexagonal Nimbus. This differs somewhat from the Nimbus à Pans, in that it is really in the form of an equilateral triangle, with a second inverted equilateral triangle back of it. Usually it has the Greek letters mentioned in the foregoing paragraph. This form of nimbus is generally confined to the Father. See Figure 20.

The Starry Nimbus. Some nimbi are in the form of two concentric circles, between which is a row of stars. This nimbus is used to distinguish the Blessed Virgin from any other persons who may be in a picture. See Figure 21.

The Inscribed Nimbus. In the fourteenth, fifteenth and sixteenth century the custom of inscribing the name of the person within his nimbus was common in Italy and Germany, and to some extent in Greek examples. In the last case, initials or abbreviations were used. An inscribed nimbus shows the name in the form of a decorative style of lettering, placed in a circular fashion within the nimbus. The Latin form of the name is generally used. See Figure 22.

Between the sixth and twelfth centuries, the nimbus was shown in a luminous, transparent form. Later it became an

opaque disc, then luminous and transparent for a time, and finally in days of decline, it was shown in perspective, as in Figure 11.

In early days the nimbus was given only to the Three Persons of the Holy Trinity, later to angels, apostles and martyrs, and finally to other persons noted for their holiness of life. The nimbus is purely a symbol of sanctity, or of great distinction in the Church. In general, it ought to be restricted to the Holy Trinity, to archangels and angels, to apostles, martyrs and very distinguished men and women of the Church. The modern custom of commercial glass men, fortunately not common, of picturing an angel with the idealized face of some recently deceased member of the parish, and encircling the head with a nimbus, is shockingly bad in taste.

The Lamb of God, the peacock, the pelican, the Lion of the Tribe of Judah, the unicorn, and other such representatives of our Saviour, are pictured with the cruciform nimbus. Our Lord must always have the tri-radiant, or cruciform form of nimbus. Angels, apostles and saints must *never* have the tri-radiant form.

An aureole is an elongated nimbus surrounding the entire body. We show two forms, figures 7 and 18. The first is of the *vesica piscis* form, having pointed ends, and the latter is the oval, or more properly, *the elliptical form*. It is customary to restrict the aureole only to our Lord when shown in glory, and to pictures of the Virgin Mother when shown holding the Holy Child in her arms.

The aureole may be simple rays of glory proceeding from the figure enclosed within it. It may be in the form of flames of glory, or alternating rays and flames. Often the figure surrounded by the aureole also has a nimbus.

The Circular Aureole. In addition to the aureole of vesica shape, and the elliptical aureole, the circular form has been used.

The Quatrefoil Form. An aureole of quatrefoil form is sometimes used to surround seated figures, where the composition calls for something wider than the elliptical form.

The Cruciform Aureole. Examples exist of an aureole surrounding an entire figure, and with radiating bands resembling the tri-radiant nimbus. These are either three or four in number, and may be either straight or else of the patée form.

The Rayed Form. Occasionally the aureole takes the form of rays which seem to proceed from behind the body, rather than from an ellipse or vesica that does not touch the body.

The Double Form. In old paintings and miniatures one sometimes meets with double aureoles. These are usually used with seated figures.

The Cloud-Like Aureole. This is quite like an oval or a vesica shaped aureole, except that it has wavy, nebulous bands of conventionalized clouds surrounding it.

The Foliated Aureole. In old French art, aureoles of an elliptical form exist, from which grow conventionalized branches and leaves, with seven medallions of Jesse Tree

character, each one containing a nimbed dove, symbolical of the Seven Gifts of the Holy Ghost.

All of these forms are used chiefly to surround representations of the Three Divine Persons, or the Virgin when she holds the Holy Child, or is represented in the vision of the Woman of the Apocalypse. The *vesica piscis* form is perhaps the most symbolic, recalling the rebus formed by the initials of the sentence Ἰησοῦς Χριστὸς Θεοῦ Υἱὸς Σωτήρ (See Chapter VI.) This vesica is sometimes known as the "mystic almond."

The Glory. Audsley defines the glory as a combination of both nimbus and aureole, but most authorities apply the term to a flood of golden light that proceeds from one or more figures, such as our Lord, Moses and Elias on the Mount of Transfiguration, or our Lord as the Great Judge of the quick and dead. Generally it envelops more than one figure.

In the sixteenth century, when all forms of Christian art were declining, both the nimbus and the aureole fell into disuse. Even in the present day there is a puritanical prejudice, especially on the part of persons under the influence of rationalism, that would begrudge to our Lord and the eminent leaders of His Church the innocent artistic symbol known as the nimbus, just as the same aftermath of the days of rationalism and pietism would, with the matter-of-fact spirit that might be forgiven in the case of some of the "plain" sects among the Pennsylvania Germans, deny to

the Apostles the word "saint," and call them simply John and Paul and Peter.

The Horns of Moses. In some instances pictures of Moses are shown with two horn-like rays of light proceeding from his brow. This is derived from the statement of Scripture that the face of Moses shone when he came down out of the mountain. In Michael Angelo's famous figure of Moses, these rays actually take the form of hard horns. If the horn-like nimbus of Moses is used, it is better to show it as two rays of light, or two groups each containing three or more rays, or else it ceases at once to be a nimbus.

The cruciform nimbus is always shown surrounding the Hand of God, or *Manus Dei*, and the head of such symbols of our Saviour as the Lamb of God, the Pelican, etc. It is always given to the Dove of the Holy Ghost. A plain nimbus surrounds the winged man, the lion, the ox and the eagle of the Four Evangelists.

CHAPTER XII.

THE WORD, SACRAMENTS AND SACRED RITES

PREVIOUS to the Reformation the Western Church taught that there were seven Sacraments. These were: Holy Baptism, Confirmation, the Lord's Supper, Penance, Extreme Unction, Holy Matrimony and Holy Orders. The symbols for these are the font, a dove, a chalice, a whip, an oil stock, clasped hands and a stole.

After the Reformation two diverse tendencies appeared among the reformed bodies. The Lutheran group held firmly to the doctrine of Baptismal Regeneration, and the Real Presence of our Lord's Body and Blood, in, with and under the bread and wine, which doctrine all orthodox Lutherans hold firmly to this day. The Lutheran bodies still lay utmost stress upon Confirmation, but look upon it as a sacred rite, but not a Sacrament that may be insisted upon as essential to salvation. They still retain Ordination, Holy Matrimony, Confession and Absolution, and one who dies in the faith is given the Last Sacrament. But Ordination, Holy Matrimony and Confession and Absolution are regarded as very solemn rites, but are not called Sacraments.

The Calvinistic bodies retain Holy Baptism and the

Lord's Supper, but regard these as memorials, rather than Sacraments in the strict sense of the term. Thus they hold Holy Baptism to be symbolical of the washing away of sins, and the Lord's Supper a memorial feast, to which all who chance to be in church, and love the Lord, may be invited. Many of these bodies do not confirm, nor do they lay stress upon Absolution, nor do all of them administer the Last Rites to the dying. All of them recognize Holy Matrimony, but in the light of a church ceremony.

A change is taking place among the Calvinistic bodies. Along with a growing liberalistic group, there is also a growing group who favor a restoration at least of the outward forms of Holy Baptism, the Lord's Supper, and in some cases of Confirmation. We have seen fine new Presbyterian, Congregational and even Unitarian churches, in which is a true altar, with cross and candlesticks, as well as a baptismal font. A number of such churches have come into existence within the last few years, especially in the larger cities in the eastern states.

Holy Baptism. The universal symbol for this Sacrament is a font. Even the presence of the actual font itself in a church is symbolical as well as utilitarian, for it is the outward expression of the congregation's belief in Holy Baptism. With the immersionist bodies, the larger container is the expression of their teachings.

A font is pictured either as round, or as octagonal. In ancient times, fonts were of stone, and very often round, and of massive proportions. Nowadays most fonts are oc-

tagonal, because the octagon is the symbol of regeneration. The font is pictured with a cover, ranging from a simple, octagonal pyramid to an elaborate spire fifteen or more feet high. The cover may be crowned with the cross, symbolizing redemption, or the dove, symbolical of the Holy Spirit.

The Lord's Supper. The usual symbol for the Holy Eucharist is a chalice, with a host rising out of it. The chalice is shown with a hexagonal base, as a rule, symbolizing the Six Attributes of the Deity, and with a richly wrought stem of gold, studded with precious stones. The host is shown as the typical circular wafer, upon which may be imprinted the letters I. N. R. I., from which proceed rays of light, symbolical of the Real Presence, in, with and under the bread and wine.

An altar, upon which is set a cross, two or more candles in their tall candlesticks, a chalice and a ciborium, is another symbol often seen. The actual altar itself is both symbolical and utilitarian, and its use in the form of a carving, a cut on a church announcement, or a painting on the wall, or in a stained glass window, symbolizes the Sacrament of the Lord's Supper.

The Word. Since it is the Word of God which causes the water of Holy Baptism, and the bread and wine of the Eucharist to produce such marvellous effects, it is fitting that this should have a symbol. The usual form is to show an open Bible. Among those of us who believe in the verbal and complete inspiration of the Holy Scriptures, it

is customary to inscribe the letters V. D. M. A. on the open Bible, or else to spell out the entire sentence: *Verbum Dei Manet in Aeternum*, that is, "The Word of God endureth for ever,"—I Peter 1, 25. A burning light or a candle also symbolizes the Word.

Another symbol for the Word of God is a picture of two scrolls, one symbolical of the Old Testament and the other of the New. In the Jewish Church, one scroll may represent the Law and the other the Prophets.

Confirmation. Among all Roman, Greek, and Anglo-Catholic churches, this is regarded as a Sacrament. Among Lutherans, moderate Episcopalians and certain groups in other church bodies, Confirmation is regarded as a solemn rite, and a condition of church membership and reception of the Holy Eucharist. The usual symbol is the dove, reminding us of the words from the liturgy, "renew and increase in thee the gift of the Holy Ghost." Hence the dove, the symbol of the Holy Spirit.

Another symbol, if such it may be called, and one more readily recognized and not mistaken for something else, is that of a clergyman, clad in the ancient vestments of his office, laying his right hand upon the head of a child who kneels on a *prie-dieu* before him. Above may be seen a dove, symbolizing the Holy Spirit.

The Office of the Keys. Since the Office of the Keys is "the peculiar church power which Christ has given to His Church on earth to forgive the sins of penitent sinners unto them, but to retain the sins of the impenitent, as long as

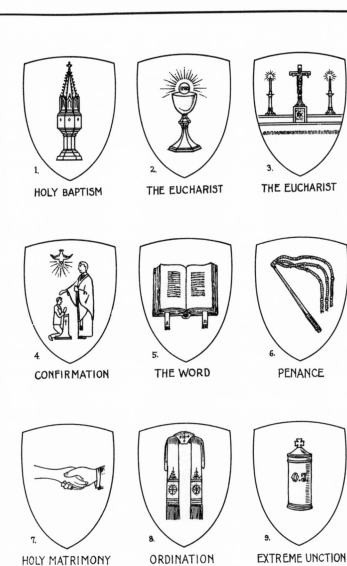

1. HOLY BAPTISM

2. THE EUCHARIST

3. THE EUCHARIST

4. CONFIRMATION

5. THE WORD

6. PENANCE

7. HOLY MATRIMONY

8. ORDINATION

9. EXTREME UNCTION

Sacraments, Ordinances, etc.

PLATE XVI.

they do not repent," it is fitting that the symbol for this power is two keys saltire. The one key represents Excommunication, by which the door is locked upon the wilful and impenitent sinner. The other key is Absolution, by which the door to the Kingdom is gladly opened to the sinner, when he repents. This symbol is highly significant, and soundly Biblical, and we ought to use it oftener than we do.

Confession. Confession, mentioned in the Catechism, whether public, as before Holy Communion, or private, is symbolized by a small fald-stool, or *prie-dieu.*

Absolution. In addition to the key, mentioned above, a bunch of hyssop may be used to symbolize the Absolution pronounced to the sinner who confesses his sins. The reference is to a section of the *Miserere mei Deus,* which reads, "Purge me with hyssop and I shall be clean,"— Psalm 51, 7. Hyssop, dipped in the blood of the slain lamb, was used by Israel of old, and is the symbol of Absolution today, recalling to our minds the fact of the cleansing power of the blood of the Lamb of God.

Holy Matrimony. This sacred rite is symbolized by two clasped hands. Occasionally a third hand, nimbus-encircled, is seen above them, with the thumb and first two fingers extended in benediction. This represents the blessing of the Triune God which rests upon this holy estate.

The fact that marriage is a life-long union of one man and one woman may be symbolized by a nugget of pure

gold, since gold is said to be indissoluble in anything other than Aqua Regia, which, we presume symbolizes death.

Ordination. This may be symbolized by a head, upon which are laid several hands. An old-time symbol of the same rite is the stole, or a chalice set upon a Bible, or upon a missal, with a folded stole hanging over the book.

Minor Symbols. There are several symbols that pertain to the liturgical service of the church. For example, *prayer*, which occupies so large a part of the liturgy, is symbolized by the censer and the smoking incense. This from earliest days has been the symbol of prayer, which ascends heavenward as a sweet-smelling savour. The *chanted parts of the liturgy* are symbolized by a scroll, upon which is a staff of four lines with Gregorian notes, and several words in Latin, such as *Sanctus, Sanctus, Sanctus, Dominus Deus Sabaoth*, that is, "Holy, Holy, Holy, Lord God of Sabaoth." *Hymnody* is often shown on printed programs in the form of a choir boy, in cassock and cotta, singing. Another form, often seen carved on the case of fine modern organs, is to show shields with the instruments of music mentioned in Psalm 150, namely, the trumpet, the psaltery, the harp, the timbrel, the stringed instrument, the primitive organ and the cymbals.

In one or two recent churches we have seen the heads of St. Ambrose, St. Gregory, St. Cecilia and others, each with a musical instrument, carved on the ends of the choir stalls, representing the Ambrosian, the Gregorian, and the Primitive phases of Christian music. Might not some such

man as Paul Gerhardt be included as a representative of modern hymnody?

Yet another symbol of sacred music is an ancient lectern, with a head somewhat like a truncated pyramid of four sloping sides, and on each face a book of ancient chants.

The Gospel and the Epistle are shown by picturing a double-headed lectern, with an open Bible on each face. The *sermon* is usually represented by an octagon pulpit, upon which lies an open Bible, or by a trumpet, with the inscription: "*Etenim si incertam vocem tuba det, quis apparabitur ad bellum?*"—"For if the trumpet give an uncertain sound, who shall prepare himself to the battle?" —I Cor. 14, 8.

The Benediction is expressed by picturing an upraised hand, with thumb and first two fingers extended, but without the three-rayed nimbus which belongs only to the Holy Trinity. •

Plate XXXVII is an interesting set of symbols, which we reproduce through the kindness of Mr. Karl Schubert. Holy Baptism is represented by a great Romanesque font, over which is a dove; Confirmation by a descending dove; the Sacrament of the Altar by an altar prepared for the celebration of the Blessed Sacrament; Penance by the two Keys saltire and the traditional whip; Holy Matrimony by clasped hands; Ordination by a chalice, stole and missal; and Extreme Unction by an oil stock. One often sees these symbols enclosed by a circle, and with a stole arranged above them in semi-circular form to denote that each is a churchly function.

CHAPTER XIII

SYMBOLS OF THE BLESSED VIRGIN

OUR best friends are persons whom we may or may not like personally, but with whom we live peaceably because of religion, relationship or business associations. The same thing is true in Christian art. There are certain age-old traditions, and various ways of expressing things which the reader of these lines may or may not like personally, depending upon his religious preferences and prejudices. But whether the reader may like them or not, he will admit that we are justified in including an account of them in this book, because they have occupied an important place in Christian art in bygone centuries.

Among the more extreme Calvinistic bodies, and among the Puritans, there have been times when the very mention of the Virgin Mother was anathema. This is due to the violent reactions which accompanied the Calvinistic phases of the Reformation. Even Bible pictures were hated. The notorious "Blue Dick" Culmer, placed in charge of Canterbury at the time of the Commonwealth, was a man of such supersensitive views that the stained glass which once made Canterbury cathedral a thing of unearthly glory was

hateful to him. He leaves a statement telling of his right-
eous glee as he stood upon a ladder "sixty steps high" and
with a pike pole rattled down the splendid glass that once
filled the great windows. The few windows in the east end
that he did not destroy rank among the very finest in the
world, and indicate what the world lost when all Christian
art perished in those troubled days, except a few fragments
here and there that were overlooked, or hastily concealed.
Theodore Beza and his friends broke into Orléans by night,
undermined the great piers, and sang devout praises to the
Most High when that majestic fabric crashed down into a
heap of shapeless ruins. Fanatics smashed the fine glass at
Angoulême, broke down the altars and the carved figures,
and destroyed the beautiful tapestries. The great store of
vessels of gold and silver were melted and turned into
money—a practice quite common among the destroyers,
by the way.

That great abuses existed none will deny. In the days
of religious corruption, choir boys staged a burlesque mass
at Laon, to the great amusement of the populace. Such
things as the Festival of the Fools might well shock us to-
day, to say nothing of theatrical performances staged with-
in Laon and other great cathedrals in the fifteenth century.

When the reaction came, it came with grim vengeance,
and a vast amount of splendid things perished along with
what was objectionable. Men went so far as to cast out
almost all that Luther had retained, for they believed that

his work had not gone very far, for he held that only those things that were unscriptural must be destroyed.

Among the more extreme Calvinists and Puritans, the very mention of the Virgin Mother was anathema. No doubt there had been times when the veneration paid her eclipsed that of her Divine Son. That was one extreme. There was no reason however, for men to jump to the opposite extreme, and to despise her whom God's messenger angel had called blessed among women. No amount of man-twisted Biblical exegesis can get rid of St. Luke 1, 28. We ought to be willing to go as far as God's Word goes.

A visit to the catacombs will convince the most sceptical that the Virgin Mother occupied her proper place in early Christian art, even though some would have us believe that pictures of her, holding the Blessed Christ Child, are representations of some pious woman who lies buried within the catacombs! Sour-faced fanaticism could not well go farther.

In the earliest days the Virgin Mary was neither unduly apotheosized, nor was she unjustly slighted. She was looked upon as one who was highly favored of God in that she was permitted to hold the Divine Child in her arms, and croon Him to sleep with her gentle lullaby. It was she who stood loyally beside His cross after so many of His followers had fled in cowardly panic.

In the days of the Byzantine artists, and in the Middle Ages, she occupies an important place. When churches were filled with splendid stained glass in the eleventh,

twelfth, thirteenth and fourteenth centuries, and their walls covered with Bible pictures, she is represented in pictures of the Annunciation, the Visitation, the Flight into Egypt, the Epiphany, the Crucifixion and the Resurrection. No efforts of self-constituted archaeologists can get rid of this fact by advancing the laughable idea that it is not the Blessed Virgin, but rather some pious Christian woman of later days who is pictured.

Certain symbols of the Virgin Mary are necessary even today, for in stained glass work especially, it is necessary to picture her in representations of the New Testament scenes which we have just mentioned. Even the most abject Protestant cannot deny her such things as her Annunciation Lily, the emblem of virginity, or the fleur-de-lys, or the flowering almond, nor could there be any objection to placing her monogram on a shield as a symbol of our Lord's human nature.

The Encircled Globe. The earth, with a serpent coiled about it, is a symbol of the fall of man. It has also been used to represent the Blessed Virgin, a verse from Genesis, in Latin, stating that the Seed of the woman (Jesus Christ) shall bruise the head of the serpent, which symbolizes the devil. See Plate XVII, Figure 1.

The Lily. One of the most common symbols of the Virgin, especially from the twelfth century onward, is the *Lilium candidum*, popularly called the Madonna Lily. In almost all pictures of the Annunciation, she is shown holding it, or else it grows in a jar at her side. The lily is a sym-

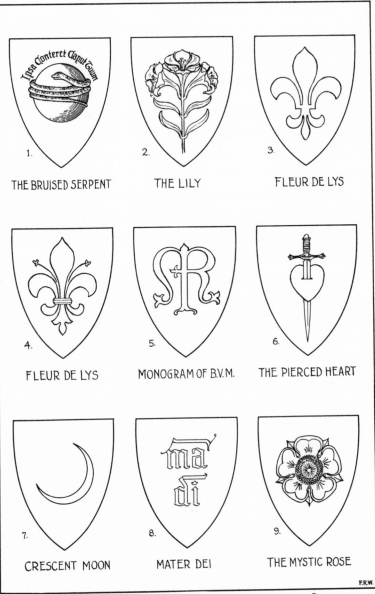

1. THE BRUISED SERPENT

2. THE LILY

3. FLEUR DE LYS

4. FLEUR DE LYS

5. MONOGRAM OF B.V.M.

6. THE PIERCED HEART

7. CRESCENT MOON

8. MATER DEI

9. THE MYSTIC ROSE

The Blessed Virgin

PLATE XVII

bol of virginity and of purity, and hence of the Virgin Birth, reminding us that our Lord was conceived sinless of an undefiled Virgin. For a representation of the lily see Figure 2.

The Fleur-de-Lys. Even a dictionary maker is not always an infallible guide in matters of religious symbolism, for such men have been known to state that the fleur-de-lys is a symbol of the old French kings. This was true enough, but the French kings drew upon Christian symbolism for this device. The fleur-de-lys is a symbol of the Holy Trinity, also of the Blessed Virgin. It is thought by many authorities to be a conventionalized form of the Annunciation lily. Many forms of the fleur-de-lys exist. Geldart gives an entire page of them. Their details may vary, but there is always the erect, spear-like vertical petal, and two other petals which curve downward on either side. Sometimes stamens are shown, and even the tips of two more petals. Many examples are highly decorative, and some of the most splendid examples of Mediaeval diaper work that we have seen employ the fleur-de-lys as a motive. In Figure 3 we have drawn a fourteenth century example, and in Figure 4 a modern rendering of the fleur-de-lys.

The Flowering Almond. This symbol may often be found either in the form of a conventionalized sprig displayed upon a shield, or else an entire shrub growing in a pot. It is based upon the account of the budding of Aaron's rod, in Numbers 17, 1-8, which became a symbol centuries later of the Virgin Birth. Because an undefiled

Virgin, by a miracle, and contrary to biological laws, brought forth a Son, the rod of Aaron which burst into bloom contrary to the usual laws of nature, was adopted as its symbol.

The Rose. A rose, either white or pink, is a common symbol of Our Lady. The usual form is that of the heraldic rose, which we show in Figure 9.

The Gilly Flower. Geldart, and other pre-eminent authorities, list the gilly flower as a symbol of the Virgin Mary. It is usually shown growing in a pot, and flowering most profusely.

The Snow-Drop. Because it is one of the emblems of purity and of virginity, the snow-drop has long been a symbol of the Virgin.

The Hawthorn. Under the symbols of our Lord Jesus Christ we have mentioned the legend of the flowering of St. Joseph of Arimathaea's thornwood staff. Because this staff is said to have burst into bloom, and because the old thorn tree blooms to this day at Christmas time, it is both a symbol of our Saviour, and of His Mother, who brought forth a Son in a most miraculous manner, and in a most unexpected place, the cattle shed.

The Virgin's Monogram. In old stained glass, and in the elaborately decorated, hand-lettered ancient manuscripts, one often finds the Monogram of the Blessed Virgin. Many meanings are read into it. The usual form of this monogram is as shown in Figure 5, which we borrow from Pugin's "Glossary." It will be noted that the five let-

ters forming the name MARIA are woven together. Likewise the Hebrew form of her name, MIRIAM, may be found there. Again, the letters A. M. R. are to be seen, which the churchmen of Mediaeval days interpreted as *Ave, Maria, Regina*, or "Hail, Mary, the Queen." With a slight modification of the design, the letters A. M. G. P. D. T. are formed, meaning *Ave Maria, gratia plena, Dominus tecum*, which was the Mediaeval rendering of the words of salutation addressed by the Archangel to the Virgin. The monogram may be shown as in Figure 5, or it may have a crown over it, as is often seen in Mediaeval art.

The Pierced Heart. We have all seen the horribly realistic "Sacred Heart of Mary" pictures, with the red, bleeding heart with a dagger driven through it. Much better is the somewhat heraldic form which we reproduce in Figure 6. It is a symbol of the prophecy uttered by the aged Simeon, "Yea, a sword shall pierce through thy own soul also."—St. Luke 2, 35. In some old examples the heart is shown with wings.

The Sun and Moon. Even as early as the days of the catacombs, the twelfth chapter of the Revelation was interpreted by some to mean the Virgin and her Child. In this vision of St. John, he sees a woman clad in glory, crowned with twelve stars, with the moon at her feet, about to give birth to a Child destined to rule the whole earth, and to be caught up into Heaven and to the throne of God. A dragon stood waiting to destroy the Child, and the woman fled to the wilderness where God had prepared a place for her to

hide. In a splendid fresco in the catacombs, this woman is represented as a type of the Virgin, and the child the Holy Christ Child. In time, the sun, the moon and twelve stars, originally the symbol of Jacob and his wife and their sons, came to represent this scene taken from the Apocalypse. At the time of the Reformation, the woman crowned with stars was declared to be the Church, and is so understood by many today.

The Crescent Moon. Often the crescent moon is shown as a symbol of the vision of St. John just mentioned. Visitors to the old English parish churches may have been puzzled at the frequent carvings of a crescent moon upon a shield, and some have even declared it to mean the heathen goddess Diana. But it refers to the Virgin Mother, whose glory is borrowed from the Sun of Righteousness, Jesus Christ, as the light of the moon is reflected from the sun. Murillo, who lived somewhat too late to produce the finest art, shows the Blessed Virgin, upon a voided crescent moon. Care should be taken, if it is desired to use this symbol, that the moon be not turned backward, nor placed vertically. Figure 7 shows the proper form.

The Starry Crown. From the same twelfth chapter of the Apocalypse is taken the crown of the Virgin. Usually this is shown as a crown with upright spikes, each one of which terminates with a five-pointed star. In Botticelli's famous "Madonna of the Magnificat," the crowning of the Virgin is shown.

The Star. The Hebrew form of Mary is Miriam, which

means a star. Therefore this familiar symbol of the Epi-
phany is frequently given to the Blessed Virgin.

The Balsam. This is a symbol of the Virgin, but is not
so common, perhaps, as the ones just mentioned.

The Ark of the Covenant. The ark of the covenant,
described in Exodus 25, is a symbol of God's promise to
Israel. It also has been used as a symbol, (or more prop-
erly, a type) of the promised mercy of God fulfilled in the
birth of our Lord.

The Speculum. The speculum, or mirror, is listed among
the Virgin's symbols, and refers to the old belief that the
Virgin Mother's virginity was preserved both before and
after the birth of our Lord.

The Apple. Since sin entered the world when Eve
tasted of the forbidden fruit, pictured in art as an apple, the
same fruit sometimes is given to the Virgin Mary, for it
was her Son Who took away the curse of sin.

The Myrtle. This symbol of unspotted maidenhood is
given to the Virgin in works of art, because of her undefiled
life and character.

The Symbols from the Canticles. The Mediaeval church-
man understood the woman mentioned in the fourth
chapter of the Song of Solomon to be a type of the Virgin
Mary. Hence the symbols of the Enclosed Garden, the
Sealed Fountain, the Tower of David, the Spring Shut
Up, the Orchard of Pomegranates, Camphire and Spike-
nard, Spikenard and Saffron, Calamus and Cinnamon,
Myrrh and Aloes, the Fountain of Living Waters, the

Fountain of Gardens, the Streams from Lebanon, etc., have been used to represent her.

The Palm, Cypress and Olive. These symbols denote peace, Heaven and hope. They are symbols of the Virgin as she ponders in silent wonder over the heavenly tidings made known to her by the Angel Gabriel.

The Closed Gate. The closed gate of Ezekiel's prophecy is said to have been used as a symbol of chastity, and has thus been assigned to the Virgin.

The Book of Wisdom. In some pictures of the Virgin, she is shown holding this book in her hands.

The Sealed Book. This has reference to Isaiah 29, 11-12, because the miracle of the Virgin Birth is too profound a truth for men to understand, much less explain.

The Rod of Jesse. The reference here is to Isaiah 11, 1. Our Lord Jesus, according to His human nature, was a descendent from the patriarch Jesse, the father of David. Since Jesse is the father of King David, and the Virgin Mary the end of the line of descent, the symbol of the Rod of Jesse is used to remind us of her Son's royal lineage.

Other Symbols. The lily of the valley, symbol of humility is given the Virgin, also the House of Gold, the City of God, the Vessel of Honor and the Seat of Wisdom.

Other symbols of the Virgin employed in olden days are the Gate of Heaven, the Judgment Seat, the Golden House, the Crown of Lilies and Stars, a serpent or dragon under her feet, signifying the fact that the Seed of the woman shall crush the head of the serpent, and the Queen of Heaven

Unless one has an understanding of the meaning of these symbols, he will not be able to grasp the imagery of the old paintings, nor will he understand many of the carved figures that crowd the deeply recessed portals of the old French cathedrals, and the twelfth, thirteenth and fourteenth century glass that yet remains in many places. Next to our Saviour Himself, no one figures so prominently in Mediaeval art as His Mother, for she is pictured prominently in the favorite Annunciation and Nativity pictures, as well as the Visitation, the Presentation, the Flight into Egypt, the Circumcision, the Child in the Temple and the Crucifixion—all favorite subjects found again and again in Mediaeval carvings, paintings, stained glass and illuminated books.

CHAPTER XIV.

THE FOUR EVANGELISTS

WHEN the architect, the glass painter, the decorator or the needlewoman wishes to fill four spaces, the usual manner is to show the symbols of the Four Evangelists, St. Matthew, St. Mark, St. Luke and St. John. If five spaces are to be treated decoratively, the symbols of our Saviour and the Four Evangelists are often employed. If eight spaces are to be filled, as for example, on the opposite sides of the nave of a church, it is often done by showing the symbols of the Four Major Prophets on the one side, and the Four Evangelists on the other, symbolizing the days of the Old Testament and of the New, just as the Twelve Minor Prophets are often used to balance the Twelve Apostles.

The symbols of the Four Evangelists may be traced backward almost to the beginning of the Christian era. It is certain that they were known and used in the fourth century. In the fifth and sixth centuries they were widely used.

The Winged Creatures. The symbols most frequently met with are the four winged creatures mentioned in the Book of Ezekiel, as well as in the fourth chapter of Revelation, namely the winged man, the winged lion, the

winged calf and the eagle. While these winged creatures have been used from most ancient times, yet in early days they were not used in the same order as is customary today.

Irenaeus, who died just at the opening of the third century, described the figures as follows: The winged man signifies the human nature of our Lord Jesus. The winged lion represents His royal character, since the lion is the king of beasts. The winged calf testifies as to His sacerdotal nature, for the calf is the emblem of sacrifice. The flying eagle represents the grace of the Holy Spirit which was ever upon the Saviour.

Thus understanding these prophetic symbols, Irenaeus attributed to St. Matthew the winged man, because St. Matthew lays stress upon the Incarnation of the Son of God. He undersood the eagle to represent St. Mark, because that inspired writer speaks of the grace of our Lord. The calf he associates with St. Luke, because of the simplicity and earnestness with which St. Luke described the sacerdotal office and the death of our Lord. He believes that the lion symbolizes St. John, who speaks of the divine nature of our Saviour and His Kingly Office.

Athanasius follows much the same line of argument, except that he attributes the calf to St. Mark and the lion to St. Luke.

St. Augustine and the Venerable Bede understand the symbols differently, giving the lion to St. Matthew, the man to St. Mark, the calf to St. Luke and the eagle to St. John.

In Mediaeval and modern times, the present association

SYMBOLS OF THE

THE FOUR EVANGELISTS
(FROM THE CATACOMBS)

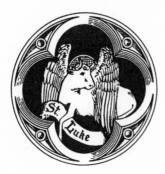

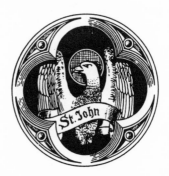

FOUR EVANGELISTS

The Four Evangelists

PLATE XVIII.

of symbols and Evangelists became generally used, namely the winged man symbolizing St. Matthew, the winged lion St. Mark, the winged ox St. Luke and the eagle St. John. This is the significance of the four symbols today.

Nowadays the usual explanation is this: The winged man is the symbol of St. Matthew, because that Evangelist begins his Gospel by tracing the human descent of our Lord. The lion denotes St. Mark, because that writer opens his inspired Gospel by describing St. John the Baptist who was the voice of one crying in the wilderness. The ox is a representation of St. Luke because he gives a very full account of the sacrificial death of our Lord. The symbol of St. John is the eagle, because from first to last his Gospel soars on eagles' wings to the very throne of Heaven.

Some of the Church Fathers state that the four symbols represent the four chief events of our Lord's earthly life, namely: the winged man typical of the Incarnation; the winged ox symbolizing His sacrificial Death; the winged lion His Resurrection (since the lion was once thought to be born dead, and only raised to life on the third day by the voice of its parent); and the eagle of His Ascension.

In Mediaeval times it was common to adorn the covers of the Holy Scriptures with these four symbols. They were, and always have been, widely used by the wood-carver, the illuminator of manuscripts, the painter, the enameller, the glassworker, the needlewoman, the book binder, the craftsman in precious metals, the printer, the engraver and the mural decorator. Countless altar crosses exist, both of

Mediaeval and modern workmanship, with the symbols of the Four Evangelists in the four ends of the cross, and our Lord in the center.

When used to embellish an altar or a processional cross, the usual arrangement is to place the eagle of St. John at the top, the winged ox of St. Luke at the base, the winged man of St. Matthew at our Lord's right and the winged lion of St. Mark at His left hand. Either a figure of our Lord, or else an *Agnus Dei* is, of course, placed in the center of the cross. At Minden, in the cathedral, the positions of the lion and the calf are reversed, thus causing the calf to be on the observer's right and the lion on his left.

If used on a book cover, or on an altar frontal, the traditional arrangement is to place the winged man in the upper left-hand corner, the eagle in the upper right-hand corner, the winged lion in the lower left-hand corner, and the winged calf in the lower right-hand corner, although this rule has had its exceptions even in very good work.

These winged creatures always are shown with a nimbus. Often merely the heads and wings are shown. Sometimes the entire bodies of the living creatures are pictured. Often they are shown in medallions composed of a combination of the square and the quatrefoil. Again they are shown within a simple quatrefoil, or even within a plain square frame. Occasionally the foot of the man, the paw of the lion, the hoof of the ox and the claw of the eagle are shown. Ancient baptismal fonts exist, supported by these symbols. Other fonts exist, supported by the entire figures of the

man, the lion, the ox and the eagle, all nimbus crowned.

Nowadays it is common to embellish the lectern with these four symbols, either shown as supporting the four upright corners of the lectern's standard, or else carved in wood on the four corners of the book-rest. The metal missal-stand, or altar-desk, may likewise bear these four symbols, surrounded with quatrefoils.

Beautiful lecterns and pulpits exist, with full-length carvings of the Saviour and the Four Evangelists, each with his appropriate symbol on a shield beneath him. If seven spaces are to be filled, sometimes our Lord, the Four Evangelists, St. Peter and St. Paul are used. In one or two notable cases we have seen the Archangels St. Michael and St. Gabriel used, instead of St. Peter and St. Paul.

The Tetramorph. An ancient symbol, not very popular today, is the Tetramorph, based upon Old Testament prophetic symbolism. Often this creature is shown with four heads: the man, the lion, the ox and the eagle. Each head is surrounded by a nimbus. There are eight wings, two of which are crossed above, two beneath, and four used for flying. The feet are those of an angel, and they rest upon wheels full of eyes, and with wings. This symbolical figure is a free adaptation of Ezekiel 10, 14.

The Four Scrolls. Much more ancient than the pictures of the four winged living creatures, and dating back to the catacombs, are the symbols of the four scrolls. Each scroll represents an ancient Jewish book. Upon each scroll is inscribed, either in Greek or else in Latin letters, the name

of one of the Four Evangelists. In stained glass work it is common to picture the figures of the Four Evangelists, each one of whom holds such a scroll, with his name inscribed upon it.

The Four Rivers. Based upon the Vision of St. John on Patmos is the symbol of the four rivers. These may be seen in the catacombs. Usually these are shown flowing from the throne of the Lamb of God. In early Christian painting, in sculptured figures, and in old mosaics, these four rivers are common. The River Gihon is ascribed to St. Matthew, the River Tigris to St. Mark, the River Euphrates to St. Luke and the River Pison to St. John. These, of course, represent the Four Gospels, flowing from the Throne of God, to irrigate the earth with the waters of life.

The Four Urns. Somewhat less common are the four urns, each held by a human figure representing one of the Four Evangelists. The urns are inclined, and out of each one flows the living water, symbolical of the Gospel.

The Four Books. A well-known symbol of the Four Evangelists, existing in the catacombs, and widely copied, is that of the four books. A Cross Patée is shown, and in each of its corners is an open book, surrounded by a nimbus. Surrounding the Cross Patée is the circle of Eternity, and about that is the square, symbolizing the earth, which, in ancient poetry and art was supposed to have four proverbial corners. The symbol seems to teach us that the Gospels given us by the four Inspired Evangelists shall exist forever upon earth. *Verbum Dei manet in aeternum!*

The Four Fountains. A symbol not so well known is that of the four fountains, treated as in heraldry. These represent the life-giving nature of the writings of the Four Evangelists.

In stained glass work one sometimes sees merely the full-length figures of the Four Evangelists, each with his proper winged creature at his feet, or else with a small shield beneath his feet, bearing his traditional symbol.

The Four Pillars. In the superb "Notre Dame de la Belle Verrière" window in the south choir ambulatory at Chartres is a square medallion representing the Four Evangelists as four pillars, upheld by angels, supporting the throne of Heaven.

CHAPTER XV.

THE HOLY APOSTLES

THE traditional symbols of the Twelve Apostles have long been used abroad, but it is only within the past three decades that they have become popular in America. It is not surprising that the liturgical churches, such as the Episcopalians, the Lutheran bodies and the Roman Catholics have made use of these symbols, for these denominations never broke entirely with Church art. Within the past twenty years a number of other church bodies have returned to the good old ways which their forefathers of four centuries ago, in days when religious excitement was acute, had abandoned.

The three examples of shields of the Apostles which we include among the plates at the end of this volume, will serve to show what is being done today. Those at First Baptist Church in Pittsburgh are carved in stone over the main doorway, and are excellent. Those at Tabernacle Presbyterian Church in Indianapolis, are likewise very fine. They are carved in oak, and finished in proper heraldic colour and gold. The West Hartford examples are particularly interesting. These are but three of a great many examples that might be pictured. Concordia Lutheran Semi-

nary, at St. Louis, has a set of these apostolic shields carved in stone, which are among the best examples in America.

Each of the Twelve Apostles has several traditional symbols, recognized the world over, and of ancient origin.

St. Peter. St. Peter's most usual shield shows two large keys saltire, that is, crossed like the letter X. Plate XIX, Figure 1 shows this form. The background may be red, and one key gold and the other silver. They recall Peter's confession and our Lord's statement regarding the Office of the Keys, which He committed to the Church on earth. See St. Matthew 16, 13-19.

Another form of St. Peter's shield shows the inverted cross upon which he died. See Figure 2. A third form shows the inverted cross and the crossed keys, as in Figure 3. A fourth form of his shield shows a patriarchal cross, with the two keys, as in Figure 4. A fifth form shows a cock, recalling Simon Peter's denial of his Lord, and this contains a warning to men to be bold in confessing the Saviour. A sixth variation of Simon Peter's shield shows a great church built upon a rock, recalling Peter's confession of his Lord, and our Lord's answer. A seventh form shows fetters, either with or without the crossed keys.

St. Peter is said to have been crucified at Rome, requesting that he be crucified head downward, for he did not consider himself worthy to die in the same position as that of his Lord.

St. James the Greater. The usual form of this Apostle's shield shows three escallop shells, two above and one be-

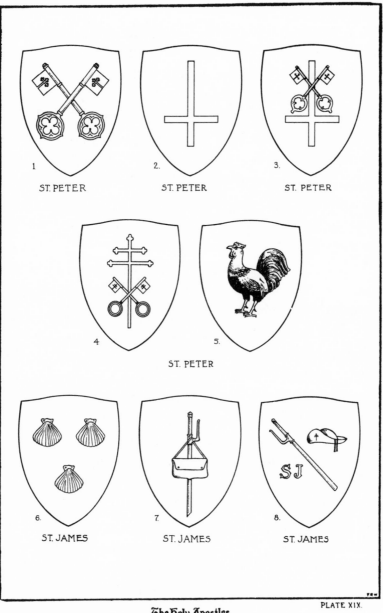

1 2. 3.

ST. PETER ST. PETER ST. PETER

4 5.

ST. PETER

6. 7. 8.

ST. JAMES ST. JAMES ST. JAMES

low, as we show in Figure 6. The escallop shell is the symbol of pilgrimage. The shells are placed with their narrow ends upward, and they are usually gold on a background of red. A second form of his shield is shown in Figure 7, and represents a pilgrim's staff upon which is hung the pilgrim's wallet. Figure 8 shows a third form, with a pilgrim's staff dexter, a pilgrim's hat and the initials "S. J." meaning Saint James. In Figure 9 we show a fourth form of the shield of St. James, which shows a vertical cross-hilted sword and an escallop, signifying pilgrimage and martyrdom, for this Apostle suffered death at the hands of Herod, as recorded in Acts 12, 2. Figure 10 shows a fifth form of his shield, where the pilgrim's staff and the sword of martyrdom are displayed saltirewise. A sixth form shows a white horse and a white banner.

St. James lived for fourteen years after his Lord's crucifixion. Clemens Alexandrinus gives us a vivid account of his martyrdom. As he was about to be beheaded, the soldier who had accused him before Herod was so impressed because of the Apostle's great Christian courage and faith that he fell down and implored forgiveness, humbly confessing his sins. The Apostle absolved him, saying, "Peace, my son, peace be unto thee, and the pardon of thy faults." The soldier arose and confessed Jesus Christ, and was beheaded by Herod, soon after the martyrdom of St. James. Little wonder that so many churches have been named for this Disciple, who combined such noteworthy zeal, mis-

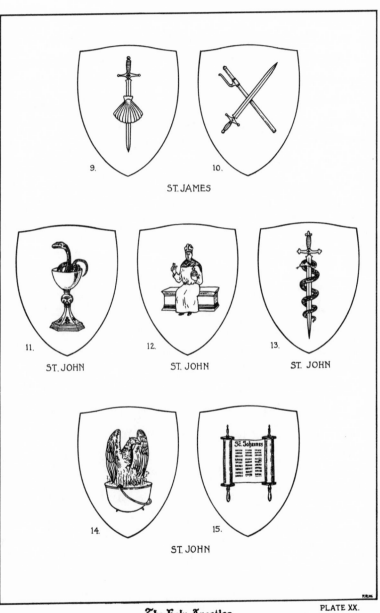

9.

10.

ST. JAMES

11.

ST. JOHN

12.

ST. JOHN

13.

ST. JOHN

14.

15.

ST. JOHN

𝕮𝖍𝖊 𝕳𝖔𝖑𝖞 𝕬𝖕𝖔𝖘𝖙𝖑𝖊𝖘

PLATE XX.

sionary spirit, courage and forgiveness! Francis Bond lists
414 churches in England alone, named for St. James.

St. John. When shown as an Apostle rather than among
the Four Evangelists, St. John's most usual shield has upon
it a chalice out of which issues a serpent. See Figure 11.
Early writers state that an attempt was made to slay this
Apostle by giving him a poisoned chalice, from which the
Lord spared him. Hence the chalice and serpent. A sec-
ond rendering of his shield, which we reproduce in Figure
12, shows a Prester John seated upon a stone tomb. He
wears a bishop's mitre, his right hand is raised in the atti-
tude of benediction, and in his left hand he holds either a
cross-crowned orb or else an open Bible. Sometimes he is
shown holding a sword in his mouth, symbolical of the
Sword of the Spirit, which is the Word of God, which pro-
ceeded out of his mouth. A third shield, Figure 13, shows
a serpent and a sword, recalling the fact of man's sin, and
the power of the Sword of the Spirit over sin. A fourth
form, Figure 14, shows an eagle rising out of a cauldron of
boiling oil, recalling another attempt made on this Apos-
tle's life by the tyrant Domitian, from which he was mirac-
ulously delivered. A fifth shield, Figure 15, shows a scroll
containing the Gospel of St. John. A sixth shield shows a
scroll containing the Book of Revelation. A seventh form
shows a grave. Of the symbols of St. John when shown as
an Evangelist, more has been said in the chapter on the
Four Evangelists.

Although many attempts were made to kill him, yet St.

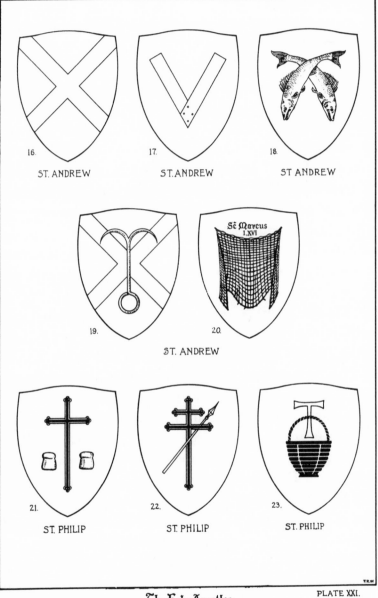

16.
ST. ANDREW

17.
ST. ANDREW

18.
ST ANDREW

19.

20.

ST. ANDREW

Sͭ Marcus
I.XVI

21.
ST. PHILIP

22.
ST. PHILIP

23.
ST. PHILIP

T.R.W

𝕮𝖍𝖊 𝕳𝖔𝖑𝖞 𝕬𝖕𝖔𝖘𝖙𝖑𝖊𝖘

PLATE XXI.

John is said to be the only Apostle who died a natural death, having attained a great age.

St. Andrew. The most common form of St. Andrew's shield is a cross saltire, with its ends reaching the border of the shield. See Figure 16. St. Andrew is believed to have died while preaching the Gospel in Greece, on a cross of this sort. This tradition bears every mark of authenticity. A second form of his shield, Figure 17, shows a V shaped frame of wood. A third form shows the same frame of wood and a vertical spear. A fourth form shows two fishes crossed, as in Figure 18, recalling his original occupation, and his call to become a fisher of men. A fifth form shows a cross saltire, and a great boat-hook. Figure 19. A sixth form shows a fisherman's net, as in Figure 20.

St. Philip. This Apostle's most usual shield shows a tall, slender cross and two loaves of bread, as in Figure 21, recalling his remark when our Lord fed the multitude. St. John 6, 7. A second form of his shield shows a patriarchal cross and a spear, as shown in Figure 22, recalling his supposed martyrdom after valiant missionary activity in Phrygia and Galatia. A third form shows a vertical spear, the instrument of his martyrdom. A fourth shield shows a basket and a Tau cross. See Figure 23. A fifth form shows a knotted cross of wood. A sixth variation shows a slender cross and a carpenter's square. See Figure 24. A seventh form shows a Tau cross and a pilgrim's staff, which we show in Figure 25. An eighth form shows a pillar and a spear. A ninth form shows a tall cross and a book. Yet a tenth

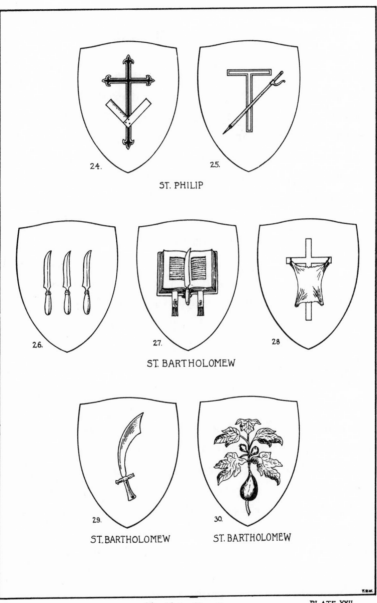

24.

25.

ST. PHILIP

26.

27.

28.

ST. BARTHOLOMEW

29.

30.

ST. BARTHOLOMEW ST. BARTHOLOMEW

𝕿𝖍𝖊 𝕳𝖔𝖑𝖞 𝕬𝖕𝖔𝖘𝖙𝖑𝖊𝖘

PLATE XXII.

form shows a tall cross and a scroll. Other symbols are: an inverted cross; a dragon; a fallen idol.

After successful missionary labours in Galatia and Phrygia, this Apostle is said to have suffered a cruel death. When scourging failed to silence him, he was stoned, crucified and finally run through with a spear to hasten his death.

St. Bartholomew. This Apostle, thought to be the same as Nathanael, is said to have been flayed alive and then crucified. His most usual shield shows three flaying knives placed vertically, as in Figure 26. An open Bible and a flaying knife, Figure 27, recall his faith in God's Word, and his martyrdom. A third shield shows a human skin and a cross, referring to his death by flaying and crucifixion. A fourth form, Figure 29, shows a great scimitar. While preaching in Albanople, Hippolytus states that he was seized by the governor, flayed, crucified, and his dead body decapitated with a scimitar. A fifth form of his shield shows a branch of the fig tree mentioned in St. John 1, 48. See Figure 30.

St. Thomas. This Apostle's shield shows a carpenter's square and a vertical spear, as in Figure 31. A second form shows the square alone, or a builder's rule. A third form, which we show in Figure 32, shows a carpenter's square, a spear and four arrows. A fourth form shows a spear, a lance and several arrows, and sometimes three stones. See Figure 33. A fifth form shows a leather girdle and three stones. Figure 34. This gloomy and once doubtful Apostle, is believed to have preached the Gospel in India. There

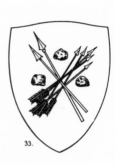

31. 32. 33.

ST. THOMAS

34. 35.

ST. THOMAS ST. JAMES THE LESS

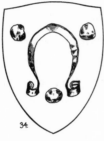

36. 37. 38.

ST. JAMES THE LESS

PLATE XXIII.

he was stoned, shot down with arrows, and left dying
alone, until a pagan priest ran him through with a spear.
He is said to have erected with his own hands a church
building at Malipur, in East India, hence the carpenter's
square. He is the patron saint of builders. Fine examples
of his shield, and sculptured scenes from his life, may be
seen at St. Thomas's Episcopal Church in New York City.

St. James the Less. This Apostle's shield shows a ver-
tical saw, with the handle upward. See Figure 35. A sec-
ond form shows a vertical fuller's bat, as in Figure 36. A
third variation shows three stones, as represented in Figure
37. A fourth form shows a windmill. See Figure 38. A fifth
form shows an halberd. This Apostle laboured diligently in
and about Jerusalem. Hegesippus, a very ancient historian,
declares that he was taken to the top of the temple and
pushed into mid-air. He was seriously injured, but stag-
gered to his knees imploring the Lord to forgive his ene-
mies. The enraged Jews stoned him, and as he lay dying,
a fuller dashed out his brains with a fuller's bat. He is said
to have been ninety-six years of age when he suffered this
horrible martyrdom. His dead body was sawn asunder,
hence the symbol shown in Figure 35.

St. Matthew. When shown among the Apostles and not
as one of the Four Evangelists, St. Matthew's usual symbol
is a shield upon which are three purses, referring to his orig-
inal calling. See Figure 39. A second form of his shield
shows a battle-axe, as indicated in Figure 40. A third form
shows a Tau cross upon a shield. A fourth form shows a

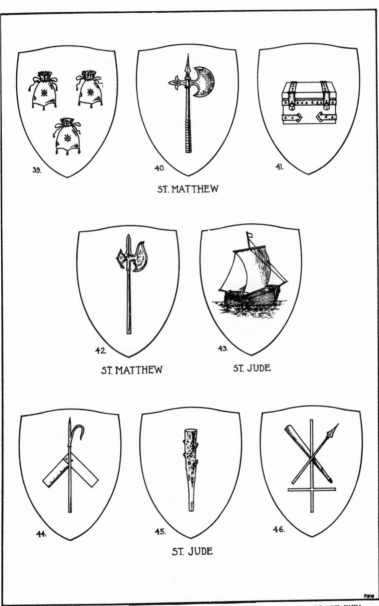

39.

40.

41.

ST. MATTHEW

42.

43.

ST. MATTHEW

ST. JUDE

44.

45.

46.

ST. JUDE

dolphin. A fifth form is that of an iron-bound money chest, as shown in Figure 41. A sixth form shows an halberd. Figure 42. A seventh form shows an angel holding an ink-horn.

This Apostle is said to have been crucified in Ethiopia on a Tau cross, and his head severed from his dead body with a battle axe or an halberd.

St. Jude. This Apostle, also called Thaddaeus and Lebbaeus, traveled far with St. Simon on missionary journeys. Hence he is given a sail-boat with a cross-shaped mast, as shown in Figure 43. A second form of his shield shows a carpenter's square and a boat-hook. See Figure 44. A third form shows a knotted club, as in Figure 45. A fourth form shows a slender inverted cross, a club and a lance. This is shown in Figure 46. A fifth form shows the inverted cross. A sixth form shows loaves of bread and a fish.

This Apostle was a tireless missionary, having visited Arabia, Syria and Mesopotamia. The exact manner of his death is unknown.

St. Simon. The companion of St. Jude on many of his missionary tours was St. Simon. His most familiar symbol is a book upon which lies a fish. See Figure 47. This is given him because he was a great fisher of men, through the power of the Gospel. A second form of his shield shows a huge saw and an oar saltire. A third form shows the same saw and oar, and a primitive battle-axe. See Figure 48. A fourth form shows a fish impaled upon a boat-hook, as in Figure 49. A fifth form is a fuller's club. A sixth form

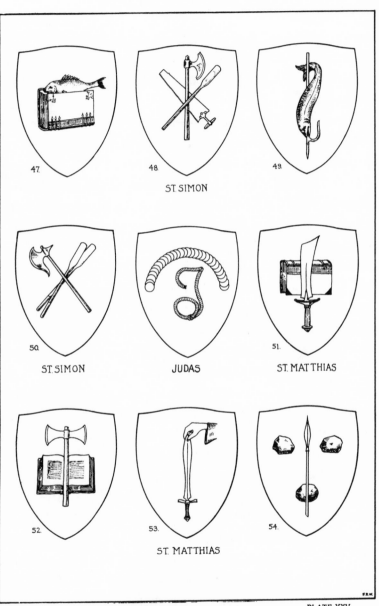

47.
48.
49.

ST. SIMON

50.
JUDAS
51.

ST. SIMON JUDAS ST. MATTHIAS

52.
53.
54.

ST. MATTHIAS

F.R.W.

The Holy Apostles & Judas PLATE XXV.

shows two fishes. A seventh form shows an oar and a bat-
tle-axe, or a pair of oars and a battle-axe, as in Figure 50.
An eighth variation shows an halberd. Yet a ninth form
shows a ship.

The exact manner of St. Simon's death is not told us, but
he is generally supposed to have been sawn asunder, or else
beheaded. That he suffered martyrdom is quite certain.

Judas Iscariot. The common form of the shield of this
miserable traitor and self-murderer is a blank shield of a
dirty yellow color. Or, a money bag and thirty pieces of
silver may be shown. A third form shows the head of
Judas, with a rope around his neck, and thirty pieces of
silver forming a nimbus of disgrace above his head. A
fourth shield, which we have drawn, but have refused to
number (since he is not worthy to be counted among the
Apostles), is a shield upon which are displayed his thirty
pieces of silver and a rope.

St. Matthias. This Apostle, who was chosen to take the
place of Judas, is often substituted for the traitor who be-
trayed our Saviour. His most common shield is an open
Bible and a double battle-axe of primitive type. See Fig-
ure 52. Sometimes a sword or a scimitar, is shown, held
by the point, as in Figure 53. Again, a third form shows
a lance and three stones, as shown in Figure 54. A fourth
shows a book and an halberd. Figure 51. A fifth shows a
carpenter's square. A sixth form shows a battle-axe and two
stones. This Apostle is said to have been stoned and then
beheaded, after missionary work in Judaea.

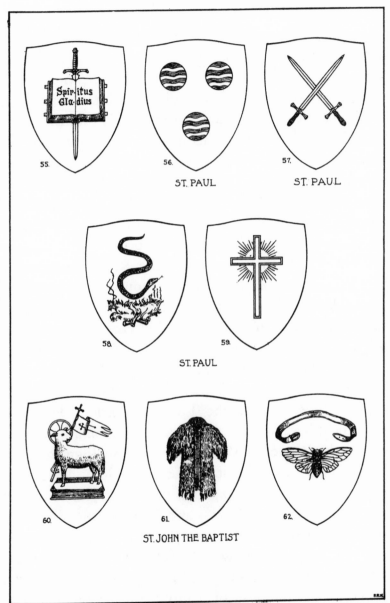

55.

56.

ST. PAUL

57.

ST. PAUL

58.

59.

ST. PAUL

60.

61.

62.

ST. JOHN THE BAPTIST

The Holy Apostles

PLATE XXVI.

St Paul. This great Apostle's shield is often shown along with the other Apostles. The most common form by far is an open Bible bearing the words *Spiritus Gladius*, and behind the Bible a Sword of the Spirit, cross-hilted. This is a familiar device often carved in stone over the doorways of churches bearing his name. See Figure 55. A second form of his shield shows three fountains of water, treated heraldically, as shown in Figure 56. A third form shows two swords saltire. See Figure 57. A fourth form shows the serpent of Melita cast into the fire, as in Figure 58. A fifth form shows the Phoenix, because of this Apostle's stress upon the doctrine of the Resurrection. See Plate VII, Figure 22. A sixth form shows a palm tree, likewise a Resurrection symbol. A seventh form shows the Shield of Faith, namely a rayed Latin cross upon a shield, which is seen in Figure 59 on Plate XXVI. An eighth shows the armour of God. A ninth form shows a scourge.

St. John the Baptist. Sometimes the great Forerunner is shown together with the Twelve Apostles. His most usual shield is a nimbed Lamb, standing upon a book, and bearing the Banner of Victory, because St. John the Baptist pointed to Jesus Christ, the Lamb of God. See Figure 60. The words *Ecce Agnus Dei* may be added. Another form shows a long staff-cross and a white banner. A less common shield shows his camel's hair tunic, as in Figure 61. Another form shows a locust and a leathern girdle. See Figure 62. A gruesome form shows a silver platter upon which is the head of St. John the Baptist. A sixth

variation of his shield shows a scroll bearing the words *Ecce Agnus Dei.*

Since the nave of a church building signifies the Church Militant and the chancel the Church Triumphant, it is proper to display the shields of the Apostles, with their correct heraldic colors, in the nave of the church rather than within the chancel. Often they are carved on the bases of the exposed roof trusses, or displayed in the panels or bosses ceiling. The shield of the Apostle for whom a church is named may be shown carved in stone over its entrance, or on the cornerstone, or on the church's official seal.

Sometimes full length figures of the Apostles are shown, each one bearing a scroll upon which is written a part of the Apostles Creed. Their scrolls are inscribed as follows: St. Peter—"Credo in Deum Patrem omnipotentem, Creatorem coeli et terrae;" St. Andrew—"Et in Jesum Christum Filium ejus unicum, Dominum nostrum;" St. James Major—"Qui conceptus est de Spiritu Sancto, natus ex Maria Virgine;" St. John—"Passus sub Pontio Pilato, crucifixus, mortuus, et supultus;" St. Philip—"Descendit ad inferos; tertia die resurrexit a mortuis;" St. James Minor —"Ascendit ad coelos, sedet ad dexteram Dei Patris omnipotentis;" St. Thomas—"Inde venturus est judicare vivos et mortuos;" St. Bartholomew—"Credo in Spiritum Sanctum;" St. Matthew—"Sanctam Ecclesiam Catholicam, sanctorum communionem;" St. Simon—"Remissionem peccatorum;" St. Jude—"Carnis resurrectionem;" St. Matthias—"Et Vitam aeternam." We have given the list as

found in Geldart's work. It will be seen that St. Andrew is given second in the list, which is the old order, we believe.

The Apostles were sometimes shown as twelve sheep, in very early carvings, or as twelve men each with a sheep. Twelve doves have been used, as at St. Clement's at Rome. In old German illuminated books, the Twelve Apostles are shown as human figures, each holding in his hand his customary symbol—the keys in St. Peter's hand, the chalice and serpent in St. John's hand, the flaying knife held by St. Bartholomew, etc.

Geldart and others state that old English rood screens often bore carved figures or symbols of the Apostles, most of which have disappeared, for we recall few existing examples. Probably many of these things disappeared when destroyers stripped their beautiful parish churches of all things which they considered "exceeding superstitious!"

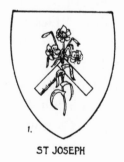
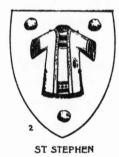
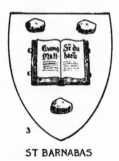

ST JOSEPH ST STEPHEN ST BARNABAS

CHAPTER XVI.

THE NINE CHOIRS OF ANGELS

IN the fine old Byzantine churches with their splendid interiors, as well as in the days of Gothic art, it was customary to picture the Nine Choirs of Angels surrounding the throne of God. We have included an example or two of these among the plates at the end of this volume. Lately there has been an awakening of interest in the traditional and symbolical representation of the holy angels. The graceful winged female figures with long golden hair, sweet faces, saffron garments and huge, dove-like wings, were quite popular from the days following Fra Angelico down to the era of the "picture windows" of the past generation. There is a better way, however, and that is the symbolic way. Some of the noble churches built by the late John T. Comes, who did as much to rescue the Roman Catholics from the chains of artistic subterfuge as Cram and Goodhue and their contemporaries have done for the Protestant bodies, show a return to the old symbolical manner of picturing the angels. Lately the fine new Wheeling Cathedral, by Mr. Edward J. Weber, has given us food for thought. Mr. F. B. Lieftuchter, a painter pos-

sessing noble talent, has given the world some notable examples of his genius in this respect.

There is no good reason why the Protestant church bodies should hesitate to use the traditional renderings of the angels. Badly painted angels lead to bad theology, because the eye teaches as well as the ear. By badly painted angels, we do not mean bad technique, for that is frequently excellent. We mean the sentimental fashion of picturing angels as charming young women in impossible flowing robes, receiving good human beings into their celestial choirs. This is contrary to Scripture, and a violation of all sound theology, for there is a marked difference between the angelic hosts and redeemed saints. Good human beings never are transformed into angels, but become saints, through Jesus Christ.

In picturing the holy angels, whether in the days of the marvellous mosaics of the early Christian centuries; or in the days when almost every parish church was resplendent within because of the glorious, but not gaudy, paintings; and in illuminated manuscripts and stained glass, a certain orderly tradition was followed.

The idea of various choirs of angels is supposed to date back to Old Testament days. Some authorities believe that the Jewish people of old were familiar with the idea of various ranks of heavenly beings. The holy prophets spoke of Cherubim, of Seraphim and of Angels. St. Paul mentions "thrones, or dominions, or principalities, or powers." The artists of Byzantine and Gothic days believed that this had

reference to a certain order or grouping of the heavenly host.

The Nine Choirs of Angels, as they came to be called, were classified under three heads: Counsellors, Governors and Messengers.

The Counsellors include three orders: Seraphim, Cherubim and Thrones.

The Governors are composed of Dominions, Powers and Virtues.

The Messengers embrace Principalities, Archangels and Angels.

All of these were used in old-time Christian art, and there was a traditional manner of indicating each one of the nine choirs.

I. *The Counsellors* are said to stand around the throne of God, and to have little or no contact with the mundane affairs of mortals. Of the three orders of angels who make up this group, the proverbial representation is as follows:

Seraphim. These are heavenly beings, based upon the description found in Isaiah 6, 2, "And above it stood the seraphims: each one had six wings; with twain he covered his face, and with twain he covered his feet, and with twain he did fly." The great painters, glass workers, illuminators and embroiderers usually picture the Seraphim in this manner. The usual colour of the Seraphim is crimson. Often they are pictured standing upon winged wheels, and having both bodies and wings full of eyes. They bear a scroll, upon which are written the words of the Prophet Isaiah,

"Holy, Holy, Holy is the Lord of Hosts." Their office is to attend the Lord upon His heavenly throne, singing their praises to Him. Their leader is Uriel.

Cherubim. Christian art bases its treatment of the Cherubim upon the vision recorded in Ezekiel, chapter 10. Cherubim are pictured with four wings, "full of eyes," with the "likeness of the hands of a man" under their wings. Their color is sapphire blue, and usually they stand upon winged wheels, and are shown holding an opened scroll, or a book. In earlier Christian art they are pictured with great dignity, but in the days of the later painters, and in modern times, they are shown as chubby infants, without bodies, with two wings each, and without the wheels, books and scrolls of the early painters. They are led by Jophiel. Many an ancient gravestone contains a carving of the winged head of a cherub at its top.

Thrones. These are the angels that bear up the throne of God. They are types of God's justice and majesty. They are shown with winged wheels, the color of fire, and full of eyes. Often they sit upon golden thrones, or hold towers in their hands. Their leader is Japhkiel.

II. *The second group* of angelic beings is the Choir of Rulers or Governors. This is likewise subdivided into three choirs or orders. This group is pictured in early Christian painting as clad in long white albs, golden girdles and green stoles. Upon their right hands are rings of gold. Within their right hands they carry a golden sceptre, cross-tipped, and in their left hands the letters IC XC, meaning

Jesus Christ. They wear crowns. Sometimes they are pictured carrying globes. They are shown as possessing bodies resembling those of human beings.

Dominions. These angels are clad as just described, and carry a sword, a sceptre, a cross or an orb. They are usually crowned. They represent the power of God. Their leader is Zadkiel.

Virtues. These angels are frequently pictured in shining armor, carrying battle axes, swords or spears. They are possessed of invincible courage. Sometimes they are shown bearing the symbols of our Saviour's Passion. Their leader is Haniel.

Powers. These are the protectors of mankind. They bear flaming swords, or batons, and often hold chains with which they are supposed to bind Satan and his evil angels. Sometimes they are shown holding chained devils. They are led by Raphael.

III. *The third choir of angels* is composed of the messengers of God. They are shown as soldiers in full armor, human in body, wearing golden girdles, and holding javelins, spears, swords or lances. They are likewise subdivided into three choirs.

Principalities. These are ministering angels, shown as winged human beings, and clad in armor. They carry a sceptre, a cross, palms, vials or a lily. They are the protectors of rulers. Their leader is Chamael.

Archangels. These are winged beings, with human bodies, clad in full armor. They are led by St. Michael.

The names of two of them are given in the Holy Scriptures, and two more in the extra-canonical books of the Old Testament. But from the statement of the Apocalypse concerning the seven angels, Christian art has accepted seven archangelic beings, and has given attributes to each.

St. Michael, "who is like unto God," is the first. He is shown as the militant angel, of princely rank, and he represents the power of God. It was he who fought the old dragon and overcame him, and cast out Lucifer and his rebels. He was the protector of the Jewish nation, and in Christian times was accepted as the guardian angel of the Church. It was he who disputed with Satan concerning the body of Moses.

Many a Mediaeval church was dedicated to him. It is noteworthy that most of the churches bearing his name are built upon high peaks of rock, such as St. Michael Le Puy; the famous Mont St. Michel, off the northern coast of France; the church across the Channel in Cornwall, almost equally famous; the gaunt tower on Tor Hill, at Glastonbury; and countless other such churches situated on lone, rocky peaks.

St. Michael is shown in full armor, carrying a flaming sword and a shield, as well as a pair of balances, for it is he who is supposed to weigh the souls of men at the Saviour's command at the Last Day, thus separating the righteous from the condemned. Often he bears a scroll, upon which are the words *Quis est Deus?* Numerous famous carvings exist, picturing him in full armor, with shield and javelin,

trampling upon the dragon, Satan, whom he is transfixing with his javelin. Since St. George is likewise shown in the act of slaying a dragon, it is often hard to determine which person is thus represented. St. Michael is said to be the leader of the Archangels and guardian of the souls of men.

St. Gabriel, "God is my strength," is the great Archangel who is believed to stand in the presence of God. He represents the royal dignity of God, and is the messenger angel par excellent. He is pictured countless times in Christian art as the messenger of the Annunciation, a fact which is entirely Scriptural. He carries a lily and a sceptre, sometimes a palm branch, a sprig of olive, or a shield of the Virgin. He wears a cope and alb. He is the angel of the Day of Judgment, and when thus shown, bears a trumpet.

St. Raphael. "God is my health." This Archangel represents the High Priestly office of our Lord Jesus. He is leader of the Powers, and chief of the guardian angels. He carries a pilgrim's staff and a gourd, sometimes a wallet and a fish. He was the faithful guardian of Tobias.

St. Uriel. "God is my light." This Archangel is the leader of the Seraphim. He is said to have guarded the sepulchre of our Lord. He is looked upon as the interpreter of prophecy. His symbol is a scroll or a book, which he carries in his hand. He appeared in a vision to Esdras.

St. Jophiel, or Zophiel. "The Beauty of God." He is the angel representing the splendor of God, and is the leader of the band of Seraphim. It was he who is reputed to have driven Adam out of Eden, hence his symbol is a

flaming sword, which he holds aloft to guard the gates of Eden. He is the guardian of truth-seekers.

St. Chamael, or Chemuel. This is the angel of God's wrath. It is he who is said to have wrestled with Jacob—a tradition hardly accurate from the standpoint of the Inspired Word. Chamael carries a cup and a staff, for he is also said to be the angel who appeared to our Lord in Gethsemane and strengthened Him. He is leader of the Principalities.

St. Zadkiel. "The Righteousness of God." This is the angel of God's justice. It is he who is reputed to have stayed the hand of Abraham, when about to offer up his son Isaac. Zadkiel is pictured with his symbol, the sacrificial knife. He is leader of the Dominions.

St. Japhkiel. "The Purity of God." Occasionally we find mention of Japhkiel, an angel who guided the Jews in the wilderness, better known as the leader of the Thrones.

The seven Archangels of Christian art are shown in some instances with seven trumpets. This is based upon the prophetic symbolism of the Apocalypse.

Angels. The last of the nine orders of heavenly beings are the angels. No subject in Christian art has been more misunderstood and more woefully abused.

Angels are properly represented as beardless, sexless beings, winged, human in form, and barefooted. Often they are arrayed in the vestments of deacons, and carry the wand of authority. Again, they are shown in long tunics,

with golden girdles about their waists, sometimes with a stole or pallium.

Angels are pictured as carrying various objects. If they carry a pilgrim's staff, a scroll, a book, a sceptre or a sword, it is a representation of their office as heavenly beings, or as the guardians of mankind. If shown with a censer or a thurible, it is a symbol of the adoration which they offer to God. They may be pictured with musical instruments, indicating the praises which they sing to God. If they carry a palm branch or a sprig of olive leaves, it denotes victory or peace. If shown placing a wreath of laurel on the brow of a human being, it is a mark of distinction, either in poetry or literature in the service of Christianity. The laurel wreath is not for warriors. A wreath of oak leaves is a symbol of strength. Yew leaves express the idea of immortality, and cypress leaves of mourning.

If an angel carries a lily, it is a token of purity, of virginity or of the Annunciation. A flaming sword held by an angel represents God's judgment. A blunted sword denotes justice and mercy. A sharp pointed sword means judgment. A pair of balances likewise is indicative of justice. A sceptre held by an angel denotes authority. A kneeling angel, looking upward, with hands clasped, conveys the idea of intercession. Looking downward, with hands clasped, the idea of prayer is expressed. An angel kneeling before the equilateral triangle of the Holy Trinity means adoration. An angel with the right hand extended slightly, palm open, means guardianship of human beings.

In Mediaeval days, when many of the great churches were splendid within with colour and gold and when every wall surface, every carving in stone and in wood, and every detail was adorned with carving or colour it was often customary to fill the spandrels of arches, and the upper wall surfaces with paintings of great hosts of angels, singing their praises to God. The early Byzantine churches still have the same idea expressed in splendid mosaics. Every church in olden days had its hosts of adoring angels. Some of the mosaics remain, and in many cases, the carved angels on beams and corbels remain. Sometimes they hold great shields, bearing the symbols of our Lord's Passion, or of prophets, apostles, evangelists and martyrs of early days. Again they may hold stringed instruments.

In early painting, angels were treated with great dignity and majesty, so that the deepest feeling was stirred within the beholder, rather than his admiration. But with Fra Angelico, who died in 1455, we see the first signs of sentimentality. His famous angels are undoubtedly works of superb genius, and yet they show the first hints of simpering sweetness. The latter half of the same century shows signs of decline. We grant that the painting of the days following was extraordinarily good from a standpoint of color, and anatomy, and chiaroscuro. But from the religious standpoint, the spiritual quality begins to recede the moment paintings become realistic, or clever, or emotional. The appeal is no longer to man's inner nature, but

to his admiration. No longer is he stirred to devotion, but rather is he led to assume the attitude of an art critic.

In later Renaissance and in modern painting, angels are nearly always treated in the most outrageous fashion imaginable. They are nothing more than pretty female figures, with faces devoid of character, and with all the charms and curves of womanly anatomy faithfully recorded. What a contrast to the devout angelic beings on the west front of Reims! Cherubs degenerated into fat infants with mischievous faces. Much modern stained glass, especially that of the "picture window" sort, has reached a stage of commercialized vulgarity and "inane elaboration and panic-stricken incapacity" that staggers one's vocabulary of opprobrious epithets.

What can be more utterly lacking in devotion than a church window crowded with comely young office girls with their beaming faces impossibly idealized, wearing flowing robes of vivid green and blue chiffon, with long, white, feathered wings and yards of silken hair? Equally objectionable is a memorial window in a parish church or mortuary chapel, showing the features of some deceased person, perhaps a bearded parishioner, with face idealized beyond all reason, and dressed in flowing robes and great white wings, and playing upon a harp of gold. In our own city an example exists of a red-faced, good-natured mother in Israel, unmistakably soon to be a mother again, but provided with wings and flowing garments, looking down

from a transept window where she is perpetuated in
Munich glass!

Such things are bad art as well as bad theology. Angels
are sexless heavenly beings, of a given number which is
never increased or diminished, and who neither marry nor
are given in marriage. They are not human beings who
have become angels. The Christian believer becomes a
saint, not an angel, and to presume to show him otherwise
is to take unwarranted liberties with Holy Writ.

CHAPTER XVII.

THE GREEK AND LATIN FATHERS

A GROUP of brilliant leaders appeared in the ancient Christian Church, who have always been known as the Church Fathers. The earliest of these, called the Apostolic Fathers, include such men as SS. Barnabas, Hermas, Clement of Rome, Ignatius, Polycarp, Papias, Aristides of Athens, Justin Martyr, Tatian, Theophilus of Antioch, Clement of Alexandria, Origen and others.

These men do not figure so prominently in Christian art as the group of eminent leaders known as the Greek and Latin Fathers. There are four Greek Fathers, namely SS. Athanasius, Basil the Great, John Chrysostom and Gregory Nazianzus. To this group St. Cyril of Alexandria occasionally is added. The Latin Fathers are four in number also. They are SS. Jerome, Ambrose, Augustine of Hippo and Gregory the Great.

These eight Fathers figure very prominently in Christian art, especially in stained glass work and painting. So important are they in Christian art that no book on symbolism is considered complete, no matter how small, unless mention is made of them. In Christian art, the eight Fathers are often shown in company with the Four

Evangelists, because the Fathers are looked upon as the great defenders of the teachings of the Evangelists, in the days of storm and stress that overtook the Church in the fourth, fifth and sixth centuries.

St. Jerome, foremost of the Latin, or Western Church Fathers, was born about 340 in Stridon, and died in 420 A. D. He is best known for the important part which he took in the translation of the Bible into Latin. This is known as the Vulgate edition. He was an eminent writer, and a foe of the Pelagians and of Origen. He has many symbols. He is pictured as bald, with a long beard. Often he wears a cardinal's hat and robe, although it is very doubtful that such a thing as a cardinal was known in his day. A lion is invariably pictured at his side. He is said to have come upon a sick lion at one time. Discovering that the lion suffered from infection, due to a large thorn in his foot, Jerome extracted the thorn and dressed the wound, the beast licking his hands and otherwise show- ing gratitude. This led to various legends concerning the lion, which is said to have followed him, befriending him in various ways. Hence this lion has become a familiar symbol of the saint. Another common symbol is a Cross Potent, fitched at the bottom. Figure 1. Often a stone is used. Again, a fox, emblem of wisdom, or else a hare, a stag, a partridge or a fawn, have been employed. An open Bible, a stone and a whip of penance are also used. Again an open Bible (the Vulgate), and a pen, emblem of Jerome as an early Church historian, may be found as his symbols.

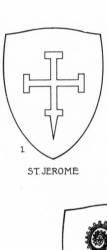

1.

ST. JEROME

2.

ST. AMBROSE

3.

ST. AUGUSTINE OF HIPPO

4.

ST. GREGORY THE GREAT

5.

ST. ATHANASIUS

6.

ST. BASIL THE GREAT

7.

ST. CHRYSOSTOM

8.

ST. GREGORY NAZIANZUS

The Greek and Latin Fathers

PLATE XXVII

He is given the Resurrection trumpet, for he is said to have
had no fear of death; or else a skull. Nymphs are pictured
occasionally, referring to his temptations to lead a worldly,
sensual life, which he steadfastly resisted, preferring severe
mortification of the flesh.

St. Ambrose. This famous Bishop of Milan was born
about 340, supposedly at Treves, and died in 397. He is
known as the Father of Church Music, because of his
reforms in sacred song, his encouragement of congrega-
tional singing, his introduction of antiphonal singing into
the Church, and his ability as a hymn writer. The Am-
brosian Chants are world famous. Likewise he defended
the Church against the assaults of the Arians and the
pagans. As a lawyer he attended a dispute between the
Latins and the Arians. A child cried out,"Ambrose, our
Bishop!" The excited crowd took up the cry, and he was
made Bishop much against his will, for he was not even
baptized at the time. But by diligent study he fitted him-
self for the position thrust upon him, and in time became a
great theologian. Like St. John Chrysostom, he was a man
of matchless eloquence, and entirely fearless. One of his
most famous acts was his excommunication of the Emperor
Theodosius because of the massacre of the people of Thes-
salonica, and his refusal of absolution until the Emperor
had done public penance. His most usual symbol is a bee-
hive, the emblem of eloquence, Figure 2, for it is said that
when he was an infant, a swarm of bees settled upon his
mouth, causing his elders to predict great oratorical gifts.

Two knotted scourges are shown, recalling his demand that the Emperor do penance for his sins. A book of ancient music, a pen, a writing table and books, a chalice, a bull, a goose and a dove are among his other symbols. Sometimes a heart, surmounted with heraldic flames, is used to typify his intense zeal.

St. Augustine of Hippo. This celebrated Bishop of Hippo must not be confused with St. Augustine of Canterbury. He was born in Tagaste in 354, and died in 430 A. D. He was the son of a famous woman named Monica. After a youth of wild dissipation, he was converted by hearing a little child cry, *"Tolle, lege!"* Seizing a Bible, he opened to Romans 13, and the study of this chapter brought him to bitter repentance. Through the influence of his mother, and of St. Ambrose, he was led to Christianity. His *Confessions* remain to this day one of the famous writings of the ages. He became a champion of the Church, contending against the heresies of the Manichaeans, the Donatists and the Pelagians. He was a great writer. His most common symbol is a heart surmounted by heraldic flames, symbolical of zeal, and transfixed by two arrows, signifying his remorse for the iniquities of his youth. Figure 3. A chalice is often used, or a scroll with an inscription in Latin from his writings, or a dove, recalling his defense of the doctrine of Inspiration; or a pen and a book, symbols of the theologian; or a small church held in his hand; or a Bible opened to the 13th chapter of

Romans, referring to his conversion. In pictures of him, he holds a scourge.

St. Gregory the Great. This noted leader, who was successively a monk, a regionary deacon, an abbot, and finally one of the early popes, was born in Rome in 540, and died in 604 A. D. He reformed the ritual of the Church, and, like St. Ambrose, became a reformer of Church music. Various Plain Chants which he collected and edited remain to this day, and are widely used and highly prized by Roman Catholics, Lutherans and Episcopalians. In recent years they have been used in various other church bodies. This music, variously called Plain Chant, Plain Song and the Gregorian Mode, is extremely simple and dignified, beautiful beyond description if rightly sung, but somewhat difficult for ears accustomed to jazz. It is much to be preferred to the florid, flamboyant fripperies of the later schools. St. Gregory likewise opposed the Lombards; sent missionaries to the Anglo-Saxons, who had lapsed into paganism; strengthened monasticism; banished slavery; relieved the miserable condition of the poor; encouraged a celibate life for the clergy; and because of his insistence upon the primacy of the Bishop of Rome, he might almost be called the father of the papal system. His symbol is a Bishop's staff, Figure 4, a book and a pen, a dove, a papal tiara, a church, a sheet of music written in Gregorian style (four lines, with square notes), or a scroll with the words, *"Ora pro nobis Deum."*

St. Athanasius, St. Athanasius, Bishop of Alexandria,

known as the "Father of Orthodoxy" because of his valiant defense of the doctrine of the Trinity against the Arians, was born in Alexandria in 296 A. D., and died in 373 A. D. At the Council of Nicaea, although yet a youth and an humble secretary to one of the delegates, he proved to be the hero of the day, for through his keen logic he was able to turn threatened defeat into victory for the Trinitarian theologians. Although he did not write the Athanasian Creed, one of the three great creeds accepted by all Christians, yet his terse, simple statements of New Testament teaching later took shape and eventually became known as the Athanasian Creed. He suffered terrible persecution, and was exiled no less than five times. His symbol is an equilateral triangle, because of his courageous defense of the doctrine of the Holy Trinity. Other symbols given him are the archbishop's pallium, because he became Primate of Alexandria; a boat on the Nile, recalling a remarkable escape from death at the hands of his enemies; a Bible between two Grecian Doric columns, Figure 5; and sometimes a scroll with his famous prayer, "Often and anew do we flee to Thee, O God."

St. Basil the Great. This famous Bishop of Caesarea, one of the "three great Cappadocians" (SS. Basil, Gregory of Nyssa and Gregory Nazianzus), was born in Caesarea about 328, and died in 379 A. D. He was a son of St. Basil the Elder, and a brother of St. Gregory of Nyssa and St. Peter of Sebaste. He was a champion of the Church, an ardent exponent of the ascetic life (he himself gave his

entire fortune to the poor and lived in poverty), and may
be considered the father of the monastic system, although
not exactly its founder. He was a prolific writer and a
famous orator. He is pictured in bishop's robes, or in a
black tunic and cowl, a leather girdle or a rope, and he
wears a patriarchal beard. His symbol is a scroll, with the
words in Greek, "The ascetic life is both difficult and peril-
ous." See Figure 6. Often another Greek inscription is
used, namely, "None of us who are in bondage to fleshly
desires, are worthy." Often he is shown holding a model
of a church in his right hand.

St. John Chrysostom. This prince of orators, and Bishop
of Constantinople, called "The Golden Mouthed," be-
cause of his almost supernatural oratorical gifts, was born
in Antioch about 346, and died in 407 A. D. He was one
of the ablest theologians of the School of Antioch. His
fearless denunciation of the age of worldly pleasure in
which he lived, and his championing of strict asceticism of
life, made bitter enemies. They started a foul-mouthed
slander in regard to him, charging him with having
brought about the downfall of a king's daughter, whom
they accused of having lived with him in a cave. Finally he
is said to have tried to murder her. We mention this, not to
be muck-raking, but to explain the curious things so often
seen in art. Unfortunately this wretched lie has been
passed down the ages, and even the great Dürer and
Cranach are both guilty of picturing it. The good bishop
is shown walking on all fours, like a wild beast, entirely

nude, which is said to have been his penance. Of course it is untrue from start to finish. His usual symbol is a chalice standing upon a Bible. Figure 7. Another symbol is a beehive, the traditional emblem of eloquence. Again a white dove is shown, for at his ordination a snow white dove was seen to fly in through the window, and people predicted great things for him. He is likewise shown by means of a scroll, containing the words, "God our God, Who hast given us for food the Bread of Life." His enemies drove him into exile, and he died uttering the beautiful prayer which he never finished, but which is found among our Collects under the usual title of "The Prayer of St. Chrysostom."

St. Gregory Nazianzus. This Bishop of Constantinople was born in Arianzus in 330, and died in 390 A. D. His greatest work was his fearless defense of the Nicene Creed against the terrific assaults of the Arian heretics. He was a brother of St. Basil the great, and was successively a priest, a bishop and finally became archbishop. He has left many poems, orations and letters. His symbol is an epigonation, an embroidered lozenge worn by the Eastern bishop. Figure 8. Other symbols are eastern bishop's vestments, or a scroll with the words, "God the Holy among the Holies, the Thrice Holy," written in Greek.

St. Cyril of Alexandria, sometimes included among the Greek Fathers, or even substituted for St. Gregory Nazianzus, was born at the close of the fourth century, and died in 444 A. D. He is noted for his bitter controversies with

the Nestorians, and his valiant defense of the doctrine of our Lord's Incarnation. One blot upon his record is the story, doubtless much exaggerated, and turned into a sentimental account of martyrdom by a comparatively modern novelist, namely his weakness in failing to stop the murder of the fair Hypatia at the hands of a fanatical mob. He is pictured wearing a cap, a hood or a veil upon his head. His symbol is a pen, or a scroll with the Greek word Θεοτόκος in old-time Christian art. This refers to his defense of the doctrine of the Theotokos. A sword might well be given him, for he was not above appearing at a council with an armed escort. Another symbol is a purse.

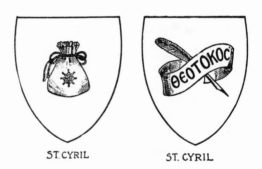

ST. CYRIL ST. CYRIL

CHAPTER XVIII.

SYMBOLS OF THE CHRISTIAN CHURCH

THE Kingdom of Grace on earth, commonly called the Church, was founded on the Day of Pentecost, when the Holy Spirit descended upon one hundred and twenty believers who had tarried in Jerusalem in obedience to their Lord's command, and were gathered in the upper room.

The Church is not limited to any particular denomination, but it is to be found wherever the Word of God is taught in its truth and purity, and the Holy Sacraments rightly administered. This Word of God, when undefiled by the additions or subtractions of men, and the unmutilated Sacraments, are the marks as well as the tests of the Christian Church. He who believes firmly in these things is a member of the true Church.

Certain symbols have been used to represent the Church. Even in primitive days we find such things employed.

The Ark. From most ancient times the Ark of Noah has been used as a symbol of the Christian Church. When the destroying waters of the flood overwhelmed the earth, eight believers were saved by means of the Ark. Our Lord refers to the ark (St. Matthew 24, 37-39), in speak-

ing of the unbelief in this world. Noah is mentioned in
Hebrews 11, 7 as an example of faith. The eight souls
saved from destruction by the flood are mentioned in
I Peter 3, 20, in connection with the saving power of Holy
Baptism. Another reference to Noah and the flood is
found in II Peter 2, 5. Perhaps it was these statements that
gave rise to the symbol of the ark as a representative of the
Church, with her saving Word and Sacraments. At any
rate it is a familiar type in early Christian art, and is used
to this day.

The Ship. Closely allied to this symbol is the symbol
of the ship. A ship, with a cross-shaped mast, is shown
sailing through troubled waters. This recalls the ship in
which the apostles sailed across the Sea of Galilee, when
our Lord stilled the tempest. It represents the Ship of the
Church, tossed by the stormy waves of persecution, heresy
and schisms; threatened with destruction by rationalism,
by indifference, by negative critics and by false teachers
who arise. But the presence of the Saviour is a positive
assurance of safety.

Sometimes the apostles are shown rowing the ship.
Again they are shown seated in the ship, with St. Peter or
St. Paul at the helm. In some examples to be found in the
catacombs, St. Paul is to be seen preaching from the stern
of the ship. An early lamp exists, made in the form of a
ship, with one of the apostles steering it, and another
preaching from its prow. Other representations show the
apostles aboard, with the hand of God extended over them,

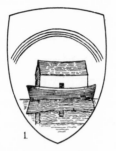

1.

THE ARK

2.

THE SHIP

3.

ARK OF THE COVENANT

4.

THE VINE

5.

THE ROCK

6.

THE HILL-SET CITY

7.

THE GOSPEL MILL
FROM VÉZELAI

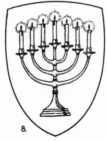

8.

THE CANDLESTICK

9.

WHEAT AND TARES
ST. MATT. XIII, 24-30

FRW

𝕿𝖍𝖊 𝕮𝖍𝖚𝖗𝖈𝖍

PLATE XXVIII.

protecting the Church from schism and heresy. Many examples of the Ship of the Church exist in old sculptures and stained glass. One of the noted examples in America is a fine carving at First Baptist Church, Pittsburgh.

The Crowned Woman. On many of the old cathedrals are the allegorical figures of the Church and the Synagogue. The Church is shown as a noble woman wearing a crown, and holding a long, slender cross in her hand. High up on the south transept of Reims, next to one of the great rose windows, was a splendid figure of the Church, shown as a fair woman, crowned, holding a chalice in her right hand and a tall, slender staff in her left, the staff terminating in a cross. On the opposite side of the rose window was the figure of the Synagogue, shown as a swaying female figure, blindfolded, with her crown slipping from her head. This idea is quite common in Mediaeval art. In our own day, and in a land where every man enjoys religious freedom, such polemical representations have ceased to be used as much as in olden days, for it is difficult to win friends to a cause by using a club.

The Ark of the Covenant. To the Old Testament believer, the Ark of the Covenant was the representation of the presence of God. In Christian days it has been used as a symbol to convey the idea of the presence of our Lord Jesus Christ in His Church, whenever two or three are gathered in His name. The custom of erecting a small tabernacle upon the altar not only in parishes where the host is reserved, but occasionally by those who believe in

the Real Presence in the Holy Eucharist, and use the taber-nacle merely as a symbol, may be an outgrowth of this idea.

The Vine. In its more immediate sense, the symbol of the True Vine represents our Lord Jesus. In a secondary sense it has been used as a symbol of the Christian Church, which is made up of true believers who must abide in the True Vine, Jesus Christ. He is the Vine and they are the branches. Birds pictured within the branches of the Vine represent human souls. The symbol of the Vine conveys the idea of the union of the true Church with her Lord.

The Woman and the Dragon. In thirteenth century carv-ing, painting and illumination, the Church was shown at times as a woman with a chalice, a crown and a sceptre, trampling the dragon, Satan, underfoot. It meant that the Church, through her means of grace, is able to subdue sin and the power of the devil. The same idea was expressed in different form by showing the Church as a woman riding in a carriage drawn by the Four Evangelists, signifying the fact that the Gospel has the power to lead the Church onward in triumph.

The Bride of Christ. The Church has been represented as a Virgin, clad in allegorical vestments, holding a chalice and a book, symbolizing her Sacraments and the Word of God. Various hideous beasts, allegorical of sin and the devil, are shown trying to drag her down. But they strive in vain so long as she holds firmly to her Book and her chalice. It is a symbol of the invincible power of the

Church, so long as she holds fast her pure Word and unmutilated Sacraments.

The Two Crosses. In one of the old French cathedrals may be seen the cross of the Eastern Church and that of the Western Church, standing at the opposite ends of the high altar. It is a symbol of the divided state of Christendom, and the need of reunion—a thing absolutely impossible, by the way, unless its basis is true unity of doctrine and practice, rather than the outward veneer of union through external organization, which is a vain delusion of the present day. Those to blame for the divided state of the "churches" are all schismatics, whose return to the true faith is essential before there can be any talk of reunion.

The House on a Rock. This symbol is based upon one of our Lord's parables. Its traditional delineation is that of a Mediaeval church building standing high upon a great rock, such as at Mt. St. Michel, St. Michael's at Le Puy, and St. Michael's in Cornwall.

The Leaven. This symbol represents the power of the Gospel, which the Church proclaims, to permeate and transform the whole world.

The Mustard Seed. This represents the Church and her everlasting Gospel, which seems to be a little thing, but is able to grow into a great tree.

The Hill-set City. A walled city, set upon a high hill, is a symbol used to remind us that the influence of the true Church cannot be hid, nor can it be overthrown.

The Mill. This curious symbol is found in Mediaeval

art. A hand-mill is pictured, with prophets, law-givers, evangelists and apostles emptying grain into the mill. The Church is turning the mill, and our Lord stands by with His right hand raised in blessing. It is intended to represent the precious seeds of Old Testament prophecy and New Testament truth converted into flour which is transformed into the Bread of Life. Examples of this mill are to be seen at St. Denis near Paris, St. Etienne at Bourges, Canterbury, and Vézelay in Bergundy.

The Dove. In Mediaeval glass painting the Church is pictured sometimes as a dove with head and wings of silver and body of gold. She has wings on her head, her body, her back and her feet. The silver symbolizes the Church's eloquence, her learning and her spiritual wisdom. The gold represents her charity. The many wings are said to picture the swiftness of the Gospel in its flight throughout the world.

The Candlestick. The symbol of the candle, or shining light, is based upon the Apocalypse. The Church is said to be a candlestick, holding aloft a burning candle, because she holds aloft the enlightening Gospel of Jesus Christ.

The Vineyard. This expresses the fact that all true believers must be workers in the Kingdom on earth.

The Flock. A flock of sheep, used in earliest Christian days, represented the Church as the sheep of the Good Shepherd.

The Wheat and Tares. A head of wheat and a head of darnel have been used to teach the fact that both true Chris-

tians and hypocrites are to be found within the Church, and will remain there until the final separation at the Last Day.

The Drag Net. This symbol teaches us that the Church on earth is able to enclose a great multitude of souls, both bad and good, but will be drawn to the shore on the Last Day, the bad rejected and the good saved.

Symbols of the Church Year. It is not often that one sees the Christian Year represented in symbolic form. This is surprising because the subject lends itself splendidly to representation, and exhibits the life of our Lord in orderly sequence. There is a series in St. James', Lakewood.

Advent is shown by a scroll with the words *Ecce Virgo concipiet et pariet Filium,* from Isaiah's prophecy: the Immaculate Conception by a shield charged with the monogram of the Blessed Virgin; the Nativity by a Glastonbury thorn in blossom; the Epiphany by a star; the Purification by two drinking doves; Lent by two scourges saltire; Palm Sunday by the palms; Maundy Thursday by a chalice; Good Friday by a Latin cross and crown of thorns; Easter Day by a bursting pomegranate; the Annunciation by a budding fleur-de-lys; the Ascension by a fiery chariot; Whitsunday by the descending Paraclete; Trinity Sunday by three fishes arranged in a circular formation; the Visitation by the faces of two children; the Assumption by a palm and two lilies crossed; Michaelmas by a sword and the scales with which St. Michael is said to weigh men's souls; and All Saints by a rayed Manus Dei, denoting that the hand of God is over the souls of the righteous.

CHAPTER XIX.

TYPES OF OUR LORD JESUS CHRIST

MANY books which discuss Christian symbolism include a list of the traditional types of our Lord Jesus. These symbolical types were much used in Mediaeval sculpture, painting and stained glass work, as well as in illustrated books.

A word of warning may not be out of place. There is a difference between a symbol, a type and a picture. All three are different. A letter received from Mr. E. Donald Robb, one of the architects to the great Washington Cathedral, comes just in time to be included in this chapter. Mr. Robb, who is eminently qualified to speak with authority upon this subject, says:

"Most people are apt to confuse a symbol with a type. For example, a cross is a symbol of the Christian Church, but St. George is a type of Christian courage; or Jacob wrestling with the angel an example of strength. It seems to me that things and animals should be used as symbols, and historic characters always as types or representatives."

A more clear-cut definition would be hard to find. As long as we confine ourselves to animals, birds and inanimate objects, we are dealing with symbols. As soon as an

historic character, such as Adam, Abraham, Moses or David is introduced, we enter into the field of symbolic types. Both symbols and types may properly be used in decorating our churches. Many notable examples of sculpture, painting, stained glass and illuminated manuscripts contain both symbolism and symbolic types. The *Biblia Pauperum* and the *Speculum humanae Salvationis* are two famous Mediaeval works of tremendous importance in which artist and scribe laid the foundations for all later typology.

The Annunciation. The visit of the angels to Abraham, announcing the birth of Isaac, is a familiar type of the Annunciation of our Lord. The appearance of God to Moses in the burning bush, announcing the delivery of Israel from bondage, is likewise a type of the Annunciation. The budding of Aaron's rod is a type of the announcement that the Rod of Jesse should burst into blossom and bear fruit. The announcement of the birth of Samson, and likewise of Samuel are types of the Annunciation of our Lord's birth to the Blessed Virgin.

The Incarnation. The fleece of Gideon is used in the *Speculum* as a type of the Incarnation, because this sinful world was moistened with the dew of God's gracious love. In Roman Catholic art, Jacob's ladder has been used as a type of the Incarnation, which united Heaven and earth. We recall having seen this used in a Presbyterian chapel, at Christmas time, as a type of the same truth.

The Nativity. The flowering of Aaron's rod has been

used also as a type of the Nativity, for the Tree of Jesse bore its greatest fruit in the gift of our Divine Saviour. In the Sistene Chapel frescoes, the birth of Eve is used as a type of the birth of our Saviour, for through Eve sin entered into the world, and through our Lord sin was overcome. In the same chapel, Moses in the bulrushes is used as a type of the Holy Christ Child in the manger.

The Presentation. The presentation of the first-born of Israel in the temple is used as a type of our Lord's presentation in the temple. The presentation of the child Samuel in the temple is a type of the presentation of the Christ Child. Jacob's joy at the sight of his long lost son is a type of the aged Simeon's joy at the long expected Messiah.

The Epiphany. The visit of the Gentile Queen of Sheba to King Solomon is a type of the visit of the Gentile wise men to the Redeemer King. Abner's visit to David at Hebron, Joseph's brethren bowing before him in Egypt, and the three mighty men bringing water to David, are all used as types of the visit of the Magi to our Infant Lord.

The Flight into Egypt. The flight of Jacob to Laban, in order to escape his brother's wicked wrath, is a type of the flight of the Holy Family into Egypt. The hiding of Moses from the destroying soldiers of Pharaoh is another type. David's escape through the window, the escape of the two spies from the house of Rahab, and Jacob's flight into Egypt to escape famine are all types of the same thing.

The Holy Innocents. The slaughter of the innocents by Herod finds its type in the slaughter of the infants of Israel

by Pharaoh. Saul's destruction of the priests of the Lord, and Athaliah's murder of the sons of the King, are two other types of the massacre of the children of Bethlehem.

The Holy Family in Egypt. The early Christians had a tradition which stated that the idols of Egypt fell from their places when the Infant Redeemer was brought to their land. In Mediaeval art, the destruction of the golden calf by Moses was used as a type of this legend. The overthrow of the idol Dagon is another type often used. The sojourn of the father and brothers of Joseph in Egypt, in order to escape death by famine, is a type of the sojourn of the Holy Family in Egypt to escape death at the hands of the tyrant Herod. In southwest England we came upon a legend of curious character, for the tin miners of Cornwall sometimes say that the Child Jesus was brought later to their land for health and safety.

The Return from Egypt. The return of Jacob to his father's land is a type of the return of the Holy Family to their own country. David's return to Hebron is likewise a type of the return of the Holy Family.

St. John the Baptist. Isaac is a type of St. John the Baptist, our Lord's Forerunner. Both were children of faith, both were born to aged mothers through a miracle of God, the mothers of both had been barren, and both were consecrated to the Lord at an early age. In like manner, the birth of Samuel is a type of St. John the Baptist. Elijah is also a type of the Baptist, for Malachi calls him the second Elijah. Both Elijah and St. John were voices in the wilder-

ness, both were clad in camel's hair, both preached repentance to a wicked generation, and both led the solitary life.

Our Lord's Baptism. The circumcision of the son of Moses and Zipporah is used in the Sistene Chapel as a type of our Lord's Baptism.

The Temptation. Esau tempted to sell his birthright is used as a type, by way of contrast, to our Lord's temptation in the wilderness. Adam and Eve tempted by Satan is likewise used by way of contrast to our Lord's temptation. Joseph fleeing from Potiphar's wife is a type of our Lord turning away from Satan. Moses overcoming the Egyptians and the shepherds is a type of the same thing. Samson rending the lion has been used to represent our Lord overcoming the ravening lion, Satan. David slaying the lion, and David slaying Goliath are two other types.

The Sermon on the Mount. Moses on Mt. Sinai is used in the Sistene Chapel frescoes to typify our Lord's sermon on the mount.

The Raising of Lazarus. The raising of the son of the widow of Sarepta by Elijah, and the raising of the Shunammite's son by Elisha are favourite types of the raising of Lazarus, a scene often used in Christian art to exemplify our Lord's power to perform mighty miracles.

The Transfiguration. The transfiguration of Moses is a type of our Lord's Transfiguration. So also is the appearance of the angels to Abraham a type of the two heavenly persons who appeared on the Mount of Transfiguration. Nebuchadnezzar beholding the three youths in the fiery

furnace is a type of the apostles who beheld the glory of our Lord, Moses and Elias.

The Triumphal Entry. The sons of the prophets going forth to meet Elisha at Bethel is a type of the people who went forth crying their hosannas when our Lord entered Jerusalem. David's triumphal return, bearing the head of Goliath, and the joy of his people, has been used to represent our Lord's entry into Jerusalem on Palm Sunday.

Our Lord Weeps over Jerusalem. Jeremiah weeping over wicked Jerusalem is a favourite type of our Lord weeping over Jerusalem.

Cleansing the Temple. Judas Maccabeus gave orders that the profaned temple be cleansed. King Darius ordered Esdras to cleanse the temple. These two scenes are used in Christian art to typify our Lord's cleansing of the temple.

The Last Supper. Melchizedek bringing food to Abraham, Israel fed by manna in the wilderness, and the feast of the sons and daughters of Job are old-time types of the Last Supper. The parting conversation between Moses and Joshua is a type of our Lord's last conversation with His disciples.

The Traitor Revealed. Micaiah's prediction of the death of the wicked Ahab, Elisha's prediction of the death of the king's servant, and Daniel's prediction of the death of Belshazzar are three familiar types of our Lord's prediction of His death through the treachery of Judas.

Our Lord in Gethsemane. The perfect obedience of Abraham to the will of God is a type of our Lord's perfect

obedience to the will of the Father. Jacob wrestling with the angel is a type of our Saviour wrestling in prayer. Elijah comforted by the angel is a type of the angel appearing to our Redeemer and comforting Him.

The Betrayal. Joseph sold by his brothers to the traders, Joseph sold to Potiphar, Joab's treacherous murder' of the good Abner, Absolom's plot against the life of David and Jonathan's betrayal at the hands of Tryphon are favorite types of olden time of the betrayal of our Lord by Judas. Saul's treachery in casting his javelin at David, returning evil for good, is a type of the treachery of Judas. The miserable covetousness of Gehazi is a type of the sordid, mercenary spirit of Judas.

The Accusation before Pilate. Daniel falsely accused by the Babylonians, Elijah accused wrongly by Jezebel and Job's great patience under suffering are three types of our Lord's sufferings at the hands of those who accused Him before Pilate.

The Crowning with Thorns. The King of Ammon disfiguring the messengers of David, and Elisha mocked at Bethel are types of the crowning of thorns inflicted upon our Blessed Lord.

Our Saviour Mocked. The children mocking Elisha, Hur mocked by the Jews and spat upon, Noah mocked by Ham, and Samson mocked by the Philistines are four types of the mockery hurled at our Saviour by His malignant foes.

The Scourging. Lamech tormented by his wicked wives,

Achor bound to a tree, and Job tormented by the devil are types of the scourging of our Lord, and were thus used in the *Speculum.*

Bearing the Cross. Isaac bearing the wood for his own intended sacrifice, and the woman of Sarepta carrying the two bundles of wood in the form of a cross, are ancient types of our Lord bearing His own cross.

The Sacrifice on Calvary. There are many types of our Blessed Saviour's Crucifixion. Among the most familiar of these are the following: The unjust murder of the righteous Abel; the willingness of Isaac to yield to his father's will on Mount Moriah; the sacrifice of the son of the King of Moab; the lifting up of the brazen serpent in the wilderness by Moses; Joseph in prison between two thieves; and the traditional martyrdom of the good prophet Isaiah. Even the modern evangelist is fond of using types of our Lord's atoning Sacrifice, such as the death of Arnold von Winkelried, who impaled himself upon a sheaf of Austrian spears in order to make a breach in the battle front; the death of Henry Lee in Civil War days in order that his friend might go free; the death of the little newsboy at Gary, Indiana, in order to save a patient in the hospital; the death of John Maynard on Lake Erie, who stood bravely at the wheel in order to put the burning "Ocean Queen" ashore with all aboard. These things only prove the truth of Mr. Cram's words in the foreword of this volume, namely that if we reject the old-time symbols, men will invent others to take their places.

The Seamless Coat. Joseph's brethren, who took his coat of many colors from him, is a scene used to represent the taking of our Lord's coat by the soldiers under the cross.

The Pierced Side. Eve taken from Adam's side, and Moses bringing forth water from the smitten rock are used in the *Biblia Pauperum* as types of the piercing of our Lord's side by Longinus, the soldier.

The Virgin Mother's Sorrow. Adam and Eve lamenting over the murdered Abel, Naomi weeping over her sons, and Jacob's grief upon seeing the blood-stained coat of Joseph are the usual types of the sorrow of the Mother of our Lord over her Son.

The Descent from the Cross. Rizpah, and her sons who were hanged has been used as a type of the taking of our Lord's body from the cross.

The Entombment. Joseph placed in the pit, Jonah cast into the sea, the burial of Jacob, the burial of Abner and the burial of Moses have all been employed as types of the entombment.

The Descent into Hell. Our Lord descended into hell, not to be punished, but to proclaim His victory over His foes. Types of this descent into hell are: Samson overcoming the lion; Moses delivering Israel from bondage; Elijah overthrowing the 450 priests of Baal; David slaying Goliath; and the overthrow of the walls of Jericho.

The Resurrection. Elijah's ascent in a chariot of fire is used in a fine sculpture in the catacombs as a type of our Lord's Resurrection. In later days this event came to be

used as a type of the Ascension. Samson carrying off the
gates of Gaza is an old and favorite type of the Resur-
rection, for our Lord broke down the gates of death and
hell. Jonah delivered from the belly of the great fish,
Daniel rescued from the lion's den, and the three Hebrew
youths coming forth alive from the fiery furnace are three
subjects often used as Resurrection types.

The Women at the Tomb. Reuben searching for the
missing Joseph, and the Daughter of Sion of Solomon's
Song, who searched for her missing spouse, are two ancient
types of the women at the empty tomb on Easter Day.

The Appearance to Mary. Our Lord's appearance to
Mary Magdalene after His Resurrection finds its type in
the appearance of Daniel after having been rescued from
the lion's den. Other types are Jonah's appearance after
his experience in the fish's belly; the appearance of the
three Hebrew young men; and the finding of her spouse
by the Daughter of Sion in Solomon's Song.

The Appearance to the Disciples. Joseph revealing him-
self to his brothers is a type of our Lord's appearance to His
disciples after the Resurrection. The prodigal son, forgiven
by his father, is a type of the disciples whose cowardice was
forgiven by their risen Lord.

Thomas. The appearance of the angel to Gideon, and
the coming of the angel to the patriarch Jacob are types of
our Lord's appearance to Thomas, the Apostle.

The Ascension. The ascension of Elijah into Heaven in
the chariot of fire, and the translation of Enoch are two

ancient types of our Lord's Ascension. In the Sistene paintings, Moses going up for the last time into the mountain is likewise a type.

Pentecost. The two tables of stone given to Moses and the descent of fire upon Elijah's altar are two Mediaeval types of the descent of the Holy Ghost at Pentecost.

The Second Coming. Our Lord will come again in glory, not to set up an earthly millennial kingdom, but to judge the world. To teach otherwise is to upset half the Bible. This Judgment of the World is typified in the *Biblia Pauperum* by Solomon's judgment of the two mothers and their babes, and by David's judgment of the Amalekite.

The Unbelievers. The rejection of the unbelievers is typified by the expulsion of Hagar and her son; also by the judgment and destruction of Korah, Dathan and Abiram; by the destruction of wicked Sodom; by the destruction of Jericho; and by the writing on the wall at Belshazzar's feast.

The Believers. Our Lord taking the saved to the joys of Heaven is shown by Joshua leading Israel into Canaan; by Daniel called forth from the lion's den; by the Hebrew children taken out of the furnace of fire; and by the children of Israel coming out of the Red Sea while Pharaoh's soldiers perish. The feast of the sons of Job has been used to represent the marriage feast of the Lamb. Jacob's ladder has been used to picture the ascent of the believers into Heaven. Our Lord as Saviour of the believing righteous people finds His type in Joseph saving his brethren from famine and death.

The Church. The Church on earth has been typified by the eight souls finding safety in the ark of Noah. Solomon building his temple has been used as a type of our Lord building His Church. The laying of the cornerstone of the temple has been used as a type of our Lord, the Cornerstone of the Church. The meeting of Isaac and Rebecca was used by the early Church Fathers as a type of the Church, the Bride of Christ, and this idea found its way into Christian art.

Holy Baptism. The deluge, which cleansed the world of sin, is a type of the washing of regeneration and the renewing of the Holy Ghost through the Sacrament of Holy Baptism. Pharaoh engulfed in the Red Sea is an old type of the washing away of all sins and evil lusts in Holy Baptism. The washing of Naaman the Syrian has been used in the same sense.

The Holy Eucharist. The Blessed Sacrament of the Lord's Supper has been represented by Melchizedek, priest and king, who brought bread and wine to Abraham. A famous example of this type is that by Memling in the Munich gallery. Rubens uses the scene of Elijah sustained by angels as a type of the Eucharist.

These types are very useful in working out subjects for stained glass windows. In the case of a church of the clerestory type, where there are a number of aisle windows, (which ought to be small in size), one might well work out the entire life of our Lord in the form of small medallions.

Pairs of such medallions may be used, one containing the type and the other the actual scene from our Lord's life.

Such symbolic types not only add to the interest of the church, but they enable one to do as the monks of old are said to have done when they conducted strangers, or children, or the unlearned through their great abbey churches. They are said to have used such storied windows, as well as carvings and paintings, to tell the story of the Old Testament and its fulfillment in the coming of our Lord, and to drive home their own distinctive doctrines while explaining the windows, the carvings, and the paintings to persons whom they conducted through the church. We have met with vergers in the old English cathedrals who follow this custom to the present day, so that when one has made the rounds of an old cathedral, he has had everything explained to him, and has received a lecture of an hour or two in length on the distinctive doctrinal position of the Church of England. They use the carvings and stained glass as the basis for such expositions.

At the great Swedenborgian church at Bryn Athyn, north of Philadelphia, just this is done. The church as a whole is worked out in a symbolic manner, as well as all its details. As the verger conducts one through, he uses the interesting structural features of this magnificent building, and its carvings in stone and wood, its beaten metal work and its stained glass (all of which things are produced entirely at the building site), to explain to the visitor the doctrines of the Swedenborgian church. In like manner could the in-

teresting symbols of St. Vincent Ferrer, or St. John's and St. George's at Newport, or St. Mark's and St. Clement's at Philadelphia, or Concordia Seminary at St. Louis, be used. What would St. Alban's be, were there no carvings or glass of any sort, or Chichester, or Gloucester, or Norwich, or Freiburg, or Hildesheim, or Seville, or Segovia? A church without the products of intelligent craftsmanship is painfully lacking in devotional atmosphere.

It would not be hard to work out a scheme in the form of stained glass, paintings and carvings, which would enable one to explain the way of salvation and the teachings of one's own church to the young, or to visitors, while conducting them through the church building. In this way even the stones and the windows may be made to testify.

CONCLUSION

AS ONE studies almost any of the Old Mediaeval churches, or modern churches by Sir Giles Gilbert Scott, Sir Robert Lorimer, the late G. F. Bodley, Edmund Sedding, the late J. D. Sedding, the late J. F. Bentley, or in our own country by Cram, Goodhue and Ferguson, Frohman, Robb and Little, the late Henry Vaughan, the late John T. Comes, and many other eminent men, we can see at once how an intelligent use may be made of craftsmanship. Banks, department stores and business houses have found that it is a wise investment of money to make their buildings as interesting to the eye as possible. The use of symbolism is more than mere ornament. It is educational as well.

Let us take Cram, Goodhue and Ferguson's Episcopal Chapel of the Intercession as a typical case. As one approaches its main portals, he notices over twenty beautifully carved symbols surrounding the doorway. See halftone plate. These are the Four Evangelists, the cross, the dove, the pomegranate, the star, the three crowns, and various other things. On the tympanum is a great carving of our Lord trampling the dragon underfoot. Above Him, within the deep recession of the doorway, is an arched

vault, upon which is carved a twining vine, with the symbols of the Seven Sacraments on large medallions.

Inside of the church are countless symbols. The west gallery paneling contains the shields of the Twelve Apostles. The great stone font is twelve-sided, and contains twenty-four panels, each of which includes the symbol of a Christian virtue. Above is a splendid spire-like cover, elegantly carved. Crowning this spire, twenty-five feet above the floor, is the dove of the Holy Ghost. Eight carved panels contain representations of such scenes as the baptism of our Lord, the baptism of the eunuch, the baptism of Aethelbert, etc. In the cresting are the writers of the New Testament. Upon shields are the symbols of the Seven Sacraments.

The altar is a magnificent piece of work, with a fine carved dorsal canopy and frame, with the pelican-in-her-piety upon it. The frame-work and the canopy are finished in gold. Lectern, pulpit, choir stalls, organ case and panel work are beautifully carved, and contain interesting symbols. Everywhere, even to the richly coloured ceiling-beams, symbols greet the eye. In the very perfect Lady Chapel, which is but thirteen feet wide by forty and one-half feet long, is a richly carved and coloured altar and triptych, full of symbolism in color and gold and exquisite carvings. On the walls of this little chapel are carvings in stone of the rose, the fleur-de-lys, the vessel, the MA monogram with crown, the tower of David, the ark, the gate and the gilly flower.

All of the exterior doorways are rich in symbols carved in stone. Symbols greet one everywhere, even high up on the walls and upon the tower.

St. Thomas's Church, St. Vincent Ferrer, St. Mark's at Mt. Kisco, St. Paul's at Detroit, Calvary at Pittsburgh, are likewise full of symbolism. St. Thomas's will repay an entire day's study, so elaborate is its interior.

We have able men, both in America and abroad. Why should we not allow them to make our church buildings just as beautiful as possible, so that they may once more be great, colorful picture-books of Bible and Church history? Mr. Klauder has demonstrated at St. Louis what may be done in the way of perpetuating Biblical and ecclesiastical history in stone and glass. Mr. Maene's carving of the Perry County log cabin is a work of true genius.

Not only have we capable architects, designers and craftsmen, but in men such as Mr. Edward A. Wehr and Mr. Henry W. Horst, we have builders who are artists as well. Both of these men are noted for the painstaking study, and great sacrifice of time and money, devoted to projects entrusted to them. They do not look upon the building of a church or a great educational group as a chance for revenue, but have been known to sacrifice thousands of dollars, and much time and energy in order that the buildings which they erect may be as worthy as possible, as enduring as can be, and as interesting in detail as lies within the power of skilled men to make them.

We believe that if as much money were set apart for

carved and painted detail as is set apart for the grati-
fication of the flesh, our churches would again become
intensely interesting. We are not arguing against gymna-
siums, bowling alleys, banquet halls or parish houses.
While all of these things combined do not interest the
writer as much as one square foot of good carving or good
glass, yet we would never be so ungenerous as to deny them
to our young people if they want them, and if all things are
done properly and decently. We do plead, however, for
equal rights.

What do we mean by equal rights? We mean this:
Spend as much money and effort upon the task of making
the Lord's house as attractive as possible as we spend upon
the recreational unit. It strikes us as rather unfair to the
Lord to see a new church erected, and $250,000 spent for
the parish house and hardly a beggarly $75,000 for the
church proper. It is too much like the old proverb of plac-
ing one's cart before his horse, or the tail wagging the dog.

We have no objections to a $45,000 gymnasium, but we
should like to see an adequate sum set apart for good stained
glass, or a beautiful altar, or an elaborately carved reredos,
or an excellent organ. We firmly believe that good glass,
good carvings, good paintings and good music will attract
quite as many people as a good parish hall. Why not have
both? Why have a church kitchen, complete to the last
nickel-plated coffee urn, and all this obtained at the cost
of worthy chancel furnishings? Coffee urns and skittle
alleys doubtless have their legitimate place in modern

church life, so long as they are not obtained at the expense of proper fittings for the church proper.

When a church is erected, it is not only necessary to set apart an adequte sum of money in order to make it just as enduring and honest in construction as possible, but we believe that a generous sum ought to be kept intact for the purpose of making a start towards genuine craftsmanship.

If it can be demonstrated that an attractive hotel or an attractive bank building will draw more patronage than a cheap, bleak looking structure, is not the same true in the case of one's parish church? The Cistercian monks believed in a beautiful sort of architectural austerity, and the Puritans practiced a repellent severity, but it cannot be demonstrated that either of them won more friends to their cause than did the builders of Reims and Chartres and Amiens and Exeter and St. Michael's at Hildesheim. To argue that our churches must be quite bare of all color and atmosphere is as foolish as to argue that a woman in a faded house dress, old slippers, and her hair in curl-papers is more beautiful than the same woman in her "Sunday best," or whatever it is called nowadays.

Religious fanatics may have destroyed the wonderful carvings at Lyons, wrecked the great astronomical clock and laid low the beautiful choir school; they may have hacked to pieces the fine sculptured figures on the west front of Meaux, or destroyed much at Rouen; or in days of storm and stress the populace may have demolished the sculptured figures at Aix and Albi and Ely and St. Cuth-

bert's, Wells, or made havoc of the fine Tour de Puy-Ber-
land at Bordeaux. But after all these, and countless other
acts of insane vandalism were performed, can it be demon-
strated that any more people go to church today than they
did when carvings were intact, symbolism unmolested, and
windows filled with glowing glories of stained glass?

We believe most emphatically in purity of doctrine and
practice, and in the power of God's Word to turn man from
sin to salvation through Jesus Christ. But the fact remains
that we must first get a man into the church before he can
hear the Word of God, or receive the Sacraments. Will a
bare, austere, barn-like church attract men any quicker
than one that is genuine, and beautiful in line, in form, in
proportions, in symbolical detail? We believe not. When
the Almighty commanded Solomon to build the temple,
He gave explicit directions for the building of a most beau-
tiful place of worship; not a barn-like thing as devoid of
feeling as the interior of an interurban car. Can we not
combine purity of doctrine and practice with beauty? Was
the Lord Himself ever known to create ugliness? Ugliness
comes in the wake of commercialism, with its piles of
smoking furnace-slag, its poisoned rivers, its belching fac-
tory chimneys and its endless rows of squalid, hideous tene-
ment houses. A beautiful church building has never
caused a single soul to be lost, or alienated from the parish,
but who knows how many men and women, with a natural
appreciation for beauty, have passed by with indifference
the ugly, uninteresting church buildings that we often

erect, imagining (perhaps very wrongfully) that the preaching and the order of worship within is as dull and uninteresting as the exterior?

A devout spirit calls for church buildings of beautiful proportions, excellent workmanship, structural honesty, adorned within and without with carvings in stone and in wood, with only the best stained glass, the best paintings, the best work in metal, in wood, in color and gold and in needlework. Add to that the right sort of a dignified liturgy and the proper sort of music, and you will have a setting that is worthy of the pure Gospel and the treasured Sacraments. It is not impossible, nor is it really very expensive, if only we distribute our dollars wisely. It may mean a little less size in order to have genuine craftsmanship, or it may mean getting things gradually, adding interesting things from time to time, as we are able. By giving careful thought to such things, and by insisting upon honest craftsmanship, good materials and intelligent decoration, our churches will become devout in their atmosphere and express outwardly the beauty of Word and Sacrament.

THE MORE IMPORTANT SAINTS OF CHURCH ART

THE date of death, if known, is given after each name, followed by the most common symbols used in church art. We list only the more important names. For brevity's sake, such self-evident symbols as the palm of the martyr, the crown of the king, and the mitre of the bishop, are omitted.

ABBREVIATIONS

A.	Apostle	D.	Doctor	Mg.	Magus
Ab.	Abbot	Dc.	Deacon	Pen.	Penitent
Abs.	Abbess	Emp.	Emperor	P.	Pope
Ar.	Archbishop	Eps.	Empress	Q.	Queen
Ard.	Archdeacon	Ev.	Evangelist	V.	Virgin
B.	Bishop	H.	Hermit	W.	Widow
C.	Confessor	K.	King	c.	about
Car.	Cardinal	M.	Martyr	cen.	century

SS. Abdon and Sennen, MM. c. 252. Fur tunics, swords, Phrygian caps; two crowns.

S. Abraham, H. c. 360. Dragon devouring white dove.

S. Achilleus, M. 1st c. Column; fire; rope; sword; model of church.

S. Adelaide, Eps. 999. Boat; open purse; conventual buildings.

S. Adalbert of Gnesen, Ab. M. 997. Pilgrim's staff; open book.

S. Adrian, M. 304. Armour; lion couchant; anvil and hammer; iron bar; severed limbs; large key; scourge; sword; wheel.

S. Afra, Pen. M. 304. Stake and fagots; cauldron; sword.

S. Agapetus, M. 275. Lion couchant; scourge; sword.

S. Agapius of Palestine, M. 306. Dove flying out of his mouth.

S. Agatha, V. M. c. 251. Breasts in dish or on book; pincers; pillar; shears; chafing dish; vase of ointment; scourge; broken pottery; live coals; blazing fagots; long veil; salver; sword.

S. Agnes, V. M. c. 304. Lamb on book; sword piercing neck; book and sword; dove holding ring; burning fagots; lamb; sword.

S. Aidan, B. C. 651. Stag couchant; torch or taper; horse; fire.

S. Aignan, B. C. 453. (S. Anianus.) Corner-stone; asperge; cobbler's knife.

S. Alban, M. c. 303. Cross; square cap and sword, sun radiant above; book; tall cross and sword; fountain at his feet; sword and crown.

S. Albert of Liége, B. M. 1193. Eight daggers; earthen vessel.

S. Albinus of Angers, B. 549. Staff tipped with cross; pulpit.

S. Aldhelm; Ab. B. 709. (S. Althemus, S. Ealdhelm.) Pen and inkhorn; staff; model of Malmesbury abbey.

S. Alexander of Bergamo, M. c. 300. Pagan altar or idol under his feet; cross.

S. Alexander of Rome, P. M. 117. Nails; stiletto; angel with torch.

S. Alexis, C. c. 480. Pilgrim's staff; escallop; beggar's dish; staircase; ladder.

S. Aloysius, C. 1591. Cross or crucifix; lilies; crown at his feet; rosary.

S. Alphege, Ar. M. 1012. (S. Elphege, S. Aelfheah.) Chasuble full of stones; axe and skull; battle axe.

S. Amator of Auxerre, B. C. 418. Tree and axe or hatchet.

S. Ambrose, B. C. D. 397. Scourge; beehive; tower; dove; cope and mitre; scroll with staff of music; book and pen; cross; chalice; bull; knotted scourge; two scourges; goose; writing tablet and stylus; heart surmounted with flame; scroll with quotation from writings.

S. Amphibalus, M. 303. Scourge; tree.

S. Anastasia the Elder, M. c. 303. Razor; sword; pincers; severed tongue held in pincers.

S. Anastasia the Younger, V. M. 304. Ship; four posts and cords, blazing fire between them.

S. Anatolia, V. M. c. 251. Serpent or dragon; torches; sword.

S. Andrew, A. M. c. 60. Cross saltire; V or Y cross; two fishes; tall cross and book; vertical spear; primitive fish hook; fisherman's net.

SS. Andronicus, Probus and Tarachus, MM. 304. Pillar; lions; bear; sword; bright star.

S. Angelus, M. 1225. Red and white roses and lilies; three crowns and book; arrows; sword.

S. Anianus, B. C. 453. See S. Aignan.

S. Anne, 1st c. Angel; flowering rod; crown; nest of young birds; Golden Gate of Jerusalem; book; infant Virgin in crib.

S. Ansano, B. M. c. 303. Fountain; cross; cluster of dates; bleeding heart; flames; sword.

S. Anselm, Ar. C. D. 1109. Ship; papal bull; Virgin and Child.

S. Ansgar, Ar. C. 865. Staff tipped with a cross.

S. Anthony, Ab. H. C. 356. Tau staff and bell; torch and bell; belled pig; goat; Tau cross; asperge and bell; book and beads; two lions; cope charged with Greek Theta or a Latin T; flames of fire and bell; scroll with words *Quis evadet*, or with *Humilitas* and rays of light from Heaven; Tau staff and book.

S. Anthony of Padua, C. 1231. The Holy Child on a book; lilies; fishes; flask and crucifix; mule; money chest and human heart.

S. Antonius of Florence, Ar. 1459. Archepiscopal mitre; pallium; book; boat; pair of balances with fruit and scroll.

S. Apollonaris of Ravenna, B. M. c. 79. White vestments and black cross; club; hot coals; raven; crown; stones; cauldron of boiling water; chains.

S. Apollonia, V. M. c. 249. Pincers and tooth; broken idol; column of fire and fagots.

SS. Aquila and Priscilla, MM. 1st c. Shoemaker's or tentmaker's tools; tent.

S. Arsenius, H. c. 450. Basket of rushes or of palm leaves.

1.

ST. AGNES

2.

· ST. ALBAN

3.

ST. ANSELM

4.

ST. ANTHONY

5.

ST. AUGUSTINE OF CANTERBURY

6.

ST. BEDE

7.

ST. BENEDICT OF NURSIA

8.

ST. BERNARD OF CLAIRVAUX

9.

ST. BERNARDIN OF SIENN

𝕾aints

PLATE XXIX.

S. Athanasius, Ar. C. D. 373. Open book; two columns; boat on the Nile; equilateral triangle; open book between two Greek Doric columns; archbishop's pallium; scroll with quotation from his writings.

S. Aubert, B. C. 669. Baker's shovel and two loaves of bread; baker's peel and a book; ass.

S. Aubin of Angers, 6th c. Broken fetters; pulpit; armour at his feet.

S. Audrey, V. Q. Abs. C. 679. See S. Etheldreda.

S. Augustine of Canterbury, B. C. 604. Banner of the crucifixion; King Ethelbert rising out of a font; fountain; cross fitchée pastoral staff and book; cope, mitre and pallium.

S. Augustine of Hippo, B. C. D. 430. Flaming heart pierced by two arrows; eagle; child with shell and spoon; word *Veritas* with rays of light from Heaven; chalice; dove, pen and book; scroll; scourge; model of a church; Bible opened to Romans xiii.

S. Aurea, V. Abs. c. 666. Hot coals; nails; millstone.

S. Aventine of Troyes, B. C. 540. Bear; thorn.

S. Babylus of Antioch, B. M. c. 251. Chains; sword.

S. Balbina, V. 130. Broken fetters; S. Peter's chains; veil.

S. Balthazar, Mg. 1st c. Casket or cup of myrrh; star; crown.

S. Barbara of Heliopolis, V. M. c. 306. Chalice; host and paten; tower with three windows; tower and palm; monstrance; peacock feather; torches; fortress; spears; crown; book; sword.

S. Barnabas, A. M. c. 58. Dalmatic; three stones; book and staff; S. Matthew's Gospel; pilgrim's staff and wallet; burning pyre; cross; hatchet.

S. Bartholomew, A. M. c. 50. (S. Nathanael.) Flaying knife and book; three vertical flaying knives; human skin; human skin on a cross; devil under his feet; pillar; S. Matthew's Gospel; scimitar; cross.

S. Basil, Ar. C. D. 379. Model of a church; dove; column of fire; scroll with quotation from his writings.

S. Basilassa, V. M. c. 309. Lily and book; torch; lions; sword.

S. Bavon, H. c. 657. Sword and sceptre; falcon; large stone; hollow tree; ducal robes; horse and cart.

S. Beatrice, V. M. c. 303. Rope; lighted candle.

S. Bede, C. 735. Pitcher of water and light from Heaven; scroll; pen and inkhorn; volume of ecclesiastical history.

S. Bees, Abs. 650. Model of conventual buildings.

S. Benedict of Anian, Ab. 821. Model of conventual buildings.

S. Benedict Biscop, Ab. 690. Models of Wearmouth and Jarrow; conventual buildings under construction; books and pen; scroll with staff of music; model of a church school.

S. Benedict of Nursia, Ab. 543. Ball of fire; broken bell; asperge; broken cup and serpent on a book; raven with cup or pitcher; serpent issuing from loaf of bread; briars and roses; conventual buildings on a mountain; water flask; shell; crow; scroll; broken cup or broken sieve; thorny bush;

open Bible; scourge with three leaded thongs; cross-hilted sword with words *Crux sancti patris benediciti;* scroll with words *Crux sacra sit mihi lux;* devil pierced by crosier.

S. *Benignus, M. c. 179.* Dogs; saltire cross; spear; club; large nails; key.

S. *Benno, B. 1106.* Fish holding key in its mouth.

S. *Bernard of Clairvaux, Ab. 1153.* Beehive; three mitres on a book; white dog; inkhorn and pen; Passion implements; fettered demon.

S. *Bernard of Menthon, Ard. C. 1108.* Models of two Alpine hospices; castle; large dog; window; broken idol; flask; bread.

S. *Bernard Ptolomei, Ab. C. 1348.* White vestments; crosier and two olive branches; three mounds; ladder.

S. *Bernardine of Siena, C. 1444.* IHS within a circle of golden rays; open book; pile of vanities in flames.

S. *Bernward, B. c. 1022.* Cross; a silversmith's hammer; jeweled chalice; jeweled cross.

S. *Bertha, W. Abs. 725.* Altar; fountain; model of a church.

S. *Bibiana of Rome, V. M. 363.* Branch of a tree; dagger; scourge; column and scourge with leaded thongs.

S. *Blaise of Sebaste, B. M. c. 316.* Wool-corder's iron comb; pig's head; crosier and book; thorn; pig held by wolf; lighted taper; scourge; large rake; two candles saltire; sword; boar's head; fawn.

S. *Blandina, V. M. 177.* Lions; bear; scourge; red-hot grate; wild steer; net; dagger.

S. *Bonaventure, B. C. D. 1274.* Cardinal's hat; pyx; angel holding chalice and host; archbishop's vestments; rayed crucifix.

S. *Boniface, Ar. M. 755.* Sword piercing heart; Bible transfixed by sword; fallen oak; book and pen; scourge; club; fox; fountain; raven; axe and fallen oak of Thor.

S. *Botolph, Ab. c. 660.* Model of church; church with crescent moon and star over it.

S. *Brandon of Clonfert, Ab. 577.* Canaries; stone; branch.

S. *Brice of Tours, B. C. 444.* Burning coals in his hand; coals of fire held in robe; staff.

S. *Brigid of Kildare, V. Abs. 523.* (S. Bride, S. Bridget.) Column of fire above her; book; devil; goose; green branch growing from an altar; scroll and pen; corn; white wolf; cow; large bowl.

S. *Bridget of Sweden, W. Q. Abs. 1373.* Pilgrim's staff, bottle and wallet; open book and dove; crosier, lute and chain; taper; heart charged with cross.

S. *Britus, B. C. 444.* See S. Brice.

S. *Bruno, C. 1101.* Flowering crucifix; chalice and host; death's head; scroll with words *O bonitas;* star on his breast; seven stars; white scapular; olive branch.

S. *Cadocus, Ab. 540.* Models of two Welsh abbeys.

S. *Calixtus, P. M. c. 223.* (S. Callistus.) Window; model of church; stone; well; millstone or grindstone.

S. *Casimir, Prince, 1483.* Lily and crown; scroll with music.

S. *Cassian, M. 359.* Heart pierced with dagger or stylus.

S. *Catherine of Alexandria, V. Q. M. c. 305.* Wheel set with sharp knives; broken wheel; sword; crown at her feet; hailstones; bridal veil and ring; dove; scourge; book.

S. *Catherine of Bologna, V. Abs. 1463.* Palette and brushes; book.

S. *Catherine of Siena, V. 1380.* Lily; stigmata; crown of thorns; heart charged with cross or IHS; crucifix; wedding ring; white dove.

S. *Ceadda, B. (S. Chad.) 672.* Book and crosier; branch and vine; model of Lichfield cathedral.

S. *Cecilia, V. M. c. 220.* Organ, lute or harp; two wreaths of roses and lilies; dulcimer; cauldron of boiling water.

S. *Celsus, M. 4th c.* Armour; millstone; sword.

S. *Chad, B. C. 672.* See S. Ceadda.

S. *Chamael, Archangel.* (S. Chemuel.) Cup and staff.

S. *Charlemagne, E. 814.* Orb and cross; three crowns on a robe; Bible; long sword; shield charged with three fleurs-de-lys.

S. *Charles Borromeo, Ar. Car. 1584.* Altar; rope around neck; casket and crucifix; chalice and host; cardinal's hat; word *Humilitas* crowned.

S. *C h e m u e l, Archangel.* (See S. Chamael.)

S. *Cheron, M. 5th c.* Severed head in his hand; sword.

S. *Chlodulf, B. C. (S. Cloud.) 696.* Nails; hammer; cross; crown.

S. *Christina of Bolsena, V. M. c. 298.* Millstone and two arrows; three arrows; crown and book; fiery furnace; tower; broken idols; fallen image of Jupiter; tongue held in pincers; pillar and arrows; serpents; cherubim with equilateral triangle; knife and tongs.

S. .*Christopher, M. 3d c.* Staff of a palm tree; lantern; palm tree and river; the Christ Child on his shoulders.

S. *Chrysanthus, M. (SS. Chrysanthus and Daria, MM.) 3d c.* Axe and torch; flames; stones.

S. *Chrysogonus, M. c. 303.* Roman patrician's robes; sword; millstone.

S. *Chrysostom, Ar. C. D. 407.* Beehive; chalice on Bible; white dove; scroll or book; pen and inkhorn.

S. *Clare, V. Abs. 1253.* Chalice and host; tall cross; monstrance; lily; ciborium.

S. *Clement, P. M. 100.* Double or triple cross; fountain; anchor; tiara; maniple; marble temple in the sea; cross and anchor; nimbed lamb.

S. *Cleophas, 1st c.* Pilgrim's staff and book.

S. *Clotilda, Q. 545.* Crown and sceptre; shield charged with three fleurs-de-lys held by an angel; model of a church; fountain; long veil.

S. *Cloud, B. C. 696.* See S. Chlodulf.

S. *Colette, V. Abs. 1447.* Crucifix and book.

S. *Columba of Iona, Ab. 597.* Corracle; white horse; Celtic cross; devils fleeing.

S. *Columba of Sens, V. M. 274.* Angel; dove; bear; sword; chains; crown.

S. *Columbán, Ab. C. 615.* Bear's den; wolves; foliated crucifix; fountain; sunbeam.

S. *Concordia, V. M. c. 255.* Leaded scourge.

S. *Conon, B. 648.* Mitre and crosier.

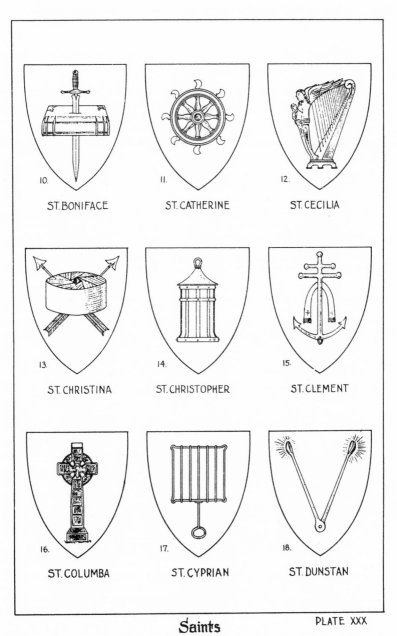

10.	11.	12.
ST. BONIFACE	ST. CATHERINE	ST. CECILIA
13.	14.	15.
ST. CHRISTINA	ST. CHRISTOPHER	ST. CLEMENT
16.	17.	18.
ST. COLUMBA	ST. CYPRIAN	ST. DUNSTAN

Saints

PLATE XXX

S. *Constantine, Emp. 335.* Chi Rho staff; the Labarum.

S. *Constantine of Govan, M. 576.* Crown and palm.

S. *Corentin, B. c. 453.* Fountain and fish; water flowing from rock.

S. *Cornelius, Centurion, B. 1st c.* Overturned idols.

S. *Cornelius, P. M. c. 250.* Horn and triple cross; cows or oxen; font; tall cross; sword.

SS. *Cosmas and Damian, MM. c. 295.* Vases; arrows; surgical instruments; phials and jars; lancet; red vestments; box of ointment; rod of Æsculapius; cylinder; stake and fagots; arrows; cross; swords; millstones.

S. *Crescentia, M. 303.* Boat piloted by an angel; cauldron of oil; sword.

SS. *Crispin and Crispian, MM. c. 287.* Shoemaker's tools; awl and knife saltire: millstones; flaying knives; rack.

S. *Cunibert, Ar. c. 660.* Dove; model of a church.

S. *Cunigunda, Q. W. 1040.* Model of a church; hot ploughshares.

S. *Cuthbert, B. C. 687.* Crowned head of S. Oswald; swan; otter; three loaves on a table; pillars of light; leaden casket containing his relics; model of Lindisfarne abbey.

SS. *Cyprian and Justina of Antioch, MM. 304.* Books of magic in flames; gridiron and sword; cauldron of boiling pitch; fleeing devils.

S. *Cyprian of Carthage, B. M. 258.* Twenty gold coins; crown; axe.

S. *Cyr, M. c. 304.* Steps; boar.

S. *Cyril of Alexandria, Ar. C. 444.* Purse; scroll with word *Theotokos* in Greek uncial letters; cap, hood and veil; pen and books; heretical books burning in a brazier.

S. *Cyril of Jerusalem, B. C. 386.* Purse; ball of fire; scroll with quotation from his writings.

S. *Cyrilla, V. M. c. 258.* Live coals.

S. *Damasius, P. C. 384.* Ring; scroll inscribed *Gloria Patri;* church door; ring set with large diamond; monstrance; model of a basilica; severed right hand.

S. *Damian, M. 295.* See SS. Cosmas and Damian.

S. *Daniel of Constantinople, H. c. 489.* Lofty pillar.

S. *Daria, V. M. 3d c.* See SS. Chrysanthus and Daria.

S. *David of Scotland, K. 1153.* Banner charged with a harp; model of a church.

S. *David of Thessalonica, H. 650.* Beehive; lion.

S. *David of Wales, Ar. C. c. 544.* Dove on shoulder; mound or hill; fountains of water; leek; harp.

S. *Demetrius, M. c. 299.* Roman proconsul's insignia; tunic charged with lozenge; arrow; scorpion; spear.

S. *Denis, B. M. (S. Dionysius.) 272.* Mitered head in his hand or on book; white chasuble; tree or stake; sword; our Lord with chalice and host.

S. *Diego, C. 1463.* (S. Didacus.) Bread and roses in a tunic; cross held by an angel.

S. *Didymus, M. 303.* Serpents; Roman armour; sword.

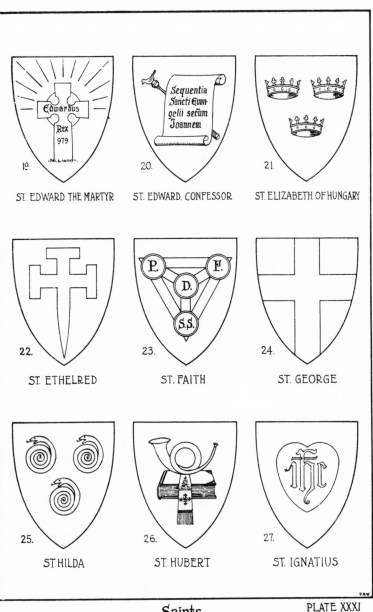

19. ST. EDWARD THE MARTYR

Edwardus
Rex
979

20. ST. EDWARD. CONFESSOR

Sequentia
Sancti Evan-
gelii secūm
Joannem

21. ST. ELIZABETH OF HUNGARY

22. ST. ETHELRED

23. ST. FAITH

P. F.
D.
S.S.

24. ST. GEORGE

25. ST. HILDA

26. ST. HUBERT

27. ST. IGNATIUS

F.R.W.

Saints

PLATE XXXI

SS. *Diomedes and Antiochus, MM. c. 299*. Lions; spear; axe.

S. *Dismas, Pen. 33*. Tall Tau cross; gates of Paradise; scroll with words *Memento mei, Domine*.

S. *Dominic, C. 1221*. Lily; dog; book; star in forehead; pilgrim's staff; rosary; cross and rosary; dog holding torch; books in a fire.

S. *Donald, C. 716*. (S. Donaveldus.) Star surrounded by nine stars.

S. *Donato of Arezzo, B. M. 362*. Dragon emerging from a well; chalice; crozier; sword.

S. *Donatian of Reims, B. c. 380*. Wheel with a candle on each spoke.

S. *Donatian, M. 303*. Roman armour; cloud and lightning; angel pouring water from a pitcher on a fire.

S. *Dorothea, M. 303*. Angel holding basket of flowers or of fruit; burning torch; apples or roses in a basket, rack; pincers; sword; crown.

S. *Drausius of Soissons, B. c. 675*. Mitre and crosier.

S. *Dubricus, B. C. 524*. Archbishop's cross and two crosiers.

S. *Dunstan, Ar. 988*. Devil held with pincers; covered cup; angels; models of Glastonbury and Canterbury; harp or organ; blacksmith's tools; palette and brushes.

S. *Eanswith, V. Abs. c. 645*. Half a hoop and two fishes; book and crosier; crown.

S. *Eata, B. 686*. Model of Melrose abbey.

S. *Ebba of Coldingham, V. Abs. M. 874*. Knife; razor and nose; convent in flames.

S. *Edgar, K. 975*. Royal robes; crown and book.

S. *Edith of Polesworth, Abs. c. 964*. Crosier; crown.

S. *Edith, V. 984*. Crown; basin and towel; model of conventual buildings or of Wilton church.

S. *Edmund, K. M. 870*. Arrows; cudgel; gray wolf.

S. *Edmund of Canterbury, Ar. 1242*. Child at his feet; B. V. M. holding a ring.

S. *Edward, K. M. 979*. Dagger and cup; dagger and sceptre; short sword and sceptre; falcon; grave with rays of glory above it.

S. *Edward Confessor, K. C. 1066*. Ring in his hand; sceptre surmounted by dove; purse; S. John's Gospel; sealed scroll.

S. *Edwyn, K. M. 633*. Three mitres and a chain.

S. *Eleazar of Sabran, 1300*. Scrolls and seals; packet of legal documents.

S. *Eleutherius of Tournay, B. M. 531*. Model of Tournay cathedral; flaming oven: dragon; scourge: angel bearing scroll.

S. *Eligius, B. C. c. 660*. (S. Eloi.) Crosier; goldsmith's hammer; fetters; horseshoe; casket of gold; red-hot pincers; bellows; anvil; small model of church in gold.

S. *Elisabeth, 1st c.* Saluting the Virgin; holding S. John Baptist; huge rock with a doorway in it.

S. *Elizabeth of Hungary, W. Q. C. 1231*. Three crowns (virgin, wife, widow); triple crown; roses; basket of bread and flask of wine; roses in a robe; infant in a cradle; model of a hospital or of Wartburg castle; distaff.

S. *Elizabeth of Portugal, Q. 1336*. Olive branch; crown; jug; widow's veil.

S. *Emerentina, V. M. c. 304.* Stones.

S. *Enurchus, B. 4th c.* (S. Evortius.) Cook's apron and utensils; dove.

SS. *Ephesus and Potitus, MM. c. 303.* Roman officers' insignia; two swords.

S. *Ephrem of Edessa, D. C. 378.* Cowl with small cross; pillar of light; scourge.

S. *Epiphanius, B. C. 403.* Beehive; open purse; sandals.

S. *Erasmus, B. M. c. 303.* (S. Elmo.) Windlass or capstan wound with his intestines; ship; ravens bringing him bread; cauldron of molten lead; red-hot armour; three-pronged hook; cauldron of boiling pitch or resin.

S. *Ercolano, B. M. 546.* Sword.

S. *Eric, K. M. 1151.* Three crowns and a banner; fountain.

S. *Erkonwald, B. 693.* Model of Chertsey abbey.

S. *Ethelbert, K. M. 794.* Altar; crown.

S. *Ethelburga, V. Abs. c. 664.* Passion instruments.

S. *Etheldredà, V. Q. Abs. C. 679.* (S. Audrey.) Regal crown and staff; crosier; crown of flowers; book and lily; sunflower; model of Ely cathedral; budding staff; open money chest.

S. *Eudoxia of Heliopolis, Pen. M. c. 113.* Jewels at her feet.

S. *Eugratia of Saragossa, V. M. 3d c.* Post; large nails; sword.

S. *Eulalia of Merida, V. M. 304.* White dove; large iron comb; nails or hooks; cross.

S. *Eunurchus, B. C. 340.* Dove on his head; pot of gold.

S. *Euphemia of Chalcedon, V. M. 303.* Crown; flames and stake; lion; bear; wheels; mallet; lily; cross; sword; serpents.

S. *Euphrasia, V. c. 410.* Stone; well.

S. *Euphrosyne, V. c. 470.* Monk's habit.

S. *Eusebius of Rome, M. 4th c.* Pincers holding severed tongue; club.

S. *Eustace, M. 119.* (S. Placidus.) White stag on a rock, with a crucifix between horns; boar spear; hunter's horn; lion; Roman armour; bear, wolf or dog; wicker basket; brazen bull with a fire under it.

S. *Eustochium, V. M. 419.* Lily; crucifix; rosary.

S. *Eutropius, B. M. 308.* Tree; tree and ladder.

SS. *Ewald the Black and Ewald the Fair, MM. c. 693.* Chalice and book; cross; crown; swords.

S. *Expeditus, M. 2d c.* Raven holding scroll; crow.

S. *Exuperius of Toulouse, B. c. 415.* Asperge; plough.

S. *Fabian, P. M. 250.* Dove; triple crown; executioner's block; club; sword.

S. *Faith, V. M. c. 287.* Iron bed; book; bundle of rods; gridiron and book; sword.

S. *Fausta, M. c. 305.* Cauldron of boiling lead; saw.

S. *Felicitas, W. M. c. 170.* Seven swords; cauldron of oil and sword; sword with seven heads; eight palms.

S. *Felix of Cantalicio, C. 1587.* Pilgrim's staff; sack; beggar's wallet; scroll with words *Deo gratias.*

S. *Felix of Dunwich, B. 646.* Three rings; mitre.

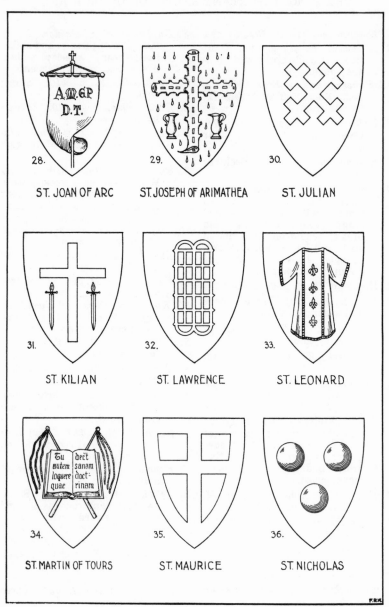

28.
ST. JOAN OF ARC

29.
ST. JOSEPH OF ARIMATHEA

30.
ST. JULIAN

31.
ST. KILIAN

32.
ST. LAWRENCE

33.
ST. LEONARD

34.
ST. MARTIN OF TOURS

35.
ST. MAURICE

36.
ST. NICHOLAS

Saints

PLATE XXXII

S. *Felix of Nola, c. 266.* Cluster of grapes; angel; broken shells or glass; spider's web.

S. *Felix of Valois, C. 1212.* Cloak with red and blue cross; white stag with cross between its horns; fountain.

S. *Ferdinand of Castile, K. 1252.* Crown; cord; orb; sword.

S. *Fiacre, H. C. c. 550.* Spade and open book; rosary; birds.

S. *Fina, V. M. 253.* Oaken plank and chains.

S. *Firmin I of Amiens, B. M. 287.* Sword and severed head mitred; tree in full leaf.

S. *Firmin II of Amiens, B. C. M. c. 287.* Sword; severed head mitred.

S. *Flavia, M. 540.* Crown.

S. *Florent of Glonne, Ab. H. 415.* Dragon; boat piloted by angel; flower.

S. *Florian, M. c. 252.* Millstone; eagle; flames and pail of water; hand extended from a tomb.

S. *Frances of Romana, W. Abs 1440.* Book of offices.

S. *Francis of Assisi, C. 1226.* Birds and animals; bag of gold and rich raiment at his feet; winged crucifix with five rays; stigmata; crown of thorns; lighted lamp: fiery chariot.

S. *Francis de Paula, H. 1507.* Staff, crucifix and rosary; word *Caritas* rayed; cloak.

S. *Francis de Sales, B. 1622.* Heart and crown of thorns rayed; flaming heart.

S. *Francis Xavier, 1552.* Pilgrim's staff; rosary; lily; font; ship and crucifix.

S. *Frediano of Lucca, B. 578.* Harrow; mitre; rock.

S. *Frideswide, V. c. 750.* Ox; book and staff.

S. *Fronto of Perigueux, B. M. 1st c.* Dragon; bishop's staff; glove; overturned image of Venus; axe.

S. *Gabriel, Arch.* Sceptre and lily; MR or AM shield; lantern; mirror; olive branch; scroll with words *Ave Maria Gratia Plena;* Resurrection trumpet.

S. *Gall of Auvergne, B. C. c. 550.* Angel holding white chasuble, or sheathing sword; book in a fire.

S. *Gall of Switzerland, Ab. C. 646.* Bear carrying wood; loaf and staff.

S. *Gamaliel, D. 1st c.* Reliquary of S. Stephen; book; scroll.

S. *Gaspar, Mg. 1st c.* Casket of gold; crown.

S. *Geminanus, B. c. 460.* Mirror; staff; model of Modena.

S. *Geneviève, V. 512.* Shepherdess' crook; distaff or loom; devil holding bellows; lighted candle; bunch of keys; medal stamped with a cross; basket of bread.

S. *George of Cappadocia, M. c. 303.* Armour, sword and spear; white banner charged with red cross; shield charged with red cross; slain dragon; broken wheel; cup of poison; boiling oil; sword; cross; nails.

S. *Gerasimus, Ab. 476.* Lion holding basket; donkey.

S. *Gereon, M.* Shield; sword; spear; well.

S. *Germanus of Auxerre, B. C. 448.* Dragon with seven heads: fetters; donkey; book and staff.

S. *Gertrude of Hamage, W. Abs. c. 655.* Model of conventual buildings.

S. *Gertrude of Nivelles, V. Abs. 655.* Mice and rats; a loaf; lily; distaff.

S. *Gertrude of Rodalsdorf, V. Abs. 1292.* Seven rings; heart with IHS.

SS. *Gervasius and Protasius, MM. c. _69.* Dalmatics; scourge loaded with lead; tree; book; sword.

S. *Getulius, M. c. 125.* Stake and flames; Roman armour; club.

S. *Gilbert, Ab. C. 1189.* Model of a church.

S. *Gildas the Wise, Ab. c. 570.* Bell; staff; fountain at his feet.

S. *Giles, H. Ab. c. 712.* (S. Egidius.) Hind pierced with arrows.

S. *Giovito, M. 2d c.* Lions; sword.

S. *Goar, Pr. C. 575.* Earthen vessels; three hinds.

S. *Grata, W. c. 300.* Head of S. Alexander.

S. *Gregory the Great, P. C. D. 605.* Desk and book; dove; altar; double or triple cross; scroll with ancient musical notation; eagle; lectern; scroll with quotation from his writings; tall cross and book.

S. *Gregory Nazianzus, Ar. C. D. 390.* Wisdom and Charity appearing to him; epigonation; scroll with quotation from his writings.

S. *Gregory of Tours, B. C. 596.* Fish; reliquary.

S. *Gregory Thaumaturgus, B. C. 270.* Devils fleeing from temple; budding staff; angel; large rock.

S. *Gudula, V. 712.* Lantern; devil with bellows; twisted taper; loom.

S. *Guenolé of Landevenec, Ab. 6th c.* Goose; fountain; fishes; bell.

S. *Guthlac, Ab. H. 714.* Scourge; serpent; model of Croyland abbey.

S. *Helena, Eps. c. 327.* Crown; large cross; hammer and nails; Cross of Jerusalem; double cross; open book and crown; model of the Church of the Holy Sepulchre.

S. *Henry, Emp. 1024.* Sword and church; lily; crown; dove on an orb; model of Bamburg cathedral.

S. *Herculanus of Perouse, B. M. 549.* Sword or knife; fallen temple.

S. *Herman-Joseph, B. C. 1226.* Pen; cross; rosebud; two rings; palette; inkhorn, pen and scroll; apple.

S. *Hermengild, K. M. 586.* IHS on his breast; axe; crown under foot.

S. *Hervé, H. c. 576.* Wolf; frog; fox.

S. *Hilarion of Gaza, H. 371.* Hour glass; basket; dragon.

S. *Hilary of Arles, Ar. C. 449.* Dove; staff.

S. *Hilary of Poitiers, B. C. 368.* Pen and three books; serpents; child in cradle; open book; equilateral triangle; trumpet; serpent entwined on a staff.

S. *Hilda, V. Abs. 680.* Snakes; bird; model of Whitby abbey; crosier.

S. *Hippolytus the Gaoler, M. c. 252.* Armour; bunch of large keys; spear; tails of wild horses; lance; iron hook.

S. *Honoré, Ar. C. 653.* Wooden shovel; three loaves on a baker's shovel; shovel putting forth sprouts and leaves.

S. *Hubert of Liége, B. 727.* Dogs; hunter's horn; white stag with crucifix between horns on a book; stole.

S. *Hugh of Grenoble, B. C. 1132.* Branch and seven stars; lantern; three flowers.

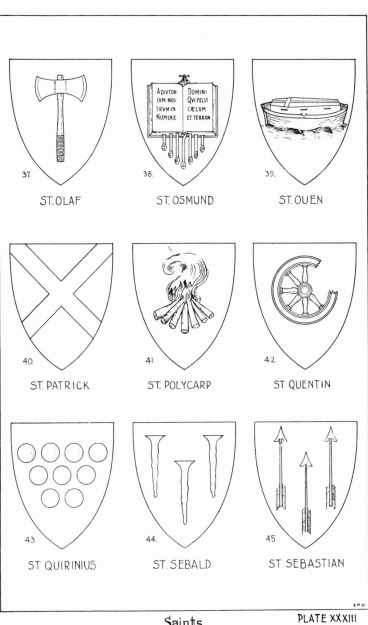

37. ST. OLAF

38. ST. OSMUND

ADIVTOR IVM NOS TRVM IN NOMINE / DOMINI QVI FECIT CÆLVM ET TERRAM

39. ST. OUEN

40. ST. PATRICK

41. ST. POLYCARP

42. ST. QUENTIN

43. ST QUIRINIUS

44. ST. SEBALD

45. ST SEBASTIAN

Saints

PLATE XXXIII

S. Hugh of Lincoln, B. c. 1200. Holy Child in chalice; swan; model of Lincoln cathedral.

S. Hugh (Little), M. 1255. Cross or crucifix.

S. Hyacinth, C. 1257. Pyx; staff; cloak; scorpion.

S. Ignatius, B. M. 107. Lions; chains; heart with IHC; crucifix.

S. Ignatius Loyola, C. 1556. A rayed IHC or IHS; heart with crown of thorns; sword and lance upon an altar; book with words *Ad Maiorem Dei Gloriam.*

S. Innocent, P. 417. Angel holding a crown.

S. Irenaeus of Lyons, B. M. 202. Lighted torch; book.

S. Irene of Constantinople, V. M. 290. Overturned idols; horse; tower.

S. Isabella, V. 1270. Lily; crown on left wrist; model of convent.

S. Isidore of Seville, B. 636. Beehive; pen.

S. Isidore, C. 1170. White oxen; spade; hoe or rake; plough.

S. Ives, B. C. c. 650. Fountain flowing from a tomb.

S. Ives of Bretagne, C. c. 1303. Scroll with legal seals; law books.

S. James Major, A. M. c. 44. Pilgrim's staff; escallop; pilgrim's hat; wallet; keys; scrip; cloak; white horse and white banner; three escallops; sword and escallop.

S. James Minor, A. M. c. 61. Vertical saw; fuller's club; windmill; halbert; three stones; loaf of bread.

S. James of Nisbis, B. c. 349. Swarm of bees.

S. James of Ulm, 1440. Glass painter's tools.

S. Januarius, B. M. c. 303. Heated oven; two phials of blood on Bible.

S. Jedoc, H. 668. Crown at his feet; pilgrim's staff tipped with crucifix; fountain; boat; chalice with hand in benediction over it.

S. Jerome, C. D. 420. Lion; stone; cardinal's hat; inkhorn and pen; skull; scroll inscribed *Ciceronianus es;* model of a small church; cross potent fitched; fox; hare; stag; partridge; open Bible; stone and scourge; fawn; copy of the Vulgate and pen; resurrection trumpet.

S. Joachim, 1st c. Basket containing doves; model of Golden Gate of Jerusalem.

S. Joan of Arc, V. M. 1431. Armour; sword; banner of the Annunciation; fleur-de-lys; tunic; stake and burning fagots.

S. Joanna, 1st c. Jar of ointment; pitcher; basket; lamb.

S. John the Almoner, Ar. c. 618. Cripple receiving alms; purse; loaf.

S. John the Apostle, A. Ev. c. 100. Cup and serpent; eagle rising out of a cauldron; serpent entwined on a sword; grave; Prester John seated on tomb, with book, orb and sword; eagle on a closed book; scroll of his Gospel; scroll of the Apocalypse; nimbed eagle.

S. John the Baptist, M. c. 31. Lamb; lamb on a book of seven seals; camel's hair tunic; girdle; locust; his head on a charger; scroll with words *Ecce Agnus Dei,* or with *Vox clamantis in deserto;* long, slender cross-tipped staff; open Bible; banner of victory.

S. *John of Beverley, B. 721.* Shrine; cross-staff.

S. *John of Bridlington, C. 1379.* Canon's habit; fish.

S. *John Calybite, H. c. 450.* Hut; beggar's dish; chains.

S. *John Capistran, C. 1456.* Crucifix; IHS banner; red cross; star.

S. *John Chrysostom, B. D. 407.* See S. Chrysostom.

S. *John Climacus, Ab. c. 605.* Ladder with thirty rungs.

S. *John of the Cross, C. 1591.* Eagle at his feet; books; cross.

S. *John Damascene, Mk., 780.* Basket; vase; axe; severed hand.

S. *John Gaulberto, Ab. 1073.* Tau staff; crucifix; church in his hand; devil under his feet.

S. *John of Matha, Ab. C. 1213.* Red and blue cross; broken chains.

S. *John Nepomuk, M. 1393.* Bridge; five or seven stars; padlock; cross.

S. *John the Obedient, H. 4th c.* Pitcher and dead tree; huge rock.

S. *John of Reomé, H. Ab. 6th c.* Chained dragon or serpent; winged serpent issuing from a well.

SS. *John and Paul of Rome, MM. 362.* Thunderbolt; sword.

S. *Jophiel, Archangel.* (S. Zophiel.) Flaming sword.

S. *Joseph of Arimathaea, C. 1st c.* Box of ointment; budding staff; the Holy Grail; thorn tree; wattled hut; model of the *Vetusa Ecclesia* of Glastonbury; circle of thirteen wattled huts; vase.

S. *Joseph of Nazareth, 1st c.* Rod blossoming with lilies and almonds; lilies and carpenter's square; saw, axe, hatchet or plane; oleander staff; dove.

S. *Juan de Dios, C. 1550.* Pomegranate and cross; crown of thorns; model of hospital; alms chest; two cups.

S. *Jude, A. M. 1st c.* Sail boat; inverted cross; square; halbert; club; loaves and fish; long cross; knotted club; boat hook; fuller's bat; lance; saw; flail; closed book.

S. *Julia of Corsica, V. M. 443.* Cross and ropes; scourge; dove.

S. *Julian of Alexandria, M. 250.* Camel; scourge; column and fagots.

SS. *Julian and Basilassa of Egypt, MM. c. 313.* Lighted torch; lily and book.

S. *Julian Hospitator, (The Ferryman), H. 9th c.* Ferry boat; oar; hawk; stag; hunter's horn.

S. *Julian of Mans, B. 3d c.* Sword; banner; fountain; dragon; broken idol; pitcher.

S. *Juliana of Nicomedia, V. M. c. 309.* Chained dragon; cauldron; fire; scourge.

SS. *Julitta and Cyricus, MM. c. 304.* Rack; sword; fountain; oxen.

SS. *Justa and Rufina, VV. MM. c. 304.* Broken images or pottery; model of Giralda tower.

S. *Justin of Auxerre, M. 3d c.* Child's head; sword.

S. *Justin of Rome, M. c. 167.* Red-hot helmet.

S. *Justina of Antioch, V. M. 303.* Scourge; iron hook; cauldron; lily; cross; sword.

S. *Justina of Padua, V. M. 303.* Unicorn; sword or dagger; crown at her feet.

S. *Kenlem, K. M. c. 821.* Thorn tree and rays of light from Heaven; falcon; lily; crown.

S. Kentigern of Scotland, B. 601.
(S. Mungo.) Salmon with ring in its gills or mouth; plough drawn by two stags; wolf; robin; bear; boar.

S. Kilian, M. 688. Cross; sword; dagger; two swords.

S. Ladislas, K. C. 1095. Globe with crosses; water flowing from rock; crown.

S. Lambert, B. M. 709. Hot coals in a surplice; dart; lance or javelin; sword and open book; cross; club.

S. Laud, B. C. 568. (S. Lo.) Dove of fire.

S. Laumur, Ab. 593. (S. Lomer, S. Launomar.) Barrel; doe; shepherd's staff; gold coins at his feet.

S. Lawrence, Dc. M. c. 258. Dalmatic; thurible; gridiron, dish of money; palm and crucifix; censer; processional cross; cross and book of Gospels; purse.

S. Lawrence of Canterbury, Ar. 619. Scourge.

S. Lazarus, M. 1st c. Tomb; bier; centurion's armour; pincers; red-hot armour; sword.

S. Leander, B. C. 596. Flaming heart; equilateral triangle; pen; image of the Virgin.

S. Leo the Great, P. 461. Image of the Virgin; pick-axe; model of S. Maria Maggiore; horse; Attila kneeling.

S. Leocadia of Toledo, V. M. 303. Scourges and cross; tower.

S. Leodegar, B. M. 678. (S. Leger.) Pick-axe and auger; two-pronged fork; bodkin; gimlet; eye held in pincers.

S. Leonard, H. Ab. C. 559. Chain and manacles; broken fetters; fountain; dalmatic charged with fleurs-de-lys.

S. Leonor of Brittany, B. C. 530. (S. Lunaire.) Stag and bell; mantle hung on sunbeam.

S. Leopold IV, Emp. C. 1136. Model of abbey; rosary.

S. Liborius of Le Mans, B. 397. Book and several small stones; peacock; peacock's feather.

S. Lieven, M. 656. His severed tongue held in tongs; sword.

S. Lifard of Orléans, Ab. 6th c. Serpent entwined on crutched staff.

S. Linus, P. M. 1st c. Triple cross; fleeing demons.

S. Longinus, M. c. 45. Centurion's armour; spear and lance; crystal vase; dragon under his feet; sword.

S. Louis, K. C. 1270. Crown and sceptre tipped with a *Manus Dei;* crown of thorns; fleurs-de-lys; three nails; banner with fleurs-de-lys; dove; pastoral staff.

S. Louis, B. 1297. Chasuble; crosier; I. N. R. I. on a tablet; crown and mitre; cope embroidered with fleurs-de-lys; three crowns at his feet.

S. Louvent, H. M. 6th c. Eagle; severed head; two sacks.

SS. Lucia and Gemianus of Rome, MM. c. 304. Scourge; temple of Jupiter in ruins; cauldron of boiling pitch; dove; swords; two palms.

S. Lucien of Antioch, B. M. 312. Altar breads on his breast; potsherds; millstone; dolphin.

S. Lucien of Beauvais, M. c. 312. Severed head; sword.

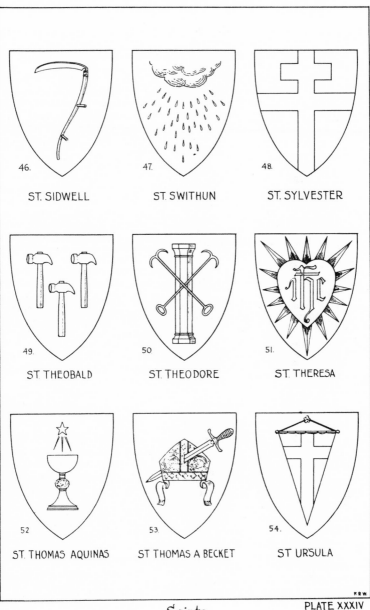

46. ST. SIDWELL

47. ST. SWITHUN

48. ST. SYLVESTER

49. ST. THEOBALD

50. ST. THEODORE

51. ST. THERESA

52. ST. THOMAS AQUINAS

53. ST THOMAS A BECKET

54. ST URSULA

F.R.W.

Saints

PLATE XXXIV

S. *Lucy of Syracuse, V. M. 303.*
Lamp; dagger; three crowns;
cauldron; two oxen; stake and
fagots; cup; sword through
his neck; poniard; ropes; eye
held in pincers; awl; eyes on
a book or in a dish. (Some
authorities state that there
were two virgins named S.
Lucy.)

S. *Ludger, B. 809.* Church; eagle;
stigmata; swan.

S. *Luke, Ev. M. 1st c.* Winged ox;
picture of the Virgin; palette
and brushes; phials of medi-
cine; physician's robes; easle;
book and pen; hatchet; wood-
en horse; books of his Gospel
and of the Acts. (Martyrdom
uncertain.)

S. *Lupicienus, H. Ab. 480.* Money
at his feet; demon throwing
stones.

S. *Lupus of Sens, Ar. 623.* Chalice
and diamond; wine cask on
wagon.

S. *Macarius the Younger, H. 394.*
Skull on a rock; sack of sand
on his shoulders; calabash;
phial of oil; lantern; hyena;
girdle of ivy leaves.

S. *Macarius of Antioch, B. C. 1012.*
Heart surmounted by three
nails.

S. *Maccald, B. 498.* Rowboat; oar;
blazing star.

S. *Machutus, B. C. c. 630.* (S. Mac-
lovius.) Child at his feet.

S. *Macrina the Elder, W. c. 312.*
Stag; two stags.

S. *Maglorious, B. C. 575.* Chalice
and host; angel.

S. *Magnus, B. M. 666.* Bear and
apple tree; sheep; serpents;
sword and club.

S. *Mammes, M. c. 274.* Doe; lion;
trident; burning coals.

S. *Marcella, V. 68.* Pilgrim's staff;
boat; scroll.

S. *Marcellina, V. 397.* Small cross
in her hand; veil.

S. *Marcellus of Paris, B. 436.*
Dragon held by a stole.

S. *Marcellus of Rome, P. M. c. 310.*
Ox and ass; crib.

SS. *Marcus and Marcellinus, MM. c.
286.* Post and large nails;
lances.

S. *Marculphus of Nanteuil, B. 6th c.*
Wolf; hare; loaf of bread.

S. *Margaret of Antioch, V. M. 4th c.*
Chained dragon; dragon burst
asunder; girdle; sheep; gar-
land of pearls; daisy; wreath
of marguerites; long cross;
crown.

S. *Margaret of Cortona, Pen. 1297.*
Distaff; dog; skull; girdle of
cords; passion instruments.

S. *Margaret, Q. 1093.* Black cross;
sceptre and book; hospital.

S. *Marina, V. c. 756.* Wagon and
oxen; child; open tomb with
descending dove above it.

S. *Marinus, D. 4th c.* Dalmatic;
bear; stone-cutter's tools; two
oxen.

S. *Mark, Ev. 1st c.* Fig tree; pen,
book and scroll; club; barren
fig tree; scroll with words *Pax
Tibi;* winged and nimbed lion.

S. *Mark the Hermit, 4th c.* Chalice
held by an angel; skin of a
ram or of a hyena; lioness
with cub.

S. *Martha, V. c. 84.* Water pot and
asperge; cooking utensils;
ladel or skimmer; broom;
bunch of keys at her girdle;
two asperges; dragon bound
with a girdle; torch; censer;
boat.

S. *Martin of Rome, P. M. 655.* Ball
of fire; church and crosier;
three geese; prison bars.

ADVENT

IMMACULATE CONCEPTION

CHRISTMAS

EPIPHANY

PURIFICATION

LENT

PALM SUNDAY

MAUNDY THURSDAY

GOOD FRIDAY

The Church Year

PLATE XXXV

S. *Martin of Tours, B. C. c. 400.* Horse; sword and coat cut in halves; goose; scourge; hare; broken images; chair in flames; demon at his feet.

S. *Martina, V. M. 255.* Hay fork with two prongs; lictor's axe or sword; red-hot pincers; lion; cauldron of oil.

S. *Mary of Bethany, V. 1st c.* Footstool; jar of ointment; boat.

S. *Mary of Clopas, 1st c.* Boat, toy windmill, fish and cup held by four children.

S. *Mary of Egypt, Pen. H. 5th c.* Three small loaves; death's head; scourge; ship; robe held by an angel; lion digging grave.

S. *Mary Magdalene, c. 68.* Rich raiment; box of ointment; skull; book; vase of sweet spices; crucifix; open book; boat.

S. *Mary the Penitent, H.* See S. Mary of Egypt.

S. *Mary the Virgin, 1st c.* See Chapter XIII.

S. *Maternus, B. C. c. 348.* Three mitres; pilgrim's staff; models of Cologne, Tongres and Treves.

S. *Matilda, Q. 968.* Church and crucifix; money bag; altar.

S. *Mathurinus, Pr. C. c. 380.* Chasuble; covered vessel; chains.

S. *Matthew, A. Ev. M. c. 90.* Money bag; money chest; winged man; dolphin; battle axe; carpenter's square; tiara; pen and ink-horn; halbert; tall cross; Tau cross; scroll of his Gospel; sword.

S. *Matthias, A. M. 1st c.* Halbert; lance; carpenter's square; sword held by its point; axe; saw; scroll; scimitar and book; stone; battle axe; two stones; long cross; hatchet.

S. *Maurice, M. 286.* Armour; banner with lion rampant; sword; seven stars; eagle on a shield; red cross.

S. *Maurilius of Angers, B. C. c. 438.* Fish with a key, or two keys, in its mouth; gardner's tools; dove; staff surmounted by a dove.

S. *Maurus, Ab. 584.* Book and censer; pair of scales; pilgrim's staff; crutch; pastoral staff and crutch; spade.

S. *Maxentius of Poitiers, Ab. c. 515.* Birds; dove.

SS. *Medard and Geldard, BB. MM. 545.* Two white doves; three white doves; eagle; knife; ox; colt; torch; tooth.

S. *Melania the Younger, W. 439.* Model of a church; open purse.

S. *Melanius of Rennes, B. C. 530.* Dragon at his feet; boat without sails or rudder.

S. *Melchoir, Mg. 1st c.* Casket of frankincense; crown.

S. *Mello of Rouen, B. 304.* (S. Melanius.) Serpent or dragon; staff.

S. *Menéhould of Perthes, V. 5th c.* Spindle; lantern.

S. *Mercurius, M. 3d c.* White horse; spear or lance.

S. *Michael, Archangel.* In armour; lance and shield; scales; shown weighing souls; millstone; piercing dragon or devil; banner charged with a dove.

S. *Milburga, V. Abs. 722.* Flock of wild swans, or of geese; model of a church.

S. *Mildred, V. Abs. c. 680.* Lamp; model of her abbey.

S. *Minias of Florence, M. 254.* (S. Miniato.) Crown; spear; arrows; javelin; lily; lions; cauldron of oil; sword.

S. *Modwenna, V. Abs. c. 650.* Staff and book; red cow.

S. *Monegonda, H. Abs. c. 570. Cruet* of vinegar; barrel of salt.

S. *Monica, W. 387.* Monstrance; IHC on a tablet; veil or handkerchief; open book; girdle or staff.

S. *Mungo, B. 601.* See S. Kentigern.

SS. *Nabor and Felix, MM. c. 304.* Armour; in secular or classical costumes.

S. *Narcissus, B. M. 216.* Book; pitcher of water; thistle; narcissus; sword.

S. *Natalia, W. M. c. 304.* Anvil; lion; tomb.

SS. *Nazarius and Celsis, MM. c. 69.* Swords; armour and millstones.

S. *Neot, C. c. 878.* Pilgrim's hat and wallet; cross-tipped staff; doe; four stags hitched to a plough.

SS. *Nereus and Achilleus, MM. 1st c.* Two posts and lions; fire; two swords.

S. *Nicasius of Reims, B. M. 406.* Upper half of a mitred head.

S. *Nicephorus, M. 260.* Crown; tub with holes in it.

S. *Nicholas of Myra, B. C. 326.* Three children in a trough or tub; three golden balls on a book; six golden balls; three golden apples; three loaves; three purses; anchor; ship; Trinity symbol on a cope; angel; small church.

S. *Nicolas Tolentino, C. 1309.* Crucifix and wreath of lilies; flaming star; doves and dish; partridge; fountain.

S. *Nicomede, Pr. M. c. 90.* Spiked club.

S. *Nicodemus, 1st c.* Lantern; vase of ointment; shroud; sculptor's tools.

S. *Nilus, Ab. 1005.* Sanctuary lamp.

S. *Ninan, B. 432.* Crosier; large chain; budding staff; fountain.

S. *Norbert, Ar. 1134.* Monstrance and chalice; chained devil; chalice with large spider over it; ciborium.

S. *Nothburga, V. 1315.* Sickle or scythe; bunch of keys.

S. *Odilo, Ab. 1049.* Two cups; banner with red and white cross; skull.

S. *Odo, Ar. 960.* Model of Canterbury cathedral.

S. *Olaf, K. M. 1030.* (S. Olave.) Battle-axe; crown, sceptre and sword; dagger; ladder; loaf; stones; halbert.

S. *Olivia of Brescia, M. 2d c.* Redhot brazier; leaden ropes.

S. *Omobuono, 2d c.* Shears; tailor's iron; wallet; tunic and fur cap; wine flasks.

S. *Onesimus, M. 1st c.* Club.

S. *Onophrius, H. 4th c.* (S. Onofrio.) Branch of a tree; tunic of palm leaves; staff; rosary; crown and sceptre at his feet.

S. *Osmund of Salisbury, B. C. 1099.* Book of Sarum Use; model of a church.

S. *Oswald, K. M. 642.* Sceptre and crown; large wooden cross; ciborium; raven carrying ring or oil-stock; letter and box of ointment; horn; silver dish; dove; sword.

S. *Oswyn, K. M. 651.* Spear; spear and sceptre; crown.

S. *Osyth, V. M. c. 870.* Three loaves; bunch of keys; severed head; stag; crown.

S. *Othilia, V. Abs. c. 770.* (S. Ottilia.) Lily; eyes upon a book; crosier and palm; key; chalice.

S. *Ouen, Ar. c. 685.* Cross in the air above him; coffin in a boat; well; pilgrim's staff and book.

S. *Pachomius, H. Ab. c. 346.* Sleeveless tunic; goat skin; serpents.

S. *Pancras, M. 304.* Sword and stone; armour; Saracen crown under his feet.

S. *Pancras of Taormina, B. M. 1st c.* Two broken idols; stones.

S. *Pantaleon, M. c. 304.* Budding olive branch or olive tree; vials of medicine; lion; club; sword and vase.

S. *Paphuntius, M. c. 303.* Palm tree; nails.

S. *Paternus, B. C. 565.* (S. Padarn.) Serpent; bishop's staff; mitre.

S. *Patrick, B. C. 5th c.* Archbishop's cross; shamrock; serpent; dragon; fire; font; mitre and crosier; long staff; tall cross; wallet; serpent entwined on a bishop's crosier; Irish harp.

S. *Patroclus of Colombières, Ab.* Cross or crucifix and staff.

S. *Paul, A. M. c. 68.* Book and sword, three fountains; two swords; scourge; serpent and a fire; armour of God; twelve scrolls with names of his Epistles; phoenix; palm tree; shield of faith.

S. *Paul the Anchorite, H. c. 342.* Raven bringing him bread; tunic of palm leaves.

S. *Paula of Bethlehem, W. 404.* Passion instruments; book; pastoral staff; sponge; scourge.

S. *Paulinus of Nola, B. C. c. 431.* Spade; model of the Church of S. Felix; lamp; bell.

S. *Paulinus of York, Ar. 644.* Book; stone cross; model of York; mitre and archbishop's staff; font.

S. *Pelagia, Pen. c. 460.* Jewels and mask; musical instruments at her feet.

S. *Perpetua, M. c. 203.* Wild cow; spiked ladder guarded by a dragon.

S. *Peter, A. M. c. 68.* Two keys saltire; pastoral staff and two large keys; inverted cross; inverted cross and two keys saltire; crowing cock; fish; two swords; patriarchal cross and two keys saltire; two keys and a scroll; sword.

S. *Peter of Alcantara, C. 1562.* Cross of twigs or boughs; ladder and star; dove.

S. *Peter Chrysologus, Ar. 450.* Dog at his feet; bishop's staff; beehive.

S. *Peter Damian, B. Car. 1072.* Cardinal's hat; cross; cardinal's hat and mitre; scourge.

SS. *Peter Exorcista and Marcellinus, MM. 304.* Font; swords.

S. *Peter the Martyr of Verona, M. 1252.* Large knife; *Credo* written on the ground with his blood; axe; sword; cross; cross and book; crucifix; three crowns and a palm.

S. *Peter Nolasco, 1258.* White vestments; shield of K. James of Aragon; olive branch; bell and ray of light; banner with red cross and a chain.

S. *Petrock, Ab. C. c. 564.* Box of relics; model of a church.

S. *Petronilla, V. 1st c.* Keys; broom and closed book; crown of roses.

S. *Petronius, B. c. 440.* Model of the city of Bologna.

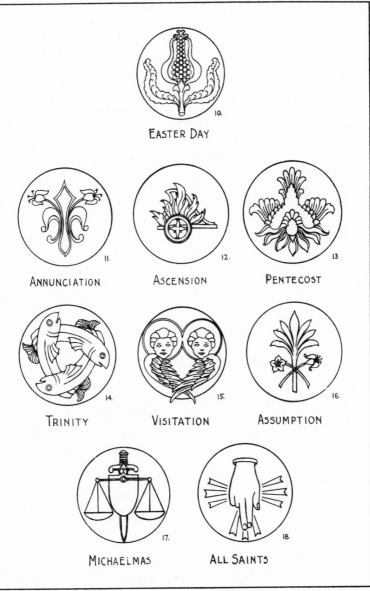

EASTER DAY

ANNUNCIATION

ASCENSION

PENTECOST

TRINITY

VISITATION

ASSUMPTION

MICHAELMAS

ALL SAINTS

The Church Year PLATE XXXVI

S. *Pharailde, V. 745.* Goose and three cakes; hen and dish with eggs; loaves.

S. *Philip, A. M. 1st c.* Basket; basket and Tau cross or letter Tau; two or three loaves and a cross; patriarchal cross and spear; knotted cross; broken idols; inverted cross; tall column; dragon; carpenter's square and cross; long staff and spear; tall cross and book.

S. *Philip Benozzi, C. 1285.* Chariot; olive branch; red robes; surgical instruments; two angels holding three crowns.

S. *Philip the Deacon, Dc. 1st c.* Dalmatic; escallop; chariot and book.

S. *Philip Neri, Pr. C. 1595.* Rosary; lily; angel holding a book.

S. *Philomena, V. M. c. 303.* Lily; javelin; scourge; anchor; two arrows; javelin with reversed head; olive branch.

S. *Phocas of Sinope, M. 303.* Spade; open purse; ship; sword.

S. *Pius I, P. M. c. 155.* Rayed IHS on an oval medallion.

S. *Placidus, M. 119.* See S. Eustace.

S. *Placidus, M. 540.* Tongue and knife; crescent; sword.

S. *Plautilla, c. 67.* Blood-stained veil of S. Paul.

S. *Pol de Leon, 573.* Bell; loaf and vessel of water.

S. *Polycarp, B. M. c. 166.* Pile of fagots in flames; oven; dagger; sword; dove.

S. *Polyeuctus, M. 259.* Roman armour; sword.

S. *Pourcain, Ab. 7th c.* Broken cup and a serpent.

SS. *Praxedes and Pudentiana, VV. MM. c. 148.* Sponge and cup or basin; two open purses; bunch of leaves or herbs.

S. *Prisca, V. M. c. 275.* Eagle; lion couchant; two lions; sword; overturned idol.

S. *Processus, M. 1st c.* Centurion's armour; hurdle; scorpions.

S. *Procopius, Ab. H. 1053.* Fallen tree; wounded hind.

S. *Procopius of Caesarea, M. 303.* Roman armour; spear; burning wood; brazier; shining cross above him; sword.

S. *Proculus, M. 445.* Axe; sword; banner and cross.

S. *Protasius, M. c. 69.* See SS. Gervasius and Protasius, MM.

S. *Protus of Cilicia, M. c. 260.* Pillar; dagger; sword.

S. *Pudentiana, V. 148.* Sponge and cup or basin; open purse; bunch of leaves or herbs.

S. *Pulcheria, Emp. 453.* Tablet of gold studded with jewels; sceptre and lily; unicorn; scroll with the word *Theotokos.*

S. *Quentin, M. 287.* (S. Quintin.) Broken wheel; iron spits saltire; dalmatic; Roman officer's armour; three large nails; wooden chair and three large nails.

S. *Quirinus, M. 130.* Hawk or falcon; shield with six or nine balls; horse; severed tongue held in pincers; dogs.

S. *Radegund, Q. Abs. 587.* Chain; two wolves; crosier and book; crown and sceptre; field of oats; broken fetters; mantle charged with fleurs-de-lys or castles; crown and long veil; sceptre tipped with a fleur-de-lys; cross.

S. *Ranieri, H. 1161.* Winged cat on a wine cask; angel; slave shirt; eagle with blazing light.

S. *Raphael Archangel.* Staff; wallet and fish; staff and gourd.

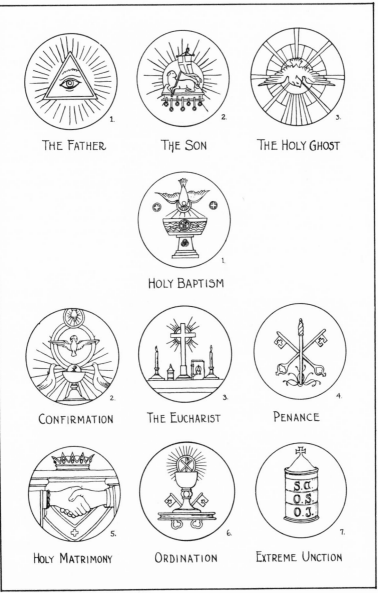

THE FATHER THE SON THE HOLY GHOST

HOLY BAPTISM

CONFIRMATION THE EUCHARIST PENANCE

HOLY MATRIMONY ORDINATION EXTREME UNCTION

The Trinity - Sacraments PLATE XXXVII

S. Raymond of Catalonia, 1275. Cloak and staff; key.

S. Raymond Nonnatus, Car. 1240. Padlock; crown of thorns; three or four crowns.

S. Regina, V. M. 251. (S. Reine, S. Alise.) Rayed cross with a dove on it; fire; sword; crown; lamb at her feet; two angels holding a crown; boiling cauldron; torch; fountain.

S. Regulus of Arles, B. 4th c. (S. Rieuil, S. Rule.) Donkey; frogs; broken chains; fountain.

S. Remigius of Reims, B. C. 533. (S. Remi.) Oil stock; dove with Holy Ampulla in its beak; birds; veil of S. Veronica; font; broken fetters.

S. Reparata, V. M. 3d c. Crown and book; white banner with red cross; sword; dove.

S. Restituta, V. M. 3d c. Burning ship.

S. Richard of Chichester, B. C. 1253. Plough or flail; book and bishop's staff; chalice at his feet.

S. Riquier, Ab. 645. Two keys; fountain and staff.

S. Robert of Knaresborough, H. c. 1240. Asperge; fleeing devil; cow.

S. Roch, C. 1348. (S. Rocco.) Pilgrim's hat and staff; angel; dog with loaf in mouth; hat with crossed keys or with escallop; plague spot on his thigh.

S. Romanus of Rouen, B. C. 639. Dragon with stole on neck.

S. Romanus of Antioch, M. 304. Roman armour; sword; bound dragon.

S. Romanus of Condate, H. Ab. 460. Money at his feet; demon hurling stones.

S. Romualdo, Ab. 1027. Crutch; ladder.

S. Romulus of Fiesole, B. M. c. 72. Bishop's robes; sword or dagger.

S. Ronan, B. H. 6th c. Devil biting crosier.

S. Rosa di Viterbo, V. 1261. Crown of roses; gray tunic; knotted girdle.

S. Rosalia of Palermo, V. H. 1160. Double Greek cross; crucifix; angel with crown of roses.

S. Rosaline, V. 1329. Reliquary containing two eyes; roses.

S. Rose of Lima, V. 1617. Crown of roses and thorns; needle and thimble; spiked crown; iron chain.

SS. Rufina and Secunda, VV. MM. 304. Broken images or pottery.

S. Rupert, B. C. 718. Salt box; model of a church; basket of eggs.

S. Rumbold of Malines, B. M. c. 775. (S. Rombold, S. Rumold.) Chest of money; hoe.

S. Sabas the Goth, M. 372. Bundle of thorns; cauldron of boiling pitch; axle tree.

S. Sabas of Palestine, Ab. 532. Apple; lion.

S. Sabina, W. M. 2d c. Temple; sword.

S. Samson, B. C. c. 565. Cross and dove; closed book and staff; mitre; model of Dol cathedral.

S. Savinian, B. M. 3d c. Host; sword; altar.

S. Scholastica, V. Abs. 543. Dove; lily; open book; model of a church; crucifix.

S. Sebald, H. c. 750. (S. Seward.) Pilgrim's staff, wallet and hat; two oxen; cloak; icicles; rosary; model of a church with two towers; escallop.

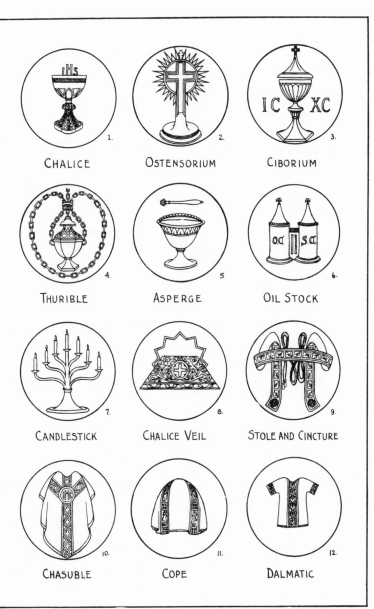

CHALICE	OSTENSORIUM	CIBORIUM
THURIBLE	ASPERGE	OIL STOCK
CANDLESTICK	CHALICE VEIL	STOLE AND CINCTURE
CHASUBLE	COPE	DALMATIC

Vessels and Vestments

PLATE XXXVIII

S. Sebastian, M. 303. Tree and cords; arrows; bow; cross and two arrows; clubs; crown; lily; shield and three arrows.

S. Secundus of Asti, M. c. 120. Roman armour; rain cloud and rain; model of church at Asti; angel with the Sacrament.

SS. Serapia and Sabina of Rome, MM. c. 126. Flaming torch; club.

SS. Sergus and Bacchus of Syria, MM. 250. Former with cross; white shield with golden cross fleurée; scourges.

S. Servatus, B. 384. Eagle; angel with mitre and pastoral staff; large silver key; fountain; dying dragon; tomb; three wooden shoes.

Seven Sleepers of Ephesus, 3d c. Three clubs, two hatchets, burning torch and large nail.

S. Severinus of Vienna, Pr. 482. Singing angels; model of a church.

S. Severus of Ravenna, B. c. 389. Weaver's shuttle; loom; dove.

S. Severus of Barcelona, B. M. c. 632. Corona of nails.

S. Sidwell, V. M. c. 740. Scythe; well; severed head.

S. Sigismund, K. H. M. 517. Well; sword.

S. Silverius, P. M. 538. Triangle; church; pilgrim's staff; bowl and loaf of bread.

S. Simeon Stylites, H. C. 459. Lofty column; scourge.

S. Simon of Jerusalem, B. M. c. 107. (S. Simeon.) Bishop's vestments; cross; fish.

S. Simon of Trent, M. 1472. Long bodkin; rope; cross.

S. Simon Zelotes, A. M. 1st c. Fish and book; two fishes; oar; fuller's bat; ship; saw; axe; cross; saw and oar saltire; fish on a boat hook; sword.

S. Sitha, V. 1272. See S. Zita.

S. Sixtus II, P. M. 258. Cross; sword.

S. Spiridion of Cyprus, B. C. 348. Large thorn; serpent; eel; sheep; rosary, book and skull.

S. Stanislaus of Cracow, B. M. 1079. Open purse; altar.

S. Stanislaus, C. 1568. Couch; lily; angel with Viaticum.

S. Stephen, D. M. c. 34. Dalmatic; three stones; stones in a napkin; stones on a book.

S. Stephen of Hungary, K. C. 1038. Cross and sword; model of a church.

S. Stephen, P. M. 257. Angel holding staff; thunderbolt and ruined temple of Mars; altar and sword.

S. Susanna, V. M. 290. Crown at her feet; sword.

S. Swidbert, B. C. 713. Star; crosier with star; lamp.

S. Swithun, B. 862. Cross; rain cloud and rain; crosier and closed book.

S. Sybard, H. 6th c. (S. Cybar.) Broken fetters; doe; bag of money emptied on the ground.

S. Sylvester, P. C. 335. (S. Silvester.) Patriarchal cross; ox; chained dragon; font; keys; triple cross.

S. Symphorian of Autun, M. c. 270. Statue of Cybele and axe; vase of incense overturned; angel holding crown.

S. Syrus of Pavia, B. c. 100. Loaves of bread and fishes.

S. Sytha of Lucca, V. 1272. See S. Zita.

S. Teilo, B. 580. (S. Elios, S. Madoc.) Bell and chain.

S. Teresa, V. Abs. 1582. See S. Theresa.

S. Thais, Pen. 348. Jewels; scroll with words *Qui plasmati me, miserere mei.*

S. Theckla, V. M. 1st c. Lion; tiger; two or more serpents; globe of fire; flaming fagots; Greek cross.

S. Theobald of Sens, C. 1066. Two swans; shoemaker's tools.

S. Theodora, V. M. 303. Sword; veil.

S. Theodore, M. 306. Post and iron hooks; white horse; temple of Cybele in flames; crown of thorns; cross; Roman armour; sword.

S. Theodore, B. C. 613. Dragon or crocodile and spear; horse.

S. Theodosius of Palestine, H. 529. Purse; hour glass; ears of wheat; coffin.

S. Theodotus of Galatia, M. c. 304. Torch and sword; rack; wheel.

S. Theophilus, Pen. c. 540. Scroll held by the Virgin.

S. Theresa, V. 1582. Roses and lilies; inflamed heart; IHS on a heart; flaming arrows; dove; book and pen; crown of thorns; heart transfixed with flaming arrows; scapulary; crucifix and lily.

S. Thierry of Reims, Ab. H. 6th c. (S. Theodoric.) Eagle.

S. Thomas, A. M. 1st c. Spear and lance; carpenter's square and lance; builder's rule; arrows; five wounds of our Lord; girdle; book and spear.

S. Thomas Aquinas, C. D. 1274. Chalice and Blessed Sacrament; dove at his ear; star or sun on his breast; books; pen and inkhorn; radiant sun with an eye within it; scroll with words *Bene scripsisti de me, Thoma.*

S. Thomas à Becket, Ar. M. 1170. Sword through a mitre; pallium and archbishop's cross; battle axe and crosier; red chasuble; altar and sword.

S. Thomas of Villanueva, Ar. C. 1555. (The Almoner.) Open purse; wallet.

S. Timothy, B. M. c. 97. Club and stones; broken image of Diana.

S. Titus, B. 1st c. Broken images; ruined temple of Jupiter.

S. Torpé of Pisa, M. c. 70. (S. Torpet, S. Tropes.) White banner with red cross; boat piloted by an angel; lion; sword.

S. Ulrich of Augsburg, B. 973. Fish on a book; angel with cross and chalice; cross or crosier; fish.

S. Urban, M. 230. Vine and grapes; fallen idol beneath broken column; scourge; stake; severed head.

S. Uriel, Archangel. Sword; scroll; book; flames in his left hand.

S. Ursinus of Ravenna, M. 1st c. Sword; severed head.

S. Ursula. V. M. c. 451. Large mantle lined with ermine; two arrows; three arrows; dove; book; ship; white banner charged with red cross; book and arrow; crown; pilgrim's staff; arrow and furled banner.

S. Valentine of Rome, M. 269. Sun in his hand; sword; heart.

S. Valerian, M. Sword; iron hooks.

S. Valérie of Limoges, V. M. c. 250. Severed head.

S. *Vedast of Arras, B. C. 539.* Wolf holding a goose in his mouth; bear tied with a rope.

S. *Venantius, M. 3d c.* Roman armour; banner; plan of Camerino; fountain.

S. *Venantius of Tourraine, Ab. 6th c.* Lion's cub.

S. *Verdiana, V. R. 1242.* Serpents; basket.

S. *Verena, V. 3d c.* Large comb; crown of thorns; wreath of roses.

S. *Veronica, M. 1st c.* Handkerchief imprinted with our Lord's face; phial of blood of S. John Baptist.

S. *Victor of Marseilles, M. 303.* Chain mail; severed foot; millstone and sword; banner; windmill; shield charged with an escarbuncle; dragon at his feet; overturned pagan altar; banner with a cross upon it.

S. *Victor of Milan, M. 303.* Broken pagan altar; flaming oven; rack; ladel and molten lead; two lions.

S. *Victoria of Rome, V. M. c. 250.* Dragon; angel; dagger or sword; arrows.

S. *Victoricus, M. c. 303.* Arrows; sword.

S. *Victorin of Diospolis, M. c. 284.* Large mortar and pestle; overturned pagan altar; severed leg; globe and banner.

S. *Vigor of Bayeux, B. 537.* Destroyed pagan temple; dragon.

S. *Vincent of Saragossa, D. M. 304.* Iron hook or fork; spiked gridiron; vine; canoe; book and dalmatic; crow or raven; millstone; two cruets; broken glass; pottery and sharp stones.

S. *Vincent Ferrer, C. 1419.* Crucifix and open book winged; lily; an IHS on a heart; pulpit and trumpet; heraldic wings; knotted scourge; sun with an IHS in its midst.

S. *Vincent de Paul, C. 1660.* Model of an orphanage or a hospital; model of a hospice; child in his arms.

S. *Vitalis of Ravenna, M. 1st c.* Pit; stones.

S. *Vitalis of Bologna, M. c. 304.* White war horse; spiked club; post; cross and nails.

S. *Vitus, M. 303.* (S. Guy.) Wolf or lion; cockatrice on a book; fire; cock; chained dog; cauldron of boiling oil.

S. *Vulmar, Ab. c. 690.* Hollow tree; loaf; board; mallet.

S. *Walburga, V. Abs. 779.* (S. Walpurgis.) Ears of wheat; crosier and flask of oil; crown; book; model of a church; oil flowing from her tomb.

S. *Walstan, C. 1016.* Sceptre and scythe; crown; ermine cape; calf or two calves.

S. *Wenceslas, K. M. c. 935.* Armour; corn; black eagle; coffin held by angels; sword and purse; red banner charged with a white eagle.

·S. *Wendelin, H. 1015.* Sheep; dog; oxen; shrine.

S. *Werburga, V. Abs. 609.* Veiled crosier; model of a church; crown at her feet.

S. *Wilfrid, Ar. 709.* Fallen idols; fish; font; pallium and crosier; model of a cathedral; ship and staff.

S. *Wilgefortis, V. M.* (S. Uncumber.) Crucifix and ropes; Tau cross.

RESURRECTION·

REDEMPTION

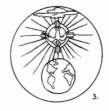

DESCENT OF THE HOLY GHOST

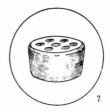

CRUCIFIXION

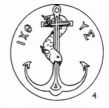

EUCHARIST

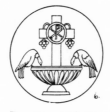

FOUNTAIN OF LIFE

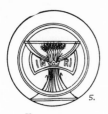

LIGHT OF THE WORD

CHRISTIAN KNOWLEDGE

Abstract Truths PLATE XXXIX

S. *Willebrord, Ar. 739.* Cask; fountain; crescent on his breast.

S. *William of Aquitaine, H. 812.* Book and staff; chain armour.

S. *William of Bourges, Ar. 1209.* Monstrance; chalice and host.

S. *William of Monte Virgine, Ab. 1142.* Wolf; trowel; lily; Passion flower.

S. *William of Norwich, M. c. 1144.* Crucified child; three nails; hammer; crown of thorns; knife.

S. *William of York, Ar. C. 1154.* Archepiscopal cross; shield charged with eight lozenges; mitre and cross.

S. *Willibald, B. c. 786.* Fallen tree and axe; broken glass; *Spes, Fides* anu *Charitas* written on his breast; model of a church.

S. *Winifred, V. M. c. 600.* Pastoral staff; severed head; sword.

S. *Winwallow, Ab. c. 529.* (S. Winwaloe.) Bell; fishes; church on his shoulder.

S. *Withburga, V. Abs. 744.* Two does; church; crosier and book.

S. *Wolfgang, B. 994.* Church in his hand; h a t c h e t; fountain; crown.

S. *Wulfram, Ar. 720.* (S. Wolfram.) Crosier and font.

S. *Wulstan, B. C. 1095.* (S. Wulfstan, S. Wolstan.) His crosier fixed in S. Edward Confessor's tomb; sealed scroll.

S. *Yvo, 1335.* The host; open purse; cat.

S. *Zacharias, 1st c.* Priest's robes; thurible; altar; angel; lighted taper; Phrygian helmet.

S. *Zadkiel, Archangel.* Abraham's sacrificial knife.

S. *Zeno of Verona, B. C. c. 380.* Fish and crosier; fishing tackle.

S. *Zenobius of Florence, B. C. 417.* Elm tree in full leaf; cope charged with a red lily.

S. *Zephyrinus, P. C. M. c. 220.* Monstrance; triple cross.

S. *Zita, V. 1272.* (S. Sitha, S. Sytha.) Pitcher; basket of fruit; keys; three keys and a book; purse; rosary and book; loaves in her apron; rosary and a key or two keys; two keys and three loaves; key, bag and book; well.

S. *Zolius, M. c. 350.* Crown of leaves; sword.

S. *Zophiel, Archangel.* (S. Jophiel.) Flaming sword.

S. *Zozimus, H. M. c. 290.* Cauldron of molten lead; severed ears.

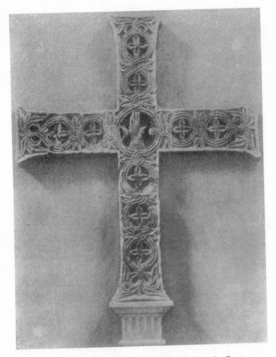

Terra Cotta Cross, With Manus Dei, Tenth Century.
Ravenna Museum.

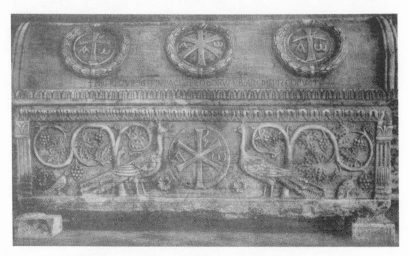

Sarcophagus of Archbishop Theodore, St. Apollinare in Classe, Ravenna, Showing the Chi Rho, Alpha and Omega, Peacocks and Vine. Sixth Century.

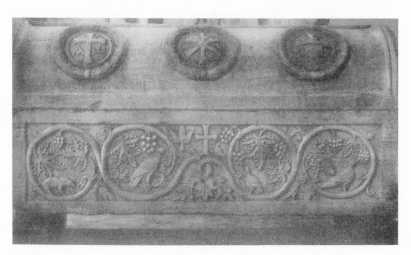

Sarcophagus of Archbishop Theodore, St. Apollinare in Classe, Ravenna, Showing the Chi Rho, Alpha and Omega, Doves and Vine. Sixth Century.

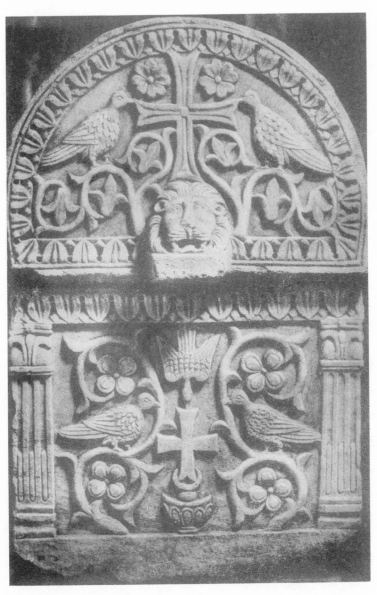

*End View of Sarcophagus of Archbishop Theodore, St. Apollinare in Classe,
Ravenna, Showing Crosses, Lion, Doves and Vine. Sixth Century.*

303

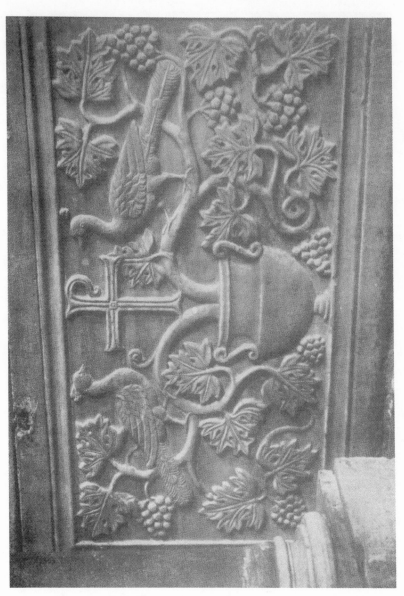

Panel in the Reliquary Chapel, St. Apollinare Nuovo, Ravenna, Showing the Chi Rho Monogram, Peacocks and the Vine. Sixth Century.

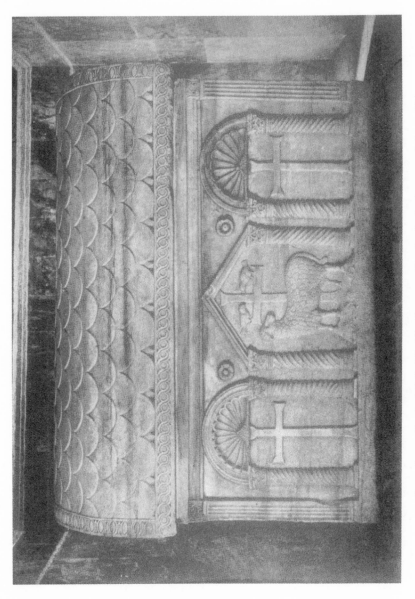

Sarcophagus, Tomb of Galla Placidia, Ravenna, Showing Latin Crosses and Agnus Dei.

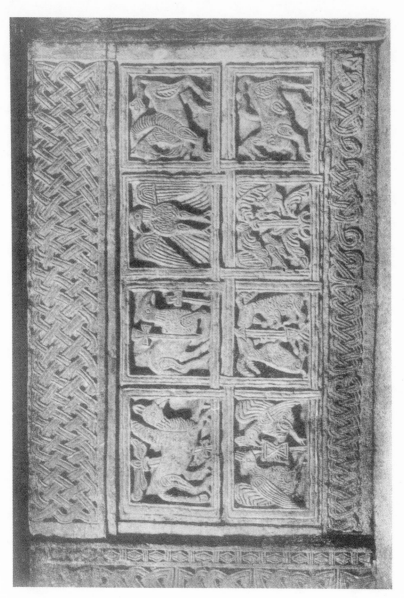

Bas Relief on the Altar, Cathedral of Aquileia. Eighth Century.
DESIGNED AND CARVED BY TRANSENNA.

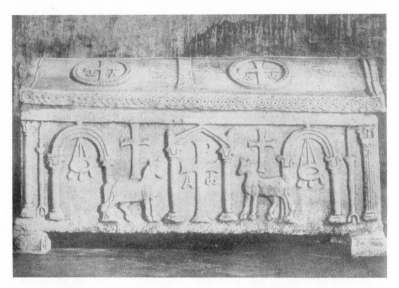

Sarcophagus of Archbishop Felice, St. Apollinare in Classe, Ravenna, Showing Lambs, Crosses, Alpha and Omega and Chi Rho.706-723 A.D.

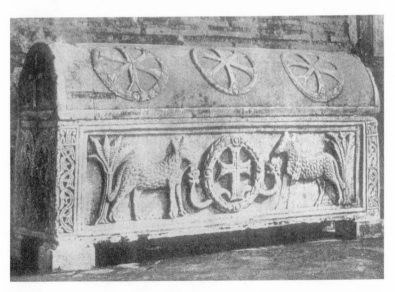

Sarcophagus in St. Apollinare in Classe, Ravenna, Showing XI Monograms, Lambs, Palm Trees and a Wreathed Cross. Eighth Century.

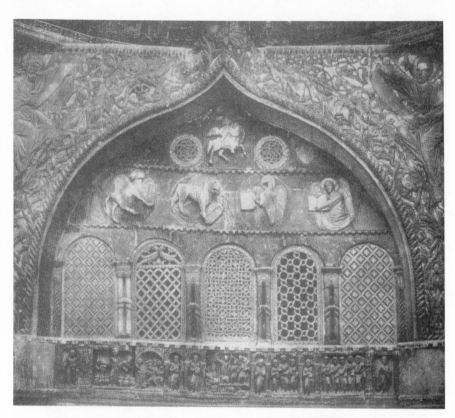

Lunette over Main Portal, St. Mark's, Venice, Showing Symbols of Our Lord and the Four Evangelists. Twelfth Century.

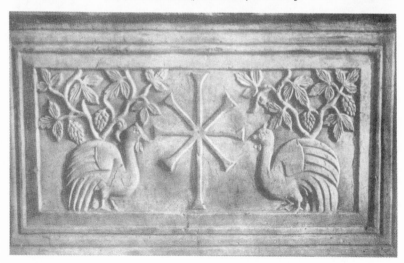

Panel in the Altar of St. Agatha's Church, Ravenna, Showing Christian Monogram, Peacocks and Vine. Sixth Century.

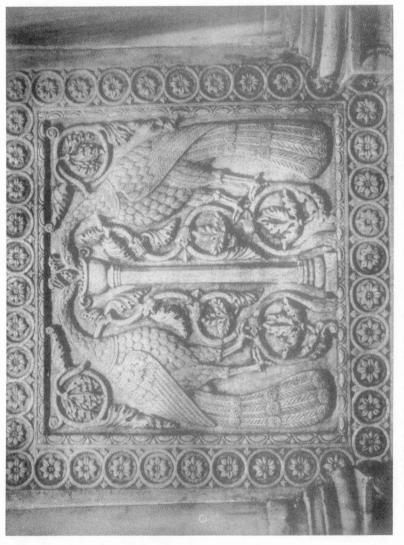

Bas Relief, Cathedral at Isola del Corcello, Showing Peacocks, Vase and the Vine. Twelfth Century.

Mosaics in the Vaulting, Cefalu Cathedral, Showing the Angelic Choirs. Twelfth Century.

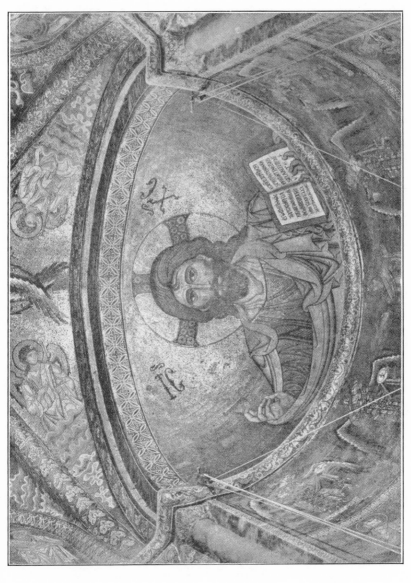

Mosaics in Cefalu Cathedral, Showing Our Lord with Tri-Radiant Nimbus and IC XC Symbols, 1148 A.D.

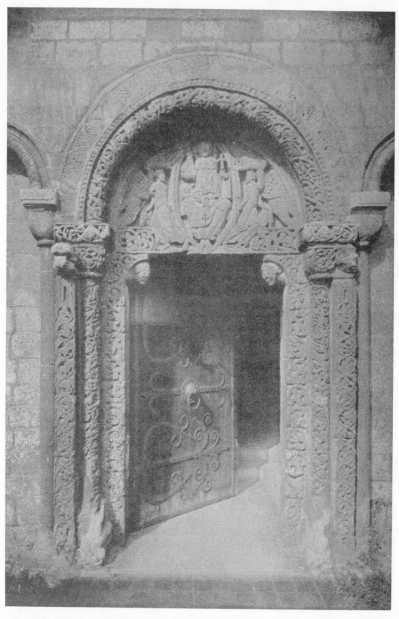

Symbolic Sculptures on Prior's Doorway, Ely Cathedral, Showing One of the Most Famous Examples of Symbolic Sculpture of the Norman Period.

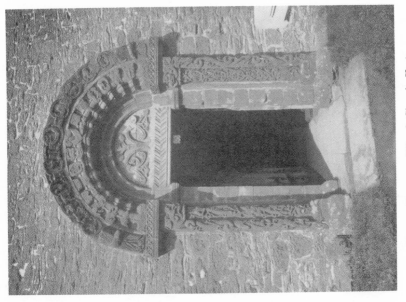

Norman Doorway, Kilpeck Church, Herts.
Signs of Zodiac and Animal Symbolism.

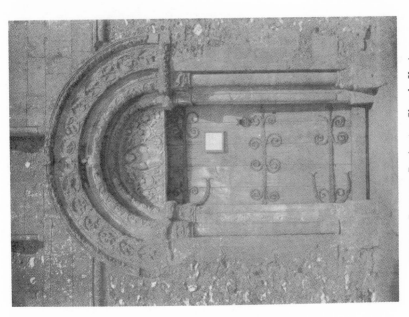

Norman Doorway, Barfreston Church, Kent.
Our Lord in Judgment, with Kings, Bishops and Others.

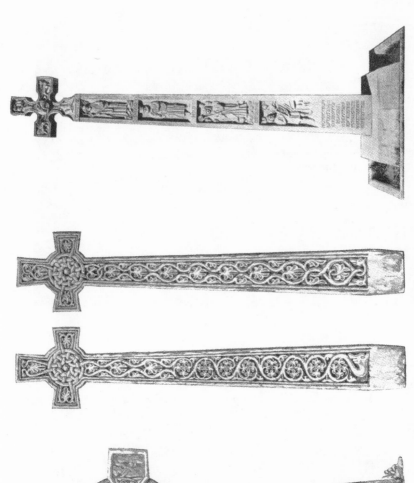

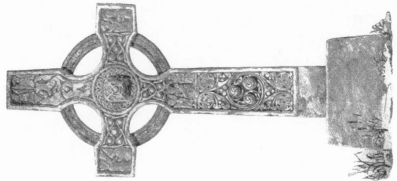

Some Celtic Crosses with Symbolic Carvings.

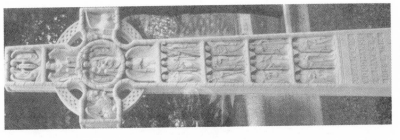

Memorial Cross
Presbrey-Leland Studios.

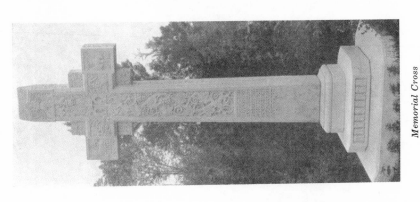

Memorial Cross
Presbrey-Leland Studios.

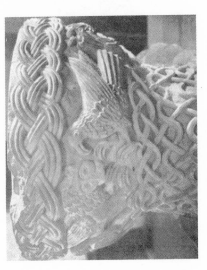

Dove from Hanwell, St. Thomas's, London
EDWARD MAUFE, ARCHITECT.
Pelican-in-Her-Piety, Detail from Altar Crucifix.
CARVED BY ANDREW GALLOWAY.
EXECUTED BY THE LITURGICAL ARTS GUILD.

Norman Font, Castle Frome, Herefordshire

315

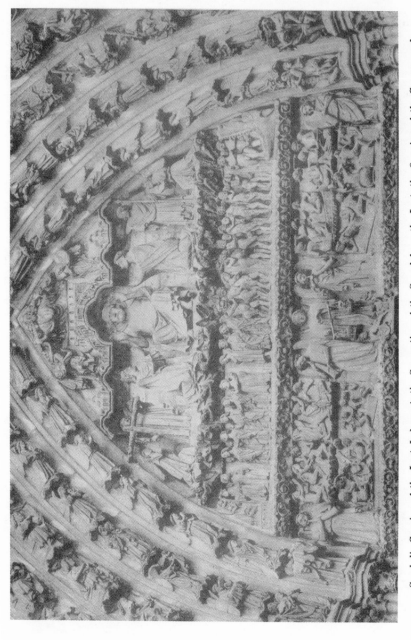

Symbolic Carving of the Last Judgment, the Separation of the Saved from the Lost, the Opening of the Graves, and St. Michael Weighing Souls, Central Portal of Amiens Cathedral, West Front.

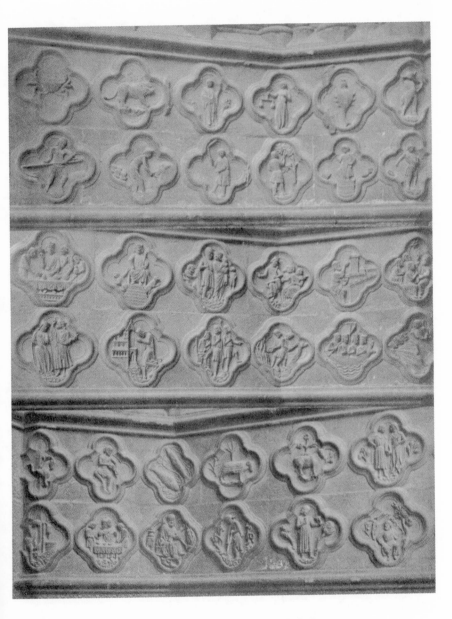

Medallions, Facade—Amiens Cathedral.

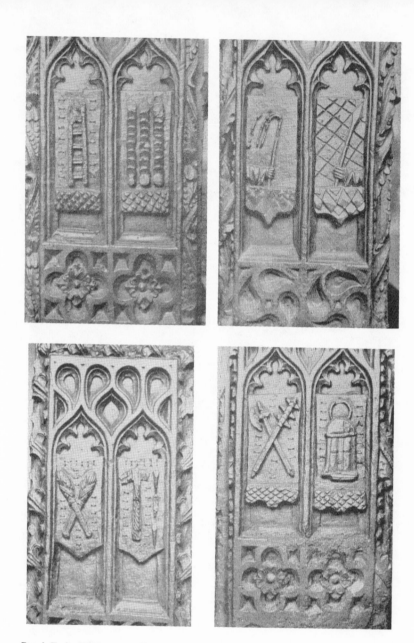

Bench Ends, Kilkhampton Church, Cornwall, Showing Symbols of Our Lord's Passion.

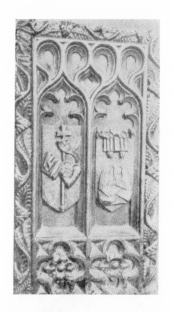
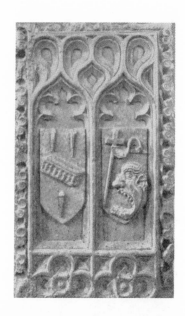
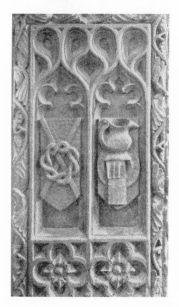
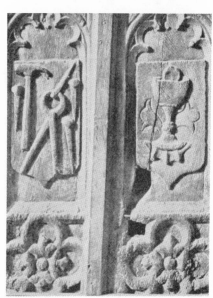

*Bench Ends, Launcells and Mullion Churches, Cornwall, Showing Symbols of
Our Lord's Passion.*

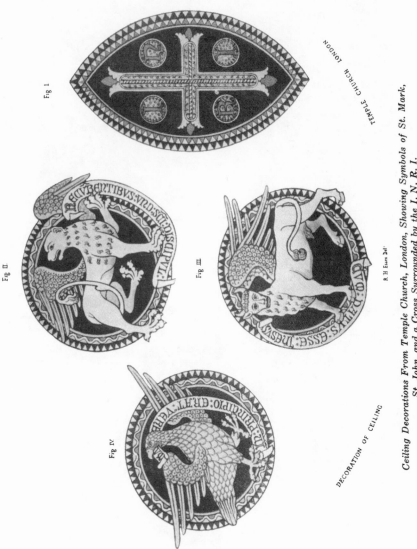

Fig 1

TEMPLE CHURCH LONDON

Fig II

Fig III

R H Essex Del.ᵗ

Fig IV

DECORATION OF CEILING

*Ceiling Decorations From Temple Church, London, Showing Symbols of St. Mark,
St. John, and a Cross Surrounded by the I. N. R. I.*

320

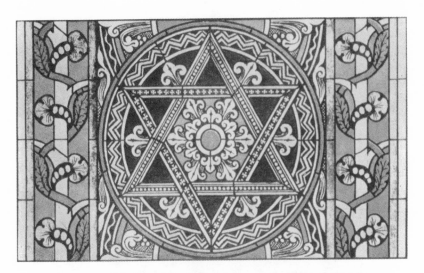

Interwoven Triangles of the Holy Trinity and the Circle of Eternity,
Temple Church, London

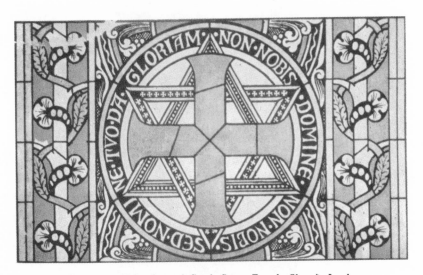

Interwoven Triangles and Greek Cross, Temple Church, London

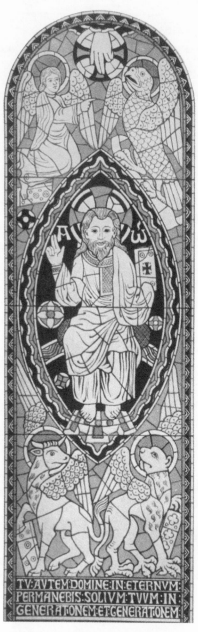

*Window from Temple Church, London,
Showing Our Lord, the Manus Dei
and the Four Evangelists.*

322

*The Famous Jesse Tree Window in
the West Facade of Chartres Ca-
thedral. Twelfth Century.*

323

Cover, Fuller Memorial Font, Methodist Church, Willoughby, Ohio
DESIGNED AND EXECUTED BY GANDOLA BROTHERS.

Fuller Memorial Font, Methodist Church,
Willoughby, Ohio
DESIGNED AND EXECUTED BY GANDOLA BROTHERS.

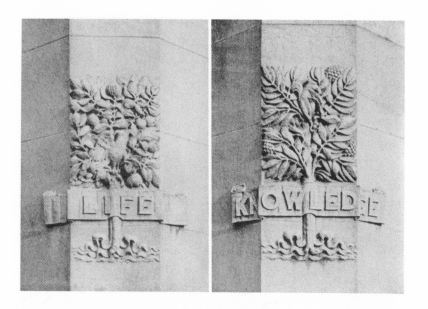

Tree of Life, Tree of Knowledge and Fleur-de-Lys From Women's College Gateway,
Cleveland, CHARLES F. SCHWEINFURTH, ARCHITECT, PETER YOUNG, SCULPTOR,
and IHS and Cross from the Church of the Covenant, Cleveland,
CRAM, GOODHUE AND FERGUSON, ARCHITECTS.

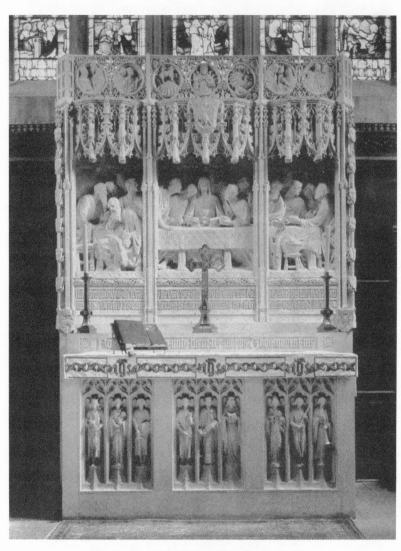

Altar in St. John's Church, West Hartford, Conn.
CRAM, GOODHUE AND FERGUSON, ARCHITECTS.
LEE O. LAWRIE, SCULPTOR

Cresting from the Reredos, St. John's Church, West Hartford, Conn.
CRAM, GOODHUE AND FERGUSON, ARCHITECTS, LEE O. LAWRIE, SCULPTOR

Shields of the Twelve Apostles, Tabernacle Presbyterian Church, Indianapolis, Ind.
J. W. C. CORBUSIER, ARCHITECT

Carved Medallions over North Narthex Doorway, Chapel of the Intercession, New York, Symbolizing the Invocations from the Litany, The Father (Hand), the Son (Lamb), the Holy Ghost (Dove), the Trinity (Fishes), the Nativity (Star), Baptism (Font), the Crucifixion (Cross, Crown of Thorns and Nails) and the Ressurection (Peacock).
CRAM, GOODHUE AND FERGUSON, ARCHITECTS.

327

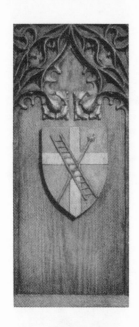

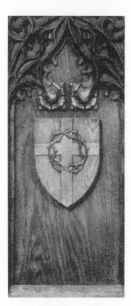

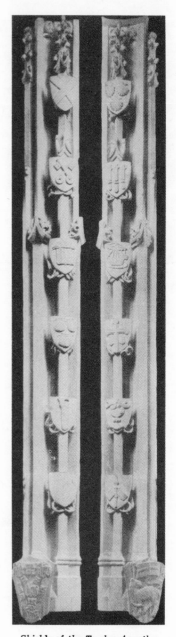

Cross and Crown of Thorns,
and Cross, Reed and
Sponge,
Tabernacle Presbyterian
Church,
Indianapolis, Ind.

J. W. C. CORBUSIER,
ARCHITECT

Shields of the Twelve Apostles,
St. John's Church, West
Hartford, Conn.

CRAM, GOODHUE AND FERGUSON,
ARCHITECTS.

LEE O. LAWRIE, SCULPTOR

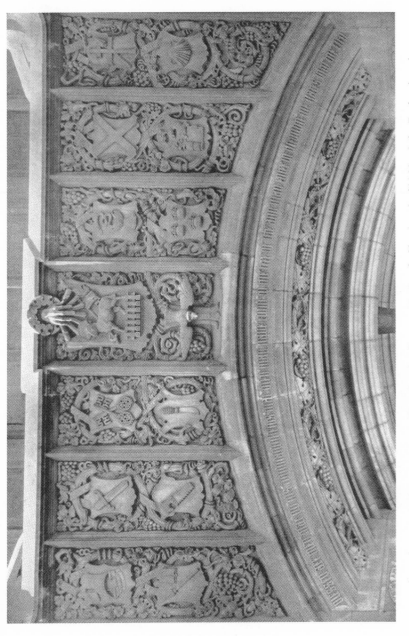

Symbols over the Main Entrance, First Baptist Church, Pittsburgh, Showing the Shields of the Twelve Apostles. CRAM, GOODHUE AND FERGUSON, ARCHITECTS. LEE O. LAWRIE, SCULPTOR.

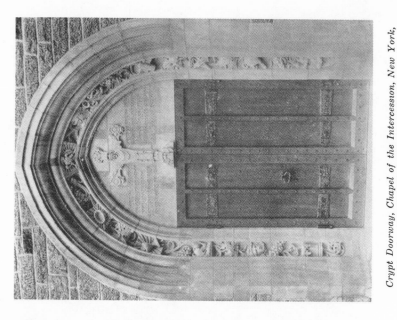

Crypt Doorway, Chapel of the Intercession, New York,
Showing Our Lord Reigning from the Tree, and
Eleven Symbols of the Development of the

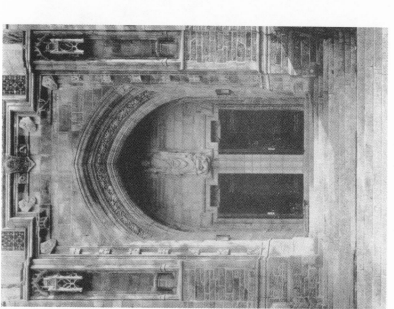

Main Doorway, Chapel of the Intercession, New York.
Showing Symbols of Eighteen Events in the Life of
Our Lord

Details of the Jambs of the Main Doorway, Chapel of the Intercession, New York,
Showing (Begin at Lower Left and Read Upward) the Annunciation, Visita-
tion, Nativity, Epiphany, Purification, Flight into Egypt, Baptism;
(Upper Right, Reading Downward) Crown of Thorns, Five Wounds,
Crucifixion, Resurrection, Christ the Conqueror, Pentecost, and
the Last Judgment.

CRAM, GOODHUE AND FERGUSON, ARCHITECTS.

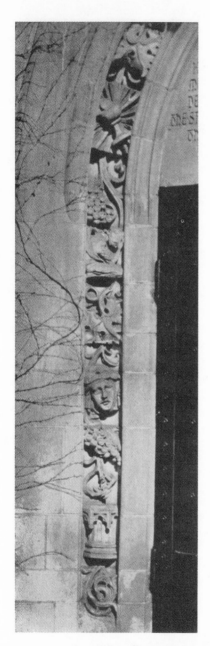
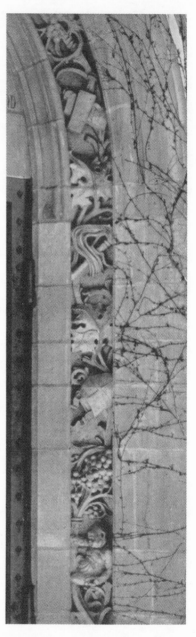

Details of Crypt Doorway, Chapel of the Intercession, New York, Showing Bread and Wine (on the Right Jamb) and Chalice and Paten (on Left) Symbolizing the Eucharist; Whip (on Right) and Penitent Figure (on Left) Symbols of Penitence; Bishop's Mitre (Right) and Hand Laid on a Head (Left), Signifying Confirmation; and Cherub (Right) and Font (Left) Representing Birth and Holy Baptism

CRAM, GOODHUE AND FERGUSON, ARCHITECTS.

Details of South Narthex Doorway, Chapel of the Intersession, New York, Showing Symbols of the Work of Christian Mercy: Instructing the Ignorant (Books); Feeding the Hungry (Bread and Knife); Giving Drink to the Thirsty (Ewer and Cup); Clothing the Naked (Cloak); Ransoming the Captive (Broken Manacles); Harbouring the Harbourless (Open Door); Visiting the Sick (Flowers and Fruit); Burying the Dead (Coffin, Spade and Pickaxe).

CRAM, GOODHUE AND FERGUSON, ARCHITECTS.

Details of North Narthex Doorway, Chapel of the Intercession, New York, Showing Symbols of the Litany Petitions, The Church (Ship, Caravel), Crown, Sceptre and "Pax," Holy Orders (Mitre, Chalice, Paten), Heart on Tablet of the Ten Commandments, Fruits of the Spirit (Rayed Dove), Satan under Foot, Land and Water (Winged Sandal and Oar), Fruits of the Earth, Agnus Dei and Cross, and IHC in Rayed Vesica.

CRAM, GOODHUE AND FERGUSON, ARCHITECTS.

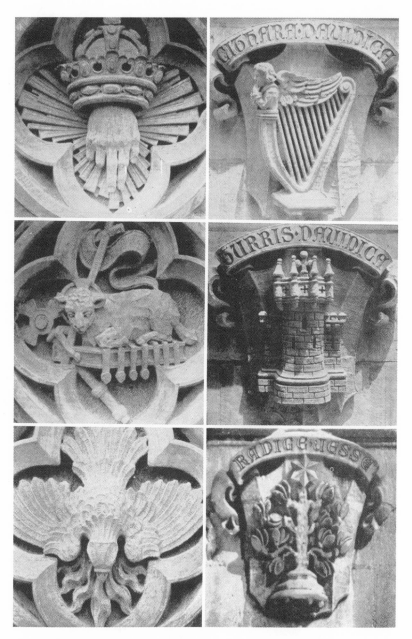

Six Symbols from the Exterior of the Chapel of the Intercession, New York. On the Left Are Shown the Symbols of the Father, the Son and the Holy Ghost. On the Right May Be Seen the Harp of David, the Tower of David and the Root of Jesse.

CRAM, GOODHUE AND FERGUSON, ARCHITECTS.

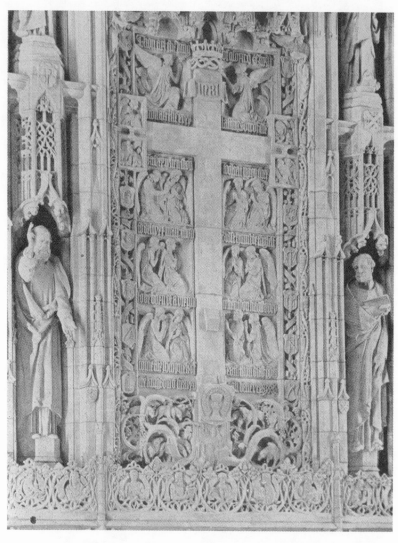

Portion of the Reredos, St. Thomas' Church, New York, Showing the Cross, the
Four Evangelists, the Passion Symbols, the Crown of Thorns, the Crown,
Adoring Angels, etc.
CRAM, GOODHUE AND FERGUSON, ARCHITECTS.
LEE O. LAWRIE, SCULPTOR

*Symbols from the Stained Glass at Concordia Evangelical Lutheran
Theological Seminary, St. Louis, Showing the Ship, the Rod of
Aaron, the Lion, the Pelican, the Anchor and Fish and
St. Peter's Keys.*
CHARLES ZELLAR KLAUDER, ARCHITECT.
NICOLAI D'ASCENZO, ARTIST.

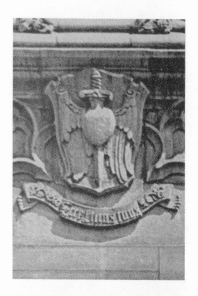

Symbols of the Virgin Mary, St. John, a Figure Surrounded by an Aureole, and the Ship of the Church, First Three from St. Vincent Ferrer, New York. BERTRAM G. GOODHUE, ARCHITECT. *Ship From First Baptist Church, Pittsburgh,* CRAM, GOODHUE AND FERGUSON, ARCHITECTS.

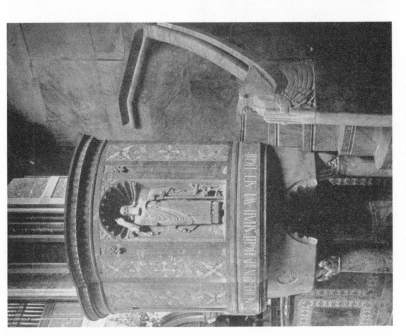

Eagle Lectern, St. Bartholomew's Church, New York.
BERTRAM G. GOODHUE ASSOCIATES, ARCHITECTS.
LEE O. LAWRIE, SCULPTOR.

Pulpit, St. Bartholomew's Church, New York
BERTRAM G. GOODHUE ASSOCIATES, ARCHITECTS.
LEE O. LAWRIE, SCULPTOR.

339

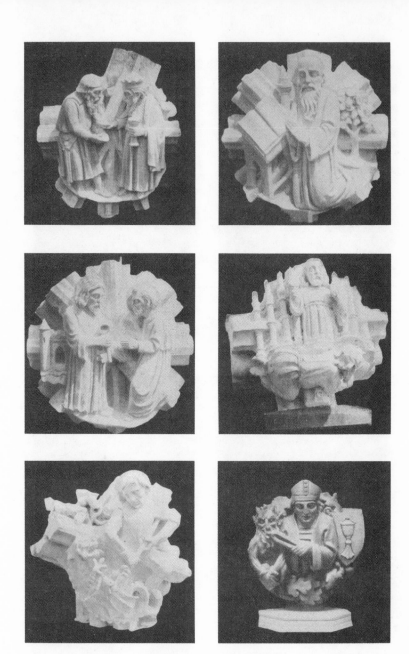

Six Bosses from Washington Cathedral, Washington, D. C., Showing Melchizedek and Abraham, St. Jerome, St. Peter Receiving the Keys, St. John's Vision, St. George and the Dragon, St. Dunstan.
FROHMAN, ROBB AND LITTLE, ARCHITECTS.
RALPH ADAMS CRAM, CONSULTING ARCHITECT.

Six Bosses from Washington Cathedral, Washington, D. C., Showing St. Columba, St. Theresa, the Chi Rho, Grapes, the Preacher and the Bishop's Mitre.

FROHMAN, ROBB AND LITTLE, ARCHITECTS.

RALPH ADAMS CRAM, CONSULTING ARCHITECT.

Six Bosses from Washington Cathedral, Washington, D. C., Showing Moses,
Aaron, St. Stephen, St. Agnes, Hope and Holy Fear.
FROHMAN, ROBB AND LITTLE, ARCHITECTS.
RALPH ADAMS CRAM, CONSULTING ARCHITECT.

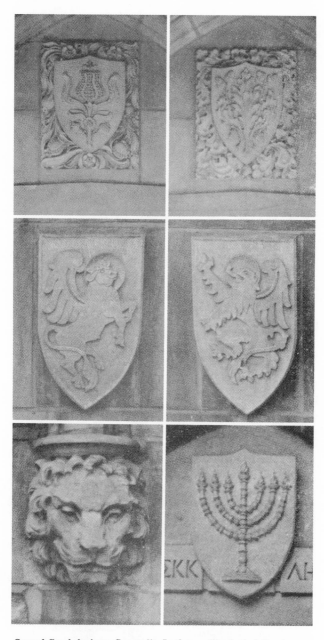

Carved Symbols from Concordia Lutheran Theological Seminary,
St. Louis, Showing the Pomegranate, the Oak, the Winged
Ox, the Winged Lion, the Lion of the Tribe of Judah
and the Seven-Branched Candlestick.
CHARLES ZELLAR KLAUDER, ARCHITECT.
JOHN J. MAENE, SCULPTOR

343

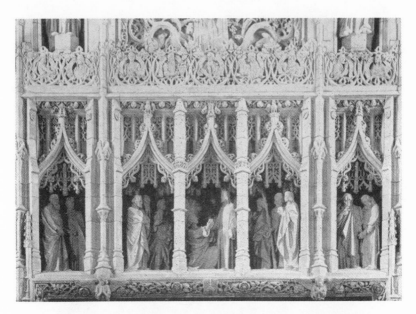

*Portion of the Rededos, St. Thomas's Church, New York, Showing the Vine, Lambs
Drinking from the River of Life, Bible Characters with Their Emblems
St. Thomas Confessing His Lord, etc.*
CRAM, GOODHUE AND FERGUSON, ARCHITECTS. LEE O. LAWRIE, SCULPTOR.

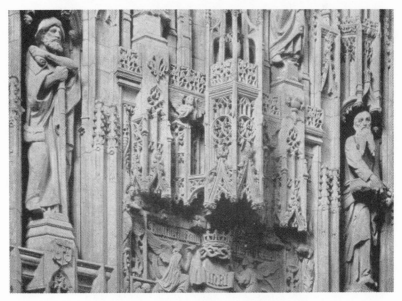

*Portion, of the Reredos, St. Thomas's Church, New York, Showing Passion Symbols,
Symbols of the Virgin Mary, the Apostles, etc.*
CRAM, GOODHUE AND FERGUSON, ARCHITECTS. LEE O. LAWRIE, SCULPTOR.

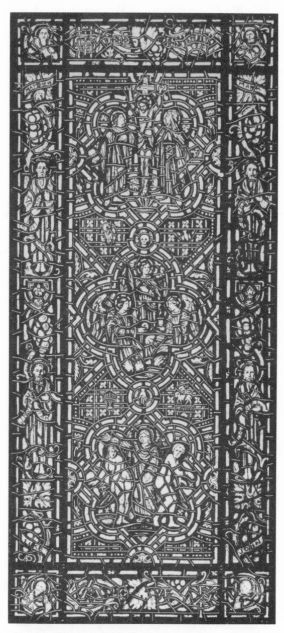

*Sacristy Window, Faith Evangelical Lutheran Church,
Cleveland, Showing Symbols of the Crucifixion, the
Fall, the Means of Grace, the Holy Trinity,
the Redemption, the Four Major Prophets,
the Four Evangelists, etc.*
DESIGNED AND MADE BY R. TOLAND WRIGHT

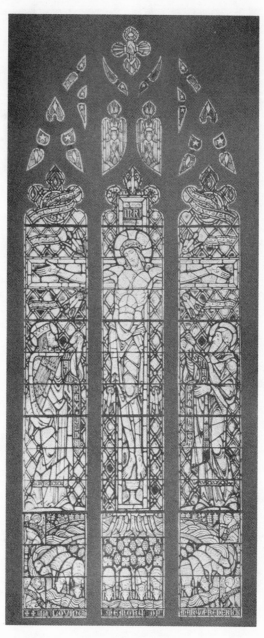

Crucifixion Windows in St. Dominic's Church, San Francisco, Showing Symbols of the Father, the Holy Ghost, the Seven Gifts of the Spirit, Seraphim, the Two-Fold Nature of Our Lord, Inspiration, Subservience of the Universe, the Twelve Apostles Drinking from the Seven Streams of Living Water, the Four Evangelists, the Vine, and the Eucharist, etc.
DESIGNED AND MADE BY CHARLES J. CONNICK.

Altar, St. Paul's Church, Malden, Mass. Twelve Symbols: (1) Cross, Symbol of the Trinity and Crowned Orb. (2) Seven Doves (3) Wheat and Grapes. (4) Flaming Heart Offering to God. (5) Dragon. (6) Crowned Rose and Cross. (7) Dove and Alpha Omega. (8) IHC, Four Crowns and Two Sceptres. (9) Triquetra and "Gloria in Excelsis Deo." (10) Thurible. (11) Lily. (12) Greek Cross, Victor's Wreath and IC XC NIKA. CRAM AND FERGUSON, ARCHITECTS. IRVING AND CASSON, CARVERS.

*Font and Font Cover, Chapel of the Intercession, New York. Font Has 24 Panels,
Each One Containing a Symbol of a Christian Virtue. The Font Cover, 18 Feet
High, Contains Symbols of Holy Baptism, of the Inspired Writers of the
New Testament, the Seven Sacraments, the Coats of Arms of the
Episcopal Diocese of New York, Trinity Parish, and the Vicar
of the Parish.*
BERTRAM G. GOODHUE, ARCHITECT. LEE O. LAWRIE, SCULPTOR.

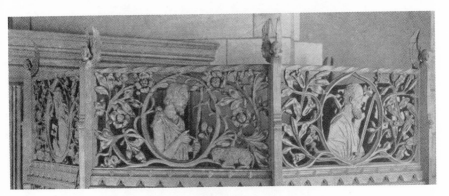

Carved Oak Cresting from Pulpit Canopy, First Baptist Church, Pittsburgh, Showing St. Peter, St. John the Baptist an d St. Paul, with Their Symbols,
CRAM, GOODHUE AND FERGUSON, ARCHITECTS.

Fish Symbol From Concordia Lutheran Seminary, St. Louis.
CHARLES Z. KLAUDER, ARCHITECT.
NICOLAI D'ASCENZO, GLASS PAINTER

Symbols of Faith, Hope and Charity, from the Rectory, Chapel of the Intercession, New York.
CRAM, GOODHUE AND FERGUSON, ARCHITECTS.

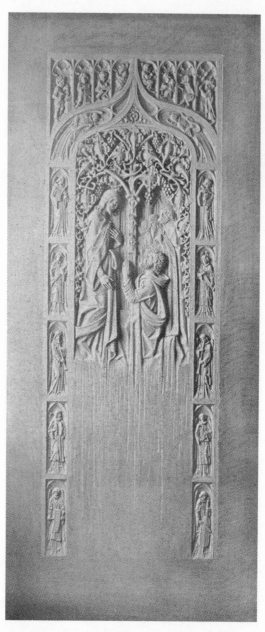

Carved Door for Christ Church, Cranbrook, Michigan, Showing Angels Bearing Instruments of Music Symbolizing Praise. In the Upper Panels Are Figures with the Symbols of the Metal Worker, Sculptor, Designer, Painter, Wood Carver, etc. This Door Was Designed and Carved by J. KIRCHMAYER. MAYERS, MURRAY AND PHILIP, Architects of the Church.

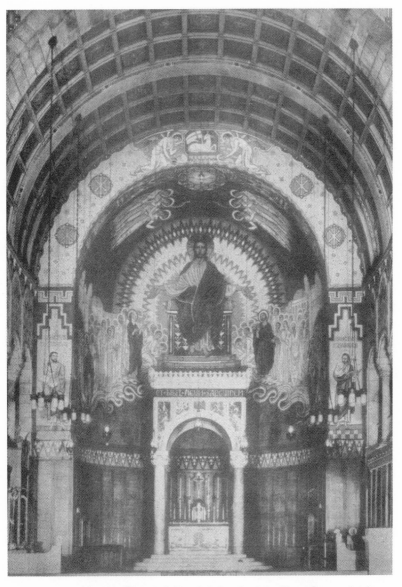

Sanctuary, Wheeling Cathedral, Showing Our Lord in Glory, Surrounded by the Heavenly Host.
EDWARD J. WEBER, ARCHITECT. FELIX B. LIEFTUCHER, PAINTER

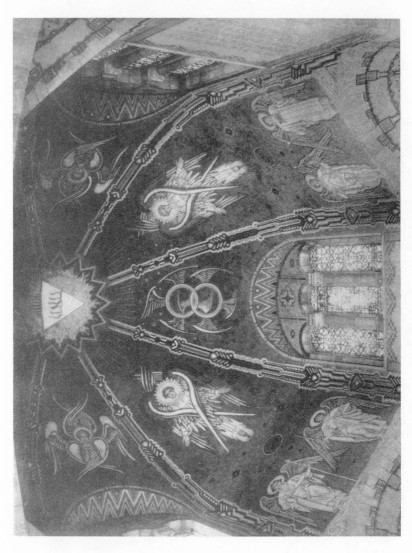

Decorations in Dome of Wheeling Cathedral, Wheeling, West Virginia,
Showing the Nine Choirs of Angels.

EDWARD J. WEBER, ARCHITECT FELIX B. LIEFTUCHER, PAINTER

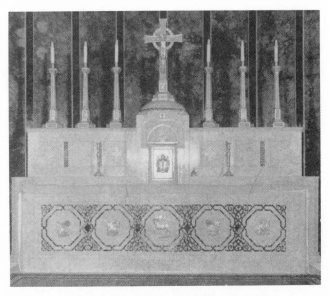

Altar, St. James' Church, Lakewood, Ohio.
ERECTED BY JOHN W. WINTERICH AND ASSOCIATES. E. T. P. GRAHAM, ARCHITECT

Mural Decorations, St. James' Church, Lakewood, Ohio.
SCHUBERT FRESCO CO., E. T. P. GRAHAM, ARCHITECT.

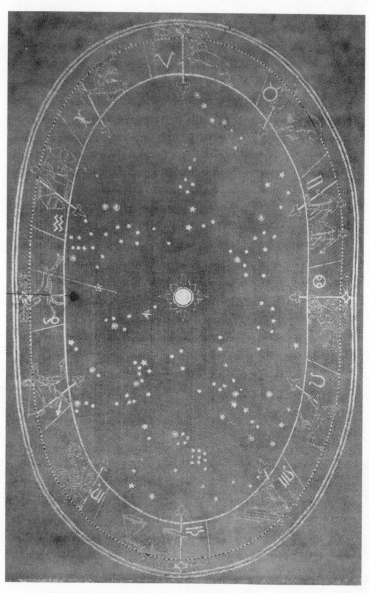

The Signs of the Zodiac, St. James' Church, Lakewood, Ohio.
SCHUBERT FRESCO CO., E. T. P. GRAHAM, ARCHITECT

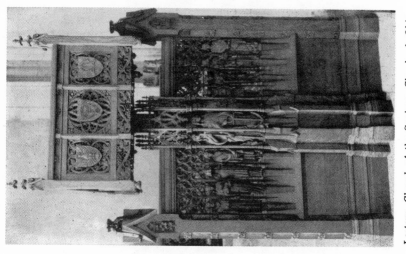

Lectern, Church of the Saviour, Cleveland, Ohio.
WM. F. ROSS & CO., CARVERS.
THE LATE J. W. C. CORBUSIER, ARCHITECT.

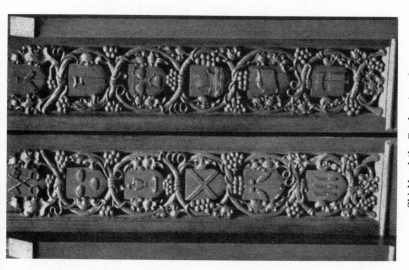

Shields of the Twelve Apostles.
THE LITURGICAL ARTS GUILD.

355

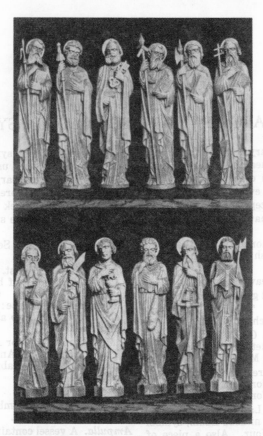

*The Twelve Apostles, Church of Our Lady of Sorrows,
South Orange, N. J.*
CARVED BY ADELBERT ZWINK OF THOMAS & CO.
MAGINNIS & WALSH, ARCHITECTS.

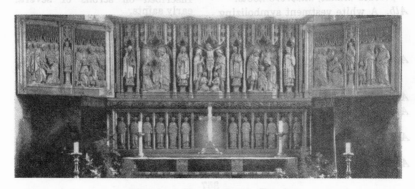

Triptych, Ashburton Parish Church.
HERBERT READ, ESQ., SCULPTOR.

A GLOSSARY OF THE MORE COMMON SYMBOLS

THIS glossary is added for the sake of comparison. Many symbols have several meanings. Others have different meanings when used in combination with other symbols. The definitions in this glossary are very brief, and in every case it would be well to refer to the foregoing text. With the exception of the Twelve Apostles and the Greek and Latin Fathers, we have omitted the enormous list of emblems of the saints.

Acacia. Immortality of the soul. Acacia bush in flames: call of Moses.

Acanthus. Heavenly gardens.

Acorn. Latent greatness or strength.

Adder. Sin. The devil. Temptation. Treachery. Dan.

Adelphotheos. Greek for "brother of God." Sometimes found on scroll of S. James Minor.

Adonai. Hebrew for "Lord." In a circle of glory, or a triangle: a substitute for the name *Jehovah.*

Agnus Dei. Latin for "Lamb of God." The nimbed Lamb, symbol of our Saviour. Also a piece of wax, stamped with a lamb, blessed on Holy Saturday, and a reminder of the baptismal covenant. It is inscribed *Agnus Dei, qui tollis peccata mundi, miserere nobis.*

Alb. A white vestment symbolizing the white robe of our Lord. Innocence. Our Lord's prophetic office.

Almond. Divine approval or favor. (Num. 17, 1-8.) Aaron. The Virgin.

Alms Box. Charity. Benevolence.

Almuce. A vestment signifying dignity.

Aloes. Vessel of myrrh and aloes: a Passion symbol. The Virgin.

Alpha and Omega. See Chapter VII.

Alpha, Mu, Omega. See Chapter VII.

Altar. The Eucharist. Worship. Presence of God. Of burnt offering: O. T. worship. Our Lord's Sacrifice. Of incense: O. T. worship. Prayer. Two altars: Cain and Abel.

A. M. Abbreviation for *Ave Maria.* The Virgin. The Annunciation. On a shield: S. Gabriel, Archangel.

Ambo. Word of God.

Amice. A vestment symbolizing the Helmet of Salvation.

Ampulla. A vessel containing consecrated oil. Consecration.

Analogion. A portable lectern in the Greek Church. Word of God.

Anargyri. Greek for "unmercinary." Inscribed on scrolls of several early saints.

Anchor. Hope. Our Lord the Anchor of the Soul. (Heb. 6, 19.) With fish: the Christian's hope in Christ. Anchor cross: Jesus Christ our sure Anchor.

Angel. God's messenger. Annunciation. Nativity. Flight into Egypt, and Return. Resurrection. Holding chalice: the Agony in Gethsemane. Kneeling: Adoration. Intercession. Thanksgiving. With hand extended: Guardianship. Both hands extended: Invitation.

With trumpet: Resurrection Day. Nimbed: S. Matthew. Holding inkhorn: S. Matthew. Issuing from clouds: Malachi. Feet of an angel emerging from clouds on mountain top: Nahum. Angel kneeling before an equilateral triangle: adoration. With flaming sword: expulsion from Eden. Sheathing sword: God's vengeance turned aside.

Angels, Nine Choirs of. See Chapter XVI.

Ankh. See Ansata.

Annunciation Lily. S. Gabriel. The Virgin.

Ansata, the Crux. A looped cross, denoting life.

Ant. Christian i n d u s t r y. (Prov. 6,6.)

Anticipatory Cross. The Tau Cross. Escape from Egypt.

Anvil. An instrument of martyrdom of certain saints.

Ape. Levity. Lust. Cruelty. Fraud. Scoffers.

Apple. Fall of man. Sin. Eve. Discord. The Virgin.

Arch. Triumph. Broken: Untimely death. Chancel arch: passing from this world to eternal life.

Archangel. The Annunciation. With dragon underfoot: S: Michael. With lily: S. Gabriel. With trumpet: the Resurrection. With sword and balances: S. Michael. See Chapter XVI.

Ark. The Deluge. Noah. Salvation. Our Lord. The Church. Holy Baptism. Of the covenant: O. T. worship. Presence of God. The Saviour. The Virgin.

Arm. Protection. Defence. Strength. Hairy arms: Jacob's deception of Isaac.

A'rmour. Resistance of evil. Protection. Security. Of God: Girdle of Truth, Breastplate of Righteousness, Shield of Faith, Helmet of Salvation, Sword of the Spirit. (Eph. 6, 13-17.)

A r r o w s. Martyrdom. Pestilence. Persecution. Remorse. The fiery darts of the wicked. With spear and stones, or square and spear, or a girdle and stones: S. Thomas. Two arrows in a heart: S. Augustine of Hippo.

Ashes. Penitence. Mourning.

Asomati. Greek for "bodiless ones." The angels.

Ass. Humility. Patience. Service. Peace. Burden-bearing. Gentile nations. Zechariah. With ox: the Nativity. With two burdens: Issachar. J a w b o n e of: Samson. Stumbling ass: unbelievers.

Asperge. Holiness. Purity. With water pot: S. Martha.

Aureole. See Chapter XI.

Axe. See Battle-axe.

Babel. Tower of: sinful presumption.

Baculum Pastorale. The crosier. Pastoral authority.

Bag of Money. The Betrayal. S. Cyril. Alone, or with 30 coins: Judas. Three bags: S. Matthew. Open bag: charity to the poor.

Balances. With or without sword: Justice. With flaming sword and shield: S. Michael. With tiny figure on one pan: Day of Judgment. Devil pulling down one pan: Day of Judgment. (See plate of Amiens at end of volume.)

Balsam. The Virgin. With olive: Two-fold nature of our Lord.

Bandage and Reed. A Passion symbol.

Banner. Triumph. Victory. Rejoicing. Gad. The Resurrection. Of victory: a three-pointed white pennant, charged with a red Latin cross, held by the Lamb of God. Symbolizes our Saviour, also S. John the Baptist, also the sibyl Phrygiana. Victory over sin and death. Banner and white horse: S. James Major.

Basilisk. A fabled reptile with a horn-like growth on its head. Has the head of a cock and body of a reptile and is hatched from a cock's egg laid on a dunghill. Serpents are said to flee from it, and its glance kills a man. To slay it, one must look into a crystal vessel, which reflects the venom of the reptile. A symbol of the devil. The crystal vessel represents the power of the Gospel over Satan and hell. The basilisk is also called a cockatrice.

Basin and Ewer. A Passion symbol. Pilate.

Basket. Alone, or with two loaves, or with a Tau cross: S. Philip. Alone: charity to the poor. In bulrushes: Birth of Moses.

Bat. Night. Desolation. Death. Fuller's bat: See Fuller's Club.

Battle-Axe. Martyrdom. Warfare. S. Matthew. S. Simon. S. Matthias. With two stones: S. Matthias. With oar and saw, or two oars: S. Simon. Sometimes also S. Jude.

Bay Leaves. Death. Mourning. Reward.

Beads. Prayer.

Bear. Self-restraint. Solitary life. Martyrdom. Satan.

Beaver. The ancients believed that the beaver has a sac containing a fluid of medicinal value. If pursued it bites off the sac, sacrificing that which it prizes most in order to escape further pursuit. A symbol of the Christian who purges himself of whatever may interfere with his spiritual life.

Bee. Tireless activity. Regal power. Chastity. Fecundity. The Risen Lord. The Virgin.

Bee Hive. Eloquence. Industry. S. Ambrose. S. Chrysostom. S. Bernard. With two scourges saltire: S. Ambrose.

Bell. Invitation. Call to worship. Exorcism. Sanctus bell: rung at the Sanctus, the Elevation and the Priest's Communion. Angelus: Prayer. It is rung thrice daily. Bell tapped thrice (among Lutherans): the Lord's Prayer. Passing bell: a bell tolled to mark the departure of a soul. Bell on a Tau staff: S. Anthony.

Bellows. Temptation. With lighted candle: attempts of the devil to extinguish the spiritual life

Benediction. See Chapter V.

Bible. See under Book.

Birch. The school. Authority.

Birds. Human souls. With Chi Rho: Souls meditating on our Lord. See plates at end of volume. Drinking from vase: souls partaking of the Water of Life. Also the Eucharist. In a vine: souls abiding in Christ. With olive branch: Noah. With food: Elijah.

Bishop's Staff. Pastoral authority.

Black. A liturgical color, signifying mourning and death, sometimes sin, evil, despair and hopelessness. Used only on Good Friday and on days of national humiliation and prayer.

Blood. Sacrifice. Death. Martyrdom. The Atonement.

Blue. A color, canonical in some churches, s i g n i f y i n g Heaven, truth, constancy, faithfulness, wisdom and charity, the Virgin, the Cherubim. Sometimes substituted for Violet during Advent.

Boar. Ferocity. Sensuality.

Boat. See Ship.

Boat Hook. With cross saltire: S. Andrew. With builder's square: S. Jude. With fish: S. Simon.

Book. The Bible. Divine authorship. With chalice on it: S. Chrysostom. With chalice and stole on it: Ordination. With *Spiritus Gladius* on it, and cross-hilted sword: S. Paul. Open, with flaying knife: S. Bartholomew. Closed, vertical, and with fish on it: S. Simon. Open, with battle-axe: S. Matthias. Between two Greek Doric columns: S. Athanasius. Closed, transfixed by sword: S. Boniface. Opened to S. Matthew's Gospel: S. Bartholomew or S. Barnabas. With three stones: S. Barnabas. Opened to Romans 13: S. Augustine of Hippo. Four books: the Four Evangelists. The Four Gospels. With a large knife or scimitar: S. Matthias. Closed eagle on it: S. John. Closed, with seven seals, and a Lamb on it: our Lord. S. John the Baptist. Book and halbert: S. Matthias. With spear: S. Thomas. With scroll or tall cross: S. Philip. S. Andrew. Open, with stone and whip: S. Jerome. With writing table and pen: S. Ambrose. Book of Wisdom, or Sealed Book: the Virgin. Closed book: S. Jude. Book, font and chalice: the Means of Grace.

Bough. Frutiful bough over well: Joseph.

Bow and Arrows. Esau.

Box of Ointment. Burial of our Lord. S. Mary of Bethany. S. Mary Magdalene.

Branch of Jesse. Our Lord. See Chapter VI.

Brazen Serpent. Our Lord. See Chapter VI.

Brazier. With wood and knife: Abraham and Isaac.

Bread. Bread of Life. The Word of God. Our Lord. With wine: the Eucharist. Melchizedek. Loaf of: S. James Minor. Two loaves and basket, or slender cross, or Tau cross: S. Philip. A loaf also denotes charity to the poor. Loaf carried by a raven: Elijah.

Breastplate. O. T. priesthood. Aaron. Righteousness.

Briars. Sin. Worldly interests and cares.

Bricks. With whip: bondage in Egypt.

Bridle. Self-restraint. Self-control. Temperance.

Broken Column. A hackneyed symbol of death.

Budding Rod. Aaron. S. Joseph of Nazareth. S. Joseph of Arimathaea.

Builder's Rule. See Rule.

Builder's Square. See Square.

Bullock. Sacrifice. Atonement. Our Lord. S. Ambrose. S. Luke.

Bulrushes. Basket in: Birth of Moses.

Burial Cloth. A Passion symbol.

Bush. Burning: call of Moses.

Butterfly. The Resurrection. See Chapter VI.

Cable. Strength.

Caladrius. Our Lord. See Chapter VI.

Calamus and Cinnamon. The Virgin.

Calf. Golden: Aaron. Nimbed and winged: S. Luke.

Calvary. A carving of the Crucifixion, with our Lord, the Virgin and S. John. Placed on rood beam to symbolize our passing from this life (the nave) to Heaven (the chancel) only by way of the Crucified Lord.

Camel's Hair Tunic. S. John the Baptist.

C a m p h i r e and Spikenard. The Virgin.

Candle. Jesus Christ the Light of the World. Also the symbol of devotion.

Candlestick. See under C h u r c h, Parts of.

Candlesticks, Varieties of. Altar candlesticks, with one, three, five or seven branches: see under Church, Parts of. Processional: the symbol of dignity. Elevation candlesticks, at the sides of the altar: the Lord's Supper. Standing candlesticks, before shrines and images: veneration. Paschal candlestick, standing at the Gospel side of the altar from Holy Saturday until the Ascension: symbolizes the forty days spent by our Lord on earth after His Resurrection.

Captain of our Salvation. Our Lord. Heb. 2, 10.

Cardinal's Hat. S. Jerome.

Carpenter's S q u a r e. See under "Square."

Casket. Relic of a saint. Three caskets: the Epiphany.

Cassock. A vestment symbolizing devotion. The bishop's violet cassock: solemn authority.

Castle. Defense. Turreted: David, or the Virgin.

Cat. Cruelty. Self-indulgence. Resentment. Witchcraft.

Caterpillar. Man on this earth.

Cauldron. An implement of martyrdom. S. John, S. Boniface, etc. An eagle rising out of a boiling cauldron: S. John.

Cave. Two caves: Obadiah.

Cedar Tree. Steadfastness in the faith. Prosperity. Long life.

Censer. Prayer. Worship. Aaron. Levi. The priesthood. Crown and censer or sceptre and censer: Melchizedek.

Centaur. A monster with a man's head and a horse's body. Used on many old fonts to represent the overcoming of the Old Adam by the new man in Holy Baptism. Sometimes a symbol of Our Lord's two-fold nature.

Chain. Imprisonment. St. Peter. Strength. Security. Slavery. Chain and sceptre: Joseph's advancement. Broken chains: Liberation of the imprisoned. Sin overcome.

Chalice. A cup of silver, lined with gold, used in the celebration of the Blessed Sacrament. Chalice and rayed host: the Eucharist. With cross of suffering: Gethsemane. Chalice alone: faith or worship. With serpent issuing from it: St. John. Standing on closed book: S. Chrysostom. The priestly office. On closed book with stole: Ordination. Chalice and loaf: Melchizedek. Chalice and staff: S. Chamael. The six-sided base of a chalice represents the six attributes of the Diety.

Chancel. The part of the church east of the crossing. It includes choir, presbytery and sanctuary. Symbolizes the Church Triumphant.

Charadrius. The rejection of the unbeliever. See Chapter VI.

Charger. With severed head: S. John the Baptist.

Chariot. Fiery: Elijah. The Ascension. Four chariots: Zechariah.

Chasuble. A vestment, symbolizing· Christian charity.

Cherubim. See Chapter XVI.

Chest. See Money Chest.

Child. Holding apple: Our Lord's power over sin. Our Lord the Second Adam. Holding scroll: The Child in the temple. Naked child: the human soul. Birth of a new life. Naked child issuing from mouth of dying man: flight of the soul. Naked child in balances: the weighing of souls.

Chimera. A fabled monster with the head and chest of a woman, forepaws of a lion, body of a goat, hind legs of a griffin, tail of a dragon. Destruction. T e r r o r. Alarm.

Chimere. A vestment representing dutiful perseverance.

Chi Rho. (XP) An abbreviation of XPIÇTOC, meaning "Christ."

Chi Rho Sigma. (XPC) Another variation of the Chi Rho.

Chrism. Baptism. Ordination. Confirmation. Extreme unction. Dedications.

Christmas Rose. (Helleborus niger.) The Nativity of our Lord. Christmas.

Christmas Starwort. (Aster grandiflorus.) The Nativity. Christmas.

Chrismatory. A case containing holy oil or chrism, used for anointing in Baptism, Confirmation, Ordination, Extreme Unction, Dedications, etc.

Church. Built on a rock: the Church founded on Jesus Christ. S. Peter. Model held in the hands of a saint: distinction in building up the Christian Church. Also held by great builders of cathedrals, abbeys, priories, churches, etc.

Church, Parts of. The Altar: presence of our Lord. The Eucharist. Worship. The throne of God. Prayer. Altar cross: Christ the Saviour of the World. Finished Redemption. Crucifix: the Atoning Death of our Lord. Two candlesticks: the two-fold nature of our Lord. Six candlesticks: the six days of creation, or the six hours spent by our Lord on the cross. Three-branched candlestick: the Holy Trinity. Five-branched candlestick: the Five Wounds of our Lord. Seven-branched candlestick: the Church, or the Seven Gifts of the Holy Spirit, or the Seven Sacraments. Candles: Christ the Light of the World. The altar placed in the East: Ezekiel 43, 4. The altar rail: close communion. Sanctuary lamp: the Real Presence. The chalice and paten: the Eucharist. The font: Holy Baptism. Regeneration. The chancel: the Church Triumphant. The nave: the Church Militant on earth. The chancel arch: entrance to glory by means of death. The rood beam and its Calvary: Salvation by way of the Cross of Calvary. The pulpit: God's Word. Lectern: God's Word. Double-faced lectern: the Old and New Testaments, or the Epistle and Gospel. The baptistery: entry into the Kingdom. The litany desk: penitence. The paschal candle: our Lord's forty days on earth after His Resurrection. Incense: prayer. The fair-linen: the cloth in which the body of our Lord was wrapped. Five crosses on altar and fair-linen: the Five Wounds of our Lord. The door: Jesus Christ. The spire: Heavenly aspiration. The columns: the prophets, apostles and evangelists. The bell: the call of the Gospel.

Church and Synagogue. Cross and seven-branched candlestick. Two female figures, as at Reims, Strasbourg, Rochester, etc.

Ciborium. A vessel containing the altar breads, also a receptacle for the reserved host. Symbol of the Eucharist, and of the Last Supper.

Cincture. Symbol of the rope used to bind our Lord. Represents chastity, self-restraint and continence.

Cinnamon. Cinnamon and Calamus: The Virgin.

Cinquefoil. A figure composed of five equal segments, representing the five mysteries of the rosary, etc.

Circle. E t e r n i t y. Completeness. Perfection. If interwoven with an equilateral triangle, two triangles, trefoil, triquetra, cross, etc.; the eternal nature of the Holy Trinity. A circle about the head of our Lord, angels and saints denotes sanctity. See Chapter XI.

Cistern. Jeremiah.

City On a hill: the Church. The New Jerusalem. The Virgin. Walled city: Zechariah. Walled city with sword above it: Zephaniah. City of God: the Virgin. (Last from Song of Solomon.)

C l o a k. Righteousness. Christian charity.

Closed Gate. The Virgin.

Cloth. Burial cloth: a Passion symbol.

Club. Martyrdom. Fuller's club: S. James Minor. S. Simon. S. Jude. S. Mark. Club, with spear, spear and lance, inverted cross or lance and inverted cross: S. Jude. Knotted club: Cain. S. Jude.

Coal. Burning coal held in tongs: Isaiah. Burning coals: martyrdom.

Coat. Multicolored: Joseph. Without seam: a Passion symbol.

Cock. Watchfulness. Vigilance. Reproof of the cowardly or the indifferent. A Passion symbol. S. Peter. Also a symbol of the faithful preacher, who divides truth, as the cock divides the food for the flock. A symbol of liberality, for the cock calls the flock to share the food. Two fighting cocks, in the Catacombs: Christians striving with errorists. Cock on a church spire: the Church's call to all men to repent, as S. Peter repented. A symbol of the Resurrection, since the cock arises at dawn.

Cockatrice. See under "Basilisk."

Coffin. Death.

Coins. Thirty coins: Judas. Coins at the feet of a saint: charity to the poor, also renunciation of wordly gain.

Colors, Liturgical. See under White, Violet, Green, Red and Black.

Columbine. The Seven Gifts of the Holy Ghost, so used by the Flemish painters.

Column. A Passion symbol. The scourging of our Lord. An Egyptian column: Joseph. Two columns out of plumb: Samson. Two with a Bible between: S. Athanasius. One column: S. Bartholomew. One, with two scourges saltire: a Passion symbol. Tall column: S. Philip. Column and urn: a hackneyed symbol of death. Columns of a church building: apostles, prophets, evangelists. Four columns: the Four Evangelists. Twelve columns: the Twelve Apostles.

Convolvulus. Humility.

Cope. A vestment symbolical of dignity.

Cord. A Passion symbol. Seven cords: Samson.

Corn. The Eucharist.

Cornerstone. Our Lord the Head of the Church.

Cornucopia. The bounty of God Thanksgiving. Liberality. Asher.

Cotta. A vestment signifying innocency or purity.

Cradle. The sibyls Cumana and Samiana.

Creator's Star. A six-pointed star. The Creation.

Crescent Moon. The Virgin. Purity. Virginity.

Cresset. A stone bored so as to hold several candles. Also an iron frame holding a torch or flare. Symbol of the Gospel light held aloft by our Lord, or by His Church.

Crocodile. Dissimulation. Hypocrisy.

Crocus. Joy.

Crook. Shepherd's c r o o k: Abel. David. Amos. Moses: The Nativity of our Lord. Pastoral leadership.

Crosier. A pastoral staff carried by bishops and mitred abbots. Also called *Baculum Pastorale.* Signifies official dignity or ecclesiastical authority. S. Gregory the Great, etc.

Cross. Finished Redemption. The Passion. Faith. The Atonement. Pointed cross rising out of a chalice: Gethsemane. Standing on an orb: triumph of our Lord, or the Gospel. Inverted: S. Peter. S. Jude. S. Philip. Anchor cross: Our hope in Christ. Anchor of the soul. With winding sheet: a Passion symbol. With human skin: S. Bartholomew. Empty, but with three nails and I. N. R. I.: a Passion symbol. Five crosses: the

Five Wounds of our Lord. Cross and triangle: the Holy Trinity. With two horizontal arms: a patriarch. With three horizontal arms: the Pope. With two horizontal arms and one bar dexter: the Greek Catholic Church. Patriarchal cross and spear: S. Philip. Patriarchal cross and two keys saltire: S. Peter. Cross and carpenter's square: S. Philip. Rayed Latin cross on a shield: Faith. S. Paul. Cross potent fitched: S. J e r o m e. Processional cross: Christian soldiers. The sibyl Phrygiana. Cross saltire: S. Andrew. S. Patrick. Cross saltire with boat hook: S. Andrew. Knotted cross: S. Philip. Inverted cross with fuller's bat or a lance: S. Jude. Tall cross and book, or with scroll: S. Philip. S. Andrew. Cross Patée and four books: the Four Evangelists. Tall cross: S. Matthias. Cross, sceptre and lily: the choir of Principalities.

Crosses, Uses of. Altar cross: the Atonement. Finished Redemption. Processional cross: Christian soldiers. Rood cross: Entrance to Heaven by way of the Cross. Reliquary cross: relics of a saint. Consecration crosses: 12 on walls of old churches, symbols of the house set apart for God. Five crosses on altar mensa and on fair-linen: the Five Wounds of our Lord. Also called marking crosses. Pectoral cross: episcopal authority. Spire cross: Jesus Christ the Highest of the High. Pendant cross: often suspended in the west end of the nave, high overhead, to remind the departing worshippers of the atoning Death of our Lord.

Crosses, Varieties of. See Chapter VIII.

Cross-Hilted Sword. The Sword of the Spirit which is the Word of God. Christian conflict. S. Paul.

Cross-shaped Plan of a Church. The Church founded on the Crucified Christ.

Crown. Rank. Sovereignty. Royalty. Victory. Recompense. Our Lord's Kingly Office. Eternal life. Crown and sceptre: Our Lord the King forever. Melchizedek. David. Deborah. Crown and mitre: Melchizedek. Of the Virgin: Queen of Heaven. Starry crown: the Virgin. Held by a martyr: a virgin-martyr. Crown of lilies and stars: the Virgin.

Crown of Thorns. The Suffering Saviour. A Passion symbol. The sibyl Delphica. With I. N. R. I., either with or without three to four nails: a Passion symbol.

Crucifix. The Suffering Saviour. The Passion. The Atonement. With nude Corpus: The suffering of our Lord. With Figure clad in symbolic vestments: the Reigning Christ.

Cruets. Vessels containing wine and water for the Eucharist, used in some churches. Symbols of the Eucharist.

Cruse of Oil. The widow of Sarepta as a type of Christ. The inexhaustible grace and mercy of our Lord.

Crutched Staff. A staff with a head like the Latin T. A Tau staff. Symbol of various saints.

Crux Ansata. See "Ansata."

Crux Gammata. See "Gammata."

Cup. See "Chalice."

Cyclomen. Voluptuousness.

Cypress. Death. Mourning. Immortality. Since the cypress loses its leaves in gales of wind, it is a symbol of the righteous man who preserves his faith even at the cost of worldly riches and honor. Palm, cypress and olive: the Virgin.

Daisy. The Christ Child's innocency. Youth. The Sun of Righteousness. Innocency.

Dalmatic. A vestment worn by deacons, used in art as the symbol of the diaconate, S. Stephen and others. With three stones: S. Stephen, protomartyr.

David, Harp of. David. The Virgin.

David, Tower of. The Virgin.

Day Star. Our Lord. II Peter 1, 19.

Devil with Bellows. Blasts of temptation.

Devil Pulling Down Balances. Carved over portals of many French cathedrals to warn against the efforts of Satan to wrest the soul of man at death. See plate of Amiens.

Diakaios. Greek for "righteous one." Used on the scroll of certain Old Testament saints.

Distaff. Eve.

Dog. Fidelity. Loyalty. Watchfulness. Faithfulness. Orthodoxy. Loyalty to a sovereign. Three dogs: in old German art they represent the Mercy, Truth and Justice of Christ. Four dogs: At Weimar, etc., represent *Veritas, Justitia, Misericordia* and *Pax* (Truth, Justice, Mercy and Peace.) Two fighting dogs: In certain ancient manuscripts used as the symbol of the quarrels of theologians.

Dolphin. Love. Society. Our Lord bearing souls to Heaven. S. Matthew.

Doom. A carving of the Last Judgment.

Door. Salvation. Our Lord the Door to the Kingdom. Two leaves of a door: the two-fold nature of our Lord. Jambs sprinkled with blood: the Passover. The Atonement.

Doric Columns. Strength. Two Greek Doric columns and a Bible between: S. Athanasius.

Dove. Peace. Purity. Meekness. Modesty. Humility. The Holy Ghost. Divine inspiration. Innocence. Baptism of Christ. Confirmation. Hovering over waters: the Creation. On shoulder of Evangelist or Apostle: Divine inspiration. On shoulder of a saint: enlightenment. Two doves drinking from chalice: the Christian partaking of the Sacraments. Two doves eating grapes: the Eucharist. Two doves: married happiness. Seven doves: the Seven Gifts of the Holy Ghost, *q. v.* Dove with olive branch: peace, forgiveness, Noah. Dove with body of silver and gold, and many wings: the Church. Twelve doves: the Twelve Apostles. Dove on a pyx: reservation of the Sacrament. Dove on a font cover: Regeneration through the Holy Ghost. Two doves regarding the Chi Rho: the human soul meditating on Christ. Doves in a vine: human souls abiding in Christ. Dove shedding rays of glory: the Holy Ghost. Spiritual blessings. Two turtle doves: the Presentation of our Lord. In pictures of the Annunciation, a dove often hovers over the Blessed Virgin, representing the Holy Ghost. In pictures of our Lord's Baptism, the dove is always present. A dove carrying the Holy Ampulla symbolizes the baptism of Clovis.

Dragon. The devil. Sin. Spirit of evil. Pestilence. Lion slaying dragon: Our Lord slaying Satan. Dragon beneath the feet of our Lord, the Virgin and certain saints: temptation resisted. Satan overcome. Figure in armour slaying dragon: S. Michael the Archangel, or else S. George.

Dust and Ashes. Deep humiliation. Mourning. Penitence.

Eagle. Our Lord. Holy Baptism. S. John. With tri-radiant nimbus: the Holy Ghost. On closed book: S. John. Rising from a boiling cauldron: S. John. Double-headed eagle: Elisha. Eagle lectern: flight of the Gospel throughout the earth. S. John.

Ear. In old German art, the Conception of our Lord was often pictured by means of a tiny child flying into the ear of the Virgin, signifying the announcement of the holy Mystery.

Earth. Encircled by a serpent: sin encircling the world. Same, under the feet of the Virgin: symbol of Genesis 3, 15 and its fulfillment. Earth surmounted by a cross: triumph of our Lord and His Gospel. The Blessed Virgin,

Earthen Vessels. Humanity. Mortality. Isaiah 64, 8.

Easter Lily. The Resurrection of our Lord.

Ecce Agnus Dei. Latin for "Behold the Lamb of God." Often inscribed on a book or a scroll.

Eden, Four Rivers of. See "Paradise."

Egg. Bursting egg: in some lands a Resurrection symbol.

Eight. A symbolic number signifying Regeneration, Holy Baptism, the eight souls saved in the ark, the eight Beatitudes, completion, the time of circumcision, the eight sons of Jesse, etc.

Eight Canonical Hours. In Mediaeval days, eight daily services were held, each one symbolizing an event in the Passion of our Lord. Matins: our Lord before Caiaphas. Lauds: our Lord condemned by Caiaphas. Prime: His appearance before Pilate. Tierce: the scourging and crowning with thorns. Sext: our Lord on the cross, and the seven last words. Nones: death of the Saviour. Vespers: His deposition and entombment. Compline: The watch set at the tomb.

Elder Tree. Zeal.

Elephant. Priestly chastity. Also the fall of man, since many ancients, including Caesar, write that the elephant has no knee joints, and if he falls he cannot rise without assistance. Chastity, because the elephant was thought to be without passion.

Eleven. A number symbolizing the eleven faithful disciples, the eleven brothers of Joseph, the eleven curtains of the tabernacle, etc.

Elijah's Chariot. Ascension of Elijah, also of Christ.

El Shaddai. Hebrew for "the Lord." A substitute for the name *Jehovah.* See Plate V, Figure 12. Symbol of God.

Enclosed Garden. The Virgin.

Enkolpion. Greek name for a bishop's pectoral cross.

Epigonation. Greek name for the lozenge-shaped vestment worn by Eastern bishops. Symbol of dignity. S. Gregory Nazianzus.

Epiklesis. Greek for an invocation of the Holy Ghost.

Epimanikia. Greek for cuffs embroidered with crosses, a symbolical vestment of the Byzantine rite.

Epitrachelion. Greek name for the short, broad stole with ends sewn together.

Equilateral Triangle. The Holy Trinity. See Chapter IV. Also S. Athanasius. Angel before triangle: adoration.

Escallop. Pilgrimage. Our Lord's Baptism. Holy Baptism. Three escallops, with or without a sword: S. James Major.

Evergreen. Immortality of the soul.

Ewer. Holy Baptism. With basin: a Passion symbol. Pilate.

Eye. Omniscience of God. In a triangle: the Father. All-Seeing Eye: the Father.

Face of God. Face, surrounded by clouds of glory: the Father.

Fagots. Blazing fagots: martyrdom by fire.

Fair-linen. Represents the cloth used to wrap the body of our Lord. Five crosses on: the Five Wounds of our Lord.

Fald Stool. Confession and Absolution.

Fan. Purification. Separation. S. Matt. 3, 12.

Fawn. S. Jerome.

Fetters. Sin. Power of Satan. Broken fetters: sin overcome. Prisoners released.

Fiery Darts. Temptation of the devil. Persecutions.

Fifteen. A number symbolical of ascent, progression, the fifteen steps of the temple, the fifteen Gradual Psalms, the fifteen mysteries of the rosary, etc.

Fig. Fruitfulness. F i d e l i t y. S. Bartholomew.

Fire. Martyrdom. Zeal. Inspiration. Youthful fervor. Hell. Purgatory. Sacrifice. Purification. Temptation. Seven flames of: the Holy Ghost. Cloven flames of: the Holy Ghost. Pentecost. Fire and a serpent: S. Paul. Fire and a stake: death by fire. Fire and brimstone: hell. Vengeance of God.

Fish. Our Lord. For derivation of the term, see Chapter VI. Two fishes crossed: Holy Baptism. S. Simon. S. Andrew. Three fishes: the Holy Trinity. Fish on book: S. Simon. On boat-hook: S. Simon. Great fish: Jònah. The Resurrection of our Lord. Two fishes on a book, with pitcher (rare): the Virgin. Fish, or fish and wallet: S. Raphael. Fish and loaves: S. Jude. Large fish-hook, or fish-net: S. Andrew.

Five. A symbolic number denoting the Five Wounds of our Lord, our Lord and the Four Evangelists, the five senses, the five wise virgins, the five foolish virgins, the five talents, the five sparrows sold for a farthing, the five yoke of oxen, and the five thousand whom our Lord fed, etc.

Five Wounds. A Passion symbol.

Flail. S. Jude.

Flame. See under "Fire."

Flaming Heart. Great zeal. Constancy. Transfixed by two arrows: S. Augustine of Hippo.

Flaming Sword. Expulsion from Eden. With shield: S. Michael.

Flaying Knife. See "Knife."

Fleece. With bowl: Gideon.

Fleur-de-Lys. The Holy Trinity. The Virgin. With IHC: the twofold nature of our Lord.

Flowering Almond. Aaron. The Virgin.

Flowers. Beauty. Loveliness.

Font. Holy Baptism. Regeneration. It is eight sided, because, says Durandus, the world was created in seven days, and the eighth day is the Day of Regeneration.

Fork. A large fork denotes martyrdom.

Fortress. Security.

Fountain, Heraldic. Waters of Salvation. Waters of Life. Springs of Living Water. Three fountains: S. Paul. Four fountains: the Four Evangelists. Sealed fountain: the Virgin. Fountain of Living Waters or Fountain of Gardens: the Virgin.

Four. A number symbolizing the Four Major Prophets, the Four Evangelists, the Four Latin Fathers, the Four Greek Fathers, the Four Rivers of Paradise (Pison, Gihon, Tigris, Euphrates), the Four Beasts of the Apocalypse, the Four Living Creatures of Ezekiel, the Four Horsemen of the Apocalypse (C o n q u e s t, War, Pestilence, Death), the Four Cardinal Virtues (Justice, Prudence, Temperance, Fortitude), the Four Last Things (Death, J u d g m e n t, Heaven, Hell), the four cardinal points, the four "corners of the earth," the four Gospels, the four winds of Heaven, the four soldiers at the foot of the cross, the four virgin daughters of S. Philip, etc.

Forty. A symbolic number, denoting the duration of the flood, the 40 years in the wilderness, the 40 days of Moses on Mt. Sinai, the 40 days of Elijah's fasting, the 40 days of probation of the men of Nineveh, the 40 days of our

Lord's fasting, the 40 days of our Lord on earth after His Resurrection, the 40 days of our Lord's temptation, etc., etc.

Fox. Cunning. Fraud. Lust. Cruelty. Wisdom. The "spoiler of the vines," hence small sins that spoil character. In ancient times the fox was said to lie down and cover himself with sand, allowing his red tongue to remain uncovered. Birds, attracted by this seemingly toothsome morsel, were quickly siezed and devoured. Hence the fox is a symbol of Satan, for he disguises his treachery back of most alluring temptations.

Frankincense. The Old Testament priesthood. Our Lord's priestly office. Adoration. Casket of: S. Melchoir, Magus.

Frog. The Resurrection, because of its reappearance after its winter hibernation.

Fuller's Club. Martyrdom. S. James Minor. S. Simon. S. Jude. Knotted: S. James the Less. S. Jude. Together with spear and inverted cross: S. Jude.

Fylfot. See under "Gammata."

Gall. Vessel of. A Passion symbol.

Gammata, the Crux. Also called Croix Gammée, Swastika, and Fylfot. Life. Good fortune.

Garb. Heraldic name for a sheaf of wheat.

Garden. Eden. Man's innocence in his first state. Enclosed Garden: the Virgin. Fountain of Gardens: the Virgin.

Gargoyle. A fabled beast living near Rouen, slain by S. Romanus. Many gargoyles may be seen on the upper parts of the French cathedrals. Said by some to symbolize the evil passions driven out of man by the Gospel.

Garment. See under "Coat."

Gate. Turreted: Ezekiel. The Virgin. Gates of Gaza: Samson. Closed: Ezekiel. The Virgin. Gate of Heaven: the Virgin.

Gilly Flower. In Mediaeval days, probably the carnation (*Dianthus caryophyllus*). In modern days the wall-flower or stock. The Annunciation. The Virgin.

Girdle. With locust: S. John the Baptist. With arrows and stones: S. Thomas. Used with liturgical vestments: see "Cincture."

Gladiolus. The Incarnation.

Glastonbury Thorn. The Nativity. For full account, see Chapter VI.

Globe and Cross. See Orb.

Goat. O. T. sacrifice. Fraud. Lust. Cruelty.

God. See under Trinity.

Gold. Wealth. Kingliness. Splendor. Our Lord's Kingly office. Casket of: the Epiphany. S. Gaspar, Magus. House of: the Virgin.

Good Shepherd. Our Lord. See Chapter VI.

Goose. S. Ambrose. In modern days: foolishness.

Gospel. Gospel of S. Matthew: S. Bartholomew. S. Barnabas. Four Gospels on scrolls or books: the Four Evangelists.

Gourd. Jonah. With pilgrim's staff and wallet: S. Raphael, Archangel.

Grail, the Holy. The chalice used by our Lord at the Last Supper. S. Joseph of Arimathaea.

Grapes. The Eucharist. On a pole: the Promised Land. Twelve bunches of: the Apostles. Clusters of grapes on a running vine: Our Lord and His followers. The Church. Unity.

Greek Benediction. See Chapter V.

Greek Cross. See Chapter VIII. Five

Greek crosses: the Five Wounds of our Lord.

Green. A liturgical color symbolizing growth, life, hope, fidelity, immortality, the Trinity Season.

Gregorian Music. Staff of, on a scroll: S. Gregory.

Gridiron. Martyrdom. S. Lawrence, etc.

Griffin. A monster of fable, with a lion's body and an eagle's head and wings. The Incarnation. The two-fold nature of our Lord, also His omnipotence and omniscience.

Grindstone. An instrument of martyrdom.

Halbert. S. Matthew. S. Jude. S. James Minor. Book and halbert: S. Matthias.

Hammer. A Passion symbol. Often represented with two or more nails, or with the pincers.

Hand. Issuing from clouds: the Father. It is shown in benediction, always nimbed. Called *Manus Dei.* Holding several minute human figures: souls in the hand of God. Extended: protection. Palm upward: invitation. Folded: prayer. Two hands, palms together: worship or adoration. Laid on head: Confirmation. Ordination. Hand of Death. Clasped: Holy Matrimony.

Handcuffs. Imprisonment. Death. Power of hell. Broken: the Resurrection. Death and hell overcome. Release from slavery or prison. The symbol of certain saints who devoted their lives to the welfare of the imprisoned.

Hare. A Christian's haste to obtain divine gifts. S. Jerome.

Harp. Joy. Music. Worship in Heaven. David. S. Cecilia.

Harpy. A fabled monster, with head and bust of a woman, and body of a vulture. Evil. Rapacity. Plunder.

Harrow. A Christian's trials and tribulations.

Hat. Pilgrim's hat, with wallet, staff, etc.: S. James the Elder.

Hatchet. S. Matthias. And cherry tree: truthfulness (modern).

Hart. Thirst for salvation. Psalm 42, 1. Drinking from river or vase: the faithful drinking the waters of life.

Hawk. Watchfulness. Predaciousness.

Hawthorn. See Glastonbury Thorn.

Head. Of Goliath: David. Of Judas: the Betrayal. On a charger: S. John the Baptist. Many saints who were beheaded are represented in Christian art as carrying their severed heads.

Heart. Christian charity. Surmounted by a flame: intense zeal or devotion. Same, transfixed by two arrows: S. Augustine of Hippo. Transfixed by a sword, heart often with wings: the Virgin. Pierced by spear: a Passion symbol. With cross and anchor: Faith, Hope and Charity.

Heaven. Gate of, or Queen of: the Virgin.

Hell, Jaws of. The jaws of a great monster, emitting smoke and flames. Often pictured over the west portals of French cathedrals, etc., with the damned cast therein by the devil and his angels.

Helmet. The helmet of salvation.

Hen and Chickens. Solicitude of our Lord. Protection. Providence.

Heron. Since the heron is said to abhor all dead and decaying things, it is a symbol of the Christian who turns away from all false doctrine.

Hexagon. The six attributes of the Deity: Power, Wisdom, Majesty, Love, Mercy and Justice. The base of a chalice, an altar cross and altar candlesticks are often hexagonal.

High Priestly Vestments. Aaron.

Hind. Running: Naphtali.

Holly. Christmas.

Holy Thorn. See Glastonbury Thorn.

Honey. Comb of, and vessel of milk: the Promised Land.

Honour, Vessel of. The Virgin.

Hood. Pointed: Joel.

Hook. Large fish-hook: S. Andrew. Boat-hook, *q. v.*

Horn. Strength. Intelligence. Power. Seven rams' horns: entry into Jericho. Horn of oil: David. Horn of plenty: God's bounty. Liberality. Asher. Four horns: Zechariah. Horn of milk: Cimmeriana the sibyl. Horn alone: Erythraea. Delphica.

Horse. War. Red horse: Zechariah. Horse and Rider: Our Lord—Rev. 19. Four horses: see under Four. White horse and white banner: S. James Major.

Host. Rising out of a chalice: the Eucharist.

House. House of Gold: the Virgin. Built on a rock: Christian faith founded on Christ.

Hyacinth. Power and peace.

Hydra. A fabled beast with many heads, which grow on again in increased number as soon as cut off. A symbol of the fearfully prolific nature of heresy, sin and false doctrine.

Hyena. The hyena, which eats decaying corpses, has been used as a symbol of those who thrive on the filthy corpse of false doctrine. The ancients said that the hyena is able to change its sex, and used it as a symbol of the unstable man.

Hyssop. Purification. Absolution. Humility. Hyssop and reed: a Passion symbol.

Ichthus. Greek for "fish." Symbol of our Lord.

IC XC. Ancient abbreviations for "Jesus Christ." With the word *Nika*: Jesus Christ the Conqueror.

Idol. Apostasy. Paganism. Heathen world. Mammon worship. Solomon's apostasy. Fallen idols:: Flight into Egypt. Also a symbol of heathenism. Idol under foot: denial of or testimony against paganism. Shattered idol: Hosea. S. Philip.

Iesus Hominum Salvator. "Jesus Saviour of Mankind." An expression often incorrectly given as the meaning of the IHC or IHS symbol. See Chapter IX.

IHC or IHS. See under Sacred Monograms.

Image. Great image: Daniel's interpretation of dreams.

Implements of Warfare. Gad.

Incense. Prayer. Worship. Adoration. Merits of Christ

Inkhorn. Held by an angel: S. Matthew and other sacred writers.

I. N. R. I. Iesus Nazarenus Rex Iudaeorum. Latin for "Jesus of Nazareth, King of the Jews." The title over the Cross.

Interlaced Circles. See under Circles.

Inverted Cross. See under Cross.

Ivory, Tower of. The Virgin.

Ivy. Faithfulness. Memory.

Jasmine. Divine hope.

Jawbone. Of an ass: Samson.

Jaws of Hell. See under Hell.

Jerusalem. City of: the Church. Heaven.

Jesse, Rod of. Our Lord. The Virgin. See Chapter VI.

Jesse Tree. Our Lord's human genealogy. See Chapter VI.

Jewels. Ruby: Love, fervor, blood or martyrdom. Sapphire: Heaven, truth or wisdom. Emerald: Hope, life and growth. Amethyst: penitence. Diamond: Joy, purity.

Keys. Adam. Two saltire: Office of the Keys. S. Peter. Confession and Absolution. Excommunication and Restoration. With inverted cross, patriarchal cross, scroll, book, fetters, etc.: S. Peter. Bunch of: the Virgin. S. Martha.

Kiss of Betrayal. On old English bench ends this is used as a Passion symbol.

Knife. Sacrifice. Martyrdom. Death by flaying. Abraham. Isaac. S. Zadkiel the Archangel. S. Bartholomew. S. James Minor. Three flaying knives, one flaying knife and book, or flaying knife alone: S. Bartholomew.

Knotted Club. S. Jude. S. Philip.

Labarum. S. Constantine's cross, with words *In hoc signo vinces.* (By this sign conquer.) Also the Chi Rho.

Ladder. Jacob. A Passion symbol. With winding sheet, or with reed and sponge; a Passion symbol.

Lamb. Our Lord. With banner of victory: our Lord. S. John the Baptist. On book: our Lord. Also denotes the Atonement. Lamb alone: the believer. An apostle. Humility. M e e k n e s s. Faith. Twelve: the Twelve Apostles. Carried by a shepherd: the Good Shepherd and His sheep. Note: The Lamb of God, or *Agnus Dei,* is always nimbed with the tri-radiant nimbus. Lamb on an altar: Sacrifice. Abel. Slain lamb: the Passover. Christ our Passover.

Lamp. Word of God. Good works. Truth. Divine inspiration. Enlightenment. Knowledge. Seven lamps: the Holy Ghost. Lamp and book: enlightenment. Knowledge.

Lance. A Passion symbol. Martyrdom. S. Jude. With three stones: S. Matthias. With builder's square: S. Thomas. With broken sword: Micah. Piercing a heart: a Passion symbol. With spear and arrows: S. Thomas. With fuller's bat or inverted cross: S. Jude.

Lantern. A Passion symbol. Persica. S. Christopher. Often spelled "Lanthorn."

Last Things, the Four. Death, Judgment, Heaven, Hell.

Latin Benediction. See Chapter V.

Latin Cross. Finished Redemption. Faith. See under Cross.

Laurel. Reward. Victory. Good report.

Lavabo. Cleansing. Purity.

Laver, the Brazen. O. T. worship.

Law, Tables of. The Ten Commandments.

Leather Girdle. S. John the Baptist.

Leaven. Kingdom of Heaven. The Word. Christian influence.

Lebanon. Streams of: the Virgin.

Lectern. The Word. Double-headed: Old and New Testament. Law and Gospel. Epistle and Gospel. Four-headed: Church music.

Light. See under Lamp. With pitcher: Gideon.

Lightning. Destruction. Vengeance of God.

Lilium Candidum. The Annunciation. S. Gabriel, Archangel. The Virgin. Our Lord's human nature.

Lily. Purity. Innocence. Virginity. Heavenly bliss. The Virgin. The Annunciation. Our Lord's human nature. S. Gabriel carries a lily in Annunciation pictures, and one is shown growing at the Virgin's side. Madonna lily: the Virgin. Easter lily: the Resurrection. Lily and builder's square: S. Joseph of Nazareth. With IHC in triangle: two-fold nature of our Lord. Crown of lilies and stars: the Virgin. Lily, sceptre and cross: Principalities.

Lily of the Valley. Humility.

Linen Burial Cloth. A Passion symbol.

Lion. Our Lord, the Lion of the Tribe of Judah. Also strength, fortitude, courage, kingliness. Daniel. Hosea. Samson. David. See also Chapter VI. Nimbed and winged lion: S. Mark. Lion's whelp: Judah. The lion is pictured at S. Jerome's side. The devil is sometimes represented as a roaring lion. Cf. I Peter 5,8.

Litany Desk. Penitence. Prayer.

Liturgical Colors. See under White, Violet, Red, Green, Black, etc.

Living Waters. Four streams of: the Gospels. Fountain or well of: the Virgin.

Lizard. The ancients believed that when the lizard is old and blind, he stretches his head toward the rising sun, and his sight is restored. A symbol of the transforming power of the Gospel of Jesus Christ, which is able to give spiritual sight to man.

Loaf. S. James the Less. Loaves and pitcher: Obadiah. Two loaves and basket, or slender cross: S. Philip. Loaves and fish: S. Jude. Loaf and chalice: Melchizedek. The Eucharist. The Last Supper.

Locust. With or without a leather girdle above: S. John the Baptist. The Gentile nations.

Lyre. Music.

M, or *MA Crowned.* The Virgin. MA DI: *Mater Dei,* or "Mother of God."

Magpie. Evil fortune.

Man. Winged and nimbed: S. Matthew, Evangelist.

Mandrake. The Virgin.

Manger. The Nativity of our Lord. The sibyl Cumana. With enthroned Lamb: our Lord's two states, humiliation and exaltation.

Maniple. A eucharistic vestment in the form of a band worn on the left arm. Symbol of the cords used to bind our Lord, and of spirituality and purification.

Manna. The Eucharist. The Bread of Life.

Manus Dei. The hand of God. See Chapter V.

Mantle. Elijah. Elisha. Cast off: Hosea.

Marigold. The Virgin.

Mask. Hypocrisy. Insincerity.

Mattock. Adam. Toil.

Measuring Line. Zechariah.

Mermaid. The two-fold nature of our Lord.

Milk. Vessel of, and comb of honey: Canaan. Horn of: Cimmeriana the sibyl.

Mill. Gospel mill: the Church. See Chapter XVIII.

Millstone. An instrument of martyrdom by drowning.

Mirror. The Virgin. Prophecy.

Mitre. The O. T. priesthood. Also a cloven cap worn by archbishops, bishops and some abbots. Symbol of authority and oversight. Mitre and censer: Melchizedek. Triple mitre: the Pope.

Money Bag. Judas. S. Cyril. Three bags: S. Matthew. Bag with 30 pieces of silver: Judas.

Money Chest. S. Matthew.

Monograms. See Chapter VII.

Monsters, Fabled. See Dragon, Serpent, Wyvern, Centaur, Griffin, Unicorn, Cockatrice, Basilisk, Hydra, Mermaid, Sphinx, Chimera, Satyr, Harpy, Phoenix, Salamander, etc.

Monstrance. A transparent pyx containing the reserved Sacrament. Carried in procession and exposed on the altar. Symbol of the Eucharist.

Moon. Rachel. Crescent moon: the Virgin. Sun and moon: used in paintings of the Crucifixion to show the convulsions in the heavenly bodies. Also used as a symbol of the Virgin.

Mountain. Temple on a mountain: Micah. Church on a mountain: the Church founded on Christ. Mountain, and feet of an angel emerging from a cloud: Nahum.

MR. With or without a crown above: the Virgin. On a shield: S. Gabriel.

Mummy. Jacob. Joseph.

Music. On a scroll: S. Ambrose. S. Gregory the Great. S. Cecilia.

Mustard Seed. The Church.

Myrrh. Martyrdom. Sorrow. Purity. Our Lord's priestly office. Our Lord's sufferings. Vessel of myrrh and aloes: a Passion symbol. Nicodemus. The Virgin. Casket of: S. Balthazar, Magus.

Myrtle. Virginity.

Nails. Alone, or with a hammer, with pincers, or with the crown of thorns: a Passion symbol.

Napkin. With our Lord's face: S. Veronica. In R. C. art: a Passion symbol.

Net. S. Andrew. Drag net: the Church.

New Jerusalem. Heaven. Plan of: Ezekiel.

Nika. With IC XC: our Lord as Conqueror.

Nimbus. Sanctity. See Chapter XI.

Nine. A symbolic number, representing the Nine Choirs of Angels, the Nine Fruits of the Holy Ghost, the nine indifferent lepers, etc.

Nine Choirs of Angels. See Chapter XVI.

Nine Fruits of the Holy Ghost. Charitas, Gaudium, Pax, Longanimitas, Benignitas, Bonitas, Fides, Mansuetudo, Continentia. Latin for love, joy, peace, long-suffering, gentleness, goodness, faith, meekness and temperance. Gal. 5, 22.

Noah's Ark. The deluge. The Church. Salvation through our Saviour.

Nymphs. Pleasures of the world. Temptation. With S. Jerome: his victory over worldly temptations.

Oak. Strength. Eternity. Force. Virtue. Forgiveness.

Oar. Noah. With saw, or with battle-axe, or two oars saltire: S. Simon.

Octagon. Regeneration. Completion. Holy Baptism. The New Birth. Octagonal font: Regeneration through Holy Baptism. Octagon pulpit: the regenerating power of the Word of God.

Oil. Calmness. Peace. Healing. Horn of: David. Cruse of: the inexhaustible grace of our Saviour. Oil stock: Extreme unction.

Ointment. Jar or box of: S. Mary Magdalene. S. Mary of Bethany. Burial of our Lord.

Old Testament Cross. The Tau cross.

Olive. Peace. Noah. S. Gabriel the Archangel. Concord. Charity. Prosperity. Faith. Healing. The grace of our Lord. Crown of: spiritual victory. Olive and balsam: the two-fold nature of our Lord. Gnarled olive tree: Gethsemane. Palm, cypress and olive: the Virgin. Olive oil: works of mercy.

One. The unity of the Godhead. The Church.

Orante. A standing figure, with arms upraised. A very ancient symbol of prayer.

Orb. The earth. With a cross upon it: the triumph of our Saviour, or of His Gospel. Sovereignty. Victory. The Virgin. Orb, with serpent about it: sin encircling the globe. Same, at the feet of the Virgin: the Second Eve.

Orchard of Pomegranates. The Virgin.

Orpheus. Our Lord. See Chapter VI.

Ostensorium. The Eucharist.

Otter. Our Lord's descent into hell. See Chapter VI.

Owl. Mourning. Desolation. Wisdom.

Ox. Patience. Strength. Service. Endurance. Sacrifice. Our Lord's Sacrifice. Ox and ass: The Jewish people, who bore the yoke of the Law, and the Gentiles who accepted the peace and humility of our Lord. On the great towers of Laon the carved oxen represent the animals who drew the great stones to the cathedral site. Winged and nimbed ox: S. Luke. Ox goad: Cain.

Padlock. Prudence. Secrecy.

Pallium. A Y-shaped device on the chasuble, symbolical of the Crucifixion of our Lord.

Palm. Victory. Spiritual victory. Martyrdom. Victory over sin and death. Reward of the righteous (Psalm 92, 12). Immortality. The Triumphal Entry. The Resurrection. S. Gabriel the Archangel. Palm, Cypress and Olive: the Virgin.

Pansy. Humility. The Trinity.

Panther. Our Lord drawing all men to Him. See Chapter VI.

Paradise. Four rivers of: Pison, Gihon, Tigris, Euphrates.

Partridge. Symbol of the devil, because of the saying that the partridge seeks to gather all the young of other birds.

Paschal Candle. See under Candlesticks, Varieties of.

Paschal Lamb. The Old Testament. The Atonement.

Passion Flower. See Chapter IX.

Passion Symbols. See Chapter IX.

Passover. Our Lord. See I Cor. 5, 7.

Pastoral Staff. Authority. Oversight.

Paten. The vessel in which the altar breads are laid. Symbolical of the Eucharist.

Pax Tibi. On a scroll: S. Mark.

Peacock. Eternal life. The Resurrection of our Lord. Immortality. Drinking from vase: Christian drinking the waters of eternal life. In very late art the peacock became a symbol of vanity. See Chapter VI.

Pear. The Virgin. (Rare.)

Pelican. The Atonement. See Chapter VI.

Pen. Divine authorship. S. Jerome, S.Gregory, etc.

P h o e n i x. The Resurrection. See Chapter VI.

Phoinix. The date-palm (*Phoenix dactylifera*). The Resurrection. See Chapter VI.

Pierced Heart. With a lance or spear: a Passion symbol. With a sword, heart often winged: the Virgin.

Pilgrim's Hat. With staff, wallet, etc.: S. James Major.

Pilgrim's Staff. With purse, hat, sword, etc.: S. James Major. With Tau cross: S. Philip. With gourd and wallet: S. Raphael the Archangel.

Pincers. Alone, or with nails or hammer: a Passion symbol.

Pit. Joseph.

Pitcher. With light: Gideon. With ewer: Pilate. With rays above: S. Bede. With loaves: Obadiah. With dish and two fishes: the Virgin.

Plan. Of the New Jerusalem: Ezekiel.

Plenty, Horn of. The Lord's bounty. Thanksgiving.

Plough. Cain. Diligence. Labor.

Poinsettia. (*Euphorbia pulcherrima.*) A modern symbol of Christmastide, somewhat secular.

Pomegranate. The Resurrection of our Lord. Immortality. Royalty. Fertility. The Church. Hope. Unity of the Church. Used in Solomon's temple, and on the high priest's robe. Orchard of pomegranates: The Virgin.

Pottage, Mess of. Jacob and Esau.

Potter's Wheel. A Christian's life shaped by divine influence. Jeremiah.

Prester John. On a tomb: S. John.

Prince. Our Lord. (Acts 5, 31, Isaiah 9, 6, etc.)

Processional Cross. The C h u r c h Militant. Phrygiana the sibyl.

Psyche. An ancient symbol of the soul. She was wedded to an unseen lover, suffered many trials, and finally was saved by Eros.

Pulpit. Testimony. Word of God. Instruction in religion.

Purse. With 30 coins: a Passion symbol. Three purses: S. Matthew. One purse: S. Cyril. Open purse: charity to the poor. Christian beneficence.

Pyramid and Star. The flight into Egypt.

Pyramids. · Israel in Egypt. The Flight into Egypt.

Pyx. A container for altar breads. Also a small box for conveying the breads to the sick. In olden times often shaped like a dove. Symbol of the Last Supper, or of the Blessed Sacrament.

Quail. God's providence. (Exodus 16, 12-13.)

Quatrefoil. The Four Evangelists. The Four Gospels. The Four Greek Doctors. The Four Latin Doctors.

Quill. With scroll or inkhorn: divine authorship.

Rain. The Lord's impartiality. (St. Matt. 5,45.)

Rainbow. God's promise to Noah. With ark: the Deluge. Our Lord is often pictured in representations of the Last Judgment as seated on a rainbow.

Ram. Sacrifice. Sacrifice of Isaac. With four horns: Daniel. Seven rams' horns: fall of Jericho.

Raven. Unrest. Noah. Since the raven did not return to the ark, it is said to be a symbol of the indifferent and impenitent sinner. Elijah's raven: God's providence. In modern times a raven is the symbol of ill-fortune.

Red. The second of the liturgical colors. Symbol of love, fervor, holy zeal, youth, blood, martyrdom. Also the symbol of the Holy Ghost, Pentecost, the Church, the Seraphim.

Reed. With hyssop, or with a sponge, or a ladder, or a scarlet robe: a Passion symbol. Also the sibyl Samiana.

Rejected Stone. Our Lord. (S. Matt. 21, 42.)

Remora. Our Lord. See Chapter VI.

Ring. Holy Matrimony. Also an attribute of power.

Rivers of Paradise, Pison, Gihon, Tigris and Euphrates. The Four Evangelists. The Four Gospels.

Robe. Scarlet robe and reed: a Passion symbol.

Rochet. A vestment symbolical of loving administration.

Rock. Firmness. Stability. Conservatism. Our Lord the Rock of Salvation. The Church. S. Peter. Rock surmounted by a cross: our Lord. Surmounted by a church: the Church founded on Jesus Christ. With water gushing from it: Moses. With four streams flowing from it: the Four Gospels.

Rod. Official power. Also a Passion symbol. Tiburtina the sibyl. Budding: Aaron. Flowering: S. Joseph of Nazareth. The Virgin. Rod of Jesse: Our Lord. The Virgin.

Roll. The Pentateuch. The Law. Prophecy. The Holy Scriptures. Twelve rolls: the Twelve Epistles of S. Paul. Roll and sheaf of wheat: O. T. Feast of Pentecost.

Rood. Rood-beam: a great beam of wood, cambered, and supporting a carving of the Crucifixion. This is placed overhead at the entrance to the chancel of a church, to symbolize the fact that we must pass from the Church Militant to the Church Triumphant by way of the Cross of Calvary. Rood screen: An open screen of carved oak or stone, separating the chancel

from the nave. Symbolizes the gates of Heaven.

Rope. A Passion symbol. Judas' death.

Rosary. Prayer.

Rose. Messianic hope. Love. Our Lord. The Nativity. Rose of Sharon: our Lord. Mystic Rose: the Virgin. Christmas Rose: the Nativity. Red rose: n.artyrdom. Divine love. White rose: purity. The Virgin. Erythraea the sibyl. On a cross: death of our Lord.

Rosemary. (*Rosmarinus officinalis.*) The Nativity.

Rule, Builder's. S. Thomas.

Sack. Isaiah.

Sackcloth and Ashes. Mourning. Penitence.

Sacred Monograms. See Chapter VII.

Sacrificial Knife. Abraham. S. Zadkiel the Archangel.

Saffron. Saffron and Spikenard: the Virgin.

Sail Boat. S. Simon. S. Jude. On the Nile: S. Athanasius. With cross-shaped mast: the Church.

Salamander. A fabled reptile somewhat like a lizard, said to be able to resist fire. A symbol of the Christian who, by grace, resists temptation.

Salt. Wisdom. The Christian as the salt of the earth.

Saltire. An heraldic term, meaning shaped like the letter X. Saltire cross: S. Andrew. With boat-hook: S. Andrew.

Sanctuary Lamp. The Real Presence of our Lord's Body and Blood in the Eucharist. In Roman Catholic and Anglo-Catholic churches: the reserved Sacrament.

Sanctus, Sanctus, Sanctus. Latin for "Holy, Holy, Holy." The Holy Trinity.

Sapphire. Heavenly reward.

Satyr. A fabled monster with the head of a man and the legs of a goat. Symbol of the children of the devil.

Saw. An instrument of martyrdom. Isaiah. S. James the Less. S. Simon. S. Jude. S. Matthias. Saw, oar and battle-axe: S. Simon. Saw and oar or oars saltire: S. Simon.

Scales. See Balances.

Scallop. See Escallop.

Scapegoat. The Vicarious Atonement.

Sceptre. Kingly authority. Messianic hope. Our Lord's kingly office. Sceptre and chain: Joseph's advancement. Sceptre and crown: our Lord. With trumpet: Joshua. With censer: Melchizedek. With cross and lily: the Principalities. Tipped with cross: our Lord as King. Tipped with fleur-de-lys: the Virgin.

Schemhamphoras. A noted symbol carved on the n. e. corner of the parish church at Wittenberg, showing a man peering into the alimentary canal of a hog. Said by Luther to be a certain religious leader examining his sacred writings. A somewhat similar unsavory symbol is said to be seen at S. Nicholas's Church at Zerbst. Such symbols are not uncommon in the last days of the Middle Ages.

Scimitar. S. Bartholomew. With closed book: S. Matthias.

Scorpion. The devil. Sin. Rebuke. Remorse.

Scourge. A Passion symbol. Penitence. Penance. Remorse. Persecution. Two scourges and a pillar: a Passion symbol. Two scourges and a beehive: S. Ambrose. A scourge is also carried by the sibyl Agrippa.

Scrip. Pilgrimage.

Scroll. The Pentateuch. The Law. Prophecy. The Holy Scriptures. Four scrolls: the Four Gospels. Twelve scrolls: the twelve Epistles of S. Paul. With words *Sc. Joannes* or *Sc. Johannes*: S. John. With names of the Seven Gifts or the Nine Fruits of the Spirit: the Holy Ghost. With sceptre: Solomon. Winged scroll: Zechariah. With red vestment: Elijah. With I. N. R. I.: the inscription on the Cross. A Passion symbol. With two keys: S. Peter. With a sheaf of wheat: O. T. Pentecost. With word *Theotokos*: S. Cyril. With tall cross: S. Philip. With *Ecce Agnus Dei*: S. John the Baptist. With *Vox clamantis in deserto*: S. John the Baptist. With *Pax tibi*: S. Mark. With bar of Gregorian music: S. Ambrose, S. Gregory the Great, etc. With *Ora pro nobis Deum*: S. Gregory the Great. With quotation in Greek: this is given to each of the Greek Fathers.

Scythe. Death.

Sealed Book. Also a Sealed Fountain or Sealed Spring: the Virgin. Book with Seven Seals: our Lord.

Seamless Coat. A Passion symbol.

Seat. Of Wisdom or of Judgment: the Virgin.

Seeds. Three seeds of the Tree of Life: Seth.

Septfoil. A figure composed of seven segments of a circle. Symbolizes the Seven Gifts of the Holy Ghost, the Seven Sacraments of pre-Reformation times, etc.

Seraph. See Chapter XVI.

Serpent. Satan. Sin. Fall of Man. Wisdom. Subtlety. Falsity. Encircling tree: Fall of Man. Encircling globe: sin encircling the earth. Same, under the feet of the Virgin: the victory of the Seed of the Woman. Bruised serpent: the Virgin. Serpent and staff: miracles of Moses and Aaron. On Tau cross: the serpent lifted up in the wilderness. Our Lord. Battling with a fish: Satan tempting our Lord. Emerging from chalice: refers to the attempt made to poison S. John. On sword: S. John. Over a fire: S. Paul at Melita. The ancients said that the serpent fasts for 40 days and then sheds his old skin. In like manner must a man, after repenting of his sins, put on the new man. An old legend states that the serpent leaves his venom in his den before drinking water, lest he kill himself. So also must a sinner repent before partaking of the Eucharist. In ancient times a serpent was said to flee in terror from a man who quickly discards his clothing, recalling the temptation of Adam. So also will Satan flee from those who free themselves from sin, through Word and Sacrament. As the serpent exposes his whole body to his enemies, so also must the Christian not hesitate to endure afflictions for the sake of the Lord.

Surplice. A white vestment symbolical of innocency and purity.

Seven. The first of the symbolic numbers. It symbolizes the seven days of creation, the seven planets, seas, Sacraments, Gifts of the Holy Ghost, Last Words on the Cross, Penitential Psalms, days of the week, great councils of the early Church, stars in the Pleiades (supposed by the ancients to be Heaven), the lamps before the Throne of God, seals of the Book of Life, Deadly Sins, Cardinal Virtues, Works of Mercy, Patriarchs, trumpets of Jericho, baths of Naaman, Jewish festivals, deacons in the Apostolic Church, candlesticks, churches of Asia Minor, spirits before the Throne of God, candlesticks or stars or trumpets of the Apocalypse, ears of corn in Pharoah's dream, oxen of the same, joys of Mary, sorrows of Mary, champions of Christendom, ages of man, Jacob's years of service, etc., etc.

Seven Champions of Christendom. SS. George of England, Andrew of Scotland, David of Wales, Patrick of Ireland, James of Spain, Denis of France and Anthony of Italy.

Seven Christian Virtues. Humility, Liberality, Chastity, Gentleness, Temperance, Brotherly Love, Diligence.

Seven Corporal Works of Mercy. To feed the hungry, to clothe the naked, the shelter the stranger, to visit the sick, to visit the imprisoned, to visit the fatherless and widowed, to bury the dead.

Seven Councils of the Church. Nicaea, Constantinople, Ephesus, Chalcedon, Constantinople, Constantinople, Nicaea.

Seven Deadly Sins. Pride, Covetousness, Lust, Anger, Gluttony, Envy, Sloth.

Seven Flames. The Seven Gifts of the Holy Ghost.

Seven Gifts of the Holy Ghost. See Chapter X.

Seven Golden Candlesticks. The seven churches of Asia Minor.

Seven Joys of the Virgin Mary. The Annunciation, Visitation, Nativity, Epiphany, Presentation, Finding her Son in the Temple, the Assumption.

Seven Last Words. "Today shalt thou be with Me in Paradise." "Woman, behold thy son!" "Son, behold thy mother!" "I thirst!" "My God, My God, why hast Thou forsaken Me?" "Father, into Thy hands I commend My spirit!" "It is finished!"

Seven Patriarchs. Adam, Noah, Shem, Abraham, Isaac, Jacob, Joseph (or Job).

Seven Sacraments. Holy Baptism, Confirmation, the Holy Eucharist, Penance, Holy Orders, Holy Matrimony, Extreme Unction.

Seven Sorrows of the Virgin. The Prophecy of Simeon, the Flight into Egypt, the Loss of Her Son at Twelve, the Betrayal, the Crucifixion, the Entombment, the Ascension.

Seven Spiritual Works of Mercy. Instructing the ignorant, Correcting the offender, Counselling the doubting, Comforting the afflicted, Suffering injuries patiently, Forgiving offences, Praying for others.

Seven Penitential Psalms. Psalms 6, 32, 38, 51, 102, 130 and 143.

Seven-Branched Candlestick. Old Testament Worship. The Synagogue. The Church. The Seven Churches of Asia Minor. The Seven Angels of the Apocalypse. The Seven Gifts of the Holy Ghost. The Seven Sacraments.

Shamrock. The Trinity. S. Patrick.

Sheaf. Plenty. Gifts of God. Joseph's dream. Fourteen sheaves: Jacob, his wife and 12 sons. Sheaf and roll of the Law: O. T. Feast of Pentecost.

Sheep. Christians. Twelve sheep: the Twelve Apostles. Sheep and goats: the redeemed and the lost.

Sheet, Winding. With cross: a Passion symbol.

Shekinah. God's presence.

Shell. See Escallop.

Shepherd, The Good. Our Lord. See Chapter VI.

Shepherd's Crook. Abel. Amos. Moses. David. The Nativity. Christmas.

Shewbread. Table of: O. T. worship.

Shield. Protection. Faith. Blank shield: Judas. Shield of David: David. The Synagogue. The Holy Trinity. Shield of Faith: S. Paul. Shield, sword and balances, S. Michael the Archangel. Shield inscribed *Maria, AM, AMGPDT,* etc., S. Gabriel the Archangel. Shield of the Trinity: Unity of the Trinity.

Ship. The Church. Jonah. S. Simon. S. Jude. S. John (rare). In harbor: Zebulum. On the Nile: S. Athanasius.

Shovel. Adam. Man's labor.

Sibyls. See Chapter III.

Sickle. Death. End of the world.

Silver. Eloquence. Chastity. Thirty pieces of: Judas.

Six. A number symbolizing the six days of creation, the six attributes of the Deity, the six sins against the Holy Ghost, the six hours spent by our Lord on the cross, etc.

Six Attributes of the Deity. Power, Majesty, Wisdom, Love, Mercy, Justice.

Six Sins Against the Holy Ghost. Presumption of God's Mercy, Despair, Resisting the Truth, Envy, Obstinacy in sin, Persistent Impenitence Until Death.

Six Hundred Sixty-six. Antichrist. (Rev. 13, 18.)

Skeleton. Death.

Skin. Human skin: Death by flaying. Hanging on a cross, or carried over his arm: S. Bartholomew.

Skull. Death. Adam. The Fall of Man. Sin. Hosea. S. Jerome. Under the crucified Saviour: Adam's skull, representing sin.

Sling. With five stones: David and Goliath.

Snake. See Serpent.

Snow. Purity. Virginity.

Snowdrop. The Virgin.

Spade. Adam. The Fall of Man. Toil.

Spear. Warfare. Martyrdom. S. Andrew. Piercing a heart: a Passion symbol. With builder's square, or arrows, or arrows and a lance, or a book: S. Thomas. With a patriarchal cross, or a Tau cross, pillar and long staff: S. Philip. With a V-shaped frame: S. Andrew. With an inverted cross or a fuller's bat: S. Jude.

Speculum. The Virgin.

Sphinx. A fabled creature with the head and chest of a woman, and body, feet and tail of a lion. Silence. Secrecy. Mystery. Israel in Egypt. The Flight into Egypt.

Spikenard. Holiness. Death. With camphire or saffron: the Virgin.

Spindle. Eve.

Spire. Of a church: Heavenly aspiration.

Spiritus Gladius. Latin for "the Sword of the Spirit." God's Word. On a book, with cross-hilted sword: S. Paul.

Sponge and Reed. With or without ladder: a Passion symbol.

Spring. Shown heraldically as a circle with parallel wavy lines running horizontally through it. Symbol of the Springs of Living Water. Three springs: S. Paul. Four springs: the Four Gospels, or the Four Evangelists. Seven springs: the Seven Springs of Living Waters. Sealed spring: the Virgin.

Square. Builder's square: S. Thomas. S. Matthias. With a cross: S. Philip. With a spear, or with spear and arrows: S. Thomas. With a boat-hook: S. Jude. With a lily: S. Joseph of Nazareth.

Squirrel. A Christian's busy forethought of eternity. Heavenly meditation. The striving of the Holy Spirit.

SS. Abbreviation for *Spiritus Sanctus,* meaning "the Holy Spirit." Also abbreviated *Spus Scus.*

SSS. See *Sanctus, Sanctus, Sanctus.*

Spider. Patience.

Staff. Staff and serpent: Moses and Aaron before Pharaah. Shepherd's staff: Abel, Amos, Moses, David, etc. The Nativity. Pilgrim's staff, with Tau cross, pillar or spear: S. Philip. Pilgrim's staff and sword saltire, or with wallet, or pilgrim's hat, or letters S. J.: S. James Major. Pilgrim's staff, sword and wallet: S. Raphael, Archangel. Staff and cup: S. Chamael, the Archangel. Sword and straight staff saltire: a Passion symbol. Bishop's staff: pastoral authority. S. Gregory the Great, etc. Long staff and spear: S. Philip.

Stag. Trampling on a serpent or dragon: our Lord's power over Satan. Two stags drinking: Holy Baptism. Hunted stag: the persecution of the early Christians. The ancients believed that the stag is able to kill the serpent or dragon by his breath. Hence the symbol of the Word of God, which has power to destroy the works of the devil. The stag is also an attribute of S. Jerome.

Star. F o u r - p o i n t e d: the Cross Etoile. Five-pointed: the Epiphany. The Star of Jesse, or of Jacob. Heavenly wisdom. Six-pointed: the Creation. The Father. David. Seven-pointed: the Seven Gifts of the Holy Ghost. Eight-pointed: Regeneration. Holy Baptism. Nine-pointed: the Nine Fruits of the Holy Ghost. Ten-pointed: the ten Apostles who neither denied nor betrayed their Lord. Twelve-pointed: the Twelve Apostles. The Day-Star: Our Lord (2 Peter 1, 19). The Morning Star: Our Lord (Rev. 22, 16). The Mystic Star of seven or nine points: the Holy Spirit. Crown tipped with stars: the Virgin. Crown of lilies and stars: the Virgin.

Stars. The universe. Heaven. The call of Abraham. Crown of: the Virgin. Crown of lilies and stars: the Virgin. Four stars: the Four Major Prophets. The Four Evangelists. Seven stars: the Seven Churches of the Apocalypse. Sun, moon and twelve stars: Jacob and his family. Twelve stars: the Twelve Tribes of Israel. The Twelve Minor Prophets. The Twelve Apostles.

Starwort. (*Aster grandiflorus.*) The Nativity of our Lord.

Stations. The Fourteen Stations of the Cross: Our Lord Condemned to Death. He is Made to Bear His Cross. He Falls Under the Cross. He Meets His Afflicted Mother. Simon the Cyrenian Bears the Cross. S. Veronica Wipes Our Lord's Face. Our Lord Falls the Second Time. He Speaks to the Daughters of Jerusalem. He Falls the Third Time. He is Stripped of His Garments. He is Nailed to the Cross. He Dies on the Cross. He is Taken Down from the Cross. He Is Placed in the Sepulchre.

Steelyards. Justice.

Stigmata. The Five Wounds of our Lord.

Stole. A vestment symbolical of the yoke of man's sin borne by our Lord. Innocence. Willing servitude.

Stone. Martyrdom. Jeremiah. Full of eyes: Zechariah. With open Bible and whip: S. Jerome. Rejected stone: our Lord (S. Matt. 21, 42). Two stones: S. Matthew. Stones and battle-axe: S. Matthew. Three stones: S. James Minor. Three stones and dalmatic: S. Stephen, protomartyr. Five stones and sling: David. Millstone or grindstone: death by drowning. Stones with spear, or girdle, or arrows: S. Thomas. Three stones and a lance: S. Matthias.

Stream. See Rivers. Streams of Lebanon: the Virgin.

Stork. Filial piety. Birth.

Sun. Splendor. The Father. With IHC in center: our Lord. Rising: the Advent of our Lord. Setting: Death. Veiled sun and moon: subservience of the created universe. Sun, moon and 12 stars: Jacob, his wife and sons. Sun and moon at her feet: the Virgin.

Sunflower. Glory. The soul turning to Christ.

Surplice. A vestment symbolical of purity.

Swallow. The Resurrection.

Swan. Because of its black flesh under its white plumage the swan is a symbol of the hypocrite. Swan song: last effort. End of life.

Swastika. See Gammata.

Swine. I m p u r i t y. Uncleanness, Abomination. Unbelievers. They of the uncircumcision.

Sword. Power. Justice. Authority. Martyrdom. Warfare. Fortitude. The Tenth Plague of Egypt. Europeana the sibyl. Elijah. Simeon. Levi. Erythraea the sibyl. Sword and scabbard saltire: S. Peter. Flaming sword: expulsion from Eden. Piercing a heart: the Virgin. Blunt sword: Mercy. Obtusely pointed sword: religion. Pointed: Justice. Two-handed: the civil power. The State. With balances: Justice. Excalibur: a great, two-handed, jeweled sword, symbol of King Arthur. Sword and staff: a Passion symbol. Sword of the Spirit: Word of God. S. Paul. Cross-hilted sword and book inscribed *Spiritus Gladius*: S. Paul. Sword piercing a book: S. Boniface. Sword held by the point: S. Matthias. Two swords saltire: S. Paul. With serpent entwined about it: S. Paul. Sword held with hilt upward: Consecration. Allegiance. Sword and trumpet: Joshua. Broken sword and lance: Micah. Sword hanging over walled city: Zephaniah. Sword and torch saltire: a Passion symbol. Sword and pilgrim's staff saltire, or with an escallop shell: S. James Major. Flaming sword and shield: S. Michael. Christian c o n q u e s t.

Sword and palm: martyrdom (many saints).

Tabernacle. O. T. worship. A tabernacle, or small chest upon an altar: the Real Presence. The reserved host. Three tabernacles on a mountain top: the Transfiguration.

Table. Two tables of stone: the Ten Commandments. Moses. Of shewbread: O. T. worship. Writing table, pen and books: S. Ambrose.

Tambourine. Miriam. Rejoicing in the Lord.

Tares. Sinners. Wheat and tares: the Church on earth.

Tau Cross. S. Matthew. Hellespontica the sibyl. With a basket, or pilgrim's staff, or a pillar and spear: S. Philip.

Temple. Model of: Solomon. Habakkuk. Under construction: Solomon. Haggai. On a mountain: Micah. The spiritual Zion. The Church.

Ten. A number symbolizing the Ten Commandments, 10 plagues of Egypt, 10 faithful disciples, 10 wicked brothers of Joseph, the Psalmist's instrument of 10 strings, 10 sons of Haman, 10 servants of Joshua, 10 virgins, 10 lepers, 10 pieces of silver, 10 great persecutions of the early Church, etc. The number symbolizing order.

Ten Great Persecutions. Under Nero, Domitian, Trajan, Marcus Aurelius, Septimus Severus, Maximinus, Decius, Valerian, Aurelian and Diocletian.

Tent. Israel in the wilderness. Of boughs: Feast of the Tabernacles.

Tetragrammaton. The Hebrew letters Yod, He Vau and He surrounded by a rayed triangle. The Father.

Tetramorph. A figure with four heads, eight wings and with fiery wheels under foot. See Ezekiel 10. Symbol of the Four Evangelists.

Theotokos. In Greek letters on a scroll: S. Cyril of Alexandria.

Thistle. Sin. The Fall of Man.

Thorns, Crown of Alone, or with I. N. R. I. or three or four nails: a Passion symbol. Also Delphica the sibyl.

Thorn, Glastonbury. See under Glastonbury.

Thread. Thrice round the thumb: Seth.

Three. A number symbolizing the Holy Trinity, the three elements in man (body, soul, spirit), the Three Theological Virtues, elements of faith, Evangelical Counsels, notable duties, elements in repentance, sons of Noah, angels that visited Abraham, branches of the vine of the butler's dream, baskets of the baker's dream, cities, witnesses, companies of soldiers, arrows, darts, sons, years, days, months, rows of stones, pillars, cubits, prayers, Hebrew children, days of Jonah in the fish's belly, days of our Lord in the tomb, times which God's voice was heard acknowledging His Son, three-fold punishments, blessings, denial of Peter, confession of Peter, shining Beings at Transfiguration, favored disciples, days of blindness of Saul, temptations of our Lord, men who came seeking Peter, etc., etc.

Three Elements of Faith. Knowledge. Assent. Confidence.

Three Elements of Repentance. Contrition. Confession. Restitution.

Three Evangelical Counsels. Poverty. Chastity. Obedience.

Three Fishes. Symbol of the Holy Trinity.

Three Notable Duties. Fasting, Almsgiving. Prayer.

Three Theological Virtues. Faith. Hope. Charity.

Thumb. With thread thrice round it: Seth.

Thurible. A censer. Prayer.

Tiara. Temporal power. The Pope. S. Gregory the Great.

Tiger. Cruelty. Treachery. Martyrdom.

Timbers. Haggai.

Tomb. Lazarus. S. Joseph of Arimathaea. Empty: the Resurrection of our Lord. With a Prester John: S. John.

Tongs. Holding burning coal: Isaiah.

Torch. Enlightenment. Zeal. The Gospel. The Nativity. A Passion symbol. Lybica the sibyl. Upright: life. Inverted: death. With sword saltire: a Passion symbol. Two burning: Christ the Light of the World (catacombs).

Tower. Defense. Strength. God. Of Babel: presumption. Strong tower: Micah. Of David. or of Ivory: the Virgin.

Tree. Faith. With serpent coiled around it: Fall of Man. Of knowledge: Divine wisdom. Of life: Eternal Life. Fig tree: S. Bartholomew. Olive tree: Gethsemane. Tree with countless branches: divisions of Protestantism. Tree of Jesse: our Lord's human nature or geneology. Seeds of the tree of life (three): Seth.

Trefoil. Alone or with various combinations of the circle and triangle: the Holy Trinity.

A GLOSSARY OF THE MORE COMMON SYMBOLS

385

Triangle. With words *Jehovah, Adonai, El Shaddai,* one or two Yods, etc., within it: the Father. Flattened triangle: the Father. Two interwoven, or an equilateral triangle, or various combinations of the triangle with the circle, trefoil, triquetra and cross: the Trinity. See Chapters IV and V.

Trident. In the early Church sometimes said to have been used as a disguised cross.

Triquetra. Alone, or with various combinations of the triquetra and circle, triangle, trefoil, etc.: the Holy Trinity.

Trumpet. Call to worship. Call of the Holy Ghost. The Day of Judgment. The Resurrection. S. Gabriel. S. Jerome. With sword or pitcher, or with sceptre: Joshua. Trumpet of Zion: Hosea. Seven trumpets: Fall of Jericho. The Seven Archangels.

Tunic. Camel's hair: S. John the Baptist. Seamless: our Lord.

Tunicle. A vestment symbolizing service.

Turtle Dove. Constancy. Virginity. Chastity. Two: the Presentation in the Temple. The Purification.

Twelve. A number symbolical of the sons of Jacob, tribes of Israel, Apostles, stones of the altar, pillars, months, signs of the zodiac, Minor Prophets, sibyls, gates of Jerusalem, fruits of the Tree of Life (Rev. 22), men and stones of Joshua, oxen or bullocks or lambs or goats of the sacrifice, cities, princes of Israel, baskets of bread at the feast of the 5,000, thrones, legions of angels, stars in the Woman's crown, foundations of the Holy City, Epistles of S. Paul, etc., etc.

Twenty-four. The four-and-twenty elders.

Two. A number symbolizing the parents of the human race, the two-fold nature of our Lord, the sun and moon, two of every creature saved in the ark, cherubim in the tabernacle, stones, rings, golden chains, tables of stone, turtle doves and young pigeons, goats, loaves, lambs, bullocks, mites of the widow, thieves on the cross, angels at the tomb, believers on the way to Emmaus, etc.

Two-Headed Eagle. Elisha.

Unicorn. Our Lord. See Chapter VI.

Urn. Death (heathenish). Four urns with water flowing from them: the Four Streams of Living Water. The Four Evangelists. The Four Gospels.

V Frame and Spear. S. Andrew.

Vampire. Sin. Death. The devil. An harlot.

Vase. Pottery vase: Man.

Veil. Renunciation of the world. Modesty. Mystery.

Vesica. Two intersecting segments of a circle. Our Lord.

Vessel. Of vinegar and gall, or of myrrh and aloes: a Passion symbol. Of honor: the Virgin.

Vestment. Red vestment and scroll: Elijah.

Vestments, Symbolical. See under Alb, Almuce, Amice, Cassock, Chasuble, Chimere, Cope, Cotta, Cincture, Dalmatic, Maniple, Stole, Surplice, Tunicle, Rochet.

Victory, Banner of. See under Banner.

Violet. Humility.

Violet. A canonical color, symbolical of penitence, preparation, mourning, humiliation, the Passion, Advent, Lent.

Vine. Noah. Our Lord. The Church. True believers abiding in the Lord. With twelve bunches of grapes: the Apostles. Birds in the branches represent souls abiding in Christ. Grapes represent unity. A vine, with heads of wheat: the Eucharist.

Vinegar and Gall. A Passion symbol.

Vineyard. The Church.

Viper. The devil. Sin. Evil. Ingratitude. Treachery.

Virtues. The four: Justice, Prudence, Temperance, Fortitude. The seven Christian: Humility, Liberality, Chastity, Meekness, Temperance, Brotherly Love, Diligence. Virtues, the Twenty-four. (From the font of the Chapel of the Intercession, New York.) Faithfulness (ivy). Righteousness (b r e a s t p l a t e). Mercy (blunt sword). Chastity (unicorn). Diligence (plough). Faith (cross). Meekness (yoke). Fidelity (dog). W i s d o m (serpent). M o d e s t y (dove). Industry (beehive). Liberality (horn of plenty). Truth (hatchet and cherry tree). Patience (spider). Purity (lily). Hope (anchor). Humility (lily of the valley). Good Report (laurel). Love (rose). Peacefulness (olive). Forgiveness (oak). Innocence (daisy). Loveliness (flowers). Charity (heart).

Volcano. Divine retribution.

Vox clamantis in deserto. Latin for "the voice (of one) crying in the wilderness." Shown on a scroll: S. John the Baptist.

Vulture. Evil.

Walled City. With sword above: Zephaniah.

Wallet. Pilgrimage. With pilgrim's staff, or hat, or sword, or letters S. J.: S. James Major. With staff and gourd, or a fish: S. Raphael the Archangel.

Wand and Staff. Official authority. Jeremiah.

Water. The Deluge. Reuben. Refreshment. Purification. Holy Baptism. Regeneration. Four streams of: the Four Rivers of Paradise. The Four Gospels. The Four Evangelists. Fountain or Well of Living Waters: the Virgin.

Water Lily. Charity.

Waterpots. Our Lord's first miracle.

Weather Vane. Religious instability.

Weighing of Souls. Judgment Day. S. Michael.

Well. Spiritual refreshment. The Gospel. Fruitful bough above: Joseph. Of living Waters: the Virgin.

Whale. See Great Fish. The ancients believed that whales of such enormous size existed that sailors mistook them for barren islands, landed upon them and built fires. The whale, arosed by the heat, plunged downward, engulfing all. A symbol of Satan, whose wiles are not always detected. The fish swimming unsuspectingly into the jaws of the whale, thinking it a cavern of safety, was also a symbol of the man who goes blindly into the traps of the devil.

Wheat. With the vine, or with grapes: the Eucharist. Wisp of: Ruth. Wheat and tares: believers and unbelievers. The Church on earth. Sheaf of: Bounty of God. Thanksgiving. With sickel: hackneyed symbol of death.

Wheel. Winged: Cherubim. Thrones. The Holy Ghost. Set with knives: Martyrdom. S. Catherine, etc. Potter's wheel: Our lives shaped by divine power.

Whelp. Lion's: Judah.

Whip. Penance. Penitence. Conscience. Remorse. With open Bible and stone: S. Jerome. With pile of bricks: Israel in bondage.

Whipping Post. A Passion symbol. With two scourges saltire: a Passion symbol.

White. A liturgical color, symbolizing light, purity, innocency, joy, virginity, purification. The color of our Lord, His Mother and those saints who did not suffer martyrdom. Also Christmas, Easter, the Annunciation, the Epiphany, etc. S. John.

Willow. Mourning. Death. Grief.

Winding Sheet. On the cross: a Passion symbol.

Windmill. S. James the Less.

Wine. Gladness. Rejoicing. The Eucharist.

Wine Cruse and Napkin. The Good Samaritan.

Wine Press. Wrath of God. Our Lord (Rev. 19, 15-16). Patient and solitary labor or suffering.

Wings. Aspiration. Flight of the Gospel.

Winged Creatures. Four: the vision of Ezekiel. The Four Evangelists. The creatures of the Apocalypse. Cherubim. Thrones.

Winged Heart. Transfixed by a sword: the Virgin.

Wisdom, Seat of. The Virgin. Book of: the Virgin.

Wolf. The devil. False doctrine. False prophets. The hypocrite. Famine. Lust. Cruelty. Fraud. Deceit. R a p a c i t y. Benjamin. Among the ancients, the wolf was a symbol of the wiles of Satan, because he was said to seek his

prey by night, to magnify his voice in order to terrorize his victims, to approach the fold against the wind, and to make his footsteps inaudible with his spittle.

Woman. Motherhood.

Wood. Cross-shaped bundle of: Abraham and Isaac. The widow of Sarepta.

Wreath. Of ivy: conviviality. Of oak: strength. Hospitality. Victory on the seas. Of laurel: distinction in literature or music. Of olive: peace. Of bay: death. Mourning. Of willow: bereavement. Death. Mourning. Of cypress: Mourning. Of yew: Immortality.

Writing Table. With pen and books: S. Ambrose.

Wyvern. A fabled monster with wings, two legs, claws, dragon's head, and barbed tail coiled into a knot. A symbol of Satan. Of heraldic origin.

X. The initial letter of XPICTOC, Greek for "Christ." Very commonly used as a symbol, or abbreviation of our Lord's name. XP: The Chi Rho, or Greek letters for CH and R. A symbol or abbreviation of the name "Christ." XI alone, or with Greek Cross: Christ.

X Cross. The Cross Saltire, q. v.

Y Cross. S. Andrew.

Year. Symbols of the Church Year. Advent: a scroll of prophecy. Christmas: any of the Nativity symbols. Epiphany: a five-pointed star. The Transfiguration: three tabernacles. Lent: a scourge. Palm Sunday: palm branches. Maundy Thursday: Chalice and

host. Good Friday: Cross and crown of thorns, or any other Passion symbol. Easter Day: the phoenix, pomegranate, etc. The Ascension: Elijah's chariot. Whitsunday: the Dove, seven flames, etc. The Festival of the Holy Trinity: any of the Trinity symbols. The Annunciation: lily, fleur-de-lys, etc. The Visitation: two nimbed heads. The Purification: two turtle doves in a basket. Michaelmas: sword, shield and balances. All Saints' Day: souls of the righteous in the Hand of God.

Yellow. A non-liturgical color, symbolical of cowardice, disloyalty, treachery and of Judas. Orange or golden yellow: divine wisdom or goodness. Glory.

Yew. Immortality.

Yoke. Cain. Burden-bearing. The Law. Our Lord bearing our sins. Patient service. Trials. Meekness. Broken: Nahum.

Yod. A letter of the Hebrew alphabet. One or more yods within a circle of rays, or a triangle or two triangles: the name of God.

Zodiac. In the Mediaeval Church, the signs of the zodiac were sometimes used as a symbol of the dignity of labor. Also of the year.

BIBLIOGRAPHY

Symbolism and Archaeology

The Miroure of Man's Saluacionne. A Fifteenth Century Translation into English of the Speculum Humanæ Salvationis, etc., Privately Printed for the Roxburghe Club. 177 p., 4 to. London, 1888.

Speculum Humanæ Salvationis. Edited by J. Lutz and P. Perdrizet. 140 p., 145 plates. Leipzig, 1907-1909.

Biblia Pauperum. Reproduced in Facsimile from One of the Copies in the British Museum. 38 p., 40 plates, 4 to. London, 1859.

Durandus, G.: Rationale Divinorum Officiorum.

Durandus, G.: The Symbolism of Churches and Church Ornaments. A Translation of the First Book of the Rationale Divinorum Officiorum, by J. M. Neale and B. Webb. 252 p., 8 vo. Leeds, 1843.

Durantus, J. E.: De Ritibus Ecclesiæ. 4 to. Lugduni, J. Myt, 1518.

Lauchert, Fr.: Geschichte des Physiologus. 312 p. Strasbourg, 1889.

Du Cange, C.: Glossarium Mediæ et Infimæ Latinitatis. 7 vols., 4 to. Edited by G. A. L. Henschel, Paris, 1840-1850.

Crosnier, l'Abbé.: Iconographie Chrétienne. Caen, 1848.

Pugin, A. W.: A Glossary of Ecclesiastical Ornament and Costume. 245 p., 4 to., 73 color plates. London, 1846.

Didron, A. N.: Manual d'Iconographie Chrétienne. Paris, 1845.

Didron, A. N.: Histoire de Dieu, Iconographie des Personnes Divines. 600 p., 4 to . Paris, 1843.

Didron, A. N.: Christian Iconography. A Translation by E. J. Millington and Margaret Stokes. 2 vols., 8 vo. London, 1896.

Geldart, E.: A Manual of Church Decoration and Symbolism. 206 p., sm., 4 to. Oxford, 1899.

Barbier de Montault, X.: Traité d'Iconographie Chretiénne. 923 p., 2 vols., large 8 vo. Paris, 1890.

Audsley, W. and G. A.: Handbook of Christian Symbolism, 146 p., 8 vo. London, 1865.

Hulme, F. E.: Symbolism in Christian Art. 234 p., 8 vo. London, 1910.

Palmer, Wm.: An Introduction to Early Christian Symbolism. London, 1884.

Nieuwbarm, M. C.: Church Symbolism. 167 p., 8 vo. London, 1910.

Jenner, H.: Christian Symbolism. 192 p., 16 mo. London, 1910.

Tyrwhitt, R.: Christian Art and Symbolism. London, 1881. 262 p.

Clement, C. E.: A Handbook of Christian Symbols and Stories of the Saints. 349 p., 8 vo. Boston, 1886.

Smith, E. B.: Early Christian Iconography. 276 p., 4 to. New Haven, 1918.

Twining, L.: Symbols and Emblems of Early and Mediaeval Christian Art. 220 p., 8 vo. London, 1885.

Smith, H. J.: Illustrated Symbols and Emblems. 224 p., 4 to. Philadelphia, 1900.

Allen, J. R.: Christian Symbolism in Great Britain. 408 p., 8 vo. London, 1887.

Clement, C. E.: Chapters on Christian Symbolism. London, 1897.

Bailey, H. T. and Poole, E.: Symbolism for Artists, Creative and Appreciative. 239 p., 8 vo. Worcester, 1925.

Goldsmith, E. E.: Sacred Symbols in Art. 296 p., 8 vo. New York, 1912.

Heth, S. H.: The Romance of Symbolism. London, 1909.

Vinycomb, J.: Fictitious and Symbolic Creatures in Art. 276 p., 8 vo. London, 1906.

Evans, E. P.: Animal Symbolism in Ecclesiastical Architecture. 375 p., 8 vo. New York, 1896.

Collins, A. H.: Symbolism of Animals and Birds. 239 p., 8 vo. New York and London, 1913.

Neff, E. C.: An Anglican Study in Christian Symbolism. 238 p., 8 vo. Cleveland, 1898.

Bréhier, L.: L'Art Chrétien, son Développment Iconographique. 456 p. Paris, 1918.

Williams, M.: Christian Symbolism. 83 p., 8 vo. 1909.

Auber, C. A.: Histoire et Théorie du Symbolisme religieux avant et depuis le Christianisme. 4 vols. Poitiers, 1872.

Strzygowski, J.: Origin of Christian Art. 267 p., 46 pl., 4 to. Oxford, 1923.

Uvarov, A. S.: Khristianskaia Simvolika. 1908.

Mackenzie, D. A.: The Migration of Symbols and their Relations to Beliefs and Customs. 219 p., large 8 vo. New York, 1926.

Menzel, W.: Christliche Symbolik. 2 vols. Regensberg, 1854.

Cahier, C.: Mélanges d'Archéologie. 4 vols., folio. Paris, 1874-1876.

Cahier, C.: Noveaux Mélanges d'Archéologie. 4 vols. Paris, 1874-1877.

Piper, F.: Mythologie und Symbolik der christlichen Kunst von den aeltesten Zeit bis in das 16 Jahrhundert. 2 vols. 8 vo. Weimar, 1847-1851. Last part lacking.)

Kaufmann, C. M.: Handbuch der christlichen Archaeologie. 814 p., 8 vo. Paderborn, 1922.

Bennett, C. W.: Christian Archaeology. 608 p., large 8 vo. New York, 1908.

Walcott, M. E. C.: Sacred Archaeology. 640 p. London, 1868.

Bingham: Antiquities of the Christian Church. 9 vols., 8 vo. London, 1840.

Schultze, V.: Archaeologie der Altchristlichen Kunst. 2 vols. Fribourg, 1895-1897.

Augusti, J. C. W.: Handbuch der christlichen Archaeologie. 3 vols. Leipzig 1836-1837.

Barbier de Montault, X.: Iconographie du Chemin de la Croix. 1860.

Wall, J. C.: Devils, 152 p., 8 vo. London, 1904.

Wesseley, J. E.: Die Gestalten des Todes und des Teufels in der darstellenden Kunst. Leipzig, 1876.

Wilridge, T. T.: The Grotesque in Church Art. 228 p., 8 vo. London, 1899.

Lacroix, Paul: The Arts in the Middle Ages at the Period of the Renaissance. 520 p., 19 plates, 4 to. London, 1870.

Prior, Edwin S.: An Account of the Mediæval Figure Sculpture in England. 734 p., 8 vo. Cambridge, 1912.

Das Handbuch der Malerei von Berge Athos. Translated by G. Schaefer. 470 p. Trier, 1855.

Mabillon, J.: Vetera Analecta. 573 p. Paris, 1723.

Blunt, J. H.: The Annotated Book of Common Prayer. 610 p., 4 to. Oxford, 1876.

The Catacombs

Northcote, J. S. and Brownlow, W. R.: Roma Sotterranea. 2 vols. London, 1879.

Wilpert, J.: Roma Sotterranea. 2 vols., 549 p., 267 plates, 4 to. Rome, 1903.

Perret, L.: Catacombes de Rome. 6 vols., fo. Paris, 1850.

Fox, H. E.: Christian Inscriptions in Ancient Rome. 72 p., 8 vo. London, 1920.

Scott, B.: The Catacombs at Rome. London.

Bosio, A.: Roma Sotterranea. 704 p., 4 to. Rome, 1650.

Aringhi, P.: Roma Subterranea Novissima. 2 vols., fo. Paris, 1659.

Corpus Inscriptionum Latinarum. vol. 6. 1863.

De Rossi, G. B.: La Roma Sotterranea Christiana. 5 vols., fo. Rome, 1864-1879.

Bellermann, C. F.: Ueber die Aeltesten christlichen Begraebnissstaetten u. besonders die Katakomben zu Neapel. 4 to. Hamburg, 1839.

Maitland, C.: The Church in the Catacombs. 396 p. London, 1847.

Besnier, M.: Les Catacombes de Rome, 290 p., 8 vo. Paris, 1914.

Withrow, W. H.: The Catacombs of Rome. 560 p., 8 vo. New York, 1888.

Scott, B.: The Contents and Teachings of the Catacombs of Rome. 1860.

Lenormant: Les Catacombes. Paris, 1858.

Grousset: Etude sur l'Historie des Sarcophages Chrétiens. Paris, 1885.

Burgon, J. W.: Letters from Rome. London, 1862.

McCall: Christian Epitaphs of the First Six Centuries. Toronto, 1869.

Frothingham, A. L.: The Monuments of Christian Rome. 412 p., 8 vo. New York, 1908.

Hasenclever: Der altchristliche Graeberschmuck. Braunschweig, 1886.

Lundy, J. P.: Monumental Christianity. 459 p., 4 to. New York, 1882.

Lowrie, W.: Monuments of the Early Church. 432 p., 8 vo. New York, 1923.

Byzantine and Gothic Art

Wulff, O.: Altchristliche u. Byzantinische Kunst. 2 vols., 4 to. Berlin, 1914-1924.

Colasanti, A.: L'Arte Bisantina in Italia. 10 p., 100 plates. Milan, 1923.

Bayet, C.: L'Art Byzantin. 320 p. Paris, 1883.

Quast, A. F.: Die alt-christlichen Bauwerke von Ravenna. 50 p., 10 plates, fo. Berlin, 1842.

Dalton, O. M.: Byzantine Art and Archaeology. 727 p., 4 to. Oxford, 1911.

Dalton, O. M.: East Christian Art. 396 p., 4 to. Oxford, 1925.

Andrews, W.: Antiquities and Curiosities of the Church. 285 p. London, 1897.

Barvet de Jouy, H.: Les Mosaiques Chrétiennes des Basiliques at des Englises de Rome. Paris, 1857.

Viollet-le-Duc, E. E.: Dictionnaire Raisonné de l'Architecture Francaise, du 11me au 16me Siecle. 10 vols., 4 to. Paris, 1853.

Dehli, A.: Selections of Byzantine Ornament. 2 vols., fo. New York, 1890.

Baudot, A de: La Sculpture Francaise au Moyen Age et la Renaissance. 40 p., 120 plates. Paris, 1884.

Martin, C.: L'Art Gothique en France. 2 vols., 16 p., 80 plates, fo. Paris, 1913.

Garrucci, R.: Storia della Arte Cristiana. 6 vols., folio, 500 plates. 1880-1881.

Westlake, N. H. J.: History of Design in Mural Painting from the Earliest Times to the Twelfth Century. 2 vols. London and Oxford, 1902.

Franz: Geschichte der christlichen Malerei. Freiburg im Bresigau. 1897.

Glueck, H.: Die christliche Kunst des Ostens. 132 p., 4 to. Berlin, 1923.

Kraus, F. X.: Geschichte der christlichen Kunst. 2 vols., 4 to. Freiburg, 1896-1908.

Kendon, F.: Mural Paintings in English Churches During the Middle Ages. 238 p., 17 pl., 8 vo. London, 1923.

Rio, A. F.: De l'Art Chrétien. 4 vols. Paris, 1861-1867.

Weerth, E.: Kunstdenkmaeler des christlichen Mittelalters in den Reinlanden. 5 vols. Leipzig, 1857-1868.
York, 1908.

Cutts, E. L.: History of Early Christian Art. 368 p., 8 vo. London, 1893.

Male, E.: Religious Art in France. 414 p., 4 to . London, 1913.

Seta, A. della: Religion and Art. A Study in the Evolution of Sculpture, Painting and Architecture. 415 p., 55 pl., 4 to . London, 1914.

Taylor, H. O.: The Mediæval Mind. 2 vols., large 8 vo. New York, 1919.

Keyser, C. E.: Norman Tympana and Lintels. 65 p., 4 to. London, 1904.

Adams, Henry: Mont-Saint-Michel and Chartres. 400 p., 4 to. Boston and New York, 1913.

Stabb, J.: Devon Church Antiquities. 152 p., 8 vo. London, 1909.

Stabb, J.: Some Old Devon Churches. 152 p., 125 plates, 8

Spelman, H.: The History and Fate of Sacrilege. 355 p., 8 vo. London, 1698.

Walcott, M. E. C.: The Minsters and Abbey Ruins of the United Kingdom. 256 p., 8 vo. London, 1860. vo. London, 1908.

Gasquet, F. A.: Henry VIII and the English Monasteries. 2 vols., 8 vo. London, 1895.

Cram, R. A.: The Ruined Abbeys of Great Britain. 315 p., 8 vo. London, 1906.

Beedham, L. E.: Ruined and Deserted Churches. 106 p., 8 vo. London, 1908.

The Saints

Cahier, C.: Charactéristiques des Saints dans l'Art. Populaire. 2 vols. Paris, 1867.

Drake, M.: Saints and their Emblems. 235 p., 11 pl., 4 to. London, 1916.

Baring-Gould, S : Lives of the Saints. 16 vols., 8 vo. Edinburgh, 1914.

Tabor, M. E.: The Saints in Art. 208 p., 8 vo. London, 1924.

Butler, A.: Lives of the Saints. 12 vols., 8 vo. New York, 1895.

Ditchfield, P. H.: Symbolism of the Saints. Oxford, 1910.

Green, E. A.: Saints and their Symbols. 190 p. London, 1885.

Radewitz, J. M. von: The Saints in Art. Rome, 1898.

Bles, A. de: How to Distinguish the Saints in Art by their Costume, Symbols and Attributes. 168 p., 4 to. New York, 1925.

Clement, C. E.: The Saints in Art. 428 p., 8 vo. London, 1899.

Clement, C. E.: A Handbook of Legendary and Mythological Art. 541 p., 8 vo. Boston, 1880.

Bell, A.: The Saints in Christian Art. 3 vols., large 8 vo. London, 1902-1904.

Bond, F.: Dedications and Patron Saints of English Churches. 343 p., 8 vo. Oxford, 1914.

Jameson, Mrs.: Sacred and Legendary Art. 2 vols. London, 1870.

Jameson, Mrs.: History of Our Lord in Art. 2 vols., 860 p., 8 vo. London, 1890.

Jameson, Mrs.: Legends of the Madonna. 344 p., 8 vo. London, 1890.

Jameson, Mrs.: Legends of the Monastic Orders. 461 p., 8 vo. London, 1890.

Heraldry

Fox-Davies, A. C.: Complete Guide to Heraldry. 647 p., large 8 vo. London, 1925.

Fox-Davies, A. C.: The Art of Heraldry. 503 p., 153 plates, folio. London, 1904.

Whitmore, W. H.: Elements of Heraldry. 106 p., large 8 vo. New York, 1866.

Cussans, J. E.: Handbook of Heraldry, 353 p., 8 vo. London, 1893.

Aveling, S. T.: Heraldry. London.

Grant, F. J.: The Manual of Heraldry. 142 p., 8 vo. Edinburgh, 1924.

Rothery, G. C.: The A. B. C. of Heraldry. 359 p., 8 vo. Philadelphia, 1915.

Stained Glass

Drake, M.: History of English Glass Painting. 226 p., 35 plates. London, 1912.

Winston, C.: Memoirs Illustrative of the Art of Glass Painting. London, 1865.

Winston, C.: An Inquiry into the Difference of Style Observable in Ancient Glass Paintings. 2 vols., large 8 vo. Oxford, 1847.

Winston, C.: Styles in Ancient Glass Painting. 2 vols. Oxford, 1847.

Westlake, N. H. J.: History of Design in Painted Glass. 4 vols., folio. London, 1881-1894.

Day, L. F.: Windows. A Book about Stained and Painted Glass. 420 p., large 8 vo. London, 1909.

Day, L. F.: Stained Glass. 115 p., 30 plates, 8 vo. London, 1913.

Martin and Cahier: Monographie de la Cathédral de Bourges ou Vitraux de Bourges. Paris, 1841-1844.

Hucher, E. F. F.: Vitraux Peints de la Cathédrale du Mans. 82 p., 20 pl., folio. Paris and Le Mans, 1865.

La Vieils: La Art de Peinture sur Verre et de la Vitrerie. Paris, 1774.

Langlois, E. H.: Essai Historique et Descriptif sur la Peinture sur Verre. 300 p., 7 pl., 8 vo. Rouen, 1832.

Lasteyrie, F. C. L.: Historie de la Peinture sur Verre. 2 vols., 314 p., 110 plates, folio. Paris, 1857.

Sherrill, C. H.: A Stained Glass Tour in England. 245 p., 16 pl., large 8 vo. London and New York, 1909.

Sherrill, C. H.: Stained Glass Tours in France. 285 p., 12 pl., 8 vo. New York, 1908.

Sherrill, C. H.: Stained Glass Tours in Spain and Flanders. 245 p., 8 vo. New York, 1924.

Sherrill, C. H.: A Stained Glass Tour in Italy. 174 p., 32 pl., 8 vo. London and New York, 1913.

Whall, C. W.: Stained Glass Work. 380 p., 8 vo. New York, 1905.

Nelson, Ph.: Ancient Painted Glass in England. 280 p., large 8 vo. London, 1913.

Bushnell, A. J. de H.. Storied Windows. 338 p., 8 vo. New York, 1914.

Werck, Alfred: Stained Glass. 167 p., large 8 vo. New York, 1922.

Holiday, H.: Stained Glass as an Art. 173 p., 20 pl., 4 to. New York, 1896.

394 BIBLIOGRAPHY

Arnold, H., and Saint, L. B.: Stained Glass of the Middle Ages in England and France. 269 p., 8 vo. London, 1913.

Balet, L.: Schwaebische Glasmalerei. 165 p., 8 pl., 4 to. Stuttgart and Leipzig, 1912.

Gessert, M.: Geschichte der Glasmalerie. 312 p., 8 vo. Stuttgart, 1839.

Suffling, E. R.: A Treatise on the Art of Glass Painting. 144 p., 8 vo., London, 1902.

Eden, F. S.: Ancient Stained and Painted Glass. 160 p., 8 vo. Cambridge and New York, 1913.

Meison: Les Vitraux.

Dillon, Edw.: Glass. 373 p., 49 plates, 4 to. London, 1907.

Lind, K.: Meisterwerke der Kirchlichen Glasmalerei. 7 p., 50 color plates, folio. Vienna, 1894-1897.

Fischer, J. L.: Handbuch der Glasmalerei. 318 p., 135 plates, large 8 vo. Leipzig, 1914.

Le Couteur, J. D.: English Mediæval Painted Glass. 184 p., 8 vo. London, 1926.

Read, H.: English Stained Glass. 260 p., 29 plates, 4 to. London and New York, 1926.

Connick, Chas. J.: Adventures in Light and Color 428. XXII pp. 36 color plates. New York, 1937.

Wood Carvings

Bond and Camm: Rood Screens and Rood Lofts. 2 vols., 448 p., 4 to. London, 1909.

Howard and Crossley: English Church Woodwork. 370 p., 4 to. London, 1917.

Bond, F.: Screens and Galleries in English Churches. 192 p., 8 vo. Oxford, 1908.

Bond, F.: Fonts and Font Covers. 374 p., 8 vo. Oxford, 1908.

Bond, F.: Wood Carvings in English Churches. 2 vols., 375 p., 8 vo. Oxford, 1910.

Bond, F.: The Chancel in English Churches. 274 p., 8 vo. Oxford, 1916.

Cox, J. C.: Pulpits, Lecterns and Organs. 228 p., 8 vo. Oxford, 1915.

Cox, J. C.: Bench Ends in English Churches. 208 p., 8 vo. Oxford, 1916.

Cox, J. C.: English Church Fittings, Furniture and Accessories. 320 p., large 8 vo. London, 1923.

Cox, J. C., and Harvey, A.: English Church Furniture. 397 p., large 8 vo. New York, 1907.

Seymour, W. W.: The Cross in Tradition, History and Art. 489 p., 4 to. New York and London, 1898.

Tyack, G. S.: The Cross in Ritual, Architecture and Art. 126 p., 8 vo. London, 1896.

INDEX TO THE TEXT

NOTE: The Introduction and the Preface are not included in this index. Since the list of decorative crosses, the list of saints and the items in the glossary are all alphabetically arranged, it was thought best not to include these items in the index.